TIMES OF THE
TECHNOCULTURE

The late twentieth century has seen a rapid succession of technological innovations, from the silicon chip to the Internet and virtual reality, each development accompanied by intense public debate, combining anxieties about change and upheaval with excitement at the new possibilities for democracy, education and recreation in the 'knowledge society'. But how much faith should we place in technology's ability to improve our lives?

Times of the Technoculture explores the issues surrounding technological change, from the politics of information to questions of culture and identity in cyberspace. Engaging with contemporary debates surrounding the Internet, the authors challenge the vision of a new world of virtual society and community. Scrutinising the unfettered optimism of corporate figures such as Bill Gates, Robins and Webster question whether the new information and communications technologies justify the utopian rhetoric with which they are promoted, suggesting, in fact, that they work to reproduce conservative social practices under a new guise.

Times of the Technoculture explores the social and cultural meaning of new technologies, tracing developments from the 'coming of the machine' with the Industrial Revolution and the development of mass production in the early twentieth century to the information revolution and the global network society. It looks at how the military has influenced the development of the information society, how commercial imperatives have determined its course, and how government has sought to guide its direction. Robins and Webster provide a wide-ranging discussion that moves from virtual spaces to the military information society; from the history of propaganda to the politics of education; and from the marketing of progress to the meaning of Luddism.

Kevin Robins is Professor of Communications, Goldsmiths College, University of London. **Frank Webster** is Professor of Sociology in the Department of Cultural Studies and Sociology at the University of Birmingham.

COMEDIA
Series Editor: David Morley

TIMES OF THE TECHNOCULTURE

From the information society to the virtual life

Kevin Robins and Frank Webster

London and New York

First published 1999
by Routledge
11 New Fetter Lane, London EC4P 4EE

Simultaneously published in the USA and Canada
by Routledge
29 West 35th Street, New York, NY 10001

Routledge is an imprint of the Taylor & Francis Group

© 1999 Kevin Robins and Frank Webster

Typeset in Garamond by Routledge
Printed and bound in Great Britain by MPG Books Ltd, Bodmin

British Library Cataloguing in Publication Data
A catalogue record for this book is available from the British Library

Library of Congress Cataloging in Publication Data
A catalogue record for this book has been requested

ISBN 0–415–16115–0 (hbk)
ISBN 0–415–16116–9 (pbk)

CONTENTS

CONTENTS

INTRODUCTION
The changing technoscape

Over the past two decades or so, there has been the constant sense that we are going through a period of particularly rapid and intensive change. Indeed, it has been frequently argued that this last quarter of the twentieth century is without precedent in the scale, scope and speed of historical transformation. The only certainty for the future, we are told, is that it will be very different from today, and that it will become different more quickly than ever before. No-one will be able to absent themselves from these great transformations, no-one's daily life will be immune from the upheaval and turmoil of change. And, of course, we are told that the reason for these escalating transformations – the reason for their necessity and inevitability – is technological revolution. The idea of technological revolution has become normative – routine and commonplace – in our technocultural times.

The discourse of technological revolution has taken a rapid succession of forms. At the end of the 1970s, the principal concern was with the silicon chips that made the new technologies possible, and the talk was of the 'microelectronics revolution'. A little later, the concern shifted to the capacity of the new technologies to process and store information, and we heard about the 'IT revolution'. Then, through the 1980s, interest turned to the communications function of the new technologies, and the revolution was said to be one in both information and communications technologies (ICTs). There was growing interest, into the 1990s, in the Internet, with plans to inaugurate the 'information superhighway', and with projected scenarios for the global 'network society'. Now, at the end of the 1990s, the agenda is commonly defined in terms of 'cyber-revolution' and the advent of the 'virtual society'. We may regard these changing discourses on techno-logical revolution as reflecting the changing technoscape of the last twenty years.

Over this period, the pubic discussion of the new technologies has taken a variety of forms, with different social and political issues becoming salient as the nature and significance of technological innovation has seemed to change. During the early 1980s, the prime concern was with the likely effects of 'IT' on work and employment. Many commentators regarded the

new 'heartland' technology as a 'job killer', foreseeing the 'collapse of work', with implications not only for the shop floor in manufacturing industries, but also, and increasingly, for the service sector and even for many manage-rial functions. At this time, there was even speculation about the reorgani-sation of work – through a shorter working week, early retirement, shared jobs, regular sabbaticals, etc. – and the possible creation of a 'leisure society'.[1] Through the 1980s, concern was centred on both the economic and political significance of the 'information society'. There were questions posed about the shift to a 'post-industrial society', in which new types of occupation would predominate, particularly in the service sector, where new educational initiatives would be necessary to provide the workforce with the requisite skills. At the same time, there were debates about equity issues in information skills and resources, with concerns about the division between the 'haves' and the 'have nots', the 'information rich' and the 'information poor'. The policy agenda was concerned with finding a balance between the imperative of economic competitiveness, on the one hand, and questions of social justice and public culture, on the other.

More recently, we have seen a shift in the nature of the debate on new technologies. The economic realities of globalisation have eclipsed some of the more idealistic aspects of what we might now call the early information age. The new information agenda is entirely pragmatic in its concern to adapt to the conditions of the global economy. In Britain, New Labour aspires to make Britain the 'knowledge capital of Europe'. Now it is a question of developing the information resources and the information skills necessary to compete in world markets. The economic priority is to foster the development of the new class of what Robert Reich has called 'symbolic analysts'.[2] These are the information and knowledge specialists who are engaged in 'managing ideas', and who possess the 'intellectual capital' that will be crucial for success in the new 'enterprise networks' of twenty-first century capitalism. Consequently, the education system must be geared up to turn out the new generation of information workers and promote a new work ethic (no talk now of a coming leisure society).

At the same time, however, that we have seen this new realism, there has also been a new strand of idealism, associated with a cultural appropriation of the technological agenda. A distinctive technoculture emerged in the 1990s, fired with enthusiasm for what were perceived as the emancipatory possibilities of 'cyberspace' and 'virtual reality'. There have been those who see the possibilities of using the new virtual technologies to enhance democracy, and they have put forward schemes for the development of the 'electronic agora'. There has also been a strong interest in the possibilities of using network technologies to build 'virtual communities', groups of people globally linked together on the basis of interest and affinity, rather than the 'accident' of geographical location.[3] Virtual communitarianism has been a significant theme in recent years – no doubt as a compensation for the

disruptive effects of economic globalisation. There has also been a cultural agenda concerned with the implications of cyberspace for questions of identity. This has manifested itself as an aspect of popular culture – movies, fiction, magazines, etc. – around the theme of 'cyberpunk', with the fiction of William Gibson as a reference point.[4] The figure of the 'cyborg' (part cybernetic, part organic) has also become the focus for debates around human 'nature', with important questions being raised about embodied and disembodied identities.[5] The technoculture has moved a long way since the heroic days of the 'mighty micro'.

This, then, has been the changing shape of the technoscape. The overall shift, over the last twenty years or so, has been from a political economic to a cultural perspective. There has been an opening up of the agenda, from a concern with the information society to an interest in the virtual life. Rather than being about the displacement of older agendas by new ones, we would describe the process as one of broadening and accumulation of agendas and perspectives. The technocultural project, as it is concerned with information and communications technologies, now embraces a very broad range of issues – from economic policy to virtual popular culture – and consequently mobilises a variety of discourses. Given this range, there has tended to be a fragmentation in the public debate on new technologies – a consequence of the ever more refined intellectual and academic division of labour. Those interested in cyberpunk will have little to say about the information economy. Those who have something to say about virtual community will know little about the military information society. And those who specialise in communications policy will contribute little to debates on education and training in the information society. In this book, we have sought to bring together as many of these agendas as we could, and we mobilise a range of discourses – economic, political and cultural. We think it is important to be engaged as much with the political economy of the information society as with the cultural politics of the virtual society.

Times of the Technoculture is the product of a long engagement with these issues. We have followed the changing course of debates since we first started writing about information technologies at the end of the 1970s.[6] In this book, we have tried to give a sense of the contours of change since the politics of information technology first came on the agenda. We sustain the discourses of the 1980s, but also take up the approaches and perspectives that have characterised the new cultural orientation of the 1990s. We hope, then, that this book will help to bridge the divide between political economy and cyberculture agendas. The range of issues covered is broad: from virtual spaces to the military information society; from the history of propaganda to the politics of education; from the marketing of progress to the meaning of Luddism. In bringing together agendas that normally stay separate, we want to contribute towards broadening the debate on new technologies. And we want to do so in the direction and spirit of critical interrogation.

At this point it might be useful to say a little about our own leanings and dispositions with respect to the range of issues under consideration. First, we should say that our perspective is a political one. This is immediately apparent in the way that we think about the nature of technologies. We have always rejected the approach to technologies that regard them as socially neutral – an approach that thinks of value-free technologies as having 'impacts' upon the social realm, that tends to think in terms of 'technical fixes' for social problems, and that tends towards technologically deterministic accounts of social change. In our view, technologies always articulate particular social values and priorities. Indeed, we may see technologies as articulating the social relations of the societies in which they are mobilised – and, of course, that must mean articulating the power relations. Within our own society, then, we need to be concerned with the way in which technologies mediate capitalist social relations. On this basis, our account has a strong political-economic orientation, critically exploring the capitalist mobilisation of social and human resources, and the ways in which new technologies have been implicated in this process. Our understanding of 'information' similarly seeks to go beyond technical interpretations, to argue that information is also a social relation. In considering the new cyberculture, too, we are concerned with how it relates to the prevailing power relations. Our judgement of the prevailing virtual culture is that it lacks critical edge with respect to the (capitalist) dynamics of the network society. While there was a good deal of resistance to corporate logics in the 1980s, the present decade has been characterised by relative political quiescence. It is sometimes easy to feel that virtual communitarians and cyberpunk enthusiasts simply function as promotional aids for the cause of Microsoft.

Second, we argue that, in order to understand the nature and significance of contemporary developments, it is necessary to situate them in a historical context. Most accounts of the 'information revolution' have tended to think of it as entirely new and unprecedented – something that came out of the blue (and, of course, something to which we must now adapt). Our own approach is concerned with where the information society actually came from – which, after all, isn't such a mystery. In Part I we consider the most fundamental origins in the context of historical capitalism. For what is unfolding now is the continuation of what was set in motion in the early nineteenth century: what we now call the global information economy is, we argue, the most recent expression of the capitalist mobilisation of society. In Part II of the book, we look more closely at the long history of the twentieth-century 'information revolution' itself. This takes us back to the early decades of the century, where we can identify the origins of organised and systematic information gathering, analysis and distribution, in the workplace, in the organisation of consumption, and in political relations. Like James Beniger, we consider that this period marked the real take off of the twentieth-century 'control revolution'.[7] Our insistence on a historical

perspective is also motivated by the desire to identify continuities in the development of the new technology agenda. Whilst we recognise that there are certain kinds of innovation, we want to suggest that there is much about the 'information revolution' that is just business as usual (if the technologies are new, the social visions that they generate tend to be surprisingly conservative).

Third, we should say something here about the prevailing tendency to judge all accounts of technological innovation according to the simple and binary measure of 'optimism' versus 'pessimism', and particularly about our response to this way of organising the debate on new technologies. There are many now who seem to feel that their optimism about the new 'challenges' and 'opportunities' should be regarded as some kind of mark of personal distinction. Let us give an example. In his book, *The Road Ahead*, Bill Gates can't resist telling us how optimistic he is (and of course, he wants to persuade his readers that they would do well to be similarly optimistic). What inspires his optimism, he tells us, is the prospect of a 'revolution in communications', associated with the Internet and its future transformation into a global 'information highway'. 'We are watching something historic happen', Gates intones, 'and it will affect the world seismically, rocking us in the same way the discovery of the scientific method, the invention of printing, and the arrival of the Industrial Age did.'[8] From this historic event, Gates maintains, we have everything to expect.

> The network will draw us together, if that's what we choose, or let us scatter ourselves into a million mediated communities. Above all, and in countless new ways, the information highway will give us choices that can put us in touch with entertainment, information, and each other.[9]

Of course, a revolution of this kind must confront some difficulties (described as 'unanticipated glitches'), but 'despite the problems posed by the information highway', Gates concludes, 'my enthusiasm for it remains boundless'.[10] Such is the extent of his optimism.

Now, we have always felt compelled to reject the shallow and crass quality of argumentation in this kind of techno-boosterism. We simply do not accept the premises of this wishful marketing discourse, with its magical vision of new technologies as the solution to all our social ills – promoting participatory politics, material comfort, improved pedagogy, better communications, restored community, and whatever else you might think of. So *Times of the Technoculture* should be read as an antidote to *The Road Ahead*. We just don't believe that everything will turn out for the best so long as 'progress' is allowed to continue unhindered. We've heard that one before. Throughout this century, it is what we have been told every time a new technology has come along. And the hype has never yet been substantiated. On what grounds, then, should we believe that this new technology is

5

any different from all the new technologies that went before? We are inclined, on the basis of what seems to us good evidence, to be sceptical about the claims of Gates and his fellow-travelling optimists. And it is this scepticism that evidently makes 'pessimists' of us. Within the framework in which the agenda is cast, how in fact could we be perceived in any other way?

Now, if 'pessimism' was just the badge of those who scrutinised the (historical) evidence in coming to a judgement, that would be fine. But, of course, there is a great deal more to it than that. For pessimism is always associated with some kind of unfortunate psychological disposition or sensibility, or with some kind of melancholic metaphysical orientation.[11] The pessimist is regarded as someone who is 'pessimistic by nature' – in the same sense that, in his book *Being Digital*, Nicholas Negroponte declares that he is 'optimistic by nature' (because the technological revolution that he has such belief in is 'like a force of nature').[12] It is this caricature that we reject. In so far as you might choose to regard *Times of the Technoculture* as pessimistic, we would say that it is pessimism as a form of social analysis and societal valuation, grounded in historical experience, and that there is very substantial empirical evidence for its sceptical conclusions. Without such 'pessimism' there would only be conditioning and acquiescence in the technological order (which is precisely what the self-avowed optimists seem to want). So there is 'pessimism' of a kind, if you want. But in the more fundamental and serious sense, we would argue, this is not at all a pessimistic book. It would only be so if we saw no alternative to the new technological order. But a central argument of *Times of the Technoculture* is that the debate must be extended well beyond the technological agenda. The critique of technology cannot just be a technological matter. We must be concerned to explore the limits of the technoculture in the name of values that are more important and worthwhile. Those values will be in part directed against the new technologies, but more importantly against the capitalist imperative that drives and shapes the new technology agenda. Against the simplistic technoculture and its drive towards technological order and virtual community, we would wish to counterpose more complex and challenging cultural and political values. Against technological 'empowerment', we counterpose political freedom.

It is in this context that Luddism serves as an important motif in our argument. Drawing on the work of Edward Thompson, we have sought to rescue Luddism from the scorn of those who sing the praises of 'progress', arguing that Luddism provides us with an illuminating way of reflecting on technological change. We may see in the historical moment of Luddism a movement not against technology *per se* (though technology was indisputably a key issue), but one that was mounting a protest against far more widespread changes in ways of life, as older forms of 'custom and practice' gave way to the new social mobilisations of *laissez-faire* capitalism in the opening decades

of the nineteenth century. Luddism was a response to deep-seated changes in ways of life, changes in which technology was undeniably implicated, but which were about much more than mere technical matters. What the Luddites were fighting against, more broadly, was the unfolding logic of the Enclosures movements. The Enclosures (particularly in the period between 1760 and 1820) were fundamentally about bringing realms that had hitherto been exempted into the new and expanding commercial relationships that marked the growth of capitalism. Former ways of providing food and sustenance – strip farming, labour relationships based on obligation and deference, widespread access to, and availability of, common land for grazing, hunting and collection of fuel – were denuded and done away with in the name of efficiency, progress and private property rights. In the process, agriculture was radically marketised, the farm labourer lost rights of access to land, and common land was privatised.[13] A large component of the new industrial workforce was created by these developments, as dispossessed land labourers were forced, through dire necessity, to seek employment in the growing towns. The logic of enclosure was the logic of the new capitalist order, and it was this alien order that the Luddites were seeking to resist.

How is this relevant to the 'information revolution'? At the end of the twentieth century, we would argue, what is referred to as the 'global network society' may be thought of in terms of the forward march of the Enclosure movements, in terms, that is to say, of the further and rapid extension of the reach of market criteria and conditions. This process has both extensive and intensive dimensions. It promises to enclose the entire globe, creating what Stephen Gill has called the 'global panopticon',[14] as it introduces commercial rules and regulations which drive out alternatives everywhere (customary practices, public provision, non-market habits). And it threatens to penetrate ever deeper into private, and previously sacrosanct, realms of life (leisure, child-rearing, domestic activities, even identities). We may speak now, for the first time in human history, of the entire planet being organised around a single set of economic principles (profitability, accumulation, private property, provision on the basis of ability to pay, competition in the marketplace) which are capable of being operationalised in real time across distance, and which seek to penetrate deep into the intimate spheres of everyday life. To be sure, not everything has yet been touched nor every place incorporated, yet the reach of globalised capitalism is of a scale and scope that dwarfs anything that ever went before. And the development of these new Enclosures is being massively facilitated by the introduction of information and communications technologies. Our critique of the new technologies must be situated in this broader political perspective, which is also a perspective on the logic of contemporary culture.

It is in this context that we take the opportunity, in Part I, of clarifying our conceptual approach by examining a variety of 'techno-visions'. To this end,

in Chapter 1 we review Humphrey Jennings' project to capture the meanings of the 'coming of the machine'[15] in Britain. Jennings, for too long regarded as merely a talented film-maker and aesthete, emphasises that industrialisation is not simply a matter of technological adaptation and associated changes in employment, productivity and such like. It is about these matters, but it is simultaneously about much more, about oceans of life that are excluded by such a miserable conception. Jennings' great book, *Pandaemonium*, does attend to these obvious features of the growth of industrial capitalism, but it also pays attention to associated changes in the means of creativity, culture and imagination. In such ways can we better appreciate the range and depth of the Enclosures that the 'information society' portends, while yet remaining open to possibilities that emerge. Chapter 2 then details our engagement with Luddism, endeavouring to better understand the Luddite movement in historical context, the better to take from this a more adequate comprehension and apprehension of change in the present day. Following this, in Chapter 3 we offer a critique of the recurrent language of 'progress' which seemingly accompanies each technological innovation. We examine here popular approaches to information and communications technologies, and latterly to information itself, identifying – and rejecting – the common features of these accounts.

In Part II we present a series of essays on the genealogy of the 'information age', something consonant with our stress on coming to terms with the historical roots of the present day. This extends our historical examination of Luddism to consider further features of change. Chapter 4 centres on the emergence and development, early in the twentieth century, of Scientific Management as a key element in the spread of the 'information revolution'. In this way we are able to underline a dual tendency: at once a movement towards social planning and control and, simultaneously, the growth of surveillance and control through wide sectors of social, economic and political life. In Chapter 5 we develop this argument further, in terms of the 'rational madness' of technological rationalisation and ordering. Drawing on the concepts of Jean-Paul de Gaudemar, we consider how knowledge and knowledge technologies have been implicated in the logic of social mobilisation, increasingly beyond the sphere of production and into the broader social realm. Chapter 6 re-emphasises the importance of the inter-war years in highlighting the significance of a neglected dimension of information – propaganda. Yet we see this as an integral aspect of the growth of planning and control, something acknowledged by major thinkers of the time such as Harold Lasswell and Walter Lippmann, but strangely neglected since.

In Part III of this book we turn to the politics of cyberspace, to examine several issues and areas. In Chapter 7 we centre on the military role in the making and perpetuation of the 'information society', not least because it is readily overlooked in the euphoria for the 'post-industrial' era of peace and

plentitude. We argue, to the contrary, that the military principle of 'command and control' is at the cutting edge of informational developments and that it is integrally connected to the wider search for order and control within and even without nation states. Any account of the 'information society' which attempts to relegate this, the realm of 'information warfare', is incapable of adequately appreciating what is happening in the world today. Chapters 8 and 9 focus on education, first in schools and colleges, then in the universities. We do so because so much comment on education is excessively narrow when conceived by educationalists, and at the same time because education now occupies a pivotal position amongst politicians' ambitions to guide entry into a 'knowledge society' as smoothly and as successfully as is possible. Investment in education (increasingly viewed from the perspective of 'human capital') as the privileged means to ensure economic success, and new patterns of control and discipline to be introduced by the education system, constitute a major 'technoscape' in consideration of the 'information age'. We scrutinise these ambitions, offer a critical analysis of them, and in so doing connect educational developments to wider forces and direction of change in society.

Part IV engages with currently popular themes, ones which thrive amidst conceptions of the 'virtual society' of the Internet, cyberspace and the information superhighway, and which, taken together, make up another technoscape. Here we find the vibrant hope that ICTs will revive community relationships, improve communications, and in general enhance the democratic process and public participation, all the while enriching cultural life. In Chapter 10 we cast a jaundiced eye on such aspirations for the 'virtual life', while questioning also the tacit goal – an ordered, stable and integrated world – of so much of the commentary. Chapter 11 develops this argument, concerning itself with the subject of virtual spaces, and contesting the ideals of electronic community and interaction.

PART I

TECHNO-VISIONS

1

A CULTURAL HISTORY OF PANDAEMONIUM

Humphrey Jennings (1907–50) is now remembered primarily as a documentary film-maker, associated with the Grierson school in the 1930s and creator of a series of influential patriotic films during the war. In histories of the cinema he is catalogued as the quintessential British director: 'he had his theme, which was Britain; and nothing else could stir him to quite the same response'.[1] More precisely, he was the voice of war-time Britain, 'for it was the war that fertilised his talent and created the conditions in which his best work was produced'.[2] It was against this martial background, Erik Barnouw argues, that Jennings – 'virtually a wartime poet-laureate of the British screen' – 'performs his speciality: the vignette of human behaviour under extraordinary stress'.[3] According to Lindsay Anderson, upon whose interpretation of Jennings' films the critical orthodoxy has been built, he 'is the only real poet the British cinema has yet produced'.[4] But, Anderson adds, 'it needed the hot blast of war to warm him to passion', for 'by temperament Jennings was an intellectual artist, perhaps too intellectual for the cinema'.[5] Poet, patriot, intellectual – these epithets identify the eccentric location of Humphrey Jennings in British film histories.

But alongside the celebratory paeans to Jennings the incomparable film-artist, one also frequently detects an uncomfortable note. There is the feeling that Jennings was only ever coincidentally a film-maker and that his real interests lay elsewhere. Jennings' friend Gerald Noxon has suggested that his real interest was in painting and that 'if Humphrey had inherited anything like an adequate independent income, he would have left film work and gone back to painting as the main occupation of his life'.[6] Charles Dand believes that 'Jennings was interested in film for art's sake',[7] and sees in him the 'painter's eye, poet's imagination, and critic's mind – a powerful combination of gifts. Too powerful perhaps'.[8] The common sentiment here is that Jennings' restless and protean talent could not be held within the confines of documentary film-making. What both Noxon and Dand are seeking to identify is the scope, originality and complexity of Jennings' intellectual and aesthetic endeavours. And, despite its somewhat romantic

inflexion, this assessment most certainly comes closer to a true evaluation of Jennings than the narrower accounts of his cinematic 'genius'.

Jennings' interests and concerns were extraordinarily wide-ranging and his films were only one aspect of a larger, panoramic and kaleidoscopic, project that involved him also in Mass Observation and the Surrealist Movement, as well as the *Pandaemonium* enterprise with which this chapter is concerned.[9] It is in the totality of these involvements that the coherence and importance of Jennings' work (as both practitioner and theoretician) may be seen. What this amounts to, we shall argue, is in fact an extraordinarily original, inventive and sustained intervention in British cultural life. It was an attempt, as David Mellor argues, to 'find paths through the morass of contemporary British culture' in order to 'reconstellate' that culture.[10] As such it was a Herculean project that involved Jennings in painting, photography, poetry, sociology, social history and philosophy – a perceptive contemporary observer noted 'the encyclopaedism that he extols and seeks to express in himself'.[11] It was no doubt in the nature of this encyclopaedic enterprise – and not just because of Jennings' premature death – that it should have remained fragmentary and incomplete. Only now are we becoming aware of its status as an exemplary modernist cultural undertaking, one that was animated by a constantly innovative, nomadic and transgressive spirit.

The nature and intensity of what one might almost call Jennings' existential enterprise became all the more clear with the posthumous publication in the mid-1980s of his *Pandaemonium* project. This massive documentation of the cultural impact of the Industrial Revolution and of Enlightenment thinking was fundamental to his preoccupations throughout the last twelve or so years of his life – at his death, James Merralls tells us, 'the materials collected for this work filled a tea chest'.[12] Today it appears isolated from the contexts that once made it meaningful. It speaks louder, as we shall argue, when it is relocated within the intellectual and artistic environment in which it was engendered, but even adrift in time, sixty years after its first conception, it is a powerful and vocal document. What it addresses is an issue that is of perhaps even greater concern and urgency than ever: the relation between science, technology and industrialisation, on the one hand, and the way of life, culture and subjectivity, on the other. As Murray Bookchin has written, the crucial problem we face today is that of 'the function of imagination in giving us direction, hope, and a sense of place in nature and society'.[13] This too was the great and overriding concern of Humphrey Jennings. George Pitman recalls a meeting: 'Jennings was arguing with me about the basic problem that, in his view, the film director (i.e., he, himself) has to solve. "It's the whole question", he said; somewhat cryptically, "of imagination in an industrial society"'.[14] The imaginative history of the Industrial Revolution, *Pandaemonium*, is Jennings' epic and heroic exploration of this theme. It is something from which all of those engaged in attempting to understand the present super-industrial epoch

may learn much. We seek here to reclaim the legacy of Humphrey Jennings almost half a century after his death, to restate the abiding relevance of Jennings' concerns and approach to understanding change.

What *Pandaemonium* makes clear is that Humphrey Jennings was far more than an idiosyncratic, unclassifiable documentary film-maker. This monumental documentation of the Industrial Revolution, along with his involvement in Mass Observation and the Surrealist Movement, make up an *oeuvre* of considerable moral, aesthetic and political complexity. Jennings' concerns and involvements, we believe, place him in the mainstream of British intellectual history. This is the tradition of what Fred Inglis has called 'radical earnestness', which has been involved over the last 200 years in 'rewriting the deep contradictions of Romantic feeling and Enlightenment rationalism'.[15] It is the 'culture and society' tradition that Raymond Williams so intricately traced; that line of thinking, rooted ultimately in the Romantic Movement, that has concerned itself with the historical relationship between culture, in its multiple senses, and the process of industrialisation.[16] More specifically, it is Edward Thompson's Romantic and utopian tradition of English socialism, which, at its finest, has articulated 'a rebellion of value, or aspiration, against actuality'.[17] It is within this transformed Romantic tradition, elaborated with different emphases in the accounts of Inglis, Williams and Thompson, that Humphrey Jennings surely belongs. At its most critical and radical, moral force is transformed into utopian imagination.

Like William Morris, Jennings sees not just the degradation of nature – human and physical – by the machinery of commerce and industrialism, but, more radically, he sees through the underlying relations of power. In the case of both internal and external nature, he is sensitive to that return of the repressed that haunts industrial capitalism in all its stages. For Jennings, again like Morris, the lessons of history inspire, not nostalgia or reaction (as with so much of the 'Culture and Society' tradition), but an awareness of the 'power to come' and of the possibilities for political and imaginative creativity and innovation.

CAMBRIDGE AND SURREALISM

The Imagination is not a State: it is the Human Existence itself.
(William Blake, *Milton*)

But to the Eyes of the Man of Imagination, Nature is Imagination itself. As a man is, So he Sees.
(William Blake, Letter to Dr Trusler, 23 August 1799)

In order to appreciate fully *Pandaemonium* it is first necessary to place it in the context of Jennings' intellectual development. Unrealised in his lifetime,

this ambitious project was companion to all Jennings' other involvements. At the heart of them all were the interrelated questions of the place of imagination under industrial capitalism, and the place of science in the total field of knowledge.

Humphrey Jennings was brought up in a household strongly influenced by the Guild Socialism of A. R. Orage. The attitude to science that he experienced there was no doubt reinforced by his education at the Perse School in Cambridge under its redoubtable headmaster, W. H. D. Rouse, whose liberal and classicist ideals devalued science and technology – 'the better the machine, the less it uses our intelligence' – as against the truth of poetry: 'Poetry cannot make a machine, but it is the food of the imagination: it expresses the highest part of man, his eternal hopes and fears, his most intimate feelings, his speculations on the universe, and on his own great end'.[18] We mention these early influences to suggest the cultural and intellectual heritage of Humphrey Jennings. His background and experience exposed him particularly to that anti-industrial worldview which has been called the English ideology, and which, according to Martin Wiener, managed to create 'a cultural *cordon sanitaire* encircling the forces of economic development – technology, industry, commerce'.[19] It was out of, and against, this cultural nexus that Jennings' concerns and commitments developed.

A formative moment in Humphrey Jennings' life came with his involvement, whilst at Cambridge, in the literary review, *Experiment*. Here he was associated with a group of young intellectuals and artists that included Kathleen Raine, William Empson, Jacob Bronowski and Julian Trevelyan. In Kathleen Raine's words,

> the characteristic of this literary group was its 'scientific bias' – Bronowski and Empson were mathematicians, I myself was reading Natural Sciences, and to all of us scientific raw material was regarded, without question, as part of the subject-matter of poetry.[20]

In his perceptive biographical sketch of Jennings' career, James Merralls observes that they were 'fascinated by the great imaginative upsurge from which the Industrial Revolution sprang. And they read Newton, Faraday, Darwin for their poetic content, that is their intellectual vigour, as much as for their science'.[21] Unifying the *Experiment* group (and informing all Jennings' subsequent preoccupations) was a historic and heroic concern with the intellectual consequences of the Enlightenment and the Industrial Revolution: the changed relation between science and art, reason and imagination, prose and poetry, the material and the spiritual.

A central imaginative resource and inspiration in their efforts to work on these lofty issues was the life and work of William Blake. Both Raine and Bronowski, it should be remembered, went on to become notable Blake

scholars. For Jennings, Blake was a steadfast intellectual aesthetic and moral guide. Kathleen Raine, who was later to remember Jennings as an incarnation of Blake's Los, spirit of prophecy, points to the shaping influence of Blake on the *Pandaemonium* project:

> for the Royal Society had started the whole terrible process (such was the theme of Humphrey's book), the mills of Satan appearing first, as Blake had long ago declared, in the mechanistic theorizings of Bacon, Newton and Locke; only later to be reflected in those machines, their expression and image, from whose relentless wheels it seems our world can no longer (whether in peace or war) extricate itself.[22]

Elsewhere, Raine points again to Jennings' indebtedness to Blake for his sense of the historical process: 'history, as Humphrey Jennings, like Blake, conceived it, is the realisation of human imaginings'.[23] The mark of Jennings' abilities was his capacity to absorb and develop the influence of Blake. Unlike Raine, whose work became caught in a cul-de-sac of Blakean idolatry and mysticism, Jennings was no slavish disciple.

A further, and neglected, influence on Jennings' development was the literary critic, I. A. Richards (1893–1979). As James Merralls points out, Richards, 'who sought to identify the relation of science and poetry in the mainstream of imaginative thought', was a formative influence on the *Experiment* group.[24] Richards, the author of *Principles of Literary Criticism* and *Science and Poetry* in the 1920s – a writer whom Williams, moreover, places in the 'Culture and Society' tradition[25] – was important for Jennings' understanding of science and poetry as modes of knowledge, and for his exploration of the nature of imagination in industrial capitalism. At one level, Richards argued, imagination is 'that kind of relevant connection of things ordinarily thought of as disparate which is exemplified in scientific imagination'; at another it is 'inventiveness, the bringing together of elements which are not ordinarily connected...'. Its culmination (and here he quotes from Coleridge) is that 'synthetic and magical power' which 'reveals itself in the balance or reconciliation of opposite or discordant qualities...'.[26] What is brought out here – and what becomes a crucial motif in Jennings' thought – is the creative potential and energy that comes from making connections. Through this poetic capacity it is possible to 'outwit the force of habit'; poetic vision, through its 'superior power of ordering experience' liberates us from the 'blinkers', the 'inhibitions' of routine and mundane existence.[27]

The concern with the relation between science and poetry, the emphasis on imagination, and the moral seriousness that characterised both Blake and Richards, in their different ways, remained with Jennings throughout his life. Jennings, however, was no simple Romantic or antiquarian. His own imagination was essentially modernist; his sense of history and tradition was

profound, but he spoke a contemporary language in order to address the intellectual and aesthetic issues of modernity. To this end, Jennings turned to the Surrealist Movement. Now it may seem a long way from *Experiment*, the Industrial Revolution and Blake, to Surrealism. The distance, however, is more apparent than real, for the British Surrealist Movement constituted itself as the inheritor of the Romantic tradition. As Herbert Read wrote in the *Catalogue of the International Surrealist Exhibition* (1936), 'a nation which has produced two such superrealists as William Blake and Lewis Carroll is to the manner born. Because our art and literature is the most romantic in the world, it is likely to become the most superrealistic'.[28] As the historian of English Surrealism has argued, its major emphasis – and weakness – was its continuity with Romanticism; it was seen as 'little more than an eccentric variation of what had always been available in English romanticism'.[29] Appeal was made to Surrealism's capacity to liberate the imagination, and the spectre of Blake was never far away. At the time, Anthony Blunt argued that it was 'Romanticism carried to its extreme development',[30] and suggested that a key ingredient of Surrealism was 'Blake's anti-rationalism'.[31]

This Romantic connection clearly facilitated Jennings' espousal of Surrealism, and Surrealism certainly offered an aesthetic vehicle for his creative aspirations. The objective of Surrealism was 'to free man from the shackles of reason, to remove the blinders of purely intellectual sight so that he may finally see'.[32] Surrealism could (in Blake's phrase) clean the doors of perception; it could 'outwit the force of habit' (Richards). It could transcend the limitations of reason and rationality 'to repossess for man those parts of the universe that he has lost'[33] – the unconscious, dream and desire that Freud was charting. And Surrealism was more than a narrow aesthetic movement: its ambition was to break open conventional ways of seeing and to effect a transformation of life itself. This was a movement that seemed to put imagination back on the political agenda. For Jennings, it was the spirit of Blake that should be followed, rather than the letter. Blake had to be reinvented for modernity, and Surrealism, which promised new and powerful contemporary myths,[34] seemed full of visionary scope.

If Jennings was aware of, and responsive to, the Romantic undercurrent of English Surrealism, he sought to combat its incorporation into a nostalgic Romantic conservatism. It was the modernist and innovative possibilities of Surrealism that promised imaginative liberation and political transformation. In a review of Herbert Read, Jennings laments Read's defence of Romanticism and expresses grave doubts 'about the use of Surrealism in this country'.[35] Invoking the words of André Breton, he goes on to argue that

> Surrealism has replaced the 'coincidence' for the 'apparition' and that we
> must 'allow ourselves to be guided towards the unknown by this newest

promise'. Now that is talking; and to settle Surrealism down as Romanti-
cism only is to deny this promise. It is to cling to the apparition with its
special 'haunt'. It is to look for ghosts only on battlements, and on battle-
ments only for ghosts. 'Coincidences' have the infinite freedom of appear-
ing anywhere, anytime, to anyone: in broad daylight to those whom we
most despise in places we have most loathed, not even to us at all: probably
least to petty seekers after mystery and poetry on deserted sea-shores and in
misty junk-shops.[36]

Jennings is concerned with the potentiality of Surrealism to move beyond
the mysteries and clichés of the Romantic imagination. In an observation on
Magritte's paintings he notes that 'their poetry is not necessarily derived
from the known regions of romance — a plate of ham will become as
frightening as a lion — a brick wall as mysterious as night'. Magritte 'never
allows himself to be seduced by the immediate pleasures of imitation'; he is
aware 'that a painting itself is only an image', and it is in this respect that he
is 'essentially modern'.[37]

Jennings was fundamentally a modernist,[38] and the idea and aesthetic of
'coincidence' was fundamental to his modernist imagination. This notion is
often dismissed by critics of his work as some kind of quirky and aberrant
obsession. Thus, Tom Harrisson[39] suggested that 'he was a person who liked
wild ideas. He believed, for instance that coincidence is one of the keys to
human behaviour. He was always looking for coincidences'.[40] The theory of
coincidence was, in fact, as we shall argue, no mere eccentricity: it constituted
the central aesthetic and intellectual strategy in all Jennings' work and was
especially important for the *Pandaemonium* project. Clearly this idea has
affinities with Richards' observations on the nature of imagination, and it had
its roots in Jennings' own disposition.[41] But through Surrealism, Jennings'
imaginative vision engaged with the major problems and debates of
modernist thought and escaped the provincialism of English cultural theory.

The significance of coincidence is usefully established by Max Ernst in his
observations on 'the mechanism of collage'. It is, he writes, 'the exploitation
of the chance meeting on a non-suitable plane of two mutually distant
realities' or 'the cultivation of a systematic moving out of place'. The
consequence he describes thus:

A complete, real thing, with a simple function apparently fixed once and
for all (an umbrella), coming suddenly into the presence of another real
thing, very different and no less incongruous (a sewing machine) in sur-
roundings where both must feel out of place (on a dissecting table), escapes
by this very fact from its simple function and its own identity; through a
new relationship its false absolute will be transformed into a different abso-
lute, at once true and poetic: the umbrella and the sewing machine will
make love.[42]

Radical juxtaposition of this kind produces the effect of defamiliarisation; it makes strange and outwits the force of habit. In disrupting expectation it can reveal the mysterious within the familiar. This 'business of subduing appearances and upsetting the relationships of realities', according to Ernst, would 'hasten the general crisis of consciousness due in our time'.[43]

Jennings was well aware that this aesthetic strategy might lapse into superficiality. Referring specifically to Ernst, he argues that Surrealism is limited when it does no more than 'exploit the rather temporary emotive qualities of incongruity provided by the juxtaposition of objects as objects (with literary associations)'.[44] However, at its most intense and truthful, this device can tap into a discursive logic beneath that of the rational mind. The revelatory contribution of Freud and psychoanalysis to a more profound Surrealist engagement with the relational nature of imagination is suggested by Jennings when he contemplates the extent to which ' "commonsense" relationships differ from or overlap the relationships...established in a painting, or dictated by "unconscious fantasy" '.[45] It is in the work of Magritte, he suggests, that this 'bringing together of discrete elements' is at its most profound and suggestive. Of the juxtapositions in Magritte's paintings, Jennings notes 'their simultaneous irrationality – since nothing is chosen "on purpose" – and their evident truth – since their "bringing together" is in fact an "event" beyond choice'.[46]

In his own work Jennings aimed to distil images (poetic, artistic, photographic, filmic, sociological and historical) of equal condensatory vigour. The image is a 'point of ordonnance'; its force and truth 'is not in the elements, but in their coming together at a particular moment'.[47] What characterised Jennings was his refusal of the private and subjective mythology that Surrealism often adopted under the influence of Romanticism. The image 'must be particularised, concrete and historical...above all, the image must never be invented'.[48] His predilection was for phrases from existing sources, for postcards and prints already in common circulation; the horse, the plough, the steam-train, the dome of St Paul's became the basis of his popular iconography. This was Jennings' Surrealist attraction to the *objet trouvé* and the 'ready-made', associated with the strategy of subverting the personal, expressive and creative voice of the Romantic author. But where the Surrealist 'finds in his imagination...an image which he seeks then to concretize in the external world, in a painting, a poem or an object', Jennings 'finds in the real, concrete object an image of the collective imagination'.[49] Jennings sought 'a public imagery, a public poetry',[50] through which he strove to trace the expression of collective desires and the collective imagination. Within his aesthetic the external world had primacy: Surrealism expressed itself as a political and documentary impulse.

An important aspect of Jennings' artistic activity, and one of particular concern in this present chapter, entailed his exploration of the imaginative

impact of the Enlightenment and the Industrial Revolution. Here Jennings sensitises us to the correspondences between cultural forms and socio-historic transformations. In one of his war-time poems, he writes:

I see London
I see the dome of St Paul's like the forehead of Darwin.

He associates the cathedral's architecture with the tradition of Enlightenment rationality and intellect. In a prose passage from 1938 he observes that 'the pre-eminent example of the automatic machine – the steam railway – developed at precisely the same time as the realism of Géricault, Daumier and Courbet....And also at the same time as the researches of Cuvier and Lyall'.[51] A central, and much reworked, image for the cultural and imaginative impact of industrialisation is the association of horse and locomotive. Jennings is fascinated with the correspondence of animal and machine. 'Machines are animals created by man', he writes and 'the idea of a machine which would go by itself (automatically – without the help of an animal) has long obsessed man because then it could be considered to have a life of its own – to have become a complete pseudo-animal'.[52]

Elsewhere he writes that,

the transformation of a horse into a locomotive is perfectly shown in 'The Cyclopede' and in other horse-locomotives where the horse, from pulling a truck was put inside one with a moving floor turning the wheels. The transformation of the lions and tigers also into machines you can find in Blake.[53]

This is a striking image that condenses and illuminates the interrelation between the dynamic of history and technology and that of perception and imagination. But Jennings seems to want to go further, to heal the dissociation of nature and industry. 'An image of a horse can become an image of a locomotive. How?' he asks. And the answer: 'precisely through poetry and painting – *La terre est bleue comme une orange*'.[54]

As James Merralls acutely observes, Jennings' work seeks 'the reconciliation of apparent antithesis: the juxtaposition of horses and locomotives, images of the highly strung energy of the natural order and the consuming power of the machines, of the farm and the factory, agriculture and industry, prose and poetry'.[55] In this project, inevitably no doubt, he fails. Jennings seeks to elaborate images that contain the cultural impact of rationalism and industrialism. But they remain static and frozen images: reality cannot be metamorphosed by paint of words, and reconciliation of nature and industry remains but a formal device.

POETRY AND POLITICS: MASS OBSERVATION

> I am aware that this continued defence of the poet is regarded as very
> dilettante by the now politically minded English.
>
> (Humphrey Jennings)

Mass Observation was a heroic socio-political project to study British society
in the late 1930s.[56] As such it inscribed itself within a particular intellectual
history:

> A century ago Darwin focused the camera of thought on to man as a sort of
> animal whose behaviour and history would be explained by science. In
> 1847, Marx formulated a scientific study of economic man. In 1865, Tylor
> defined the new science of anthropology which was to be applied to the
> 'primitive' and the 'savage'. In 1893, Freud and Breuer published their
> first paper on hysteria; they began to drag into daylight the unconscious
> elements of individual 'civilised' man.[57]

Its ambition was to develop the study of 'civilised' society through a vast
study of 'the beliefs and behaviour of the British Islanders'.[58] Among the
objects of concern were:

- Behaviour of people at war memorials
- Shouts and gestures of motorists
- The aspidistra cult
- Anthropology of football pools
- Bathroom behaviour
- Beards, armpits, eyebrows
- Anti-Semitism
- Distribution, diffusion and significance of the dirty joke
- Funerals and undertakers
- Female taboos about eating
- The private lives of midwives.[59]

Its concern was with 'mass fantasy and symbolism', with 'shifting popular
images', and its means of access to this subterranean information was
through the involvement of the public itself. Mass Observation recruited a
large number of 'untrained Observers' whose function was to 'describe fully,
clearly, and in simple language all that [they] see and hear in connection
with the specific problem [they are] asked to work on'.[60] Through their
recording of the small details of behaviour, the 'multitude of watchers'
would provide the points from which can be plotted the 'weather-maps of
public feeling'.[61]

Through Mass Observation, it was argued, 'the artist and the scientist, each compelled by historical necessity out of their artificial exclusiveness, are at last joining forces and turning back towards the mass from which they had detached themselves'.[62] The movement was both a poetic enterprise and a scientific project of social investigation and documentation. Retrospectively, this distinction has appeared to be grounded on the divergent interests and ideas of Madge and Jennings, on the one hand, and Harrisson, on the other. Harrisson himself, whose account of Mass Observation has become dominant and proprietary, certainly nourished this interpretation. Madge and Jennings, he suggests, 'developed the idea of setting up a nationwide panel of people who would write about themselves as a sort of "subjective literature", an idea almost poetic in concept'.[63] Their approach was 'a kind of visionary concept...an approach which was unscientific – literary, or poetic-literary. It wasn't a question of "social-realism" at all – in fact, just the opposite: a kind of social super-realism'.[64] The problem with Madge and Jennings was that they weren't doing any observing. 'I was doing the observing', says Harrisson, who vaunted his background as a biologist, ornithologist and anthropologist, 'I was taking a scientific line'.[65] The essence of scientific method was to 'spend long periods not so much listening to (let alone questioning in) words, but watching and recording exactly what he sees. Perhaps the most important...piece of technical equipment for any sort of social scientist is the ear plug'.[66]

What Harrisson reinforces, then, is a dichotomy between scientific observation and fact-gathering, on the one hand, and artistic activity, on the other. Scientific social investigation is seen as external to the literary-poetic. This has resulted in assessments of Mass Observation that consider the Jennings-Madge approach as trivial and eccentric. Julian Symons writes of 'the two sides of Mass Observation: the pretentious attempt to associate the movement with art and literature, and the realisation that this was a technique of social research, which...had its use in social research'.[67] The poetic dimension of the movement has been dismissed as naïve and anomalous, while the 'scientific' and sociological has been preserved and elevated by Harrisson and others.[68]

This polarisation of science and art (social investigation and poetry) in the work of Mass Observation is regrettable. It is, we would argue, based on the nineteenth-century dualism of 'the world' and 'the mind'. Raymond Williams has argued that this definition of the 'real world, and then a naïve separation of it from the observation and imagination of men' leads to a dichotomisation of 'real life and its recording, on the one hand, and a separable imaginative world on the other'.[69] This naturalist and positivist perspective, with its appeal to 'the facts' is clearly present in the Mass Observation project. But it is, we would argue, an ingredient contributed by the 'scientist', Harrisson. For Jennings, in contrast, the separation of the exterior, material world from the inner, imaginative realm is *not* a given, but

rather *a socio-cultural manifestation of the Enlightenment* and the *Industrial Revolution.* Documentary observation and social investigation must be continuous with poetry and the imagination. In Jennings' involvement with Mass Observation there was, we would argue, a close relation between his Surrealist aesthetics and the politics of social research.

Jennings was only fleetingly associated with Mass Observation (during 1937–38), but his involvement was undoubtedly a manifestation of his general aesthetic and intellectual concerns. In his autobiography, Julian Trevelyan writes that

> to Humphrey it was an extension of his Surrealist vision of Industrial England; the cotton workers of Bolton were the descendants of Stephenson and Watt, the dwellers in Blake's dark satanic mills reborn into a world of greyhound racing and Marks & Spencer.[70]

There is a fundamental poetic drive to his engagement; a commitment to what Charles Madge calls 'the original poetic nature of the mind' and to the principle that 'the mind is a poetic instrument and so is poetic despite itself even when it sets out to be scientific'.[71] But Jennings' Blakean and Surrealist understanding of the imaginative, poetic faculty eschews Romantic subjectivism and solipsism: it struggles to relate inner and outer realities, poetry and politics. What was so powerful about Mass Observation was that it was poetry writ large, the real world as a massive poetic text, the production of 'a poetry which is not, as at present, restricted to a handful of esoteric performers'.[72] Jennings sought to turn Surrealism into a combined poetics and politics of the real world. As Kathleen Raine remembers it

> We hoped to discern on the surfaces of dingy walls, on advertisement hoardings, or written upon the worn stones of pavements, or in the play of light and shadow cast by some street-lamp upon puddles at the corner of a shabby street, traces of the beautiful, degraded, dishonoured, suffering, sorrowful, but still the *deus absconditus*. It was a search for the lost lineaments of the most high in the most low.[73]

As with Jennings' paintings and poetry – some of which took the form, at this time, of Mass Observation reports[74] – Mass Observation is for him a kind of 'surrealism in reverse': 'Surrealism...wants to project the imagination onto the objective world in order to transform it; Mass Observation tries to recover the imagination that produced the vulgar objects and images of the everyday world'.[75] It is this imaginative engagement with the real world that makes Jennings' enterprise political (and democratic) and takes him beyond Romantic subjectivism.

Mass Observation was propelled into existence by the Abdication Crisis of December 1936, 'the biggest of all recent crises – bigger than any of the

scares of war'.[76] What was important about the crisis situation for Jennings was its ability to outwit the force of habit. Where usually there was a tendency 'to perform all our actions through sheer habit, with as little consciousness of our surroundings as though we were walking in our sleep',[77] the crisis subverted the automatic nature of social experience. Through the process of defamiliarisation, it rekindled the social imagination – Richards had made the same point in reverse: 'imagination characteristically produces effects similar to those which accompany great and sudden crises in experience'.[78]

For Jennings, however, greater issues were at stake in the crisis than its immediate politics. These are apparent in a few texts from the earliest days of Mass Observation,[79] particularly in the incandescent pamphlet, *Mass Observation*.[80] It is, of course, risky to attribute any share in this publication to Jennings, but it is difficult to avoid the conclusion that key chapters and ideas were inspired by him in that portentous historical moment. What the pamphlet does is to inscribe the crisis within wider social forces, in an analysis which seems to draw on the frames of reference of the *Experiment* group, and which prefigures the analysis of *Pandaemonium*. In so doing, it outlines the historical transformations of art and science as forms of cognition under the impact of industrial capitalism.

Science and technology, it argues, have profound cultural implications: 'the steam railway, the spinning jenny, electric power, photography, have had so great an impact on mental and physical behaviour that we are barely conscious of it'.[81] The railway is singled out:

> Not only did it create a new architecture and a new type of engineer, a new culture of the railway ticket and the railway station – but it altered irrevocably the nature of dreams and of childish fantasy (ambition to be an engine driver)....It has given us a different conception of space, of speed and of power. It has rendered possible mass activities – the Cup Final, the monster rally, the seaside holiday, the hiking excursion – whose ramifying effects on our behaviour and mentality extend almost beyond imagination.[82]

Science, technology and industrialisation have, however, had unfortunate social and cultural consequences. They have resulted in a 'widespread fatalism among the mass about present and possible future effects of science',[83] and in 'the sway of fatalism in the midst of science'.[84] It is here that Mass Observation's 'anthropology of ourselves' is so crucial: through the 'scientific study of human social behaviour'[85] the ignorance that succours superstition and fatalism can be eradicated. Here the pamphlet is at its most scientific and teleological: 'All sciences have helped to make ready the moment at which the science of man could emerge'.[86] There is, however, another approach to science that runs somewhat against this positivist grain. This is the vision that appreciates the imaginative capacity

of scientific knowledge; it understands the importance of Darwin's 'revolutionary picture of man in relation to the universe',[87] and it can see how the entrails of the dog-fish can be a source of *divina voluptas* to the zoologist.[88] Science, too, can defamiliarise, make strange, clear the doors of perception. What the pamphlet looks to – wishfully – is the healing of that dissociation of sensibility that has rent apart art and science, imagination and reason. 'The work of the greatest artists has always been akin to that of the greatest scientists';[89] each is both cognitive and imaginative. What it looks to is the 'ultimate convergence of science with art and politics'.[90] And the vehicle for this would seem to be Mass Observation where 'art and science are both turning towards the same field: the field of human behaviour which lies immediately before our eyes'.[91] If the note of scientism ultimately prevails, there is in the Mass Observation pamphlet a line of thought which understands the interrelation of culture and industrialisation, and which is utopian – albeit abstractly and wishfully – in its aspirations for the reinvigoration and reintegration of science and art as imaginative forms.

For Jennings, Mass Observation was important as a utopian – and perhaps ultimately unrealisable – concept. His one completed project was the study of *May the Twelfth* in 1937.[92] This monumental study of the Coronation, or rather the national experience of the Coronation, is composed entirely from press cuttings and from observers' reports. It is a vast and kaleidoscopic collage, cut together in the manner of a film. David Mellor describes it as 'a gigantic concordance of texts held in place by the realist-documentarist device of one (special-yet-ordinary) day's time elapsing...an endless palimpsest written on and over by many but co-ordinated by one'.[93] Its objective was to tap into the collective unconscious of England, to explore the powerful and subterranean roots of the symbols of monarchy.

Although Jennings immediately withdrew from Mass Observation, because of what 'he felt to be a banal streak in Tom [Harrisson's] expressionist quasi-anthropology',[94] *May the Twelfth* – which strikingly resembles and prefigures *Pandaemonium* – is continuous with Jennings' general intellectual and aesthetic concerns. What he achieved was an amalgamation of documentary-reportage and Surrealism that constitutes a modernist aesthetic statement. *May the Twelfth* continues to develop Jennings' Surrealist preoccupations: its Freudian concern is with the collective unconscious and imagination; it is composed of *objets trouvés* in the form of press clippings and observers' reports; it exploits juxtaposition and coincidence; it devalues the status of the (Romantic) author – Jennings is no more than a collator and editor; and it explores the possibilities of defamiliarisation ('What has become unnoticed through familiarity is raised into consciousness again'[95]). But if Jennings is a Surrealist poet working on 'ready-made' popular imagery and accounts, he is also an observer and a reporter – a poet-reporter – and his concerns always press towards documen-

tary and political involvement in social issues. In the context of the 1930s there was, in fact, a close relationship between Surrealism and documentarism: 'A new realism, supported, strengthened and broadened by the new photo-mechanical technologies, was to become, along with Surrealism, one of the leading issues on the modernist agenda'.[96] Like Surrealism, documentary de-emphasises the element of personal creativity, replacing it with the 'anonymous and impersonal "I" '[97] and with collective and co-operative cultural production. It too seeks to 'make strange' and, as such, articulates modernist perspectives. What Jennings and Mass Observation do is to amplify and extend documentary concerns by making 'the subjectivity of the observer...one of the facts under observation',[98] and by turning it into a social poetry, a democratic poetry 'which is not, as at present, restricted to a handful of esoteric performers'.[99] The project moves towards the aestheticisation of documentary and the politicisation of surrealism. Artistic and scientific imaginations are to converge in the figure of the poet-reporter whose social accounts are at once aesthetic, scientific and political.

A MICROPHYSICS OF THE IMAGINATION

The material transformer of the world had just been born. It was trotted out in its skeleton, to the music of a mineral train from the black country, with heart and lungs and muscles exposed to view in complex hideosity. It once ranged wild in the marshy forests of the Netherlands, where the electrical phenomenon and the pale blue eyes connected it with apparitions, demons, wizards and divinities.
(Humphrey Jennings, 'Report on the Industrial Revolution')

Pandaemonium, a text that Jennings never brought to completion,[100] comes to us adrift in time. For this reason it has been necessary to place it in its historical and biographical context. The significance of this oceanic text becomes more clear when it is seen as part of a lifelong concern with the relation between science, technology and imagination, a concern that unifies all Jennings' apparently varied and discrete interests. *Pandaemonium* is 'the imaginative history of the Industrial Revolution. Neither the political history, nor the mechanical history, nor the social history, nor the economic history, but the imaginative history'.[101] In its concern with how machines have become inter-woven with human life, and in its mapping of the dissociation of reason and imagination, it is Blakean in inspiration. Jennings' exploration of the total industrial landscape – both inner and outer – must be traced back to his involvement in the *Experiment* group (Raine, Bronowski, Richards). But it also places him in the wider context of the 'Culture and Society' tradition, alongside such figures as Blake, Cobbett and Morris. Of Morris, Jennings argued that he had 'joined hands truly with

the working class and come into it as an equal and a poet'.[102] For Jennings too the 'Imagination of the Poet' was crucial in political struggle.

But if contextualisation is necessary to appreciate Jennings' thematic concerns, it is all the more vital for an understanding of the aesthetic and intellectual form of *Pandaemonium*. What makes Jennings important, as we have suggested, is that his work moves well beyond the Romantic subjectivism of much of the 'Culture and Society' tradition, and is structured within modernist frames of reference. It is in this context that we ought to address the *Pandaemonium* project. It is composed of 'images' from literature, journals, diaries, autobiographies, letters, philosophical treatises and scientific reports across the period 1660–1886: a modernist collage, concordance, palimpsest, cut together as a 'film on the Industrial Revolution'.[103] Like *May the Twelfth* it comprises 'pages from a mass diary'.[104] It is perhaps the most ambitious of Jennings' attempts to achieve the reconciliation of Surrealism and Documentarism. As with Jennings' other modernist undertakings – painting, poetry, film, Mass Observation – its raw material is the 'ready-made', the *objet trouvé*. And, as in these other texts, this process is associated with the devaluation of the (expressive) authorial self – Jennings is collator and editor. Again, it exploits, through the 'mechanism of collage', the imaginative force of Surrealist 'coincidence': 'the exploitation of the chance meeting on a non-suitable plane of two mutually distant realities'. The effect of this is defamiliarisation: through juxtaposition, the text, 'with a simple function apparently fixed once and for all…escapes from its simple functions and its own identity'. Finally, the objective of *Pandaemonium* is the Surrealist documentation of the unconscious history of the Industrial Revolution, the subterranean course of the imagination. *Pandaemonium* must be read as a text of modernism. Its project is precisely that of Walter Benjamin: the 'tearing of fragments out of their context and arranging them afresh in such a way they illustrated one another'; the 'forcing of insights' by 'drilling rather than excavating'.[105]

Pandaemonium is a modernist text. Jennings' authorial presence is marginal and elusive, and there is no attempt to direct and propagandise the reader. There are, in fact, various ways of using the text: one can follow its picaresque chronological 'narrative', or, alternatively, by using the glossary, it is possible to trace 'theme sequences' across the historical period. The intention is to involve the reader in an active process of interpretation. *Pandaemonium* is committed to subverting relationships between author, text and audience: it is for us to make our own associations, connections and correspondences across and through the material Jennings has gathered.

The images from which *Pandaemonium* is composed are 'knots in a great net of tangled time and place', each with its 'particular place in an unrolling film'.[106] They are what Jennings calls 'illuminations', moments of luminescence that express the human experience of the Industrial Revolution. As the image sequence unfolds it moves sharply from key to key. The galactic is

juxtaposed against the microscopic, the bizarre accompanies the mundane. It moves from spirit-rapping to Faraday on the 'mind of Man', to Nathaniel Hawthorne's observations on charity school girls in Liverpool, to a bizarre banquet held inside the skeleton of an iguanadon, to a description of Coketown from *Hard Times*.[107] The choice of texts refuses any simple, reductionist understanding of the Industrial Revolution and bears testimony to its massive complexity and cultural ambiguity: it is both the 'stupendous system of manufacture'[108] and the exploitation and degradation of working people.[109] Jennings seeks to explore the period in all its facets through the juxtaposition and rotation of images to create a composite, almost cubist, intellectual collage. Through this method he works towards the imaginative representation – which is in fact the *re*presentation – of the texture and pores and grain of the historical process. To this end he often appropriates passages that have little apparent relation to the mechanics of industrialisation. Jennings approaches the culture of industrial capitalism by stealth, through the back doors of imagination; he forces insights through oblique and transversal drillings into the unconscious of history. His is the 'method of poetry', eschewing analytic distinctions in favour of a synthetic view of the complexity of life.[110] Jennings is the poet-observer-psychoanalyst who, through the free association of texts, seeks to come at both the neuroses and the imaginative unconscious of industrial capitalism.

For us, the particular value of *Pandaemonium* lies in its tracing of the historical interrelation of reason and imagination, science and poetry, as modes of knowledge. Jennings' great theme is the relation between the means of production and the 'means of vision': 'the relation of production to vision and vision to production has been mankind's greatest problem'.[111]

> At a certain period in human development [he writes] the means of vision and the means of production were intimately connected – or were felt to be by the people concerned – I refer to the magical systems under which it was not possible to plough the ground without a prayer – to eat without a blessing, to hunt an animal without a magic formula. To build without a sense of glory.[112]

In the period 1660–1860, however, the means of production were radically altered 'by the accumulation of capital, the freedom of trade, the invention of machines, the philosophy of materialism, the discoveries of science'.[113] What concerns Jennings is how these transformations have shaped the means of vision: the extent to which reason and imagination have become dissociated; the degree to which vision has been, or can be, accommodated within the scientific and materialist outlook. His great achievement is to trace the intricate reticulations, the filigree, of the imagination in an industrial society. *Pandaemonium* is, one might suggest, a microphysics of the imagination.

The book opens with a passage from *Paradise Lost* describing the building of Pandaemonium, which Jennings equates with the Industrial Revolution:

> Pandaemonium is the Palace of All the Devils. Its building began c. 1660.
> It will never be finished – it has to be transformed into Jerusalem. The
> building of Pandaemonium is the real history of Britain for the last three
> hundred years.[114]

Against this is juxtaposed an account of the founding meeting of the Royal Society (28 November 1660) where a college was proposed 'for the promoting of Physico-Mathematical Experimental Learning'.[115] According to Jennings the first stage of industrialisation 'is a phase of pure science, direct experiments and clear philosophical and materialist thinking. The invention as yet was only on paper. The people – the impact on life – and consequent exploitation had not yet arrived'.[116] He argues that when the bourgeoisie came to power

> The tasks that lay before them were the taking of the land from the people
> by the Enclosure Acts, the creation of the factory system and the invention
> of machines and means of power to run them. Before any of these things
> could be done it was necessary to make an analysis of the materials and
> forces existing in nature and in these islands which would contribute to the
> scheme. Hence the financial backing of the Royal Society.[117]

This process entailed a massive and historic reorientation towards the natural order. An important aspect of this is the transition from a religious to a secular conception of the 'heavens', through the emergence of a science of meteorology: 'But for the Faces of the Sky, there are so many, that many of them want proper Names; and therefore it will be convenient to agree upon some determinate ones'.[118] An early account of the effects of lightning replaces animistic language with detached and precise cataloguing and documentation.[119] Observation and classification came to cover the whole natural world:

> Observations of the fix'd stars for the perfecting of Astronomy, by the help
> of Telescopes....Observations on frozen Beer: on the figures of Snow, frozen
> Water, Urine congeal'd....Observations of the liming of Ground, for the
> improvement of the Bodies of Sheep, but spoiling their Wool: of several
> ways for preventing smutty Corn....Observations on the Bills of Mortality:
> on the leaves of Sage: on small living Flies in the Powder of Cantharides: of
> insects bred in Dew.[120]

These, suggests Jennings, are the embryonic beginnings of what was to become a bare, secularised, abstract conception of 'the modern world built up out of atoms and molecules, linked by causality'.[121]

It was this 'mechanisation of thoughts', which objectified nature (and human nature) and formed the intellectual rationale for its exploitation. The natural world came to be seen as a force, not just to be observed and classified, but dominated, capitalised and transformed by what Ruskin calls the 'Iron-dominant Genii'.[122] And, as Ruskin emphasises, this 'desecration' of the earth is 'part of the exploitation of man by man'.[123] From early experiments on animals, such as the bleeding of a mare to measure blood pressure,[124] it is not such a huge step to the use of human beings as objects of experimentation.[125] Observation, which objectifies human behaviour, results in the desecration also of human nature. This profanation, Jennings suggests, is part of a growing mechanical vision of the world. In the seventeenth century,

> the idea that living creatures are machines is…gaining ground…the anal-
> ogy which begins with insects, whose movements are compulsive, is not at
> first openly continued up to man, the animal with a soul. But the distinc-
> tion is dropped in practice, or blurred, when human labour begins to be
> organised on a ruthlessly rational basis.[126]

During the Industrial Revolution, the objectification and instrumentalisa-
tion of working people is expressed through the creation of what Robert Owen calls 'human machines'[127]: 'men, women and children are yoked together with iron and steam. The animal machine – breakable in the best case, subject to a thousand sources of suffering – is chained fast to the iron machine'.[128] Scientific experimental observation metamorphoses into surveillance and supervision of labour and its dispassionate exploitation.[129]

More even than in the material degradation of the Industrial Revolution, Jennings is concerned with the transformed means of vision that underlies this aggressive relation to nature and humanity. In his exploration of the relation between the means of production and the means of vision, he argues that alterations in the latter are 'achieved not merely as the result of changing means of production, but also [make] them possible'.[130] His concern is with the rationalisation of the inner landscape, with the sea-change in the imagination, with the way in which 'the emotional side of [our] nature has been used, altered, tempered, appealed to in these two hundred years'.[131]

A central aspect of Jennings' account of the historical odyssey of imagi-
nation involves the contrast between science and poetry as modes of cognition. 'When the enclosures forced the country-dwellers off the land', he writes, 'they not only expropriated the people but also expropriated poetry, which has its roots in the emotional links of man to the land and of man to man in a common society'.[132] A passage from an Owenite journal of 1833 suggests that 'in a perfectly rational state of society, there would be little poetry'.[133] Jennings asks whether, as the scientific and mechanical ideas of

the Enlightenment 'began to be exploited by capital and to involve many human beings, was not this the period of the repression of the clear imaginative vision in ordinary folk?'[134] What he sees is a clear separation between rationalist and imaginative cognition. Science results in a neutral, functionalist, 'non-animist' language:[135] 'Most scientific work is incompatible with poetic expression for one simple reason, that our interest in poetry does not lie in things, discoveries, inventions, formulae themselves but in their effect on people'.[136] A poignant and curious microcosm of this process comes in an autobiographical passage by Charles Darwin. 'Now for many years', he writes, 'I cannot endure to read a line of poetry'. Referring to this 'curious and lamentable loss of the higher aesthetic tastes', he continues thus:

> my mind seems to have become a kind of machine for grinding general laws out of large collections of facts, but why this should have caused the atrophy of that part of the brain alone, on which the higher tastes depend, I cannot conceive...the loss of these tastes is a loss of happiness, and may possibly be injurious to the intellect, and more probably to the moral character, by enfeebling the emotional part of our nature.[137]

What Jennings documents is the developing hegemony of rationality over the poetic imagination. His concern is with the forms in which poetry has survived the Industrial Revolution, and his ideas in this respect are complex. Reactions against the industrial machine often took the form of a sentimental and nostalgic response to nature for its picturesqueness and this superficial response became apparent in many nineteenth-century poets. Thus, the poetry of Tennyson is at its best a sentimental paean to beauty, and at its worst, in the 'Ode Sung at the Opening of the International Exhibition',[138] it is art 'prostituting [itself] to cover the nakedness of oppression'.[139]

The poetic imagination survived, Jennings suggests, in those figures who confronted the full significance of the Industrial Revolution, rather than those who averted their gaze. He refers to the poets (Milton, Blake, Shelley) and novelists (Disraeli, Dickens) who 'from time to time but only rarely, found a point in their work where it met, so to speak, the current economic and political and social revolutions on equal ground and where they were capable of recording the conflict'; to social critics (the 'Culture and Society' tradition – Cobbett, Carlyle, Ruskin, Arnold, Morris) who produced passionate accounts of this conflict; to autobiographers, diarists, letter-writers who 'not only record some of the conflicts but also show the growing consciousness of those conflicts among the people most nearly involved in them'.[140] But also, Jennings acknowledges, poetry survives in the work of scientists and philosophers 'where occasionally they are looking beyond their immediate scientific issues and recording the conflict of their own new

systems with others such as religion – Newton, Berkeley, Darwin'.[141] The writings of Faraday are a good example. His account of the 'rays of darkness' that seemed to issue from St Paul's Church is a beautiful conjugation of scientific and aesthetic perception.[142] So too his account of a balloon flight:

> Ballast was thrown out two or three times and was probably sand; but the dust of it had this effect, that a stream of golden cloud seemed to descend from the balloon, shooting downwards, for a moment, and then remained apparently stationary, the balloon and it separating very slowly. It shews the wonderful manner in which [each] particle of this dusty cloud must have made its impression on the eye by the light reflected from it, and is a fine illustration of the combination of many effects, each utterly insensible alone, into one sum of fine effect.[143]

Across the pages of *Pandaemonium*, this echoes with Blake's lines on Newton:

> You throw the sand against the wind,
> And the wind blows it back again
>
> And every sand becomes a gem
> Reflected in the beams divine.[144]

Another central theme in Jennings' documentation of the imaginative consequences of the Industrial Revolution centres on the relation between animism and materialism. Early scientific accounts retain strong elements of animism[145] and struggle hard to develop a more secular language of observation and classification. But as there developed a mechanistic and abstract language of science, so the natural world became disenchanted. As Arthur Elton wrote in the issue of *London Bulletin* devoted to 'The Impact of the Machine', 'the wind could be a God only so long as the laws of gases, of flight and meteorology went unstudied'.[146] During the eighteenth and nineteenth centuries the animist imagination – as a form of knowledge and a relationship with the natural world – is salvaged in visionary literature: in the work of Christopher Smart;[147] in Blake's 'Corporeal [and] Vegetative Eye';[148] in Samuel Bamford's account of 'the wind of heaven'.[149] By the later nineteenth century, however, it was becoming residual. Animism, in the work of Tylor, became an object of anthropological curiosity.[150] Jennings also notes 'the importance to Impressionism of "the end of animism" in removing the symbolic animistic attributes of objects'.[151] Ruskin laments the building of a railway: 'The valley is gone, and the Gods with it; and now every fool in Buxton can be at Bakewell in half-an-hour, and every fool in Bakewell at Buxton'.[152]

But if the vitality of animism as a cognitive and emotional relationship to the natural and social order becomes historically repressed and censored,

displaced by the profane outlook of science and materialism, it comes to reappear, like dream images of hysterical symptoms, in the margins and interstices of industrial society. One aspect of this is the object-cathexis associated with machinery, as Arthur Elton writes:

> The Gods had moved house. They left the clouds and forests and waves to live in the machine. Above all machines the locomotive seemed to have life and vitality. It had appetites for it ate coke. It had free will, for it moved without human agency. It was an animal. It was human. It was a demon.[153]

The image that perhaps condenses the reverence and awe felt towards the creations of science is Mary Shelley's description of a creation that, 'on the working of some powerful engine, show[s] signs of life, and stir[s] with an uneasy, half vital motion'.[154] But the animistic imagination also migrates to more arcane and bizarre recesses. A letter by Mary Howitt describes how, in the 1850s, 'the old hobgoblins and brownies seem to be let loose again' in the form of spirit-rapping and the feeling, 'pervading all classes, all sects, that the world stands upon the eve of some great spiritual revelation'.[155] Francis Galton writes to Charles Darwin of 'the extraordinary things of my last seance on Monday'.[156] In criticism of the 'table-turners', Faraday laments 'what a weak, credulous, incredulous, unbelieving world ours is, as far as concerns the mind of man'.[157] Francis Galton describes phantasmagoria and writes of 'no less than five editors of very influential newspapers who experience these night visitations in a vivid form'.[158] For Jennings, these phenomena, as much as the *Condition of the Working Class in England*, are what the Industrial Revolution is about. These apparently irrational and anomalous exotica are imaginative manifestations of the Enlightenment as much as rational and abstract thinking.

The achievement of *Pandaemonium* is its fine perception of the imaginative atoms that make up the period 1660–1886. Jennings reanimates the imaginative texture, the structures of feeling, of the Industrial Revolution. And what makes his chart of imaginative shifts and metamorphoses so valuable is the complex and dialectical nature of his understanding. Jennings, as we have argued, is not a conservative and Romantic thinker; the imagination is not for him a primal and elemental faculty to be protected from the onslaught of Rationality. Whilst he does document the repressive and dominative aspect of Enlightenment thought, his account is nuanced, transcending 'Single vision and Newton's sleep'. Jennings is also aware that the past 200 years have, potentially at least, amplified and deepened our imaginative resources. Although science and technology have brought about exploitation and desecration, they have also, at their most radical, transformed our perceptions and made the world strange.

Thus, the development of microscopic vision makes it possible 'to see hundreds of monsters of horrid shapes in a drop of water magnified so as to

appear several feet long, and to see a flea made to look as large almost as an Elephant'.[159] Astronomy opens up the scale of the universe:

> Among the many things that I showed Sir John while at Hammerfield, was a piece of white calico on which I had got printed one million spots. This was for the purpose of exhibiting one million in visible form. In astronomical subjects a million is a sort of unit, and it occurred to me to show what a million really is.[160]

And geology opens up 'the awful processes of time': 'It is not only that this vision of time must wither the Poet's hope of immortality; but it is in itself more wonderful than all the conceptions of Dante and Milton'.[161]

If on a less epic scale, technological innovation has also shifted and energised human perceptions of the world. Balloon flight has made possible 'an angel's view' of the earth:

> to feel yourself floating through the endless realms of space, and drinking in the pure thin air of the skies, as you go sailing along almost among the stars, free as 'the lark at heaven's gate', and enjoying, for a brief half hour, at least, a foretaste of that Elysian destiny which is the ultimate hope of all.[162]

But perhaps most fascinating of all for Jennings is the perceptual and emotional impact of the railway. With the train comes the experience of speed: it is 'the likest thing to a Faust's flight on the devil's mantle; or as if some huge steam night-bird had flung you on its back, and was sweeping through unknown space with you'.[163] The scale of the railway is phenomenal: 'At a recent meeting of the Metropolitan Railway Company I exhibited one million of letters, in order to show the number of passengers (thirty-seven millions) that had been conveyed during the previous twelve months'.[164] And with the coming of the railway network come strange and coincidental minglings of the population. Recalling an occasion when he fortuitously overheard the machinations of a rival business concern whilst travelling in a railway carriage, Sir Henry Bessemer sees this 'marvellous revelation' as 'more like an act of eternal justice than one of the ordinary affairs of life'.[165] Hearing a conversation, whilst on a train journey, in which it is suggested that 'no such person as "Edward Lear" exists', Lear is able to prove his existence and reduce his 'would-be extinguisher' to silence.[166]

Through the accumulation and arrangement of these fragments, Jennings reconstructs the experience and texture of that historical transformation brought about by the Industrial Revolution. His concern is with the structure of feeling, the language, the images and metaphors and conceptual frameworks through which the world is appropriated. Through his painstaking montage of images, whose power, in Benjamin's phrase, is 'not

the strength to preserve but to cleanse, to tear out of context, to destroy',[167] Jennings traces the emotional impact of Rationalism and Industrialisation, the imaginative losses, gains and possibilities.

PANDAEMONIUM OR JERUSALEM?

> The labours of the antiquary, the verbal critic, the collator of moulding manuscripts, may be preparing the way for the achievements of some splendid genius, who may combine their minute details into a magnificent system, or evolve from a multitude of particulars some general principle destined to illuminate the career of future ages.
>
> (Humphrey Jennings, 'The Boyhood of Byron')

> What are these things, these factors of process which we call fact? They are in flux. They have been made and are therefore changeable. There exists the possibility of being otherwise.
>
> (Ernst Bloch)

Some years back, Bob Young deplored 'the sequestration of issues concerning science and technology from the mainstream of culture' and argued that 'we must try to create more effective cultural forms – new ways of eliciting resonances and of moving readers dramatically, biographically, in debate'.[168] Jennings' published work is fragmentary and sparse, but, we would argue, his total project – through his painting and poetry to Mass Observation and *Pandaemonium* – was precisely to reinstate science and technology within the domain of public discourse.

The prerequisite for cultural debate of scientific and technological issues is an understanding of science and technology, not only as technical or economic phenomena, but also as cultural forces. For Jennings the fundamental political issue was the ways in which science and technology, through the Industrial Revolution, had not only shaped the natural and industrial landscape, but also informed the ideas, language, perceptions, emotions and imagination of the inner landscape. Behind the immediate political crises of the 1930s, he suggests, is the more fundamental crisis of rationalism and industrialism, the dissociation of science and poetry, and the consequent 'fatalism among the mass about present and possible future effects of science, and...tendency to leave them alone as beyond the scope of the intervention of the common man'.[169] It is this concern that places Jennings within the moral and political space of what Raymond Williams has called the 'Culture and Society' tradition in English social thought. Indeed, we would argue, Jennings' combined intellectual and aesthetic explorations make him one of its most radical and inventive protagonists.

The danger of ascribing this allegiance to Jennings is to canonise and fossilise him as a neglected Romantic thinker. His real importance, however, is to have recast the 'Culture and Society' argument within the discourse of

36

Surrealism and Modernism. It is this achievement that brings scientific issues within the sphere of cultural discourse. It is in *Pandaemonium* that Jennings' use of the Surrealist *objet trouvé* and of the principle of coincidence became most integrated with his thematic preoccupations. In this 'imaginative history of the Industrial Revolution', he is interested in the historical forces that have produced the dissociation of reason and imagination, science and poetry, materialism and animism. The force of history and tradition is central to his understanding of present political and cultural crisis, and of future possibilities. Jennings' philosophical history, like that of Ernst Bloch, seeks 'the discovery of the future in the past': 'Mankind is not yet finished; therefore, neither is its past. It continues to affect us under a different sign, in the drive of its questions, in the experiment of its answers'.[170] Jennings' appropriation of history as a political lever to open up the future translates into his transformation of antiquarianism – the collecting of historical images and quotations – into a modernist device. Just as Mass Observation built up 'museums of sound, smell, foods, clothes, domestic objects, advertisements, newspapers, etc.',[171] so is *Pandaemonium* a museum, a reference library, a collation of mouldering manuscripts. But through the fragmentation and collision of historical relics it becomes possible to escape the familiar and habitual force of history and tradition, to outwit the force of habit. Like Benjamin, Jennings discovers that

> the transmissibility of the past has been replaced by its citability and that in place of its authority there had arisen a strange power to settle down, piecemeal, in the present and to deprive it of 'peace of mind', the mindless peace of complacency.[172]

Through the process of defamiliarisation, the breaking apart of the solid and compacted immediacy of tradition and history, it becomes possible, perhaps, to appropriate the imaginative resources for change and to preserve the 'utopian obligation'.[173] The 'facts' gathered by the collator-documentarist are in flux; they have been made and are therefore changeable.

'Hope seeks the truth of history: as its most powerful know-thyself or its uncovered face'.[174] If *Pandaemonium* is the truth of history, then hope takes the form of Jerusalem and Xanadu: 'Xanadu is the palace of pleasure: the opposite of Pandaemonium. Now only a dream possibility, now only to be found in dreams or opium – only fragmentarily written down'.[175] In his utopian aspirations, Jennings is heir to Blake, but also to William Morris – *Pandaemonium* ends with a passage from *A Dream of John Ball* – whom he considered to have returned the spirit of imagination to the working-class movement.[176] Running as a thread through the montage of texts is 'the power to come': 'The people are the power to come...they are, I say, the power, worth the seduction by another Power not mighty in England now; and likely in time to come to set up yet another Power not existing in

England now'.[177] Kathleen Raine recalls walking across Battersea Bridge with Jennings shortly before his death:

> Raising his arm with a characteristic gesture towards the industrial land-scape from Lots Road Power Station to Battersea, he said, 'This has all grown up within less than two hundred years. Has anyone ever suggested that this was the way in which human beings ought to live? It will all have to go, it has been a terrible mistake!'[178]

Jennings was not only a modernist, but also a socialist-utopian inflexion of the Romantic tradition. At its most intense and complex his work seeks to overcome habit, automatic perception, fatalism. The aesthetic and intellectual strategy of dislocating and defamiliarising history and tradition seeks to open up the imaginative-utopian spaces – in science as in poetry – out of which future possibilities (Jerusalem-Xanadu) can be elaborated:

> The world is not yet completely determined, it is still somewhat open: like tomorrow's weather. There are conditions which we do not yet know or which do not even exist yet. Therefore, it can rain tomorrow or it can be pleasant. We live surrounded by possibility, not merely by presence.[179]

2

ENGAGING WITH LUDDISM

No doubt we are intelligent. But far
from changing the face of the world, on stage
we keep producing rabbits from our brains
and snow-white pigeons, swarms of pigeons
who invariably shit on the books.
You don't have to be Hegel to catch on to the fact
that Reason is both reasonable and against Reason.
(Hans Magnus Enzensberger, *The Sinking of the Titanic*)

In this chapter, we want to consider the meaning and significance of Luddism. It is an issue that we took up in the 1980s, when we wrote a book on information technology with the subtitle 'A Luddite Analysis'.[1] Reacting to the reflex dismissal of the Luddites, we urged that they be approached with more understanding, and that there should be a more historically grounded awareness of the particular circumstances to which they were responding. Our intention was never to argue for reinstating classical Luddism as a political strategy. What we acknowledged and emphasised was that the Luddism was born out of a particular historical moment: it was the uncompromising response of an emerging proletariat experiencing the displacement of traditional social relations by the relations of *laissez-faire* capitalism. Luddism represented an attitude of resistance, of refusal by working people to be defined and dominated by capital, that was appropriate to the early nineteenth century.

The point was, however, to bring the Luddite experience into play in the discussion of the new technologies of the late twentieth century – particularly because the opprobrium of being a Luddite was being directed against anyone with the least critical response to the proliferation of information technologies. What those who railed against Luddism wanted to tell us was that there was no way in which the new technologies could be opposed since there was nothing in the technology itself that could be argued about. Along with a number of other writers,[2] we were critical of those who were presenting the development of information technologies as somehow having

39

its own inevitable, progressive logic, and as in some way insulated from the rest of society and thereby developing only according to its own internal logic. From our perspective, technology had to be seen as inherently social – and in the modern period, we argued, this social nexus has been about the articulation of the capital relation, which has assumed a succession of different historical forms. We were interested in the possibilities of resisting the logic of technological domination in the present, and curious about what forms contemporary resistance could assume. The lesson we took from the Luddites was that there were other values that might be fought for in the face of expanding capitalist mastery of the social and natural worlds. Toni Negri once referred to them in terms of the 'development of the productive forces of the proletariat, defined in a marxist way as the capacity to enjoy, to invent and to be free'.[3] Essentially it is a matter of recognising that the future could be different from the way in which the prevailing capitalist-technological imaginary posits it.

In the following discussion, we seek to rehabilitate our older agenda. But, of course, we have to recognise that things have changed considerably since the time we first began to reflect on Luddism. Can the moment of Luddism still be a reference point? In the final section of this chapter, we take up the issue of what Luddism might mean at the end of the 1990s.

THE SPECTRE OF LUDDISM

Early in 1813 Mr Baron Thompson, called upon to sentence men found guilty of machine-breaking in the West Riding, took the opportunity to deliver a lesson in political economy. 'Those mischievous Associations', he intoned, had as an objective

> the destruction of machinery invented for the purpose of saving manual labour in manufactures: a notion, probably suggested by evil designing persons, to captivate the working manufacturer, and engage him in tumult and crimes, by persuading him that the use of machinery occasions a decrease of the demand for personal labour, and a consequent decrease of wages, or total want of work. A more fallacious and unfounded argument cannot be made use of. It is to the excellence of our Machinery that the existence probably, certainly the excellence and flourishing state, of our manufactures are owing. Whatever diminishes expense, increases consumption, and the demand for the article both in the home and foreign market; and were the use of machinery entirely to be abolished, the cessation of the manufacture itself would soon follow, inasmuch as other countries, to which the machinery would be banished, would be enabled to undersell us.[4]

Thus the learned judge addressed the Luddites before him in the dock. In so doing he not only offered a concise and orthodox account of an economic

doctrine then making considerable headway in Britain, but he also cruelly parodied the views of those protesting workers who had joined into Luddite bands. Mr Baron Thompson's observations were widely reported in the contemporary press and in specially printed circulars. The economic doctrine became increasingly popular throughout the nineteenth century. The parody stuck.

One can only speculate on the responses of the defendants, who remained silent while seventeen of their number were sentenced to be hanged for their part in organisations and activities which had resisted the introduction of new technologies. But if Thompson's words fell upon deaf ears that day in January 1813, the subsequent executions were not without effect. They were to signal the end of significant Luddite opposition to mechanisation in Yorkshire. Thereafter the Industrial Revolution accelerated.

We no longer have to hang opponents of technological 'revolution'. There is even small need to lecture those who demonstrate recalcitrance; it often suffices to invoke the spectre of Luddism. Homilies of the kind offered by Mr Baron Thompson are nowadays unnecessary because the very word 'Luddite' so successfully abuses any opposition that his long-winded message gets through by default. And ever since the defeat of the original Luddite revolt we have had constant reminders of the outright madness and futility of Luddism.

Almost a century ago, John Russell argued that 'the history of Luddism should teach trade-unionists, anarchists, and all who are striving, in however mistaken a way, to advance mankind...how little is accomplished by ignorant, unreasonable violence'. Resistance to technology is never worthwhile: 'the mistaken policy of frame-breaking did no more than arrest for a time the advancing tide of scientific industry'.[5] More recent accounts present the Luddites as equally hopeless. 'The Luddites', so the argument goes, 'were slow to learn their economic lessons about the impossibility of resistance to technological change.' The argument proceeds along a familiar and well-worn furrow:

> It would he unduly romantic to suppose that industrial sabotage had a useful part to play in future attempts by the working classes to agitate for their various causes. It is not necessary to be either Whiggish or Fabian to reject industrial sabotage and violence as a 'primitive' form of behaviour and a way of solving labour problems inferior to the methods employed by men who later built up powerful trade unions or attempted to use the power of the state on behalf of their sectional interests.[6]

For all concerned, Luddism is a charged concept and an opprobrious label: if you don't favour 'progress', 'improvement', 'change', the 'new', the 'future', then you risk having the dread charge laid at your door.

TECHNOLOGICAL MODERNISATION
AND ITS OTHER

In recent British politics, the spectre of Luddism has frequently been invoked by those who have stood for technological 'modernisation'. Thus, on the eve of his election to the premiership, and after three successive Conservative victories in the polls, Harold Wilson determined to revamp the outdated image of the Labour Party. At the 1963 party conference, he significantly aligned scientific development with the destiny of his own Labour Party when he advised the faithful that 'we must harness Socialism to science, and science to Socialism'. Wilson's famous Scarborough speech insisted that the Labour Party stood for everything positive and forward-looking – and what could symbolise this better than the 'white heat of this [technological] revolution'? And it went on to identify as the antithesis of the leadership's own 'modernizing' zeal all those who might stand in the way of technological progress. 'Let us be frank about one thing', Mr Wilson said, 'there is no room for Luddites in the Socialist Party.'[7] What Wilson and the Labour Party represented was the technocratic route to modernisation, opposed to all those who could not see the virtues of rational progress.

A decade on, with his own party in some disarray after a series of policy reversals preceding the electoral defeat of the Heath government, Sir Keith Joseph commenced an anguished yet fundamental rethink of the state of the nation and the adequacy of the Conservative response. Sir Keith informed the Conservative Party Conference that 'in some parts of the country there is Luddism'. Later on, in his ministerial role as Industry Secretary, he attacked 'Luddite sections' of the workforce and identified as one of the 'six poisons which wreck a country's prosperity...a politicised trade union movement associated with Luddism'.[8] When Mrs Thatcher became party leader and subsequently Prime Minister, she committed herself to extracting the 'poison' identified by her mentor, seeking to denude organised labour of its influence and authority through various legislative and policy measures and then through confrontation, most devastatingly against the National Union of Mineworkers in 1984–85. One of Thatcher's Ministers for Industry played the familiar Luddite card: 'Fears that automation will inevitably lead to higher unemployment are not new', declared Patrick Jenkin in the pages of *New Scientist*. 'In 1811 the Luddites rioted and destroyed the textile machinery which they saw as a direct threat to their jobs. Yet employment in the textile industry proceeded to grow during most of the nineteenth century.'[9] In the Thatcher period, diatribes against imagined Luddites were translated into direct action against working people. In the Conservative case, modernisation was about creating free markets, and the Luddite opposition consisted of those who stood in the way of neo-liberalism.

A key advancement for both technocratic and market modernisers came with the development, in the late 1970s, of new microelectronics technologies. And what united them all was the determination to exorcise what they

perceived, in their different ways, as the other of modernisation. There was the fear that the evil of Luddism would stand in the way of progress. Around 1980, fears that Britain might be failing to adjust to the new technological agenda became a matter of public concern. Lord Dahrendorf, a former Director of the LSE and an Oxford grandee, discerned a 'new Luddite spirit' across Europe as he looked 'into the 1980s' for *New Society*: 'There is, not only among printers, a new Luddite spirit growing. Antinuclear sentiment is part of it. And the protests against technology find their counterpart in increasing doubts in the beneficent effects of science.'[10] In the pages of *Management Today*, Michael J. Earl reiterated Dahrendorf's false polarisation – 'science or Luddism?' He, however, seemed convinced that nobody could really be persuaded by Luddite arguments:

> The uncomfortable question keeps on reappearing – will society be altered for the better? Technologists, sociologists, journalists and others have begun to sound the alarm bells. In reality, most even of the alarmists do not wish to halt technological advance; they are not natural Luddites.[11]

Perhaps the most telling example of Luddite phobia was an advertisement for IBM in 1979. IBM's advertising agency went into the business of giving history lessons.[12] Depicting a broken alarm clock, they recalled that 'between the years 1811 and 1816, a group of textile workers had just the answer to the threat of technology'. They went on to point out that, if those Luddites had been allowed to continue breaking machines, 'Britain would never have become the economic power that it did in the late nineteenth century'. The moral, of course, was that Luddite opposition was utterly futile, since 'it's not progress itself which is the threat, but the way we adapt to it'. It could only be the naïve and ignorant who would attempt to obstruct 'technology [which is] the mechanism of progress'. Only fools and miscreants – Luddites – would attempt such a course of action since it is as stupid as breaking clocks under the misapprehension that it may delay tomorrow: 'You can't stop time by smashing clocks', just as you cannot stop progress by resisting machines. Luddism is portrayed as all that is negative and hopeless in resistance to technological development: to be Luddite is to be mindless and ignorant, violent and aimlessly destructive, lacking in imagination, opposed to human progress, and so on.

And what was significant was how effectively the rhetorical intimidation worked through the 1980s. Trade unionists and critics of new technology went out of their way to avoid any accusation of Luddism. Through their very desire to avoid being seen as atavistic and obstructive, they came to accept the terms set by those who have defined Luddism through parody. Disavowals of 'latter-day Luddism' came from those who insisted on the 'responsibility' of their approach to technological innovation. For instance, Barrie Sherman, then head of research at the Association of Scientific,

Technical and Managerial Staffs (ASTMS) argued that 'we will have to embrace and adopt the new technologies', going on to claim that 'Luddisms never work'.[13] David Cockroft of the International Federation of Commercial, Clerical, Professional and Technical Employees (FIET) maintained that 'it is axiomatic now that the "Luddite" option for British trade unions is not a valid one because of the international competitive pressures which exist'. He went on to argue for 'the "middle path" between blind acceptance and mindless Luddism'.[14] A report on a workshop on new technology in process industries added that 'far from being the "Luddites" that trade unionists are often accused of being, those at the workshop complained that they were constantly urging their firms to invest and replace obsolete and sometimes dangerous equipment'.[15] And, as a final example, we had Colin Hines arguing, in an influential pamphlet, that he did not see

> a Luddite-smash-the-computer-response to these developments [as] appropriate; the need to remain internationally competitive leaves us with little alternative but to increase their application, since most other leading industrial nations already make more use of computers and microprocessors than we do in Britain.[16]

Through its rhetorical offensive, then, management was able to inhibit claims around redundancies, deskilling and changes in working conditions (and, of course, it is the case that this rhetoric about 'progress', 'realism' and 'competitiveness' need not actually convince whole-heartedly in order to be effective; it is quite functional when it imprisons potential opposition within its terms of debate, thus impeding the mobilisation of alternative discourses).

In the 1990s we have seen a great resurgence of techno-boosterism and new visions of progress.[17] What now figures at the heart of both corporate and political thinking about the technological future is the so-called 'information superhighway' (the competitive potential of the Internet, the World Wide Web, and cyberspace). The new techno-boosterism has become assimilated within the corporate ideology of globalisation and its scenarios for instituting the global network society. In this context, New Labour has elaborated a perspective that seems to combine both the technocratic and neo-liberal strands of modernisation strategies. Technocratic modernisation continues, with the Government now committed to making Britain, in the words of Peter Mandelson, 'Europe's digital pathfinder'.[18] 'The knowledge race has begun,' declared Tony Blair, at the 1995 Labour Party Conference, 'Knowledge is power. Information is opportunity. And technology can make it happen....This combination of technology and know-how will transform the lives of all of us.' But technological modernisation is now allied with market modernisation. This latter aspect of modernisation is all to do with accepting and adapting to the realities of economic globalisation. In

addressing the 1998 party conference, Blair referred to the dilemmas of 'finding security and stability in a world pushed ever faster forward by the irresistible forces of history and human invention'. 'It is', he said, 'as if capitalism has found its own version of permanent revolution.' The role of government, in this context of modernisation, must be to help us adapt to the irresistible forces of the global economy, co-ordinating the UK information strategy in order to maximise whatever gains are possible.

The explicit invocation of Luddism is probably less frequent now. To be sure, one comes across the occasional sneer, as for instance in Peter Mandelson and Roger Liddle's banal assertion that 'only a Luddite would ignore the possibilities that technological change offers'.[19] But generally it seems less necessary to invoke the Luddite bogey. Perhaps it is felt that there is less need to justify the virtues of the information society? Or perhaps it seems as if the inevitability of global change is so blindingly apparent, and as if there can no longer be any hope that the new technological order could be resisted? 'Resist change – futile', as Blair put it in his 1998 speech. The only thing now is to 'manage change, together'. But perhaps New Labour is too sanguine in its third way. Perhaps we still need Luddites to question the possibilities that technological change 'offers'. At the end of this chapter, we shall put New Labour's sense of managerial confidence into a different context. And we shall also be arguing that Luddism continues, in fact, to be a necessary force in the new global society – and, moreover, that it is alive and flourishing. Technological modernisation still feels itself being stalked by its other.

HISTORICAL LUDDISM

First, however, we must deal with the parody of Luddism by considering what historical Luddism was really about. The industrial unrest of the early nineteenth century – which includes not just the Luddites (1811–16) but also the 'agricultural Luddism' of Captain Swing – occurred in the context of major and dramatic changes in the structure of social relations right across society.[20] These were most marked by innovations in the organisation of work, but spread far beyond the immediate process of production to the recasting of social space (towns, the family, leisure, etc.). In the early nineteenth century the chief instigators of such changes were a new breed of men, the modern businessmen, who preached and practised the doctrine of *laissez-faire*. Men like William Cartwright of Rawfolds near Leeds were fervent advocates of industrial capitalism; their enthusiasm for new technologies integrated with their new political economy. These modern men placed great emphasis on the mechanisation of plant, the centralised organisation of production, anything to improve their output. Such radicalism was seen as folly not only by many employees of the new men but also by numerous local employers who preferred to stick to the older,

tried-and-true methods. The latter were, however, soon compelled to fall into line by the superior market competitiveness of those whom Eric Hobsbawm has described as 'the large modernised entrepreneurs'.[21]

It would be a mistake to see Cartwright and his kind as merely technological innovators. Their stress on innovation and improvement is better seen as the material expression of an ideological zeal which contrasts with that of the small-scale eighteenth-century masters. This is seen most distinctively in the shift from a paternal concern to the doctrine of contract which came to mediate social relations: in place of personal responsibility and responsiveness to those in one's employ there came a commitment to wages, price and profit. It was in this context of a shift in attitudes that technologies such as the hand loom made sense to people like Cartwright, since 'sense' was measured in the precise terms of liberal political economy. For the *laissez-faire* capitalists, themselves usually the industrialists who owned or managed the larger factories, new machines and centralised production meant extra output, decreased labour costs, competitive edge, and more control over the labour process (Mr Baron Thompson spoke their language).

It was against this backcloth that Luddism came into being. But this Luddism, the real Luddism, was not the cry of the empty gut against innovations which inexplicably (at least to the victims) threw people out of work. It was an answer from many ordinary working people to changes imposed from above which had repercussions on their whole way of life, notably through the 'mobilisation' of women's and children's labour in place of that of skilled men.[22] Luddism was above all else an attempt by working people to exert some control over changes that were felt to be fundamentally against their interests and mode of life. It was a protest, in the days before the existence of any organised trade union movement, against new modes of accountancy, employment patterns, work rhythms, and industrial discipline.

A number of historians, most prominently Edward Thompson, have examined the working-class responses which were expressed in Luddism. These historians have shown that the Luddites were not frenzied bigots: on the contrary, they were usually remarkably well-disciplined and organised. They did feel passionately about what was being done to them in the name of progress, but their actions were measured. Their targets were by no means indiscriminate, but carefully selected with due regard given to the actions, policies and attitudes of the particular manufacturer. (Not surprisingly, Cartwright's factory – itself, significantly, well-guarded – was the scene of the most vigorous Luddite assault in Yorkshire.) Most importantly, we now know that, despite the protestations of a long line of judges, politicians and industrial managers, the Luddites did not protest against new machines *per se* but against the changed social relations of which mechanisation was but a part. Thus we find, for example, numerous instances of factories which used new machines being attacked, but only those worked by underpaid, untrained and unskilled 'colts' being destroyed.

Luddism, in short, was an answer – a political and moral response – from working people to forces intent on destroying traditional social relations. For Edward Thompson 'Luddism must be seen as the crisis-point in the abrogation of paternalist legislation, and in the imposition of the political economy of laissez-faire upon and against the will and conscience of working people'.[23] Luddism entailed an attempt to impose their priorities upon an inhumane system of industrial capitalism. It was not a blind response, nor was it a matter of isolated protests, nor was it simply an industrial rebellion. It was a determined movement which shifted its scale of operations from local villages across counties, which planned and practised its sorties with some care, and which moved back and forth between armed raids on factories, industrial activity and calls for political reform – in short, what Thompson calls a 'quasi-insurrectionary movement'.[24] Luddism was a force which, if it looked back to better times in demanding 'full-fashioned work at the old fashion'd price established by Custom and Law', also looked towards the future times of working-class organisations and aspirations. Although we might expect the sneering dismissal which Luddism so frequently receives today, such dismissal is not what Luddism received from contemporaries; despite a large presence of troops, government spies and rewards for informers, the detection rate for Luddite activists was remarkably small. The only satisfactory explanation is that Luddism enjoyed widespread popular (if only tacit) support.

Luddism was, then, the attempt to subordinate the ravages of industrial capitalism to alternative priorities. Whilst it has invariably been dismissed as a primitive form of resistance, appropriate to 'societies where the patterns of industrialisation were incomplete'[25] we should and must put forward an alternative and positive interpretation of Luddism as 'an alternative political economy and morality to that of *laissez-faire*':

> It was Marx who saw, in the passage of the 10 Hour Bill (1847), evidence that for 'the first time…in broad daylight the political economy of the middle-class succumbed to the political economy of the working class'. The men who attacked Cartwright's mill at Rawfolds were announcing this alternative political economy, albeit in a confused midnight encounter.[26]

The political economy of Luddism carried a moral response to the changes wrought upon society by the logic of industrial capitalism. It contained the force of a critique in action and an alternative way of understanding technological change.

IN THE NAME OF PROGRESS

It is important to redeem the Luddites from the calumny that has been heaped upon them. But our discussion of the Luddites should not just be a

matter of honouring the memory of past stockingers and weavers. The more important point must be to understand how it is that their reason can now only appear as unreason. How is it that the deeds of the 'Leicestershire imbecile', Ned Ludd, could have such a powerful historical resonance? How is it that the charge of 'Luddism' could have become a ritual incantation that forecloses any real debate on the social and political implications of technological choices? We need to consider the force of the capitalist imagery of mastery – what Cornelius Castoriadis describes as 'the significa-tion of the unlimited expansion of an allegedly rational alleged mastery over everything'.[27] To address these questions, we want now to explore this signification in one of its ideal forms – in the idea of progress, which has become the great measure against which the project of the Luddites has come to appear as both atavistic and irrational. In the following section, we shall consider how the idea of progress has come to be narrowly and inextricably associated with developments in science and technology – in what we regard as a diminishing idea of progress – and how technological progress has come to function as an alien and absolute value. Then we shall be concerned with the way in which technological progression has been incorporated into the project of capital accumulation. Here it will be a question of understanding technological mastery in its political dimension, as it mediates the relation between labour and capital; we are concerned with new technological developments in terms of the role they are asked to play in the mobilisation of social labour.

The standard criticisms and commentaries on Luddism are always prem-ised on the inevitability of scientific and technological progress, in the face of which the Luddites are seen as having mounted a hopeless and retrograde action. Thus Russell refers to 'the advancing tide of scientific industry' and Thomis to 'the impossibility of resistance to technological change', and so on. It was this apparently self evident notion of scientific and technological progress that the Luddites did try to resist, and that we want now to consider.

This mythology of 'progress' draws some of its appeal from conflating the concepts of change, development and progress. While 'change' is indetermi-nate and open-ended, 'development' implies a positive direction (as opposed to simply dissolution or chaos), and 'progress', even more strongly, implies an 'enlightened' way forward. In the modern period, change has seemed to be primarily a consequence of scientific and technological innovation (Blair's 'irresistible forces of history and human innovation'). And it has been the values of science and technology that have informed our interpretation of change as social progress (in his Address to the British Association in 1885, Lyon Playfair made the point quite clearly: 'Human progress is so identified with scientific thought, both in its conception and realisation, that it seems as if they were alternative terms in the history of civilisation'). Through the mediation of science and technology, a particular kind of change gets

represented as the only rational one – that is, as the 'naturally' given form of development and hence as the unitary form and direction of 'progress'.

In reality, of course, the conditions always exist for struggle over the course of social change, and it was precisely such conflict which character-ised the moment of Luddism. The hegemonic position of capital has depended on its ability to impose its values on the nature of change (and, at the same time to deny that alternative values could have any rational validity). And here the conflation of change and progress becomes crucial, as when Thomis insists upon 'the impossibility of resistance to technological change'. The elision of two distinct terms effectively serves to remove historical 'development' from the sphere of social intentionality and to make it seem an objective 'natural' process, merely elucidated by human agency. Human choice lies only in accepting or rejecting a pre-given 'progress'. And surely rejection would be an insane choice – that was the great mistake of the Luddites. What is scandalous about Luddism is that it exposes and challenges the modern mythology of progress.

Let us consider the modern ideal of scientific and technological develop-ment (the ideal that insists on us all being anti-Luddites). Development is not seen as an inherently social phenomenon: quite the contrary, science and technology are seen as fundamentally asocial, as the neutral motor of 'progress', developing independently of all human agency and purpose. This latter dimension, the realm of the social, thereby becomes hidden, obvious only at the stage where technologies are used and applied. Accordingly, the effects of science and technology upon the social fabric – in displacing and disciplining labour, for example – come to be seen as secondary, contingent. These negative social 'effects' of new technologies are seen as fortuitous, coincidental, even unavoidable side-effects of history's juggernaut of 'progress'. These effects may be rectified, it is suggested, by sagacious use of the technologies. Thus, while acknowledging that somewhat obvious social priorities may guide the application stage, this view hides their presence in the origination of new technologies; potential alternative priorities remain undeveloped, almost as if they did not and could not exist.

Thus the origination of scientific and technological development appears independent of broader social processes. Instead it is conceptualised as an asocial phenomenon, the result of the purely intellectual capacities of scientists and technologists to read *The Book of Nature*, to elucidate and 'discover' that which is immanent within an external and autonomous nature. Such revelations of scientific laws and processes – deemed already to pre-exist within nature and merely awaiting discovery – advance along a linear continuum and result in ever-greater human knowledge and control over nature. This is then conceived in terms of the cumulative process of scientific and technological development, the continuous unveiling (and thereby the harnessing) of the laws and truths of nature – a process which is indeed 'inevitable' as long as the direction of scientific development appears rooted

in the natural order. Within such a conception, the social process is subsumed as a function of the natural order, and scientific and technological truths are simply revealed, since they are not the products of human social processes.

However, if human agency is banished, this does not mean that purposiveness is absent from this mystified scheme. The natural order – as such, and external to human social relations – is seen as a rational order, with its own providential logic, its own telos. Scientific and technological development is considered to be both a revelation and a manifestation of that order, and on this basis it is equated with 'progress'. From this mystified vantage point it is in fact impossible to see the present direction of scientific and technological change as anything other than progress: all 'rational' change moves in the direction of progress, and all scientific development is of course rational. On this discursive terrain, where the social order gets rooted in the natural order, this conception of progress is incontestable, for it is change in conformity with the natural and eternal 'order of things', an order which transcends the particularity of different historical and social values.

Thus, through this rationalist ideology, sectional values present themselves not as arbitrary and partisan values, but as emanations of a higher absolute order of the world which expresses itself through the social. It seems as if capitalist priorities – the imperative of profitability, the primacy of private property, supply on the basis of ability to pay criteria, marketability as the driving force of production, the impulse to minimise labour costs, and so on – move in the direction of progress because they derive from, and conform to, the natural order, 'the nature of things'; they articulate natural, absolute and eternal truths. And it is precisely this subsumption of the social and particular into the categories of the natural and eternal that characterises the form of the ideology of progress, a form that imposes upon our thinking a logic from which it is difficult (but not impossible) to escape. Marx was clear about the centrality and importance of this phenomenon. 'The law of capitalist accumulation', he observed, '[is] mystified by the economists into a supposed law of nature'.[28] And again:

> When the economists say that present-day relations...are natural, they imply that these are the relations in which wealth is created and productive forces developed in conformity with the laws of nature. These relations therefore are themselves natural laws independent of the influence of time. They are eternal laws which must always govern society. Thus there has been history, but there is no longer any.[29]

Consequently capitalist relations become petrified as a natural thing, as a 'second nature'. The future appears ultimately not subject to social choice, much less to struggles over values: rather, it will express a pre-ordained natural history. In this scheme, the Luddites are not the proponents of one set of social values and priorities against another, not even merely

'dysfunctional' elements within a particular social system. They are seen as being at odds with the providential 'course of events' itself: the Luddite as dinosaur. Conceived as the opponents of 'progress' as such, they must also be conceived as the deluded opponents of rationality itself. They seek to obstruct not so much social laws as the order of nature itself. As such Luddism is anomalous, unnatural, monstrous, irrational.

THE FETISHISM OF TECHNOLOGY

Just as Marx theorised commodity fetishism in capitalist society, so too we can refer to a 'technology fetish' to understand the way in which capitalist technology assumes the form of a discrete and reified entity, with its own autonomy and momentum, entirely separate from the rest of society, and to which that society must react. According to Lucio Colletti's argument, the process of alienation/fetishism pervades all aspects of capitalist societies, and it is 'always the same....It hinges upon the hypostatising, the reifying of abstractions and the consequent inversion of subject and predicate'.[30] This process has three closely interrelated attributes: (a) abstraction; (b) reification or hypostatisation, whereby 'certain *specific social relations of production between people* appear as *relations of things to people*, or else certain social relations appear as the *natural properties of things in society*';[31] and (c) inversion or domination, whereby 'the social side of human beings appears as a characteristic or property of things; [and] on the other hand, things appear to be endowed with social or human attributes'.[32]

Alienation/fetishism is, then, that process whereby 'production relations are converted into entities and rendered independent in relation to the agents of production...[and] appear to them as overwhelming natural laws that irresistibly enforce their will over them, and confront them as blind necessity.'[33] Within this process, capitalist domination expresses itself through, and derives its efficacy from, the mystification of social relations. At this point it is important to stress, however, that the 'processes of hypostatisation, the substantification of the abstract, the inversion of subject and predicate' are not just ideological illusions (in terms of mere false consciousness), but are 'located...in the structure and mode of functioning of capitalist society itself'.[34] They are real abstractions; the mystification of fetish forms in capitalist society is located in the reality itself.[35]

Georg Lukács argues that it is under the generalised commodity production characteristic of capitalist society that

> the reification produced by commodity relations assume[s] decisive importance both for the objective evolution of society and for the stance adopted by men [sic] towards it. Only then does the commodity become crucial for the subjugation of men's consciousness to the forms in which this reification finds expression and for their attempts to comprehend the process or

to rebel against its disastrous effects and liberate themselves from servitude to the 'second nature' so created.[36]

Within capitalist economic relations, labour itself becomes a commodity among all the others. As such, labour assumes the abstract and undifferentiated form of an exchange value: 'abstract, equal, comparable labour, measurable with increasing precision according to the time socially necessary for its accomplishment'.[37] Labour-power as a commodity *abstracts itself*; it becomes detached and separate from its existence and particularity as a use value. In this process 'man's activity becomes estranged from himself; it turns into a commodity which, subject to the non-human objectivity of the natural laws of society, must go its own way independently of man just like any consumer article'. Lukács argues that this estrangement and externalisation expresses itself as domination: 'What is of central importance here is that, because of this situation, a man's own activity, his own labour, becomes something objective and independent of him, something that controls him by virtue of an autonomy alien to man.'[38]

Through this process, abstract commensurable labour becomes the form and expression of social labour. Human sociality and productive powers come to exist in this estranged form in which they confront people as the extraneous and compulsive rationality of capital. It is with machinery, however, that this process reaches its culmination. Through the mediation of technology, the labour process takes on the form most adequate to the domination of capital, and abstract labour becomes ever more really and materially part of the actual experience of people. This mediation of social relations of production through the 'technology fetish' is vividly described by Marx. In the 'specifically capitalist mode of production', he argues,

> even the social form of labour appears as a form of development of capital, and hence the productive forces of social labour so developed appear as the productive forces of capitalism. Vis-à-vis labour such social forces are in fact 'capitalised'. In fact collective unity in co-operation, combination in the division of labour, the use of the forces of nature and the sciences, of the products of labour, as machinery – all these confront the individual workers as something alien, objective, ready-made, existing without their intervention, and frequently even hostile to them. They all appear quite simply as the prevailing forms of the instruments of labour. As objects they are independent of the workers whom they dominate. Though the workshop is to a degree the product of the workers' combination, its entire intelligence and will seem to be incorporated in the capitalist or his understrappers....With the development of machinery there is a sense in which the conditions of labour come to dominate labour even technologically and, at the same time, they replace it, suppress it and render it superfluous in its independent forms. In this process, then, the social characteristics of their

labour come to confront the workers so to speak in a capitalised form; thus machinery is an instance of the way in which the visible products of labour take on the appearance of its masters.[39]

What we are suggesting is that the significance of alienated or fetishised technology may be seen as the extension and intensification of abstract labour (as both mystification and domination). But it ought also to be considered from a historical perspective, in terms of the development of the modern labour process:

> If we follow the path taken by labour in its development from the handi-craft via co-operation and manufacture to machine industry we can see a continuous trend towards greater rationalisation, the progressive elimination of the qualitative, human and individual attributes of the worker.[40]

This rationalisation and mechanisation of production brings with it the dissolution of traditional patterns of life and 'destroys those bonds that had bound individuals to a community in the days when production was still "organic" '.[41] It is here that we rejoin the concerns of Edward Thompson, who situates the introduction of machinery in the context of a 'conflict... between two cultural modes or ways of life'.[42] And it is here, too, that we rejoin the Luddites, who were able to sense the real significance of mechanisation and industrialisation, and bold enough to try to have an effect on the course of events.

THE CAPITALIST MOBILISATION OF SOCIETY

The approach of Edward Thompson to Luddism and technology helps us to see technology as an integral aspect of society and, more specifically, a moment of the capital relation. The work of Harry Braverman and of André Gorz has also helped us to understand the logical as well as the historical impetus of capitalist technology.[43] The theoretical tendency that they represent contends that technological efficiency in capitalist society is inherently a mechanism of control and domination,[44] a mode of existence of capital and its development. Marx expressed this epigrammatically in *Capital* when he said that 'It would be possible to write a whole history of the inventions made since 1830 for the sole purpose of providing capital with weapons against working-class revolt'. Increasingly, and particularly since the advent of Fordism early in the twentieth century, technology has become a privileged mode of expressing the social domination of capital.

Here we want to use a set of concepts developed by the French sociologist Jean-Paul de Gaudemar in his book *La Mobilisation Générale*.[45] These concepts enable us to mark the major qualitative transformations in the

mode of capital accumulation since the Industrial Revolution, and then help us to situate the role of technology within this broader process of transformation. Gaudemar seeks to periodise capitalist development in the nineteenth and twentieth centuries in terms of the ways in which capital used labour power – in terms of the way in which whole populations have been 'mobilised'. The war metaphor is not at all accidental, for, as Gaudemar says, war mobilisation provides 'the theoretical key for understanding forms of mobility in general'.[46]

Gaudemar refers to the early nineteenth century, the period of the Luddites, as that of 'absolute mobilisation', the form of social mobilisation corresponding to the extraction of abstract surplus value. This is the period in which the traditional way of life of rural populations is systematically undermined in order to create a factory proletariat, through what Sidney Pollard calls 'the adjustment of labour to the regularity and discipline of factory work'.[47] This disciplinary process involves efforts both inside and outside the factory to produce a pliant and co-operative workforce: the penalisation of vagabondage; the undermining of traditional culture (fairs, sports, etc.); the division of labour; the discipline of the 'factory-prison'; punitive discipline and control through the wage; the campaign against (the unofficial holiday) 'Saint Monday'; the inculcation of time–thrift, work–morality and conformist values more generally, through religion and schooling; the control of social space.

During the course of nineteenth century, absolute mobilisation was replaced by the process of 'relative mobilisation'. 'Relative mobilisation introduces inside the factory that movement which hitherto had only developed outside'.[48] In this process of transformation, the earlier form of 'external' discipline and control is deepened by an internal factory discipline in which technology now plays a central role and in which control coalesces with the ulterior goal of enhancing productivity and surplus-value extraction:

> the machine as dual instrument of discipline and of increased productivity. Hence its introduction, not only as autonomous technological manna, imposing its objective rationality on the mode of production...but also as a solution to the disciplinary problems of the employers.[49]

This line of development reaches its culmination with the Scientific Management of F. W. Taylor and, classically, with the assembly line of Henry Ford.[50] With Fordism there appears on the historical stage the figure of the 'mass worker' – the worker divested of particularity and skill – rendered abstract, mobile labour power, variable capital subordinated to the logic of the machine. Within the planned factory 'various technological innovations provide a tool for controlling the class "from within" through its existence as mere "labour power"'.[51]

It is important to be aware that relative mobilisation entailed more than upheaval in the factory. For it also involved a massive restructuring of the relation between factory and outside world, and a recomposition of patterns of culture, leisure, consumption, social space (housing, travel), as was noted by Gramsci in his writings on 'Americanism and Fordism'. It is important to note that Fordism finds its complement in Keynesianism; the logic of mass production entails the modes of mass and social consumption (e.g. housing, roads, etc.) brought about by the 'Keynesian revolution'.[52] Capital then becomes increasingly involved not just in the sphere of production and the control of the forces of production, but in the sphere of consumption and reproduction. As Bob Young and Les Levidow have pointed out, there is a tendency towards 'a more directly political control over the production and reproduction of daily life, extending methods of factory discipline into the state's management of the social totality'.[53] The era of the mass worker is also, as the discipline of capital permeates the community, the era of the 'social factory'.

If all of that portrays an unremitting extension of capitalist hegemony – first in the factory and then in society more broadly – this should not be interpreted as a kind of functionalism. The logic of capitalist domination is a tendential development and always remains an unfinished business. For capital constantly comes upon the stubborn existence of those who will oppose it. As Edward Thompson put it, 'in Britain, it took two hundred years of conflict to subdue the working people to the discipline of direct economic stimuli, and the subjugation has never been more than partial'.[54] The logic of capital is to reduce the status of working people to being just labour power, variable capital. These people prove to be refractory and unpredictable, however. Resistance is always present. Gaudemar writes of the 'self-mobilisation' of working people – their struggle to achieve independence and autonomy. In the context of absolute mobilisation, the Luddites played a crucial role. As Gaudemar himself says, their struggle was

> neither reactionary behavior nor the primitive, infantile reaction of a
> working-class movement that had not yet attained the maturity of its or-
> ganised period, but a general social movement where the question of work-
> ers' autonomy and, ultimately, the fate of capitalism were at stake.[55]

During the period of relative surplus value extraction, resistance took a different form. In the early part of this century, it took the form of industrial sabotage. According to one Wobbly militant, a member of the Industrial Workers of the World (IWW),

> Of all the words of a more or less esoteric taste which have been purposely
> denaturalised and twisted by the capitalist press in order to terrify and

mystify a gullible public, 'Direct Action' and 'Sabotage' rank easily next to Anarchy, Nihilism, Free Love, Neo-Malthusianism, etc. in the hierarchy of infernal inventions.[56]

Sabotage was elaborated as a strategy of resistance by the syndicalist movement (in Europe) and the IWW (in the United States), as part of their struggle against the unrelenting encroachment of Scientific Management and Fordist industrial discipline. As one involved commentator put it: '"Scientific Management" must be met by "Scientific Sabotage" if the "Law of Progress" is not a law of which the boss is to be left a monopoly'.[57] Sabotage, like Luddism before it, must be treated seriously as a political response to the conditions of Fordism – the refusal of an industrial system of exploitation. It should not simply be discounted as mindless, directionless vandalism. Sabotage in fact encompassed a number of different tactics: ca'canny ('an unfair day's work for an unfair day's pay'); open mouth sabotage (informing the consumer about the poor quality of goods in order to prejudice the interests of capital); pearled sabotage (working slowly and inefficiently to impair the smooth running of an enterprise and to demoralise employers). And most of these tactics included no element of violence. As one proponent of direct action put it, 'Sabotage means the clogging of the machine of Capitalist industry by the use of certain forms of action, not necessarily violent and not necessarily destructive'.[58] In the face of unremitting demands for industrial efficiency, sabotage represented 'the withdrawal of efficiency' and was interpreted by its advocates as an ethical response: 'working class sabotage is distinctly social; it is aimed at the benefit of the many at the expense of the few.'.[59]

Direct action and sabotage amounted to an attempt to gain back space and time from the unrelenting machine of capital, and as such was a direct descendant of Luddism.[60] As a form of counter-mobilisation, sabotage was a strategy appropriate to the conditions of relative mobilisation. As Gaudemar argues,

> sabotage is perhaps the only form of struggle possible against the forms of relative mobilisation, at the same time as being one of the contemporary signs of the crumbling away of work as a 'redemptive principle' and of the factory as eternal figure of productive space.[61]

It must be acknowledged that syndicalist sabotage remained a gesture that never developed as part of a fully political strategy. One contemporary observer described it as 'a tangle of half expressed and shifting and richly varied desires...a human phenomenon'.[62] Defined in its widest sense (and not just as machine-wrecking), sabotage represented a strategy through which the other workers' movement sought to refuse the domination of capital. It was an example of what Toni Negri calls proletarian 'self-

valorisation', the struggle to 'withdraw from exchange value and...to reappropriate the world of use values'.[63]

LUDDISM NOW

Immanuel Wallerstein offers an interesting interpretation of the origins of the capitalist system – interesting and helpful because it goes very much against the grain of the dominant, progressivist discourse. 'I do not consider the capitalist system to have been evidence of human progress,' he writes. 'Rather, I consider it to have been the consequence of a breakdown in the historic barriers against this particular version of an exploitative system.' In other historical systems, Wallerstein suggests, whenever capitalist strata got too successful or too assertive, there were social groups who opposed them, 'utilising both their substantive power and their value-systems to assert the need to restrain and contain the profit-oriented strata'; the capitalist strata were thus 'made to give obeisance to values and practices that inhibited them'. In the Western world, says Wallerstein, 'for a specific set of reasons that were momentary – or conjunctural, or accidental – the anti-toxins were less available or less efficacious, and the virus spread rapidly, and then proved itself invulnerable to later attempts at reversing its effects.'[64] We might see the early nineteenth-century Luddites precisely in terms of the attempt to sustain barriers to exploitation, in defence of alternative social values. Perhaps the word 'Luddite' has accrued its particular symbolic force in so far as it has come to stand for the defeated values of restraint. And each time the anti-Luddite offensive has been mobilised, it has been in militant denial of alternative and moderating political principles. In Wallerstein's terms, it has been the war of the virus against the anti-toxins.

The crushing of the stockingers and weavers represents a crucial historical moment, a moment of insight into the force of capital's anti-social discipline. It was the symbolic moment when moral economy became overwhelmed by the new battalions of political economy. And since the early nineteenth century, of course, the campaign against society has been unrelenting, involving, as we have argued, new forms of social mobilisation to extend and deepen the hold of capital. In the contemporary period, what is being referred to as 'globalisation' marks a further escalation in the war – the latest phase, as Noam Chomsky ironically and scathingly puts it, in 'imposing the right priorities on a recalcitrant world'.[65] William Robinson has described the present phase of global mobilisation as a 'world war'. 'It is a war,' he says, 'of a global rich and powerful minority against the global poor, dispossessed and outcast minority....[H]umanity is entering a period that could well rival the colonial depredations of past centuries.' The barriers to unrestrained exploitation are being assaulted on a historically unprecedented scale:

> Global capitalism is tearing down all non-market structures that, in the past, placed limits on the accumulation – and the dictatorship – of capital....None of the old pre-commodity spheres provide a protective shield from the alienation of capitalism. In every aspect of our social existence, we increasingly interact with our fellow human beings through dehumanised and competitive commodity relationships.[66]

What the Luddites sought and failed to resist, in their confused midnight encounter, has now grown to quite monstrous and threatening dimensions, more defiantly than ever challenging those who would seek to restrain its imperious logic.

In this new context of global enclosures, it seems to us that, far from being some kind of residual historical reference point, Luddism is more relevant than ever. Whatever it may actually mean, 'Luddism' is a concept that we simply cannot do without. Cornelius Castoriadis has argued that capitalist mastery has been sustained 'because it still benefits from models of identification that were produced *during previous eras*':

> Why ought a judge to be honest? Why should a teacher work up a sweat over his little urchins instead of just passing the time away in class, except on the day that the education inspector is scheduled to visit? Why should a worker exhaust herself screwing in the 150th bolt if she can fool quality control? There was never anything in capitalist significations from the outset – but there is, above all, nothing in them as they have now become – that could provide an answer to these questions.[67]

Capitalism has drawn on and exploited the forms of sociality and civility that it inherited from other social formations, and these have been crucial in moderating the dissolution of social norms and values. Because it cannot and does not replenish the reserves of social signification, however, there has been a long-term erosion of the social order underpinning capitalist economies. We may think of it in terms of the exhaustion of social resources. Castoriadis describes it as 'the crisis of the identification process' – 'since there is no self-representation of society as the seat of meaning and of value'.[68] The onslaught of global neo-liberalism in the 1980s – associated with the politics of Thatcher and Reagan – was, of course, a particularly delirious moment in the long war against human society. At that time it seemed as if nothing would ever again inhibit the disciplinary logic of capital. It actually seemed as if capitalist significations could be sustaining enough. But, at a time when they could be presented as no more than pale ghosts lost in history, the Luddites were actually needed more than ever before. They would not be forgotten – for this term 'Luddite' focuses a nexus of social values and dispositions that we can never afford to forget (those that make the world socially significant).

Since the mid-1990s, there has been a growing awareness of the void at the heart of neo-liberalism. And there has been a gathering concern about the social and political deficit that distinguishes contemporary capitalist economies. Alain Touraine points to the problem of 'a technological civilisation devoid of the norms and values characteristic of previous societies that guided and controlled individual behaviour'. 'Today,' he observes, 'there no longer exists a unifying principle of social life. Social life seems constantly transformed by technological and economic changes which have become independent from social institutions and value orientations'.[69] There have been responses from a variety of different perspectives to what has been perceived as the degradation of the social fabric. And, at the same time, there has been an outcry against the exhaustion of the natural base of society, with an increasing awareness of the need for self-limitation. We would suggest that the present conjuncture is one in which a particular political formation is taking shape – in what is a kind of political division of labour – in response to the damage wrought on both the social and the natural world.

Let us consider the two key aspects of this new political formation. First, there is the response within the formal political order. In Britain, this has been apparent in the strategies of New Labour, which, as we suggested above, has sought to reintroduce a technocratic and managerial dimension into politics in order to counter the excesses of disciplinary neo-liberalism. In the terms of Kees van der Pijl, what this represents is the re-assertion of the cadre element in society, those whose role and outlook 'predisposes them to keeping society intact as a functioning whole, and not just to the defense of private property at all costs'. These are the Social Democrats, who are 'trying to reconstruct a dimension of social cohesion to a market economy which increasingly is tearing apart the fabric of society and exhausting the social and natural foundations on which capital accumulation rests'.[70] This project of co-ordinated managerial politics is embodied in the politics of the Third Way. Thus, Tony Blair, in his speech to the 1998 party conference, recognised the reality of 'a world where the spectre of a global economic crisis...now leaps on the back of change, spinning the world faster still'. And, in the face of this turmoil, with 'traditional society fractured and torn', he argued the need to reconnect social links. 'Modernise.' 'Reform.' 'This way,' said Blair, 'we face the challenge together. And if the spirit of the nation is willing, it can make the nation strong. One nation, one community.' And what Blair then sought to make clear was that it is 'a strong family life [that is] the basic unit of a strong community'. From the cadre perspective, then, some form of communitarianism seems to be the way to survive the ravages of global economic and technological turmoil.

But there is another important dimension to the contemporary political formation. Here we are referring to the development of new social movements engaged in different forms of direct action. These are the campaigners

against the A30 widening scheme in Devon, against the new runway at Manchester Airport, against the extension of the Center Parcs leisure complex in Sherwood Forest, against the Faslane Trident base outside Glasgow, and so on. In the village of Vingrau, in the south-west of France, villagers have been fighting for a decade against the Swiss mining multinational, Omya, intent on resisting the degradation of their community and the experiential degradation of their lives.[71] In many cases, the new technology of the Internet has itself become the means to distribute dissent. Thus, the recent and secretive negotiations around the Multilateral Agreement on Investment (MAI) – a highly problematical treaty to facilitate transnational investment by ensuring that governments treat all foreign and domestic firms similarly – has been strongly resisted by so-called 'network guerrillas' using the World Wide Web.[72] Examples are legion now. And they are examples of a new readiness to take on global businesses and national governments alike. As a Friends of the Earth spokesperson puts it, 'There feels a new sense of urgency....It comes from the unaccountable institutions and companies. When people see how business has stitched up the decision-making they get angry.'[73] These are all examples of a new spirit of Luddism – and one for which, judging from media responses, there is a broad sympathy and even affection. It is a Luddism appropriate to a phase of accumulation which has now moved well beyond the factory, to capitalise all aspects of society, the environment, and life itself. Through this new form of direct action, the project of self-valorisation – the project to reappropriate the world of use values – assumes a new, generalised form.

This is the new political spectrum, then: between the market-sympathetic technocracy of New Labour's Third Way and the proliferation of direct action initiatives with a generally environmental perspective. What is clear is that, after the storming assault of neo-liberalism, there is at least a certain space to open up a more socially- and environmentally-oriented debate on science and technology in capitalist societies. While there may be a certain openness in the technocratic agenda, our expectations should not be too great. The key issue concerns the possibilities that might be opened up within the new direct action movements which presently have a broad and interesting base of support. To what extent can they succeed in politicising the technology debate? Here we would suggest that there is the need for internal debate within the diverse camps of those now concerned with the science and technology question. What is increasingly clear is that there is more than one way to be a Luddite. There are quite different ways of formulating a Luddite politics – and the differences, we suggest, are crucial.

We raise this issue in the light of the recent emergence, in the United States particularly, of a self-declared neo-Luddite movement. The neo-Luddites are small in number, but have generated a large amount of publicity. The staging of the second Luddite conference in April 1996 in Barnesville, Ohio – the first was held in Nottingham in 1812 – drew a great

deal of media comment. Not surprisingly, much of the response was amused at such a gathering of alternative lifestylers and assorted 'cranks' – the usual beards and sandals jokes. Unfortunately, it was also easy to associate this neo-Luddism with the agenda of the then recently arrested 'Unabomber', Theodore Kaczynski, whose 35,000-word manifesto, 'Industrial Society and its Future', published in the *New York Times* and the *Washington Post* in September 1995, voiced considerable antipathy towards industrial society and advanced technologies.[74] But, to move beyond the predictable criticism and hostility that it has attracted, there are still absolutely fundamental problems with this neo-Luddite project. For this is a deeply conservative and fundamentalist Luddism. It is a fossilised Luddism. In our view, this movement is instructive about just what Luddism shouldn't be allowed to become.

Kirkpatrick Sale's *Rebels Against the Future* provides the most sustained account of what neo-Luddism is about. The book's starting point is the environment and, particularly, the problem of environmental sustainability in contemporary societies – it actually invokes the original Luddites as proto-environmentalists, opponents of the 'technophilic propaganda'[75] which is said to have dominated the modern era. Sale starts from the deep-ecological premise that an environmentally sensitive way of life requires people to subordinate themselves to the natural order and to commit themselves to living in sustainable bio-regions that are self-sustainable. The problem, from this perspective, is industrialisation, which has relentlessly sought to order and control the natural world.

> [T]he point is that [late-industrial technology] dominates and pervades, it is imposed throughout our lives in such a way that it mediates experience to a degree no society before has ever undergone. Less and less is human life connected to other species, to natural systems, to seasonal and regional patterns; more and more to the technosphere, to artificial and engineered constructs, to industrial patterns and procedures, even to man-made hormones, genes, cell, and life-forms.[76]

Since the early nineteenth century, what has been waged in Western societies has been the long war of the technosphere against the biosphere. The onslaught that began with the mechanical looms of the first Industrial Revolution culminates in the computers of the second.

For Sale, the problem is industrialism and the technosphere as such. This diagnosis of what is wrong with contemporary society – i.e. modernity itself inevitably leads to a highly conservative political project, involving a return to nature and what are imagined as more natural communities (and thereby confirms the stereotype of Luddism). It is a question of defending 'organic community' from 'industrial modernity'.[77] Sale expresses a profound desire to reconnect with 'traditional' ways of life and livelihood, warmly

invoking the 'enclosed communal life' of pre-industrial societies, and celebrating 'all that "community" implies – self-sufficiency, mutual aid, morality in the marketplace, stubborn tradition, regulation by custom, organic knowledge instead of mechanistic science'.[78] Sale's ideal community is the face-to-face community of common values and shared culture. Serving as a model are the Old Order Amish communities and also traditional Indian communities, both 'morally based, guided by spiritual values that place primary emphasis on living in harmony with the earth and sustaining small-scale communities'.[79] What the neo-Luddites represent, then, is one more manifestation (in a particularly American form) of the contemporary revalidation of family and community (and in their basic beliefs and aspirations they are, in fact, remarkably similar to the new breed of virtual communitarians, like Howard Rheingold).[80] There is a profound sense of nostalgia in this neo-ruralism, with its backwoods dream of primordial community. So, we argue, the neo-Luddite account is simplistic in its analysis of what is wrong about contemporary society, and its alternative social vision remains impoverished and essentially unappealing (we ourselves would never have engaged with Luddism if we had thought that its project was so basic).

What is wrong with the analysis is its conclusion that the problem resides in technology and industrialism *per se*. What the Luddites opposed was not technological and industrial innovation *tout court*, but the techno-logical and industrial articulation of the capital relation. The problem, as we have been arguing, is with the capitalist-technological signification of mastery. Once this is recognised, we are left with far better options than the return to primitivist local communities. The point is not to return to the austere, conformist conditions of small-scale community, but, as Toni Negri says, to reappropriate the world of use values, so as to be able to enjoy, invent and be free in the modern world. To this end, there are various possibilities. One might involve the revitalisation of the forms of identifica-tion and civility that were appropriated by capital from previous eras. And we are not referring here to rural values, but to the culture of urbanity elaborated over centuries of urban history. We may also benefit from the developments that have occurred as a consequence of the capitalist mobilisation of society. The complex and multicultural populations of global cities now provide an enormous cultural and political resource. The point is that you can oppose the logic of capitalist mastery in the name of a variety of causes. And we are saying that self-valorisation should be in the name of cosmopolitan values. In resisting the new global logic of techno-mobilisation, let us do so with the aim of developing the productive forces of complex cultural encounter and experience.

3

THE HOLLOWING OF PROGRESS

It is a common conceit to imagine that one's own times are of unprecedented historical importance. Indeed, this century it sometimes seems that just about every decade has made some claim or other for its singular contribution. Reflect for a moment here on our tendency to think in terms of decades – the 'depressed' thirties, the 'radical' sixties, the 'selfish' eighties – and one will readily understand the point. When one adds to this disposition the fact that we are approaching the end of the second millennium, with all the attendant temptation to 'take stock' of whence we have come and where we may be going, then it is easy enough to appreciate why we should have such an enormous amount of commentary to the effect that we live in a period of especially profound and exhilarating (if disconcerting) transformation. Heaven knows, towards the close of the nineteenth century there was an extraordinary outpouring of *fin de siècle* angst, so we ought not to be surprised that the close of a thousand years provokes a tumult of anxiety, soul-searching and pronouncements on the 'new'. So much of this has appeared recently that there is now almost a consensus that we inhabit a *post*-something or other type of society.

In all of the more recent speculation about what constitutes the new epoch and what precipitates its arrival, information has been granted a pivotal position. In the late 1970s, and especially during the opening years of the 1980s, the special focus was on information *technologies* (IT), on how developments in computing particularly were set to bring about a 'microelectronics revolution' which portended a 'silicon civilisation'. A decade or so on, we have been passing through a heightened phase of concern for the transformative potential of information and communication technologies (ICTs) which, through the 'information superhighway' especially, announces the coming of an 'information age'. More recently still, the emphasis on technology has been relegated, though many commentators still insist that we are on the edge of a new dawn, but this time one heralded by an 'information revolution', which expresses an appreciation for the key role of information/knowledge in social affairs. In this chapter we want to examine and comment on aspects of this concern for identifying information

(and information technologies) as the decisive catalyst for social change, to scrutinise its major forms and to highlight a number of difficulties with this way of seeing. We will start our examination with some observations on the presentation of IT and ICTs, then move on to consider the more recent emphasis on the transformative power of information.

INFORMATION (AND COMMUNICATION) TECHNOLOGIES

Late in 1978 the then Prime Minister, James Callaghan, urged the nation to 'wake up' to the 'microelectronics revolution'. This was but one instance – if an important one – of a host of alarm bells which rang out with the call to make ready for a technological invasion which, we were repeatedly assured, was set to change our lives dramatically. A television documentary in the *Horizon* series, broadcast in 1978, – entitled *Now the Chips are Down* – set the style for countless other programmes, newspaper features and paperback books which, though they struggled for differentiation in their titles, all said pretty much the same thing. *The Mighty Micro*, *The Wired Society*, *The Micro Millennium*, *The Silicon Civilization*, *The Micro Revolution*, and *The Third Wave* are representative titles from this period, each and every one of them convinced that this 'revolution...will change our lives' and that they had a mission to alert an ignorant and complacent public. According to these productions, everything and anything was set to be up-ended by information technology: work, school, politics, policing, entertainment – you name it, IT would change it.

In this milieu, futurism, a quasi-subject area which had been out of favour since the late 1960s, enjoyed a remarkable revival that was manifested in a host of outlets. At once reverential and alarmist, persuasive and hectoring, realistic and visionary, futurists pronounced on the immediate and long-term consequences of a technological revolution from which no-one could escape. Wilson Dizard, for instance, characteristically insisted that the

> vision of a plug-in future, of computers in the living room, of global tele-conferences, of robotics factories controlled by telepresence techniques, and of a new quality of life based on access to vast information resources is...too close to possible realisation to be dismissed any longer as sci-fi fantasy.[1]

With this we were away into speculation of a cashless society, an end to letters, telecommuting, shopping from our armchairs....The *Futurist* magazine, surely the most excitable of all the prophets, repeated month after month stories on the lines that we are 'entering an era in which the science fiction of a decade ago is now technological reality'; that an information-rich future heralded nothing less than a 'New Renaissance' for the West; that IT would rescue America from the doldrums as the 'new miracle brains' get

into 'everything from toys to kitchen equipment to machines that will play chess and backgammon', provide 'automatic machines [that] will cut your lawn...then rake the leaves without human hands', let 'capital...be generous with labour without significant cost to itself', hold down inflation, leaving a contented populace with time, inclination, and money so that 'history's wheel, having rolled through despotism and oligarchy, may...because of the miracle chip, jam forever on democracy'.[2]

There were, of course, more sober prognostications than these. Comment becomes markedly less star-struck the shorter its span of prediction. The immediate prospects, delineated by politicians and businessmen in the main, wondered about the likely effects on balance of payments, European strategic relations with Japan and the USA, or organisational aspects of the 'office of the future'. Scenarios here outlined effects on traditional operations, considered the need to invest in new technology, and the requirements of education to familiarise students with IT. The talk was correspondingly grim, realistic, and measured.

However, the sober and wild elements of futurism were usually wedded, in that comments imagined a dazzling future if only the difficult years of adjustment could be got through. For instance, James Callaghan thought in 1978 that 'we may be on the threshold of the most rapid industrial change in history' which could bring 'within reach of the budget of our people a range of goods and services they could never previously afford', but 'we must prepare for it' because 'we do not have time to lose' if we are 'to reap the maximum benefit from the new technology'.[3] This oscillation between tantalising long-term prospect and formidable problems in the near future was characteristic of much of the presentation of IT. It was, of course, the old theme of carrot and stick.

Throughout the 1980s a range of information technologies found many applications. There was, for instance, very widespread dissemination of word processors and the establishment of information networks within and between offices; personal computers were adopted, especially in the better-off homes, where they might have helped with the homework, though they more frequently provided TV-type entertainment; by the end of the decade many executives found their electronic diaries indispensable, and lap-top computers were commonplace; video games got increasingly sophisticated and were found in just about every public house in the land; cable television made a big mark on our social lives, notably with its sports and movie channels. Moreover, IT unobtrusively became an integral element of everyday lives, whether in the form of diagnostic gadgets in our cars, in 'smart' photocopiers, in the widespread computerisation of banking and retail services, or even in the automation of library catalogues.

In short, IT was taken up in varied, but generally in rather ordinary, transparent, and easily usable ways. In view of this, it was not surprising that the excitable commentary of the early 1980s declined as the decade

proceeded. There were other, more immediately compelling, matters of concern – mass unemployment and economic recession, the collapse of manufacture, European integration, a pronounced weakening in security of job tenure, inner city riots, war with Argentina, the prolonged miners' strike of 1984–85, the Chernobyl nuclear calamity – to occupy journalists and other producers of instant opinion. Anyway, IT seemed to be so undramatic and familiar in its practical consequences – an upgrading of typewriters here, an extension of television there, a more convenient way of getting cash from the building society, the itemisation of telephone bills – that the 'mighty micro' hype could not but seem overdone.

In light of this it was rather odd to observe a return of technological futurism in the mid-1990s that has centred, this time round, on the predicted consequences of information technologies when combined with communications (ICTs). US Vice-President Al Gore struck the keynote in 1994 when he enthused about the creation of a Global Information Infrastructure that would lead to an 'information superhighway' capable of delivering 'robust and sustainable economic progress, strong democracies, better solutions to global and local environmental challenges, improved health care, and – ultimately – a greater sense of shared stewardship of our small planet'.[4]

The primary concerns for today's techno-enthusiasts are matters such as 'virtual reality', the emergence of the 'information society', and what life will be like in 'cyberspace', and the most talked about subject tends to be the Internet and its potential for enhancing information exchanges, fostering electronic communities, and ending education as we know it. While some of the vocabulary has changed since the 1980s, the faith in technology remains marked. Today's commentators no longer find themselves awed by computer numerical control, robotics, and the automated factory; nowadays techno-boosters consider interactivity, multimedia and global connectivity to be 'the most powerful juggernaut in the history of technology'.[5]

However, through the years the frame has remained a shared one: technology is a *deus ex machina* that transforms everything we do and, so long as we embrace it and are not obstructive, just about everything will turn out for the better. In the early 1980s pronouncements that IT put us on the brink of a 'second industrial revolution' were commonplace.[6] In the summer of 1994 Martin Bangemann voiced the same opinion, insisting now that 'information and communications technologies are generating a new industrial revolution already as significant and far-reaching as those of the past'.[7] Bill Gates himself adds his weighty judgement to that of the European Commissioner, observing that 'we are watching something historic happen, and it will affect the world seismically, rocking us in the same way the discovery of the scientific method, the invention of printing, and the arrival of the Industrial Age did'.[8]

This time around technological utopianism has three distinctive dimensions. In the first of these it coincides with a certain strand of postmodern thinking, one that considers identities in terms of choices and options. Now, it is claimed, the new technologies make possible a world of 'postmodern virtualities',[9] one in which new and more complex possibilities are opened up in identity formation. This connects with a second dimension, fed by an apparent fusion of biology and machines, which gives rise to cyborgs (cybernetic organisms) that allow us to choose whatever bodily or post-bodily form we want, now that the certainties (of nature, of sexuality) have been undermined. Both dimensions link with a fashionable version of the 'new biology' which embraces 'chaos' and 'complexity' theory, the post-Darwinian idea that organisms are at once so astoundingly complicated that they are 'out of control',[10] yet they are simultaneously and paradoxically self-adjusting by virtue of this very quality of complexity.[11] The notion of 'spontaneous order' in the biological realm has recently been transported into the arena of information, and with it the message that life in the 'information age' is blindingly complex because it is all so much a matter of countless and unique individual actions, but yet, miracle of miracles, it all hangs together. This 'control without authority' relies crucially on the presence and rapid development of the Internet since it is the Net which 'channels the messy power of complexity',[12] transforming the chaos of participation on the giant network into a functioning maelstrom – or, to adopt Kevin Kelly's metaphor, creating a self-adapting beehive from the individual actions of millions of bees.[13]

This vision is presented, appropriately for the late 1990s, with abundant acknowledgement of environmental concern: indeed the theme borrows heavily from ecological thinking and Gaia's capacity to transform itself in spite of everything haunts such accounts. It is also readily presented as testimony to the desirability of capitalism, for instance when the market system is described as a 'spontaneous self-organizing phenomenon', a 'flexible economic order [which] emerges spontaneously from the chaos of free markets',[14] and when the likes of awestruck *Wired* editor Kevin Kelly refer to this 'mystery of the Invisible Hand – control without authority'.[15]

CRITIQUE

So have gone – and so continue to go – many analyses of new technology. It seems that we have been swamped with projections and recommendations which acknowledge that technology will have an enormous social effect, that its adoption is unavoidable, and that in the long run it will be a fine thing for us all. To be sure, the techno-boosters have met with some critical responses,[16] though in the round dissenting voices have been a minor element of the massive output in media, education and political debate. Not least because they have so overwhelmed discussion to date, we believe the

predominant responses to new technology deserve closer inspection. In the following we identify their major features.

TECHNOLOGY IS BENIGN

Technology is presented as, on the whole, benign. Typically

> most of the changes are changes for the better: better education, better news media, better forms of human communication, better entertainment, better medical responses, less pollution, less human drudgery, less use of petroleum, more efficient industry, and a better informed society with a rich texture of information sources.[17]

References to potential ill effects are made, but the overwhelming image is one of a 'benevolent technology'[18] which may create an 'electronic renaissance'.[19] Thus Nicholas Negroponte declares his 'optimism' because of the 'empowering nature of being digital', which will ensure an 'information superhighway...beyond people's wildest predictions' that is 'bound to find new hope and dignity in places where very little existed before'.[20]

TECHNOLOGY AS SPECTACLE

Technology is presented as a spectacle, as something which can evoke only a gee-whiz, awed response, since it entails regarding technology as a phenomenon that has arrived in society out of the blue, although it will have a devastating social effect. This conception of a desocialised technology which is set to have the most far-reaching social effects inevitably leads to Callaghan-like calls to wake up to the unexpected arrival. We are so accustomed to perceiving social change in terms of a history of technological development ('the Railway Age', 'the world the steam engine made'), somehow removed from human intent and decision, that the most recent developments are readily framed in this way. The past comes to be seen as a history of technological innovation, contemporary Britain the product of a 'remarkable series of inventions',[21] microelectronics and ICTs but another stage of this progression.[22] History – technological advance – comes to have its own logic and drive which shapes the society though it is devoid of social value. In this framework technology is assumed, crucially, to be separate from society at its outset (apparently having arisen from some internal process in some weird and wonderful place such as Silicon Valley), only to be introduced at a later stage as an independent variable which is the primary cause of social change.

Because so many commentators, in adopting this perspective, accept as their starting point a completed technology, they are impelled to offer the public no role other than that of consumer of the latest gadgetry. Ignoring

the processes by which technology itself comes to be constituted means that one is restricted to consideration only of the likely *impact* the latest produce will have. So long as consideration of technology starts from the technology as it is, then discussion can only be limited, restricted to the social implications of a constituted technology, and ignorant of the whole series of social choices that have been exercised in the production of the technology:

> What the media treat is the 'impact' of such development. Where were those media when they were being conceived and prepared for market? Today is yesterday's *Tomorrow's World*, but what debate occurred before Raymond Baxter and Co. were allowed to televise what's in store for us?[23]

TECHNOLOGY IS NEUTRAL

Because technology is believed to be asocial, it is also seen as neutral, a tool to be used either appropriately or not, depending on the motives of a society. From this assumption of neutrality, most comment on IT and ICTs asserts that the new technology offers choices. Across the spectrum of politics, one finds assurances that the 'technology itself is neutral: it is the way it is applied and used that determines the effects on people', and from such a proposition the idea of choice is irresistible. No less an expert than Bill Gates, boss of Microsoft, informs us that

> the network will draw us together, if that's what we choose, or let us scat-ter ourselves into a million mediated communities. Above all, and in countless new ways, the information highway will give us choices that can put us in touch with entertainment, information, and each other.[24]

Moreover, if the technology is socially neutral and leaves policy choices to the public, then on what reasonable grounds can it be suspected?

INEVITABILITY

It is paradoxical that these presentations, so often professing 'choices' that the new technology allows, invariably carry an underlying inevitabilism. There is total agreement that the new technologies must be adopted – and that as quickly as possible. Peter Large's claim that 'in a competitive world there is no alternative to using the chip as quickly and widely as possible',[25] and Anthony Hyman's view that 'the new technologies need to be intro-duced rapidly and creatively',[26] were unexceptional statements among futurists in the 1980s. They were repeated as a matter of routine fifteen years later.[27]

This inevitabilism has been reinforced by a historical legacy of what has been called the 'ideology of industrialisation', by which is meant a tradition

of thought which perceives technology as a hidden hand in development apart from the social issues of power and control. David Dickson summarises:

> The message of this ideology is that industrialisation through technological development is a practical – rather than a political – necessity for achieving social development. It implies an objectivity to the process, and seeks to remove it from debate on political issues. It thus gives a legitimacy to prophecies that appear to promote the process of industrialisation, often regardless of their political, or even social consequences....To stand in the way of technology is, almost by definition, to be labelled reactionary. Industrialisation is equated with modernisation, with progress, with a better and healthier life for all.[28]

THE PAST IN THE FUTURE

If one queries the advantages of accepting today's technological innovation, one is frequently portrayed as an unworldly romantic, in sharp contrast to the this-worldliness and foresight of its advocates.[29] This charge castigates a deep-rooted tradition in England of a rejection of 'industry' in favour of a retrospective ruralism. It is a remarkable feature of industrial capitalism that, throughout the transforming experiences of the past three centuries, the ideas of rural life have 'persisted with extraordinary power':[30] 'Real England has never been represented by the town, but by the village, and the English countryside has been converted into a vast Arcadian rural idyll in the mind of the average Englishman'.[31] This idealisation of the countryside can easily be shown to be misleading, ignorant of the misery, oppression, and deprivations of pre-industrialism. Subscribers to a rural idyll are too often ignorant of history – the real history of the countryside in which life was as hard and brutal as anything later experienced – to be taken seriously. Because of this, opposition to new technology is readily smeared and thereby discounted by association with a tradition which can appear to desire a return to the impoverishments of an earlier time. Drawing on this imagery, Wilson P. Dizard can sneer at and condemn the 'disturbing tendency to retreat from the implications of the new machines, to deny the possibility of a viable technology-powered democratic society. These anti-technology forces, the new Luddites, seek solace in astrology, artificial Waldens, and bad poetry'.[32]

Paradoxically, however, and possibly because ruralism is so deeply entrenched, perpetrators of the new technology have so often tried to steal the clothes of these opponents even while ridiculing their proposals. This is achieved by projecting a return to the past in the future, the recovery of a golden age with twenty-first-century comforts, by suggesting that adoption of ICTs will effect a return to a lost way of life. We see this posture in the

language of those who envisage the re-establishment of domestic production in the era of the electronic cottage, a period when community will be regained in a wired society, a time when pollution disappears due to 'technologies that are environmentally sound...and non-destructive of the ecology'.[33]

This capacity to combine rejection of ICTs' critics with the argument that ICTs satisfy the requirements of their criticism is remarkably common. Dizard, for example, jettisons 'anti-technology forces' for their naïvety and immediately proceeds to hymn the 'search for a new Eden through the melding of nature and the machine' that is a 'powerful force propelling us towards new forms of post-industrialism', which, in the 'information age', bring 'electronic salvation within our grasp'.[34] Similarly, Alvin Toffler dismisses 'critics of industrialism', who picture the 'rural past as warm, communal, stable, organic, and with spiritual rather than purely materialistic values', because 'historical research reveals that these supposedly lovely rural communities were...cesspools of malnutrition, disease, poverty, homelessness, and tyranny, with people helpless against hunger, cold, and the whips of their landlords and masters'.[35] Nonetheless, Toffler is no apologist for industrialism. On the contrary, 'Second Wave systems are in crisis', and their institutions 'crash about our heads' due to crises of ecology, work satisfaction, and even intimate relations. But from the ashes of this collapse, salvation rises in the form of 'third wave civilisation' which is set to supersede 'second wave' (i.e. industrial) society. Here the electronic cottage will facilitate the development (and re-establishment) of the 'prosumer' who combines the role of consumer and producer while working from home. Such a trend offers a return to lifestyles that were 'common in the early days of the industrial revolution among farm populations', though now one can 'imagine this life pattern – but with twenty-first century technology for goods and food production'.[36]

Add this together, and what is offered is a 'practopian future'[37] which looks much like – but is also much more than – the romantic visions of the past. In like manner, James Martin contends that:

> Local communities in the future may grow more of their own foods and provide their own daily needs. They will have offices for white-collar workers plugged into nationwide telecommunications networks. They will have satellite stations or other links that provide the same television facilities as in the big cities. The local bread and vegetables will be better than those that are mass-packaged for nationwide distribution. Much of the drudgery of commuting will be ended....For many the lifestyle of rural communities with excellent telecommunications will be preferable to that in the cities.[38]

The moral of all such propaganda – as if one could have missed it – is simply that

Rather than lashing out, Luddite-fashion, against the machine, those who genuinely wish to break the prison-hold of the past and present would do well to hasten the...arrival of tomorrow's technologies...[because] it is precisely the super-industrial society, the most advanced technological society ever, that extends the range of freedom.[39]

NEO-McLUHANISM

Though this futurism – imagining 'people living in what one can recognise as the old pastoral ways...but possessing great power because they have internalised the communication and productive capacities of the urban-scientific-industrial phase'[40] – has recently experienced a resurgence, it has a lengthy tradition. This was developed, especially in the United States, during the nineteenth century, as a distinctive 'industrial version of the pastoral design',[41] found its exemplar in Walt Whitman's celebration of the 'body electric',[42] and drew together a 'powerful metaphor of contradiction', 'a strong urge to believe in the rural myth along with an awareness of industrialisation as counterforce to the myth'.[43]

The most prominent recent member of this tradition was Marshall McLuhan. He himself had, significantly, a biographical connection with both the English school of literary criticism, which held to the notion of a disappearing rural 'organic community', and the 'industrial pastoral' of his native North America.[44] Moreover, most of the contemporary writers on IT and ICTs may be seen as being squarely within this tradition and its McLuhanite emphasis on the 'electronic sublime'.[45] Indeed, the presence of elements of McLuhan's work can be sensed in all the books, articles and television presentations to which we have referred. McLuhan is unashamedly rehashed: James Martin believing that the promise of satellite-age democracy will fulfil McLuhan's ideal of a global village;[46] Sam Fedida and Rex Malik[47] announcing their debt to McLuhan on the opening page of their report on viewdata; and Joseph Pelton, whose fantasia of the 'telecity' in an age of 'Global talk' is vulgar McLuhanism.[48] Even Manuel Castells, in a trilogy far superior to any of the futurism considered here, pays 'homage' to McLuhan's insight that television spelled 'the end of the Gutenberg Galaxy'.[49]

TECHNOLOGICAL DETERMINISM

It is apposite that we recall McLuhan here, first to indicate the tradition in social thought of 'the machine in the garden',[50] and second – and more importantly – to point out the technological determinism which underpins the futurism now in vogue. Starting out from the technology, this comment is invariably determinist since, acceding to the technology as it is, it then asks and only asks: what are the social implications of this technology? The

technology is assumed to be a major – and isolatable – variable which causes social change and, whether or not writers take a strong or soft line as regards the degree of causation, they all remain within a determinist frame.

In the light of recent concern with ICTs, we believe that it is appropriate to revive the criticism of McLuhan's faith in the electronic millennium, since his work represents an extreme formulation of technological determinism and today retains a certain credibility as a version of the idea that technology is the motor of history. As McLuhanism resurfaces, it is salutary to indicate its two central traits. First, technology is considered a determining factor within society, for McLuhan the determining factor: 'All media work us over completely. They are so pervasive in their personal, political, economic, aesthetic, psychological, moral, ethical, and social consequences that they leave no part of us untouched, unaffected, unaltered. The medium is the message'.[51] The difference between McLuhan's advocacy of 'utter human docility' in the face of technological change, and the now commonplace statement that we must 'adapt to the world of the silicon chip',[52] is only one of emphasis (and not much of that). Second, as detailed earlier, technology is detached from its social context and treated as an isolated phenomenon.

The conception of a determining technology is found in all popular (and not so popular) presentations of the new technology. A characteristic metaphor is that of an alien, extra-social invasion which cannot be prevented from effecting massive changes in social arrangements. The imagery of revolution created by such invaders has become the stock-in-trade of futurist offerings, and examples are legion. Burkitt and Williams commence with:

> A mysterious force has come into our lives, working silently, screened from the human eye, and understood by only a tiny few. It is smaller than a fingernail, thinner than a leaf, and is covered with microscopic markings. It is powered by minute amounts of electricity...yet it is probably one of the most significant machines ever made by man: the silicon chip.[53]

Alvin Toffler, writing of the 'great, growling engine of change – technology',[54] envisages a 'dramatically new technostructure for a Third Wave civilisation',[55] which is a 'powerful tide...surging across much of the world today, creating a new, often bizarre, environment in which to work, play, marry, raise children or retire'.[56] Frederick Williams contends that 'our lives will never be the same again' because of the 'miracles of electronic communications'.[57] Christopher Evans opens with:

> This book is about the future....It is a future which will involve a transformation of world society at all kinds of levels....It's a future which is largely moulded by a single, startling development in technology whose impact is just beginning to be felt. The piece of technology I'm talking about is, of course, the computer.[58]

Recalling these features so much in evidence, it is important to emphasise that this neo-McLuhanite perspective involves a focus on technology to the exclusion of social phenomena – the social is always adaptive and secondary to technology – and in doing so it 'abolishes history', thereby removing 'questions of human need, interest, value or goal'.[59] From this perception of desocialised technologies, McLuhanites then identify an astonishing causal capability in the technology: the technology is transformed into a *deus ex machina*, influencing society yet beyond the influence of society. It is in this way that McLuhanism is a type of 'technological fetish', one that is idealist in spite of its ostensible materialism. Though materialist in focusing on the things of this world (and how can one be more materialist than when concerned with technology?), the approach is idealist in so far as it excludes the world from these things to which it ascribes such social significance.

The speculation about ICTs' social import seems to us to have two effects worth special emphasis. The first is that it manages to dominate discussion in a straightforwardly quantitative manner which makes it difficult for alternative perspectives to be heard. Analyses of ICTs are almost totally one-sided, so that public debate and discussion is markedly impoverished. Second, the major consequence of this presentation of ICTs, while it may not persuade the populace to welcome wholeheartedly the new technology, is to create a general sense of acquiescence to innovation. We believe this happens because technology, without discernible origins, is something that ordinary people cannot understand. The technology is a mystery, and it remains a mystery even when its technical functions are explained in simplified terms, because its genesis – its social history – is ignored. In this way, technology is placed in a tradition of science fiction, as an arrival – fortunately benign – from another galaxy: as Margaret Thatcher appositely observed, 'Information Technology is friendly; it offers a helping hand; it should be embraced. We should think of it more like ET than IT'.[60] Without history, the new technologies become an unstoppable force which, though incomprehensible to natives, is understood sufficiently for them to realise that they must change their whole way of life.

For good or ill, we are obliged to adjust to the things that have arrived unannounced and unexpected. Understandably in these circumstances, a common response is one of apathy. The technology has been imposed upon us irrespective of our wishes or even imaginings, and it seems that there is little we can do other than accede to its dictates. Hence we often witness a resigned acceptance of the inevitable, a sense of helplessness, and a feeling of stale familiarity and apathy after constant but uninformative media exposure.

Starting with the palpable here-ness of new technologies, and only then moving to consider their social influence, is to accept from the outset that technology is in crucial ways out of our control. Because so very much comment on ICTs unquestioningly adopts this, in our view profoundly

misleading, framework, it has been a primary objective of our work over the past twenty years to present an alternative, more socially and historically sensitive, approach to informational and technological change.

THE TRANSFORMATIVE POWER OF INFORMATION

A most striking recent tendency has been to announce the arrival of a new epoch, one which might be designated an 'information age', which shifts attention away from the role of technologies while promoting 'information' as the axial feature of the new age. While this group of thinkers tends to presume that advanced ICTs are an important element (a technological 'infostructure')[61] of the 'information age', it is clear that the emphasis on the transformative power of information puts it far above the merely technological. 'Information' as a concept has become, for a wide variety of commentators, capable of signalling the most profound social change, so much so that the 'information society' is nowadays a routine part of the lexicon of politicians, business leaders and university heads.

Perhaps the clearest statement of this comes in the influential writing of one-time United States Secretary of Labor Robert Reich.[62] His argument is that economic activity has been radically changed since the 1950s so as to enhance, quite dramatically, the role of certain types of occupations, those he terms 'symbolic analysts'. In essence, globalisation has denuded the economic sovereignty of the nation state, so much so that the once halcyon days when American companies produced largely in America with American labour are long gone. Reich argues that globalisation means that it is now no longer feasible to conceive of an independent and distinct national economic entity. Such is the movement of capital and investment, nowadays crossing at a bewildering volume and pace (in excess of one trillion dollars per day are now traded in foreign currencies), that it is no longer possible even to identify corporate ownership in terms of nations.[63] Further, products themselves are increasingly difficult to identify as being nationally fabricated. Labels apart, Reich contends that production itself is a world-wide activity, with components manufactured in one, or more often several, places, designed in yet another, and often finally assembled only in a 'country of origin' which means little in the way of domestic jobs and real national contribution to the final product. In addition, manufacture is shifting away from high volume production towards high value products – i.e. away from mass and standardised products towards short runs of specialised and customised goods – and with this the particular location of a plant is of vastly diminished significance since the onus is on what Scott Lash and John Urry[64] have termed the 'design intensity' of products (the logo on the Nike clothing, the styling of shoes, the script of the movie, the graphics of the computer game).

The upshot of this, for Robert Reich at least, is that 'there is coming to be no such thing as an American corporation or an American industry. The American economy is but a region of the global economy'. Economic activity is increasingly pursued irrespective of national frontiers, held together by a 'global web' of relationships within and across corporate organisations that are owned by myriad and dispersed shareholders. Moreover, corporate activity is de-bureaucratising, the key work being performed by self-motivated and non-hierarchical teams of employees and entrepreneurs who ally around particular projects, tied together by a 'web' of networks that disregards national borders.

These key players are the 'symbolic analysts', the 20 per cent of the global workforce who hold together and advance the 'enterprise networks'. They are information/knowledge specialists, experts who, are 'continuously engaged in managing ideas'[65] and who possess the 'intellectual capital' crucial for success in twenty-first-century capitalism. 'Symbolic analysts solve, identify, and broker problems by manipulating symbols';[66] they are highly educated and thus in command of the key skills of abstraction, system thinking, experimentation and collaboration. These symbolic analysts are the highly qualified and credentialled information professionals who are, Reich believes, the cornerstone of the knowledge-based, high value, corporations which now predominate on the world stage and increasingly will do so. They are problem-solvers, problem-identifiers and strategic brokers in occupations such as banking, law, engineering, computing, accounting, media, management and, even university professorships.[67] They are intensely cosmopolitan, but – fortunately for Western and especially for United States politicians – are disproportionately centred in the metropolitan nations which, thanks to the excellence of their higher education systems, produce 'symbolic analysts' aplenty. All governments need to do, says Reich, is continue the high quality output of 'symbolic analysts' from their universities, while maintaining law and order (and thereby an appealing social fabric), and they will rule nations of highly paid globe-trotters who are at ease with themselves and their countries.[68]

It is not Reich's political wager which most interests us here, but rather the particular emphasis he places on the category of 'symbolic analyst'. His account promotes these information/knowledge workers as the leading forces of economic activity. Reich is by no means alone in this line of argument. For instance, Manuel Castells proceeds along much the same route. Thus, in *The Rise of the Network Society*, Castells describes the emergence of the 'horizontal corporation' to meet the challenges of globalisation, something which represents the process of 'transformation of corporations into networks',[69] wherein alliances are constantly being made and unmade, and where the key players are those infused with 'the spirit of informationalism'[70] and thereby at ease with the networking processes that are crucial to success. These networkers represent what Castells refers to as

'self-programmable labor' that is highly educated and, above all (and in consequence), flexible, able to learn and re-learn wherever and whenever necessary. They do not possess a particular set of skills, other than the skill to develop skills where they are needed. Castells estimates this category of information occupations (he calls it 'informational labor') at 30 per cent of the workforce in OECD nations (thus somewhat higher than does Reich), but a crucial link is that he too regards these as the wealth-creators of 'informational capitalism', in contradistinction to 'generic labor' which is declining, is easily mechanised, static and incapable of the fast changes a globalised economy demands.[71]

We encounter a similar emphasis on the capacities and strategic import of information/knowledge in Peter Drucker's book *Post-Capitalist Society*,[72] though this management guru has been saying much the same for the past forty years. Land, labour and capital remain important, claims Drucker, but they are eclipsed in 'post-capitalist society' by the knowledge experts – broadly managers – whose developed knowledge is the key to economic success, and something which transforms capitalism since it makes knowledge the central resource of the system. It is perhaps not surprising that we find much the same promotion in the populist writing of Alvin Toffler. In his most recent futurist tome, *Powershift*, Toffler fingers the 'highbrow' firm as the corporation of the future. It is one which owes its success to the 'intelligence' it invests in its goods and services, and, of course, it is one in which the 'cognitariat' dominate as we shift rapidly towards the 'knowledge society'.[73]

This message regarding the novel contribution of information/knowledge was sounded in Britain by Tom Stonier who published *The Wealth of Information* as early as 1983. But during the 1980s it was in the United States, especially, that the emphasis was placed on the new centrality of information. For instance, Fred Block and Larry Hirschhorn,[74] in a variety of publications, testified that work increasingly provided 'cybernetic feedback' to operatives who, in turn, were required to understand complex computer systems to be able to rectify faults and/or to reorient production appropriately. Block wrote of 'postindustrial possibilities' and Hirschhorn of 'postindustrial technology', but both laid stress – along with the much quoted Soshana Zuboff[75] – on the upgrading of employees who must, as a matter of routine, develop their informational skills to be able to retrain and re-adapt to a constantly changing situation. Such formulations, at once analytical and advocative, were in close accord with the popular theses on post-Fordist 'flexible specialisation' of Michael Piore and Charles Sabel especially.[76]

In Britain the need to prioritise information/knowledge has been a prominent theme of New Labour. Echoing Robert Reich, Tony Blair puts at the centre of policy 'education, education, education', largely because this can best ensure that his ambition to make Britain the 'knowledge capital of

Europe'[77] may be met. Much the same advocacy comes from Charles Leadbetter in a recent *Demos* essay which urges that Britain emulates California in targeting 'knowledge-based' industries such as computers, biotechnology and media, which are dominated by highly paid and highly skilled 'symbolic analysts'.[78] The writing of Scott Lash and John Urry[79] evidences a cognate theme. Arguing that we have entered a period of 'reflexive accumulation', Lash and Urry insist that information has become central to economic life in at least two related ways. First of all, work and production in general is increasingly organised around routine self and social monitoring, with feedback mechanisms built into activities such that client needs are prioritised in the production process, market patterns are observed to facilitate rapid and effective responses, and production quality is best assured. Second, there is an increasing degree of cultural and aesthetic contribution to economic affairs (Lash and Urry's 'design intensity') which highlights the importance of media production, leisure services, tourist resorts, clothing and the like. Though they acknowledge that these trends may not help shop-floor workers in the short term, and though they distinguish design from knowledge intensity (since the latter is regarded as more cognitive than aesthetic), Lash and Urry are in little doubt that 'professional-managerial workers'[80] will occupy the key positions of the future.

CRITIQUE

One cannot but be struck by this recent emphasis on information in so much social science, and indeed far beyond. However, at least four sceptical observations are in order. First of all, it requires emphasising that none of today's stress on the crucial role of information and informational labour has anything, at least in principle, in common with the argument that the 'information age' is being brought about by technological developments. To be sure, it is likely that informational labour will be adept at use of ICTs, but the emphasis on its contribution recurrently draws attention to the fact that, in the words of Manuel Castells, it 'embodie[s] knowledge and information',[81] a quality attained, as a rule, through high level education. Remember, the recent emphasis is on the capacities of 'symbolic analysts' to problem solve, to develop strategies, to think abstractly, and so on. Thus we are offered an explanation of change which hinges, not on technological innovation, but on the capacities of the education system to supply a particular type of labour force – namely, highly educated labour equipped with key 'transferable skills'. In this regard it is striking that enthusiasm for the 'information age' has shifted its ground, away from the argument that it is an outcome of information technologies, towards the more general claim that the new age is articulated through the changed characteristics of the occupational structure. In view of this a degree of doubt about the scale of the 'information revolution' itself may well be in order.

Second, accepting that there is an increased representation of 'symbolic analysts' in the labour force, one may ask questions about its novelty, its size, and its significance for contemporary capitalism. Harold Perkin's historical account of *The Rise of Professional Society* is a useful source here, since it maps in detail the rise to prominence of professional occupations, not – as with 'information age' analysts – during the last decade or so, but over the last century. The history of England since at least 1880, argues Perkin, may be understood as the emergence of a 'professional society' which claims its ascendancy especially by virtue of 'human capital created by education'.[82] Professionals are 'symbolic analysts', yet they have been on the rise, according to Perkin, for over 100 years. There are here no compelling reasons to highlight their emergence in recent years as in some way indicative of any change profound enough to merit the title 'information age'.[83]

Further, even the uppermost estimates put 'informational labor' at 30 per cent of the workforce. To remind oneself of the vast majority that will be surplus to the running of the global economy does not refute the overall thesis (especially since, in Reich at least, there is a refreshing ingenuousness in his encouragement for America to seize a disproportionate share of these occupations for its citizens), but it is sobering to acknowledge that the 'information age' will be one which excludes a great many people, from entire populations in areas such as Sub-Saharan Africa, to a large proportion of the under-educated and unskilled in the metropolitan societies.[84]

Moreover, it is useful to be reminded here of another dimension of Perkin's account. He baldly states that higher education, of itself, definitely does *not* lead to a privileged position. It may be necessary to be officially accredited, but at least of equal weight is one's location in the labour market and, notably, a profession's capacity to gain leverage over that market. If a profession can monopolise the market, then it certainly will see an enhancement of its status and privileges. If it cannot do so, however, it will be poorly rewarded and regarded. Extrapolating from this, it requires little imagination to ask questions of the alleged influence ascribed to 'symbolic analysts' by many 'information age' thinkers. They may be indispensable to the market, but whether they are key power holders or not is quite another matter. A look around at the turbo-capitalism of the late twentieth century suggests that most 'symbolic analysts' are subordinate to the marketplace, far removed from the picture of the powerful brokers envisaged by their admirers. In Britain, we have experienced over the last twenty years a sustained assault on many professions (not least university teachers, researchers, and teachers), and we have also witnessed a manifest decline in the return on higher educational certification. A great deal of this testifies to the power, not of 'symbolic analysts', but of the market system which – whatever the intellectual capacities of the employee – appears to be the most decisive factor. Bluntly, the rise of 'symbolic analysts' has done little if

anything to limit the determining power of capital in the realm of work, or anywhere else for that matter.

It may well be the case that the globalisation of capital has placed an increased premium on 'informational labor', to help with necessary tasks such as the co-ordination and general management of contemporary business affairs. There may also have been some promotion of informational work as cultural industries have grown in economic worth. However, neither of these developments says very much about the transformative capacities of information/knowledge. Rather, both underscore the central shaping role of the dynamic capitalist economy and it is surely this, and its familiar imperatives, rather than attendant labour requirements, on which analysts may most fruitfully focus.[85]

Furthermore, though it is undeniable that globalised capitalism is an extraordinarily unsettling and uncertain phenomenon for all concerned, including capitalist corporations themselves, there is good evidence to suggest that the main stakeholders are constituted by propertied classes which enjoy highly concentrated ownership of corporate stock. Moreover, they also 'form a pool from which the top corporate managers are recruited', and who operate through networks of intercorporate capital relations.[86] Doubtless all of these players are 'symbolic analysts' of one sort or another, but it is a mistake to bracket them with the remaining software engineers, accountants and journalists, who also work with symbols. At the hub of globalised capitalism are indeed symbolic analysts, but for the most part they are where they are, and able to continue there, by virtue of privileged origins, privileged education, and the inestimable advantage of inherited wealth.[87]

Third, one may cast serious doubt on those who emphasise the novelty of information in the present era by reviewing aspects of the work of one of the world's leading social theorists, Anthony Giddens. In Giddens' account of the making of the present, he acknowledges that information has become more integral to everyday life, but he is reluctant to suggest that information – or those with particularly ready access to, or capacity to use it – contains within it the transformative qualities claimed by so many 'information society' thinkers. Giddens' emphasis is on what he refers to as the *intensified reflexivity* of 'late modern' existence. What he highlights is that modernity has been a story of people's release from the strictures of nature and inhibiting forms of community – where it appeared that one had to do what one did as a matter of 'fate' – towards individuals and groups making *choices* about their own and collective destinies in circumstances of 'manufactured uncertainty'. That is, the world more and more is not bounded by fixed and unchangeable limits, but is rather recognised as malleable and the outcome of human decisions. A requisite of this is heightened self and collective interrogation, otherwise reflexivity, though this is not to be perceived as some trend towards self-absorption. Quite the contrary, it is premised on openness to ideas, information and theories from

very diverse realms, which are examined and incorporated as circumstances and people so decide.

A key point here is that a 'post-traditional'[88] society which is characterised by intensified reflexivity of actors and institutions requires information/knowledge. Some of this is local and particular (one's biography reflected upon, a company carefully scrutinising its customer records), but a great deal is also abstract, emanating especially from electronic media and from other, notably educational, institutions. If one accepts Giddens' argument that we do inhabit a world of 'high modernity' in which reflexivity is much more pronounced than hitherto, then it is feasible to conceive of this as heightening the import once of information and knowledge in contemporary life. A world of choices, for both organisations and individuals, is reliant on the availability and generation of detailed and rich information. If one follows Giddens' contention that ours is an era of intensified reflexivity on the basis of which we forge our material as well as psychical conditions, then it follows that this will sustain and will demand a complex and deep information environment.

Nevertheless, there are good reasons why we should hesitate to depict any novel 'information society' in these terms. Not least is that Anthony Giddens himself is reluctant to do so. While he does emphasise that a 'world of intensified reflexivity is a world of *clever people*',[89] he is quite unwilling to present this as other than an extension of long-term trends, hence as a 'high modern' era rather than as a novel epoch. Further, Giddens' explanation for the increase in information/knowledge neither prioritises particular occupational groups nor does it hoist information to a noticeably privileged position in economic affairs. On the contrary, he insists that it is a requisite of much wider social processes, ones which impinge upon everything that we do, from styling our bodies to deciding upon what we will eat.

Fourth, and finally, we may remind ourselves of the writing of the pioneer definer of the 'information society', Daniel Bell. Interestingly enough, present-day emphasisers of 'informational labor' arrive at precisely the same conclusion as Bell, though by a different route. It was Bell's insistence that it was a transition to a service economy, where most jobs were interpersonal and increasingly professionalised, that marked the arrival of 'post-industrialism' (aka the 'information society'). Today's commentators tend to stress the consequences of globalisation, while Bell focused on the growth of expenditure on services, but the conclusions of both parties are much the same – jobs of the future will go disproportionately to the highly educated, knowledge professionals, and this signals a major social transformation. A cascade of criticism, both empirical and conceptual, has undermined the entire 'goods to services' proposition of Bell, leaving it systematically discredited.[90] Yet as we close the millennium his conclusion is being rehashed in updated form,[91] something which ought surely to lead us to be wary of endorsing the latest trend.

THEORETICAL KNOWLEDGE

However, we evoke Daniel Bell to allow us to reflect on a particular view of the strategic significance of a certain type of information, namely *theoretical knowledge*. Bell presents this as an 'axial principle' of post-industrial society and, although the weight of his analysis leans towards quantitative increases in service – i.e. information – occupations as indicators of post-industrialism, he is emphatic that 'what is radically new today is the codification of theoretical knowledge and its centrality for innovation'.[92]

It is easy enough to understand what Bell means by this when we contrast today's post-industrialism with its predecessor, industrial society. In the past, it is argued, innovations were made, on the whole, by 'inspired and talented tinkerers who were indifferent to science and the fundamental laws underlying their investigations'.[93] In contrast to this decidedly practical and problem-solving orientation, it is suggested by Bell that nowadays innovations start from theoretical premises. That is, now that we have arrived at a situation in which it is possible to codify known scientific principles, our knowledge of these becomes the starting point of action. In this way, what was once dismissed as useless – as just 'theory' – has becomes the axis of practical innovations.

Again, it is not difficult to find illustrations of this 'change in the character of knowledge itself'.[94] For instance, Alan Turing's paper, 'On Computable Numbers' (1937), sets out mathematical principles which underpin later applications in computer science; the development of integrated circuits that enabled the 'microelectronics revolution' to get under way in the late 1970s was founded on known principles of solid-state physics; and innovations in areas as diverse as compact disk technology and nuclear energy were reliant on theoretical breakthroughs which were regarded, initially at least, as without practical consequences. It is rather difficult to think of technological applications nowadays which do not hinge on theoretical knowledge, whether it is calculating the needs of households for water supply, building a bridge, or estimating energy needs in a particular area. Not surprisingly, perhaps, we find the historian Eric Hobsbawm confirming Bell's perception, concluding that during this century 'the theorists [have been] in the driving seat…telling the practitioners what they were to look for and should find in the light of their theories'.[95]

Daniel Bell takes his argument for the 'primacy of theoretical knowledge' considerably further, to suggest that it is pre-eminent not only in the realm of technological innovation, but even in social and political affairs. For instance, governments today introduce policies based on theoretical models of the economy. These may be variable – Keynesian, monetarist, supply side and so forth – but all of them are theories which are the foundations that underpin day-to-day decisions ministers may make in response to practical exigencies. Again, we can see emerging major concerns with environmental consequences of economic policies. The response is, arguably, not just to

address a particularly pressing problem (say, an oil spillage), but to act, increasingly, on the basis of theoretical models of the ecosystem's sustainability. To be sure, such models are at present undeveloped and unrefined, but they and other instances help us to appreciate that, while theoretical knowledge does not have to be 'true' in any absolute sense, it does play an important part in life in the late twentieth century. Theoretical knowledge does, *prima facie*, define a novel use of and role for information/knowledge. If theory is at the point of initiation of developments, in contrast to one-time practical demands, then such knowledge could even be said to herald a new sort of society.

Theory evokes abstract and generalisable rules, laws and procedures and, with this, there can be agreement that advances, especially in scientific knowledge, have resulted in their codification in texts which are learned by would-be practitioners, and which in turn become integrated into their practical work. This principle can reasonably be thought to be at the heart of research and development projects at the forefront of innovations, but it is clearly in evidence too in a large range of professions such as architecture, building, handling of food, and even the design of clothing.

However, there are those who would extend the notion of theoretical knowledge to encompass a much vaster range, all of which could be cited as evidence of a knowledge-based society. Here, for example, one might include the training of many white-collar employees – in law, social services, accountancy, etc. – as evidence of the primacy of knowledge in the contemporary world. Indeed, one might also choose to argue that the whole of higher education is concerned with transmitting theoretical knowledge. Such knowledge as is transmitted is undoubtedly codified and generally abstracted from practical applications, and it is even generalisable, though it is surely of a different order of magnitude to the theoretical knowledge expounded in sciences such as chemistry and physics.

Nico Stehr, proposing that we now inhabit a 'knowledge society', does extend the definition of theory in such a way, arguing that nowadays knowledge has come to be constitutive of the way that we live.[96] Recourse to theoretical knowledge is now central to virtually everything that we do, from designing new technologies, producing everyday artifacts, to making sense of our own lives when we draw upon large repositories of knowledge to help us better understand our own location. Stehr proposes an intriguing three-fold typology of the development of knowledge, from *meaningful* (the Enlightenment ideal of knowledge for better understanding), to *productive* (knowledge applied to industry), to *action* (where knowledge is intimately connected to production – for example, with the inclusion of intelligent devices).

However attractive the idea of theoretical knowledge might appear to be, there are serious problems with arriving at a clear definition of what it means. Max Weber's conception of formal rationality, developed around the

turn of the century, which underpins purposive action (most famously manifested in the growth of bureaucratic structures) might apply on one definition. After all, it involves abstract and codifiable principles, rules and regulations (the entire bureaucratic machine), as well as requiring from participants command of abstract knowledge (how the system works). Theoretical knowledge, in these terms, is not much more than learning the rules and procedures of how bureaucracies function. If so, then one is forced also to ask what is especially new and significant about this.

This leads us to the wider complaint about the imprecision of the term theoretical knowledge. If, for instance, the 'primacy of theoretical knowledge' is taken to refer to established scientific principles (the boiling point of water, the conductivity of elements, etc.) which are codified in texts, then this is one matter. However, if theoretical knowledge is taken to include hypothetical models such as the relation between inflation and unemployment or social class and educational opportunity, then this is quite another. Again, if theoretical knowledge is conceived as the primacy of research and development funds and teams in modern innovations, then this is another matter too. Finally, if the rise of theoretical knowledge is to be charted by the spread of educational certification – a common strategy in social science – then this is to introduce still another significantly different definition. In view of such ambiguities, at best one can conclude that theoretical knowledge may be more in evidence than hitherto, but that it is a far cry from this to conclude either that it is the pre-eminent force in society or that it marks a decisive turning point in history.

Even if one were to concede that theoretical knowledge is more central today, one must protest that it does not appear to represent a new order moving us beyond capitalism. In our view, and as we document in the following chapters, information/knowledge developments, including theoretical knowledge, have been most decisively about extending and consolidating capitalist relationships ever deeper into life and on to a wider geographical scale. It has been this logic which has been predominant, and it is to this rationality that informational developments have been suborned. It is also because of this, we believe, that there is a widespread scepticism and ambiguity towards 'progress'.[97] People see change as the continuation of familiar patterns even amidst continuous adjustment and innovation, and as such a fundamental hollowness of much 'progress' is exposed. Thoreau's complaint, made in the mid-nineteenth century, that 'progress' has brought improved means for unimproved ends remains valid today.

CONCLUSION

Over the past two decades we have witnessed two major waves of techno-utopianism in which the development of new technologies is allegedly set to bring about radical, but fortunately beneficent, social change. Such thinking

remains prevalent, so much so that even today we frequently hear talk of a 'second industrial revolution' being brought about by ICTs. In this chapter we have detailed key features of this way of understanding change in order to expose it as misleading and unhelpful. We are not alone in rejecting techno-utopianism's assumptions of the neutrality of technological innovation and its endorsement of a technologically determinist view of history. Indeed, in the research community of social science it is common-place to insist on the social embeddedness of technological development.[98] Nonetheless, if intellectually discredited, techno-enthusiasm exercises a powerful hold in much commentary on the 'Information Revolution', and so for that reason it merits systematic criticism.

Perhaps it is, in part at least, in response to forceful critiques of techno-logical determinism that more recently we have been offered a range of accounts that put great store on the transformative capacities of information itself. This comes in several versions, but a common one is to identify the singular role of 'symbolic analysis' in the era of globalisation. The work here of Robert Reich and Manuel Castells in particular insists on the increased centrality of 'informational labor' in the circumstances of a 'network society'. This new and burgeoning breed of highly educated problem-solvers which communicates, analyses and plans to great effect is granted tremendous powers in this, the era of informational capitalism. We are not so convinced. While there has been an undeniable expansion of informational work – a trend long ago mapped by, amongst others, Daniel Bell – it is a step too far to argue that this growth, undertaken to suit the imperatives of global capitalism, has resulted in the metamorphosis of capitalism itself. It is to these changes in the growth of advanced capitalism which we turn our attention in the remainder of this book.

PART II

GENEALOGIES OF
INFORMATION

4

THE LONG HISTORY OF
THE INFORMATION
REVOLUTION

What is the Information Revolution? The answer to this question may seem to be self-evident. A united host of industrialists, politicians, and academics is engaged in making sure that we know that recent developments in information and communications technologies (ICTs) are laying the foundations for a new era of wealth and abundance. An array of reports and publications have made clear to us since the early 1980s that we have reached a watershed in human history as we experience a *second* Industrial Revolution. According to one observer, 'the first Industrial Revolution enormously enhanced the puny muscular power of men and animals in production; this new development will similarly extend human mental capacity to a degree which we can now only dimly envisage'.[1] It is claimed that the exploitation (and industrialisation) of information and knowledge that marks an epochal shift from industrial to post-industrial society. The promise is that through new technologies (advanced computers, robotics, communications satellites, etc.) the powers of human intelligence and reason may be enhanced beyond our wildest dreams. As such, the 'Information Revolution' reflects the symbiotic relationship between human evolution and scientific and technological progress.

In this cocktail of scientific aspiration and commercial hype, there are a number of implicit but significant assumptions. First, it is assumed that the decisive shift has been brought about by recent technological innovations: the association of information revolution and ICTs seems self-evident. Thus, discussion of the Information Revolution is located within the history of technological development and the discourse of technological 'progress'. Second, the assumption is made that this technological revolution, like the earlier Industrial Revolution, marks the opening of a new historical era. The terms 'industrial' and 'post-industrial' society – which, through a process of ideological elision, often translate into 'capitalist' and 'post-capitalist' – mark this transition from a period of constraint and limits, to one of freedom, democracy and abundance. A third assumption is that of the novelty of the Information Revolution. For the first time, as a consequence of the development and convergence of

telecommunications and data-processing, it has become possible to harness human intelligence and reason in a systematic and scientific way. Associated with this, of course, is the unquestioned assumption that organised knowledge and information are socially beneficial. Information is the major asset and resource of a post-industrial society: 'it is...the raw material of truth, beauty, creativity, innovation, productivity, competitiveness, and freedom'.[2] Information in all places and at all times – that is the utopian recipe. Finally, the issue is seen substantially as an economic matter, and information as pre-eminently an economic category. The revolution is about 'making a business of information'.[3] According to Tom Stonier, 'the accumulation of information is as important as the accumulation of capital', because 'as our knowledge expands the world gets wealthier'.[4] Information is the key to economic growth and productivity, and to the bigger pie from which we shall all have bigger slices. Reflecting this economic annexation of information and knowledge is the fast expanding field of information economics.[5]

In this chapter we confront and challenge these assumptions and their complacent promise of technological progress, economic growth, and human betterment. Thus, our own attempt to explore the significance of the new communications and information technologies in terms of their genealogy, leads us to be sceptical of the idea that they constitute a technological revolution. Whilst we would, of course, accept the scale of innovation in this area, and the degree of its exploitation, we believe that these new technologies are 'revolutionary' only in a rather trivial sense.

Of course, we do not want to imply that there are not important and ongoing transformations in the character of capitalist societies, and for sure the new information and communications technologies are implicated in these transformative processes. Some commentators have described an epochal shift from 'organised' capitalism to 'disorganised' capitalism,[6] while others have conceptualised the present period in terms of a change in the dominant regime of accumulation, from the system of Fordism to one characterised as neo- or post-Fordist.[7] Within this latter perspective, there has been, in our view, a strong tendency to over-emphasise elements of rupture: to focus on the shift from centralisation to decentralisation, massification to demassification, concentration to dispersal, rigidity to flexibility. However, there are others working within this framework who have stressed the elements of continuity between Fordism and its successor regime of accumulation. Joachim Hirsch stands out as a particularly trenchant analyst of continuities in the mode of domination and control. In his account, post-Fordism is emerging as a new system of 'hyper-industrialization', characterised by the 'micro-electronic reorganisation of Taylorism' and by the regulatory form of 'authoritarian statism', which combines 'decentralised and segmented corporatism' with new (and perhaps more flexible) technologies and strategies of repression and surveillance.[8]

The key issue here is that of change and continuity, and understanding this relation is clearly a matter of disentangling different historical temporalities. In what follows, we would like to shift attention away from the immediacy of developments in the information domain, however compelling these may be, in favour of a longer-term perspective. We urge this especially because, although most scholars have focused on recent transformations, particularly as regards work processes and forms of organisation,[9] it is our view that the mobilisation of information and communications resources may be seen to operate in terms of a much longer periodicity than it is usually accorded.

Moreover, against those accounts that see the information society in terms of technological revolution, it is also important to emphasise that the appropriation of information and information resources has always been a constitutive aspect of capitalist societies quite outside of any technological context. The appropriation of knowledge (skill) in the factory, for example, may operate solely through hierarchical control. Similarly, nation states functioned effectively for generations without benefit of computer technologies. Both here, and in wider contexts, organisational structures – culminating in bureaucratic institutions – may establish effective mechanisms for the control and management of information resources. The gathering, recording, aggregation, and exploitation of information can be – and has been – achieved on the basis of minimal technological support.

Our point is that the 'Information Revolution' is inadequately conceived, as it is conventionally, as a question of technology and technological innovation. Rather, it is better understood as a matter of differential (and unequal) access to, and control over, information resources. That is, far from being a technological issue, what should concern us is the management and control of information within and between groups. Raising this widens unavoidably the scope of discussions of social change, taking it far from 'technology effects' considerations, at the same time as it, necessarily, politicises the process of technological development itself by framing it as a matter of shifts in the availability of and access to information. Conversely, attempts to divert analysis and debate into technical and technocratic channels serve to repress these substantial political questions.

In a similar way, the prevailing tendency to consider information and information technology chiefly in terms of economic growth, productivity, and planning, again puts it in a strongly technical, calculative, and instrumental context (with the major issues being those of competitive position and the allocation of wages and profits). Against this orthodoxy, our own approach focuses upon information and information technologies in terms of their political and cultural dimensions. In both these aspects what are raised are the complex relations between technology, information, and power. In the case of the former, what is on the agenda, in the workplace and in society as a whole, is the relationship between management and control.

And in the case of the cultural dimension, what is of concern is the micro-politics of power, what Foucault calls the capillary forms of power's existence. What this raises is the shaping influence of information and communication technologies on the texture, pattern, organisation and routines of everyday life.[10] What is apparent, at both levels, we believe, is the indissociable relation between information/knowledge and power.

In tracing the cultural and political contexts in which information and communications technologies have taken shape, we suggest that they have performed two distinct but related functions, both of which are absolutely central to the cohesion and reproduction of capitalist societies. On the one hand, they have been the mechanism for social management, planning and administration; and, on the other, they have been at the heart of surveillance and control strategies. Our argument is that these two functions are closely interrelated and mutually reinforcing. To echo Foucault's words, it is not possible for social planning and administration to be exercised without surveillance, it is impossible for surveillance not to reinforce administrative cohesion, efficiency, and power.[11] There is no point in dreaming of a time when planning and management will be simply a technical and instrumental matter – the administration of things – and will cease to be embroiled in the business of power, surveillance and control.

PLANNING AND CONTROL

Some of Anthony Giddens' work throws light on this relationship between planning and control. He argues that the state must maintain an effective hold on both 'allocative resources' (planning, administration) and 'authoritative resources' (power, control). Crucial to this project, argues Giddens, is information gathering and storage, which

> is central to the role of 'authoritative resources' in the structuring of social systems spanning larger ranges of space and time than tribal cultures. Surveillance – control of information and superintendence of the activities of some groups by others – is in turn the key to the expansion of such resources.[12]

If information gathering, documentation and surveillance are vital to this end, it is also the case, Giddens argues, that the regularised gathering, storage, and control of information is crucial for administrative efficiency and maintenance of power.[13]

In the modern nation state allocative and authoritative control converge insofar as each comes to depend on the continuous, normalised, and increasingly centralised surveillance and monitoring of subject populations. Tendentially, moreover, allocative control comes to prevail through its ability to combine (and legitimate) both administrative and authoritative functions: 'surveillance as the mobilising of administrative power – through the storage

and control of information – is the primary means of the concentration of authoritative resources involved in the formation of the nation-state'.[14] In advanced capitalist societies it is this administrative-technocratic machinery of surveillance that expresses the prevailing relations of power and designates the inherently totalitarian nature of the modern state.

> The possibilities of totalitarian rule [Giddens writes] depend upon the existence of societies in which the state can successfully penetrate the day-to-day activities of most of its subject population. This, in turn, presumes a high level of surveillance...the coding of information about and the supervision of the conduct of significant segments of the population.[15]

It is, we shall go on to argue, precisely these possibilities that are developed by the new information technologies.

Further evidence of the tendency toward control through surveillance and monitoring that Giddens identifies can be seen in the field of economic analysis. For instance, one way of conceptualising transactions in the economic marketplace has been in terms of information theory. Thus Hayek writes of the 'price system as...a mechanism for communicating information'[16] and argues that 'the problem of what is the best way of utilising knowledge initially dispersed among all the people is at least one of the main problems of economic policy'.[17] Hayek's own solution to this problem was, famously, to eschew central planning – 'direction of the whole economic system according to one unified plan' – in favour of competition, which he refers to as 'decentralised planning by many separate persons'.[18] Other economists, however, have lived less comfortably with this 'problem of the utilisation of knowledge not given to anyone in its totality'.[19] The tendency in the late twentieth century has been for the economy to assume ever greater complexity. The relation between the national economy and international markets; the relation between finance and industrial sectors; the management of technological innovation; the co-ordination of production and consumption; the internal articulation of dispersed multinational conglomerates – these all become pressing issues of economic management. Alfred Chandler has argued that this reflects a point in history 'when the volume of economic activities reached a level that made administrative co-ordination more efficient and more profitable than market co-ordination'; a point at which 'the visible hand of management replaced the invisible hand of market forces'.[20] What becomes crucial is precisely the gathering in of dispersed knowledge, the concentration and centralisation of information, and the elaboration of a unified plan. Economic management in the age of transnational capital necessarily tends toward that process of administrative control by a 'directing mind' of the kind that Hayek[21] so despises. The necessity for effective and centralised information management becomes the preoccupation of an increasing number of economists. Thus, Charles

Jonscher, referring to the 'increase in the complexity of economic systems', refers to the enormous 'organisational or informational task of co-ordinating the diverse steps in the production chain...[and] the number of transactions within and among productive units'. 'The largest untapped opportunities for improving economic performance', he concludes, 'lay in the area of information handling. Consequently large research and development resources began to be directed to the creation of technologies which process, store, transport and manipulate information.'[22]

We are especially suspicious of the 'information society' scenarios sketched by the likes of Daniel Bell,[23] where information/knowledge is represented as a beneficial and progressive social force. Information, we suggest, has long been a key component of regulation in the modern nation state and in capitalist economies. And the history of information management suggests that technocratic and economic exploitation should be understood within the wider context of its disciplinary and political deployment.[24] Particularly significant in this context has been the process whereby authoritative control has become subsumed within the machinery of allocative control: power expresses itself through the discipline of calculative and rational social management and administration. Historically, this process has occurred without significant technological mediation. Increasingly, however, new technologies are drawn upon: because, as Lewis Mumford has argued, 'mechanisation, automation, cybernetic direction' overcome the system's weakness, 'its original dependence upon resistant, sometimes actively disobedient servo-mechanisms, still human enough to harbour purposes that do not always coincide with those of the system'.[25] Whether bureaucratic or technological, however, the thrust of administrative control is toward extensive and intensive documentation and surveillance of internal populations. 'With the mechanisms of information processing (the bureaucracy using people; the computer using machines), the ability to monitor behaviour is extended considerably', Mark Poster argues: 'The mode of information enormously extends the reach of normalising surveillance, constituting new modes of domination that have yet to be studied'.[26] This disciplinary and calculative management of existence in advanced capitalist societies transforms itself into their culture, their way of life, their prevailing social relations.

THE DARK SIDE OF THE INFORMATION REVOLUTION

We would stress that the logic of planning and control has always been contested. In an environment of increasing complexity and uncertainty, the urge to control may become more intensive and more neurotic, but it does not, for that, become more cohesive.[27] Moreover, the logic of control may invoke that of resistance. Populations are never simply and absolutely fixed

and compartmentalised; they remain obdurately fluid and mobile. The power of resistance is an integral and dynamic aspect of the control system, and it would be quite wrong to regard it as only a residual force. Nonetheless, if we do not underestimate the significance of this counter-force, then any balanced consideration should encourage us also not to underestimate the tenacity and resourcefulness of diverse control agencies. Thus, in the present context of a historical transition beyond Fordism, it seems to us that there are also important transformations in the modalities of surveillance and control. While control is often understood as an external and directly repressive force, its real dynamics are more complex and insidious, and, in fact, ideally exploit the compliance and even the creativity of its subjects. There are signs that, after a period of 'de-subordination'[28] and destabilisation, the present period is very much about the reassertion, and the streamlining, of control strategies. This is apparent in the image of the new model worker (the flexible, compliant, self-motivated, and self-controlling worker); and also in the new model student (again self-directed, flexible, enthusiastic, and docile).[29] As cognitive intrusion and surveillance become increasingly normalised, pervasive, and insidious, so does the logic of control – of power through visibility or 'knowability' – become internalised.

The following sections aim to explore this dark underside of the information revolution, and to do this on the basis that serious, rather than just well-meaning, responses are only possible if we confront, not just the repressive potential of information and knowledge, but more significantly the integral and necessary relation between repressive and possible emancipatory dimensions. In the following discussion we draw attention to the administrative and disciplinary exploitation of information resources and technologies, first in a discussion of the role of information in the economic contexts of production, markets and consumption, and then through an account of the relation between information technologies, communications, and the political system. Such discussion remains selective and incomplete. Our ambition here is to provide an overview, a cartography of the information society, to trace the cohesion in what might seem to be quite disparate developments. Whilst the exploitation of information/knowledge has a considerable history, our argument here is that the really significant moment occurs early in the twentieth century. It is at this time, and particularly in the complex matrix of forces surrounding the Scientific Management of Frederick Winslow Taylor, that the information society may be said to have been truly inaugurated.[30]

SCIENTIFIC MANAGEMENT AND CONSUMER CAPITALISM

Though the image of the Industrial Revolution is one of vast, impersonal mills in which multitudinous 'hands' were ruthlessly exploited by distant

capitalists, the reality was that most work – arduous though it undeniably was – took place in small units of perhaps a dozen or so employees overseen by a master.[31] It was only in the later years of the century that size became an issue when the logic of competition and cartels brought into being the corporate capitalism,[32] typically headed by oligopolistic conglomerates, that has characterised the economic and social landscape ever since. With direct supervision of labour now increasingly untenable, what became necessary were mechanisms for co-ordinating and integrating the complex and fragmented processes of production.

This requirement conjoined with the developing suspicion of an out-and-out free market and the Social Darwinist ideology that had accompanied *laissez-faire* economics.[33] Martin Sklar has traced, in the history of the United States, a growing discontent (amongst business leaders especially) with the 'wastes of competition' between the years 1890 and 1916, something which paralleled the transformation of the economy from 'proprietary-competitive' to 'corporate-administered' capitalism.[34] More generally, as Eric Hobsbawm observes, throughout the capitalist world between 1880 and 1914 '[t]he "visible hand" of modern corporate organization and management now replaced the "invisible hand" of Adam Smith's anonymous market [and] executives, engineers and accountants therefore began to take over'.[35]

It was here that the philosophy and practice of F. W. Taylor was so crucial, with its advocacy of Scientific Management throughout society in general and its application to production especially. Scientific Management meant expert direction by engineers, factory planning, time and motion study, standardisation, and the intensive division of labour. The key word in the application of engineering principles to the industrial system of production was efficiency. Taylor 'proposed a neat, understandable world in the factory, an organisation of men whose acts would be planned co-ordinated, and controlled under continuous expert direction. His system had some of the inevitableness and objectivity of science and technology'.[36] Factory production was to become a matter of efficient and scientific management: the planning and administration of workers and machines alike as components of one big machine.[37]

Two observations here relate to our broader argument. First, within the Taylor system, efficient production and administration (planning) is indissociably related to control over the workforce. Although these two aspects are often treated as distinct (and emphasis is often placed on the disciplinary function), we would argue that planning and control are each an integral part of the other: efficiency translates into domination and the engineering of people becomes subsumed within the engineering of things. The second point is that administration and control are a function of managerial appropriation of skills, knowledge and information within the workplace. According to Taylor, wherever possible workers should be

relieved of the work of planning, and all 'brain work' should be centred in the factory's planning department. In Anthony Giddens' terms, the collation and integration of information manifests itself in terms of both administration and surveillance. It is this dual articulation of information/knowledge for 'efficient' planning and for control that is at the heart of Scientific Management, and which, in our view, characterises it as the original Information Revolution.

Importantly, Taylorism as a system of factory control does not depend on technological support: information gathering and surveillance do not depend to any large extent upon information technologies. Its capacity to 'reduce the labour of the ordinary employee to an automatic perfection of routine'[38] is a consequence of organisational forms and of direct managerial intervention, of technique rather than technology. As such it may be inscribed within Mumford's history of the non-technological megamachine – the military is a paramount example – which is 'an invisible structure composed of living, but rigid, human parts, each assigned to his special office, role, and task, to make possible the immense work-output and grand design of this great collective organisation'.[39] If, however, this form of megatechnics replaces interpersonal modes of control with more rational and calculative procedures and establishes a certain degree of automaticity, it is the case that machinery can implement this principle more effectively. Insofar as it subordinates unreliable human components to the precise routines of machinery, technology enhances both efficiency and control. It is this realisation that constitutes Henry Ford's major contribution to the Scientific Management of production. Not only did Ford appropriate information/knowledge within the production process, but he also incorporated it into the technology of his production lines to achieve technical control over the labour process.[40]

The subsequent history of capitalist industry, we would argue, has been a matter of the deepening and extension of information gathering and surveillance to the combined end of planning and controlling the production process, and it is into this context that the new information and communications technologies are now inserting themselves. Thus, computer numerical control, advanced automation, robotics and so on intensify this principle of technical control. The new technologies now spreading through office and service work threaten even to 'Taylorise' intellectual labour itself. Managements have carefully analysed the information routines and requirements and are aiming to introduce information technologies that will make information flows more effective, efficient and cost-effective,[41] such that, while employees may have an enhanced degree of autonomy in their day-to-day operations, they are subject to ready and sophisticated surveillance at any time. The new technologies are also crucial in managing and co-ordinating ever more complex organisational and productive structures. The establishment and maintenance of a system of transnational corporations

depends upon effective computer communications systems to handle financial transactions, corporate directives and organisational co-ordination.

Yet Taylorism is more than just a doctrine of factory management. It became, in our view, a new social philosophy, a new principle of social revolution, and a new imaginary institution in society. Outside the factory gates, Scientific Management became a new form of social control, not just in the dominative sense of this term, but also in the more neutral sense of the 'capacity of a social organisation to regulate itself'.[42] Taylor and his various epigones believed that the idea of rational, scientific and efficient management and regulation could be extended beyond the workplace to other social activities. They spoke of 'social efficiency', by which they meant 'social harmony' under the leadership of 'competent' experts.[43]

In 1916, Henry L. Gantt took a 'dramatic step from the planning room of the factory to the world at large', with the formation of the 'New Machine', an organisation of engineers and sympathetic reformers under Gantt's leadership, which announced its intention to acquire political as well as economic power.[44] The association is made between society and the machine; society is to be regulated and maintained by social engineers. Experts and technocrats are to be the orchestrators of a programmed society.[45] As in the factory, this calculative and instrumental regime entails a combined process of administration/planning and surveillance, and depends upon the centralised appropriation and disposal of information resources. It implies 'the intelligence of the whole', and this in the form of instrumental, theoretical, quantified data. The legitimacy of technocratic rule is justified by the command of knowledge/information: it assumes 'an objective and universal rationality based on superior knowledge'.[46]

A further legitimating aspect of Scientific Management was its undoubted capacity to increase productivity, economic growth, and, consequently, social wealth. As Charles Maier argues, it promised 'an escape from zero-sum conflict' between labour and capital: what Taylorism 'offered – certainly within the plant, and ultimately, according to its author, in all spheres of government and social life – was the elimination of scarcity and constraint'.[47] Inherent in mass production was the system of mass consumption and the promise of the consumer utopia. In Scientific Management was a broad social philosophy, a promise of reform through growth and expansion, which had great appeal to social theorists and politicians of the Progressive era (and coincided, in Britain, with Fabian principles and beliefs).

This complex and expanding system of mass production and mass consumption could only be co-ordinated and regulated if the criteria of efficiency and optimality were extended from the factory to the society as a whole. The system of consumption, particularly, must be brought under the practices of Scientific Management. It became increasingly apparent that both economic and social stability depended upon continuous and regular consumption, and upon the matching of demand to cycles and patterns of

production. Ultimately what was required was the Scientific Management of need, desire and fantasy, and their reconstruction in terms of the commodity form.[48] Thus, Taylorist principles of calculation must extend into the marketing sphere.[49] The steady movement of such commodities as clothing, cigarettes, household furnishings and appliances, toiletries or processed foods, required the creation of ways of reaching customers, taking heed of their needs, wants, and dispositions, and responding by persuasion and even redesign of products to make them more or newly attractive.[50]

In this project of systematising the management of consumption, it was Henry Ford's counterpart at General Motors, Alfred P. Sloan, who played an important and formative role. It was Sloan who, in the 1920s, introduced instalment selling, used-car trade-ins, annual model changes, styling and brand image, to the automobile industry.[51] The objective was both to integrate production and demand, and also to intensify and 'speed up' consumption. As such, 'Sloanism' exemplified the principle of modern marketing, with its ambitions towards the Scientific Management of commodity markets and consumer behaviour.

The system of mass consumption (and the consumer society) is dependent upon the collection, aggregation, and dissemination of information. One consequence of this imperative to accumulate data on patterns of consumption was the rise of market research organisations, specialising in the aggregation of demographic and socio-economic information, and in the detailed recording of trends and patterns in sales. The then embryonic company, International Business Machines, developed technologies to service record-conscious and surveillance-conscious corporations. Henry C. Link, a polemical advocate of scientific marketing, described the relation between early forms of information technology and the informational needs of business:

> The most highly developed technique for measuring buying behaviour is that made possible by the electric sorting and tabulating machines. These ingenious devices have made it feasible to record and classify the behaviour of the buying public as well as the behaviour of those who serve that public on a scale heretofore impracticable. Whereas by ordinary methods hundreds of transactions may be recorded, by this method thousands may be recorded with greater ease. Not only have comprehensive records been made possible but, what is more important, the deduction from these records of important summaries and significant facts have been made relatively easy. The technique developed by various merchants, with the use of these devices...is the quantitative study and analysis of human behaviour in the nth degree.[52]

It is also vital, of course, to convey information to the consumer, and this informational task gave rise most obviously and pre-eminently to

advertising (though it was also evident in packaging and branding commodities and in their display). In a paean to American productivism, David Potter suggests that 'advertising [is] an instrument of social control'; it is, he continues, 'the only institution which we have for instilling new needs, for training people to act as consumers, for altering men's values, and thus for hastening their adjustment to potential abundance'.[53] Through their exploitation of information resources and channels, the early advertising corporations were searching 'for a means of translating Frederick W. Taylor's ideal of Scientific Management into the selling and distribution processes'.[54] What became apparent was that information resources (and information and communications technologies in their early incarnations) were the lifeblood of modern corporations and of the national and international business system.

During the second and third decades of the century, these developments were coming together to constitute a more systematic, calculative, and rationalised management of economic life. There was a concern with information management, with an emphasis on quantification and on professional and 'scientific' procedures. Thus, in advertising, concepts from psychological research were introduced and campaigns more thoroughly prepared by pre-testing and careful analysis of advertising copy and presentation; broadcast ratings were promoted and refined to differentiate types of audience, patterns of behaviour, and preferences;[55] market research flourished and increasingly drew upon survey literature, census data and social science techniques, feeding back into commercial strategies; public relations developed as 'the attempt, by information, persuasion, and adjustment, to engineer public support', and quite self-consciously proclaimed that 'engineering methods can be applied in tackling our problems'.[56] Informing these trends towards more effective control and planning was the faith that innovations were motivated, not by vulgar self-interest, but by the search for efficiency, expertise and rationality in the administration of both things and people.

It is in the context of this historical outline that we can begin to understand some aspects of the current 'Information Revolution'. Our argument is that what is commonly taken as innovation and 'revolution' is in fact no more — and no less — than the extension and intensification of processes set under way some seventy or so years ago. It was the exponents of Scientific Management, in its broadest sense, who unleashed an Information Revolution.[57] Particularly important here were the strategies of the 'consumption engineers'[58] to regulate economic transactions and consumer behaviour. It was these advocates of big business who first turned to the 'rational' and 'scientific' exploitation of information in the wider society, and it is their descendants — the multinational advertisers, market researchers, opinion pollers, data brokers, and so on — who are at the heart of information politics today. It is they who are promoting and annexing cable systems, communi-

cations satellites, telecommunications links, computer resources, and so on. Their objective is the elaboration of what has been termed a global 'network market place'[59] in which ever more social functions and activities come 'on-line' (education, shopping, entertainment, etc.). What is new in their enterprise is its scale, and also its greater reliance on advanced information and communications technologies to render the Scientific Management of consumer life more efficient and automatic. The objective of a cybernetic market place, and the fantasy of society as a producing and consuming machine, goes back, however, to Taylor, Gantt, and the rest.

World marketing in the era of transnational capital demands global market research and advertising, the ability to undertake surveillance and monitoring of markets, and to launch persuasive propaganda on behalf of a particular product or corporation. The information and intelligence agencies that undertake these tasks of 'mind management' are themselves transnational enterprises and increasingly integrated across the range of information business concerns. Thus, Saatchi and Saatchi, for a while in the 1980s the world's number one advertising agency, established skills and expertise in public relations, market research, management consultancy and sales promotion as well as in its central advertising concerns. A decade and more on, all the world's leading advertising organisations, from the WPP group to Young and Rubicam, offer a similar portfolio of services. The strategy of Saatchi and Saatchi is explicitly to direct its informational expertise toward the 'multinational advertisers who are moving towards greater co-ordination in their international marketing activities',[60] and who account for 80 per cent of America's top spenders on advertising. World marketing necessitates a major strategy of surveillance and intelligence: the 'analysis of all demographic, cultural and media trends' so that marketers 'can survey the world battlefield for their brands, observe the deployment of their forces, and plan their international advertising and marketing in a coherent and logical way'.[61] The important point, made by a Saatchi employee, is that 'a co-ordinated approach to multinational brand marketing is only as good as the information which supports it, information about consumer habits, consumer perceptions and attitudes'.[62]

The spread of global marketing is manifest, not only in new information politics, but also in its impact on communications media. The press, radio and television have long been shaped, often in decisive ways, by the pressures of advertising, and it seems likely that the new information and communications technologies will be harnessed to the same consumerist ends.[63] The possibilities exist now both for global advertising and for more targeted advertising reaching particular segments of the audience ('narrowcasting'). Cable television is particularly important here in that its two-way communication facility allows (and, indeed, requires) the recording and surveillance of precise viewing habits. This routine logging of consumer preferences can also be enhanced by the use of such devices as 'people

meters', through which each member of a monitored family is assigned a personal code which they 'tap in' when viewing and 'tap out' when leaving the set. Yet a further extension of this surveillance and information gathering is the recording of data from supermarket check-out scanners in order to establish a basis for designing specifically 'addressed' commercials to particular consumer groups. Similarly, the growth in credit cards permits the monitoring of purchasers and gives access to information about what people buy, at what price, how regularly, where, and how readily they foot the bill.

Illustrative and illuminating of these trends is Professor David Schmittlein's recognition of 'the benefits of managing customers as strategic assets'. 'Managing customers' requires 'detailed transaction histor[ies]' in order to reveal their 'asset value'. Most obviously this calls for the construction of databases on purchases, from which intricate and intimate consumer portraits may be drawn, on which in turn can be founded effective sales campaigns. Advantages 'include more loyal customers, who are less inclined to shop around or buy on price, more efficient, effective and highly targeted communications programmes, reactivation of very profitable "lost" customers at low cost, and more focused and successful development of new products'. Indeed, '[m]anagement of customers as strategic assets leads a company ultimately to organise all its activities, including the development of new products, around particular customer groups whose perceptions, preferences and purchase behaviours are tracked through time'. In addition, 'customers can be bought and sold' since they 'often have an asset value that can be evaluated reliably, especially with the availability of detailed transaction history information'. In short, 'the need actively to manage customer groups...just as other organisational assets require management' is a responsibility and requirement of any modern corporation.[64]

What the new technologies enhance, we would suggest, is the Scientific Management of marketing. 'Teleshopping', global and targeted advertising, and electronic market research surveillance, all combine to establish a more rationalised and 'efficient' network marketplace.[65] Information, surveillance, efficiency: the very principles of Taylorism become intensified, extended and automated through the application of new communications and information technologies. One fundamental aspect of the 'communications revolution' has been to refine that planning and control of consumer behaviour that was already inherent in the early philosophy of Scientific Management.

FROM PUBLIC SPHERE TO CYBERNETIC STATE

The growth of a 'programmed' market, of a regulated and coded consumer society, is a fundamentally cultural phenomenon. The stimulation of needs,

the recording of tastes, the surveillance of consumption, all reflect a more rationalised and regulated way of life. (This does not, of course, imply the necessary success of such strategies, nor does it deny the ability of individuals to derive pleasure and creativity from consumer goods.) We want now to turn to a second set of forces that have been central to the historical development of the 'information society'. We are referring to the role of information and communications resources in the political process. Here too we can trace the tendency towards combined planning and control, and here too this has been of profound significance for the cultural life of modernity.[66]

We have referred to Anthony Giddens' argument that the state, and particularly the nation state, has always been propelled into the business of surveillance and information gathering. Giddens suggests that 'storage of authoritative resources is the basis of the surveillance activities of the state', and such surveillance, he argues, entails 'the collation of information relevant to state control of the conduct of its subject population, and the direct supervision of that conduct'. The storage of authoritative resources and control depends upon 'the retention and control of information or knowledge'.[67] Information and communications capabilities have been fundamental to the state and the political sphere in a number of respects. First, they have been indispensable prerequisites for administrating and co-ordinating – maintaining the cohesion and integrity – of complex social structures. Second, they have played an important part in policing and controlling 'deviant' members of the internal population, and in the surveillance of external (potential enemy) populations. And, third, they have been central to the democratic process of political debate in the public sphere. In the following discussion we want to outline the specific shape and force that these various information functions have assumed in political life during this century.

Our historical account of the relation between information and the political system gives rise to a number of observations that can usefully be detailed at the outset. First, we should emphasise again that neither planning nor surveillance depends upon technological support. Thus, Theodore Roszak notes what the English Utilitarians recognised early in the nineteenth century, 'the persuasive force of facts and figures in the modern world': 'All the essential elements of the cult of information are there – the facade of ethical neutrality, the air of scientific rigor, the passion for technocratic control. Only one thing is missing: the computer'.[68] And the principles of disciplinary surveillance, too, have non-technological and Benthamite origins in the architecture of the Panopticon. The issue we are addressing is fundamentally about relations of power – though, having said that, we must emphasise that technologies have increasingly been deployed in the twentieth century to render the exercise of power more efficient and automatic. Our second point is that the functions of administration and control have increasingly coalesced, and regulatory and disciplinary

tendencies have increasingly expressed themselves through the calculative and 'rational' machinery of administration. Third, we argue that the idea of a democratic 'conversation' in the public sphere has given way to that of the instrumental and 'efficient' Scientific Management of political life. Along with this, surveillance has become associated with a transformation of the political identity and rights of the internal population, and comes to be directed against the 'enemy within'. Finally, we argue that, although there has always been an information politics, a particularly important moment in these processes occurred early in the twentieth century and was associated with the project of Taylorism.

To clarify these arguments, let us begin with the ideal role of information and communications in democratic political theory. In his classic account of the emergence of the bourgeois public sphere, Habermas describes the historical convergence of democratic principles, the new channels of communication and publicity, and the Enlightenment faith in Reason.[69] The public sphere is the forum, open equally to all citizens, in which matters of general and political interest are debated and ideas exchanged. It remains distinct and separate from the state, and, indeed, insofar as it is the locus of critical reasoning, it operates as a curb on state power. The fundamental principles are that 'opinions on matters of concern to the nation and publicly expressed by men outside the government...should influence or determine the actions, personnel, or structure of their government', and that 'the government will reveal and explain its decisions in order to enable people outside the government to think and talk about those decisions'.[70] Such democratic discussion within the frontiers of the extended nation state depends necessarily upon an infrastructure of communication and publicity. Indeed, it is only on this basis that the idea of a public can have any meaning. It is through these media that channels of communication and discourse, and access to information resources, are assured. On this basis the public use of reasoning could be assured. Gouldner describes the bourgeois public sphere as 'one of the great historical advances in rationality'.[71]

That was the aspiration, though many critics of Habermas have doubted whether the bourgeois public sphere – and the 'ideal speech situation' that it presupposes – were ever significant historical realities. For the present argument, however, these objections are not important. What concern us now are the subsequent transformations of the public sphere, which do have manifest historical palpability. One process that occurs is the intrusion of market and commodity relations into the public sphere, and this results in the transformation of reasoning into consumption.[72] But perhaps even more important has been that process through which political debate has come to be regulated by large corporate bodies and by the state ('refeudalisation' is Habermas's term for it). The 'public' is then 'superseded, managed and manipulated by large organisations which arrange things among themselves on the basis of technical information and their relative power positions', and

what results is 'the dominance of corporative forms within which discussion is not public but is increasingly limited to technicians and bureaucrats', with the public now becoming 'a condition of organisational action, to be instrumentally managed – i.e. manipulated'.[73] What Habermas and Gouldner both discern is the technocratic and administrative rationalisation of political life, the Scientific Management of the public sphere and of public information and communication. Gouldner goes further, however, in recognising that this rationalising tendency is, ironically, already present in the very foundations of the public sphere. He demonstrates that

> the means to bring about the communicative competence that Habermas requires for rational discourse presuppose precisely the centralisation and strengthening of that state apparatus which increasingly tends to stifle rather than facilitate the universalisation of the rational, uninhibited discourse necessary for any democratic society.[74]

The most important cultural change with regard to the public sphere is the historical shift from a principle of political and public rationality, to one of 'scientific' and administrative rationalisation. As Anthony Giddens argues, there are problems in the very scale and complexity of the modern nation state. Social integration depends upon a strengthening and centralisation of the state, and one aspect of this is the development and regulation of communication and information resources. The rationale and justification of such tendencies become a 'technical' matter of 'efficient' management and administration over the extended territory of the nation state. On this basis, political debate, exchange and disagreement in the public sphere can come to seem 'inefficient', an inhibiting and disturbing obstacle to the rational management of society. Rational and informed discourse in the public sphere gives way to rational Scientific Management of society by technicians and bureaucrats. In this process, the very nature and criteria of rationality have been transformed. In the first case, appeal is made to the reason and judgement of the individual citizen. In the second, it is made to the scientific rationality of the expert, and to the rationality of the social system. The more 'objective' rationality of Scientific Management seems to promise a more 'efficient' democratic order than the often inarticulate and irrational citizen. Reason thus becomes instrumental, the mechanism for administrating, and thereby effectively controlling, the complex social totality. The Enlightenment ideal of Reason gives birth to what Castoriadis calls the 'rationalist ideology': the illusion of omnipotence, the supremacy of economic 'calculus', the belief in the 'rational' organisation of society, the new religion of 'science' and technology.[75]

This technocratic tendency is, of course, reflected in the positivist philosophy of Saint-Simon and Comte, which, as Gouldner persuasively argues, was inimical to the ideal of a politics open to all and conducted in public,

and which maintained that public affairs were in fact scientific and technological problems, to be resolved by professionals and experts.[76] But it is with a later form of practical sociology, that associated with the extension of the principles of Scientific Management to the wider society, that such social engineering assumed its most sustained form and that the systematic exploitation of information and communications resources was taken up in earnest. And an emblematic figure here was Walter Lippmann. Scientific Management, especially when placed within the conditions of industrial democracy, embodied in the factory regime what progressive thinkers such as Walter Lippmann envisioned within society at large.[77]

Lippmann points to two dilemmas of the modern mass society. The first refers to the political competence of citizens in democratic society: 'The ideal of the omnicompetent, sovereign citizen is, in my opinion, such a false ideal. It is unattainable. The pursuit of it is misleading. The failure to produce it has produced the current disenchantment'.[78] The second dilemma is that society has attained 'a complexity now so great as to be humanly unmanageable'.[79] The implication is that central government has been compelled to assume responsibility for the control and co-ordination of this increasingly diffuse social structure. And this entails 'the need for interposing some form of expertness between the private citizen and the vast environment in which he is entangled'.[80] As in the Taylorist factory, this depends on 'systematic intelligence and information control'; the gathering of social knowledge, Lippmann argues, must necessarily become 'the normal accompaniment of action'.[81] If social control is to be effective, the control of information and communication channels is imperative. With the Scientific Management of social and political life through the centralisation of communications and intelligence activities, 'persuasion...become[s] a self-conscious art and a regular organ of popular government' and the 'manufacture of consent improve[s] enormously in technique, because it is now based on analysis rather than rule of thumb'.[82]

What is especially important here, we believe, is the association of public opinion theory with the study of propaganda in contemporary political discourse. Propaganda has commonly, and common-sensibly, been seen as inimical to rational political debate, as a force that obstructs public reasoning. In the context, however, of the social complexity and citizen 'incompetence' observed by Lippmann, propaganda assumed the guise of a more positive social force in the eyes of many social and political thinkers in the early decades of the century. An increasingly pragmatic and 'realistic' appraisal of the political process suggested that 'in a world of competing political doctrines, the partisans of democratic government cannot depend solely upon appeal to reason or abstract liberalism'.[83] It became clear that 'propaganda, as the advocacy of ideas and doctrines, has a legitimate and desirable part to play in our democratic system'.[84] The very complexity of the modern nation state is such that a 'free market' of ideas and debate must

be superseded by the management and orchestration of public opinion. Harold Lasswell makes the point succinctly:

> The modern conception of social management is profoundly affected by the propagandist outlook. Concerted action for public ends depends upon a certain concentration of motives....Propaganda is surely here to stay; the modern world is peculiarly dependent upon it for the co-ordination of atomised components in times of crisis and for the conduct of large scale 'normal' operations.[85]

Propaganda is understood here in terms of the regulation and control of channels of communication and information in democratic societies. At one level, this is a matter of disseminating and broadcasting certain categories of information.[86] At another level, it is a matter of restricting access to specific categories of information. As Walter Lippmann makes clear, 'without some form of censorship, propaganda in the strict sense of the word is impossible. In order to conduct a propaganda there must be some barrier between the public and the event'.[87] For Lippmann, propaganda and censorship are complementary, as forms of persuasion and public opinion management. There has been a shift from the idea of an informed and reasoning public, to an acceptance of the massage and manipulation of public opinion by the technicians of public relations. The state function has increasingly come to subsume and regulate the democratic principle; and this to the point that it now seems indissociable from that principle.[88]

We have spent some time in outlining the development of rationalised political management and information control because we feel, again, that this is an important historical context for the development of new information and communications technologies. Through the impetus of Scientific Management, and the development of propaganda and public opinion research, it became clear that social planning and control depended upon the exploitation of information resources and technologies. This was the historical moment of the Information Revolution. The most recent technological developments – in space and satellite technologies, data processing, and in telecommunications – extend what was in reality a fundamentally political 'revolution' in information (and communication) management. It was this historical conjuncture that spawned the 'modern' industries and bureaucracies of public relations, propaganda, public (and private) opinion polling, news management, image production and advocacy, political advertising, censorship and 'official' secrecy, think tanks, and so on. More recent innovations have come with the increase in scale and the exploitation of technological resources.

While information management took on its major features in the period between the wars, in recent decades its growth and spread have been accelerating dramatically. Ironically, however, more information management

has been accompanied by a reluctance to admit of its existence. Consider, for example, the enormous expansion and extension of the advertising industry since 1945.[89] Not only has advertising grown massively in economic worth, but it has also extended its reach to incorporate a battery of new informational and communications activities, ranging from consultancy to public relations, direct mail to corporate imagery. In tandem have developed the phenomena of 'junk mail' and free local 'newspapers', innovations designed to reach more, and to more precisely find, potential consumers. Along with these extensions into new products and new markets has come about an improved professionalism amongst practitioners (clear evidence of which is the proliferation of courses in advertising, PR and marketing available in the education system) and a notable increase in the precision of their 'campaigns' (careful market research using social science techniques such as survey samples, focus groups, etc., computerised recording and analysis of data, and carefully 'targeted' audiences).

Further evidence of the growing trend towards managing opinion, and something which reaches deep into the political domain, is the dramatic rise in Britain of lobbying concerns that penetrate Whitehall to extend the influence of their paymasters. A key constituent of this strategy is the hiring of parliamentarians by interested parties. Indeed, Adam Raphael estimated that one-third of British members of parliament are paid 'consultants',[90] with over half having commercial interests either as paid consultants, directors or shareholders.

An important rationale for the deployment of new information technologies is, then, the regulation of political life and the engineering of public opinion. Jeremy Tunstall describes the technological streamlining of political management in the United States: election campaigns 'are now managed via computers'; electronic mailing permits 'separate mailing shots...targeted at particular occupational groups or types of housing area'; electronic databases provide political and demographic information.[91] In Britain, too, electioneering is increasingly a matter of electronic techniques, with the development of software programmes to analyse voter groups and behaviour, detailed scrutiny of carefully selected subjects prior to product launch,[92] the growth of targeted mail, and computerised planning of campaigns.[93]

CONCLUSION

'Is closer and closer social control the inevitable price of "progress", a necessary concomitant of the continued development of modern social forms?'[94] We believe that this is indeed the case. Against those who see the new communications technologies as the basis for a coming 'communications era',[95] and the new information technologies as the panacea for our present 'Age of Ignorance',[96] our own argument is that their

development has, in fact, been closely associated with processes of social management and control. The scale and complexity of the modern nation state has made communications and information resources (and technologies) central to the maintenance of political and administrative cohesion.

The 'Information Revolution' is, then, not simply and straightforwardly a matter of technological 'progress', of a new technological or industrial revolution. It is significant, rather, for the new matrix of political and cultural forces that it supports. And a crucial dimension here is that of organisational form and structure. Communication and information resources (and technologies) set the conditions and limits to the scale and nature of organisational possibilities. What they permit is the development of complex and large-scale bureaucratic organisations, and also of extended corporate structures that transcend the apparent limits of space and time (transnational corporations). They also constitute the nervous system of the modern state and guarantee its cohesion as an expansive organisational form. Insofar as they guarantee and consolidate these essential power structures in modern society, information and communication are fundamental to political administrative regulation, and consequently to the social and cultural experience of modernity.

The exploitation of information resources and technologies has expressed itself, politically and culturally, through the dual tendency towards social planning and management, on the one hand, and surveillance and control on the other. In historical terms, this can be seen as the apotheosis of Lewis Mumford's megamachine: technology now increasingly fulfils what previously depended upon bureaucratic organisation and structure. But the central historical reference point is the emergence, early in the twentieth century, of Scientific Management (as a philosophy both of industrial production and of social reproduction). It was at this moment that 'scientific' planning and management moved beyond the factory to regulate the whole way of life. At this time, the 'gathering of social knowledge' became 'the normal accompaniment of action', and the manufacture of consent, through propaganda and opinion management, was increasingly 'based on analysis rather than on rule of thumb'.[97] If, through Scientific Management, the planning and administration of everyday life became pervasive, it also became the pre-eminent form and expression of social control. Planning and management were, necessarily and indissociably, a process of surveillance and of manipulation and persuasion. To the extent that these administrative and dominative information strategies were first developed on a systematic basis, it was at this historical moment, we believe, that the 'Information Revolution' was unleashed. New information and communications technologies have most certainly advanced, and automated, these combined information and intelligence activities, but they remain essentially refinements of what was fundamentally a political-administrative 'revolution'.

Recent innovations in information and communications technologies have generally been discussed from a narrow technological or economic perspective. It has been a matter of technology assessment or of the exploitation of new technologies to promote industrial competitiveness and economic growth. This, in the light of our discussion, seems a partial and blinkered vision. The central question to be raised in the context of the 'Information Revolution' today, is, we believe, the relation between knowledge/information and the system of political and corporate power. For some, knowledge is inherently and self-evidently a benevolent force, and improvements in the utilisation of knowledge are demonstrably the way to ensure social progress.[98] Information is treated as an instrumental and technical resource that will ensure the rational and efficient management of society. It is a matter of social engineering by knowledge professionals and information specialists and technocrats. For us, the problems of the 'information society' are more substantial, complex, and oblique.

This, of course, raises difficult political and philosophical issues. These are the issues that Walter Lippmann comes up against when he recognises in the Great Society 'that centralisation of power which deprives [citizens] of control over the use of that power', and when he confronts the disturbing awareness that 'the problems that vex democracy seem to be unmanageable by democratic methods'.[99] They are the issues that Lewis Mumford addresses when he argues that 'the tension between small-scale association and large-scale organisation, between personal autonomy and institutional regulation, between remote control and diffused local intervention, has now created a critical situation'.[100] And they are the monumental issues that concern Castoriadis in his analysis of instrumental reason and the 'rationalist ideology, those myths which, more than money or weapons, constitute the most formidable obstacles in the way of the reconstruction of human society'.[101]

Among the significant issues to be raised by the new information technologies are their relation to social forms of organisation, their centrality to structures of political power, and their role in the cultural logic of consumer capitalism. Sociological analysis is naïve, we believe, when it treats the new telecommunications, space, video and computing technologies as innocent technical conceptions and looks hopefully to a coming, post-industrial utopia. Better to look back to the past, to the entwined histories of reason, knowledge and technology, and to their relation to the economic development of capitalism and the political and administrative system of the modern nation state.

5

THE CYBERNETIC IMAGINATION OF CAPITALISM

The new information and communications technologies are changing not just entertainment and leisure pursuits but, potentially, all spheres of society: work (robotics, office technology); political management; policing and military activities (electronic warfare); communication; education (distance learning); consumption (electronic funds transfer, new retailing technologies). If the combined, though disaggregated, forces of corporate capital and political interests succeed in the systematic introduction of these new technologies – from robotics and data banks to the Internet and virtual reality games, then social life will be transformed in almost all aspects. The strategic development of ICTs will, then, have reverberations throughout the social structures of advanced capitalist societies.

TECHNOLOGICAL MOBILISATION AND EVERYDAY LIFE

The real meaning and significance of this can be more fully grasped if we situate the so-called information revolution in its historical context. But in terms of what kind of history? The history of 'technological revolutions'? The economic history of 'long waves' in capitalist growth (as theorised by Kondratieff and Schumpeter)? Neither of these, in fact. We prefer to draw upon the work of Jean-Paul de Gaudemar,[1] who periodises capitalist development in terms of the ways in which capital uses labour power and how populations are 'mobilised'. Gaudemar refers to the early nineteenth century as the period of 'absolute mobilisation'. At this time the traditional way of life of rural populations was systematically undermined in order to create a factory workforce. This process involved disciplinary efforts, both within the factory and across the fabric of everyday life: on the one hand, the division of labour, waged employment, time-thrift, and the discipline of the 'factory-prison'; on the other hand, the undermining of traditional culture (fairs, sports, etc.), the control of social space, and the moralisation of the workforce through religion and schooling.

During the course of the nineteenth century, absolute mobilisation was succeeded by 'relative mobilisation'. In this process the earlier form of 'external' discipline and control – the 'policing' of workers – was replaced by an internal factory discipline in which technology came to play a core role and in which control coincided with the goal of productivity and surplus value extraction: the machine as dual instrument of control and of increased productivity. This line of development found its apotheosis in the early twentieth century with the Scientific Management of Frederick Winslow Taylor and, particularly, the automated assembly line of Henry Ford. In the Fordist factory the worker was divested of particularity and skill and subordinated to the logic of the machine. In the words of a contemporary American sociologist, 'the task of the worker requires simply speed, dexterity, alertness and nervous endurance to carry the "robot" through dull, monotonous, fatiguing, relentlessly automatic operations'.[2] The Fordist plant became an integrated and automated complex, a megamachine that paced and disciplined the workforce. Control was then truly structural. The time-clock and the assembly line prevailed. Relations of power, subsumed into the functioning of technology, became automatic and invisible.

Fordism represented the culmination of relative mobilisation as a regimen within the factory. But (as with absolute mobilisation) relative mobilisation, particularly in its Fordist expression, entailed more than control over the immediate process of production: it also necessitated a restructuring of the relation between the factory and the outside world, and, consequently, an extensive recodification of the structures of everyday life. In this sense, 'Fordism' designated not just a 'revolution' in the factory, but also the creation of 'a whole way of life'. And it is this latter aspect that concerns us particularly for the purposes of our present argument.

What, then, have been the components of Fordism as a social system? Four broad and interrelated areas may be identified. First, Fordism entails the progressive intrusion into the sphere of reproduction – leisure, the family and everyday life – by capitalist social relations.[3] This has occurred largely through the *growth of consumerism as a way of life*, for where there is mass production there must necessarily be mass consumption. As John Alt has argued, 'the early social context where social relations and consciousness were largely mediated by the conditions of working class experience has been largely superseded by a socially-private existence mediated by consumerism'.[4] Where there once existed a relative independence (pig-rearing, smallholdings, weaving and sewing, etc.), there is the imposition of a thorough dependence upon capitalistically produced and marketed commodities.[5] The reproduction of social life is fuelled by the products of capitalist factories – not only its material reproduction, but also, and increasingly, its psychic reproduction.

A second characteristic aspect of Fordism has been *increasing state intervention in the management of society*. There has been a tendency towards 'a more

directly political control over the production and reproduction of daily life, extending methods of factory discipline into the state's management of the social totality'.[6] Under the conditions of Fordist production – an intricate and technologically mediated division of labour; the integration of conditions of production and reproduction/consumption; the erosion of traditional forms of social integration – society becomes more complexly interrelated and interdependent and also increasingly susceptible to fragmentation and disintegration. In order to ensure the conditions of social integration and cohesion, state management and regulation become indispensable. And this intervention, as Joachim Hirsch has suggested, may take two forms: the state as 'both the materially supporting "caretaker of existence" and the controlling, repressive "surveillance state" '. On the one hand, the state undertakes 'bureaucratically organised regulation' in order to guarantee not only the conditions of material production (e.g. economic planning, fiscal policies, scientific research and development), but also those of social reproduction (welfare, social policy). On the other hand, it becomes increasingly implicated in those surveillance and intelligence activities appropriate to what Hirsch calls the 'security-state'.[7]

The third and fourth aspects of Fordism are related and involve the attempted *annexation of time and space respectively*. Fordism extends and deepens that process through which capital has sought to impose its rhythm and tempo upon time and time consciousness. The period of relative mobilisation has been characterised by 'a gradual separation of work time from personal time...in which, paradoxically, work time and "leisure" time [have] gradually become more alike'.[8]

The times of production and reproduction have become increasingly continuous – an integrated time subject to a calculating and external time-discipline. Time is segmented and compartmentalised according to the different tasks of production/reproduction, divided and sub-divided to be used as productively, intensively and deeply as possible. As Foucault has suggested in another context, 'power is articulated directly on to time; it assures its control and guarantees its use'.[9] And, like time, so too have space and spatial relations been colonised. Under Fordism this has primarily entailed the centralisation of social structures in order to ensure monopolisation and the efficient functioning of power: the concentration and centralisation of productive units, of communications systems, of bureaucratic organisations, of urban structures, and so on. Complementing this is the increasing privatisation and marginalisation of everyday life, symbolised in the serial mobility of the private car and the isolation of televiewing.

Our argument, then, is that Fordism put social life under the dual regimen of productivity and discipline. The reign of capital, which began as a revolution in the 'manner of production', became a revolution in the 'manner of living'.[10] Now, it may appear that the account we have given so far is somewhat functionalist in the way it presents the unrelenting

domination of capital over social life. But let us be clear at this point that mobilisation inevitably involves counter-mobilisation (that of the Luddites, for example, in the early nineteenth century, or that of the Syndicalist saboteurs in the early twentieth century). The attempt to discipline populations is, then, the struggle to contain and unify an always poten-tially disruptive and unstable 'self-mobilisation'. And it is precisely in terms of this struggle between the forces of mobilisation and counter-mobilisation that we would characterise the political-economic transforma-tions associated with the 'Information Revolution'. The mobilisation of new information technologies may be seen as a response to the challenge to Fordism as a manner of production and manner of living. Although Fordism – supported by Keynesian economic strategies – produced a period of economic prosperity and comparative social detente, it also produced other, less manageable, consequences ('side-effects'): ecological pollution, the overexploitation of natural resources, the standardisation of production and consumption, and so on. In the face of these 'malfunctions', opposition was mobilised by diverse social movements (socialists and trade unionists; ecologists; the women's movement; anti-war campaigners; health cam-paigners). Throughout the 1980s capital struggled to absorb and contain these counter-mobilisations, seeking to restructure the mode of accumula-tion and the way of life. And the Information Revolution promised to do exactly this. It offered the possibility of assimilating demands related to the quality of life as the motor of a new phase of accumulation: the new ICTs promised to meet and satisfy the clamour for more freedom, democracy, leisure, decentralisation, and individual creativity. And they promised to do so on the basis of a new and more 'flexible' logic of generalised mobilisation.

Thus far we have sketched out a historical context within which to situate the 'revolution' in the new information and communications technologies. It is, however, a contextualisation that is informed by a particular theoretical and conceptual emphasis: it is through the concept of 'mobilisation', we argue, that we can best explore the historical impact of capital – especially through the exploitation of technology – upon the way of life. And it is this theoretical emphasis that allows us to examine critically the probable consequences of ICTs and to ask what the Information Revolution really adds up to. Our argument is that the so-called information revolution in fact represents a significant new stage in the strategy of relative mobilisation, one in which technological domination becomes extensively and systemati-cally used in spheres far beyond the workplace. This transformation represents both an intensification and, in important ways, a reconfiguration of Fordism as a way of life. We want to suggest that this seismic shift is important insofar as it represents a restructuring and reorganisation of relations of power. What has been lacking in most accounts of the new ICTs, particularly in the 1990s, has been a consideration of the ways in which they

articulate and express power relations. Our concern in the following discussion, then, is with the new technologies as cultural and political forces, shaping and informing the structures of everyday life. We are not saying that capital and its new technologies will necessarily get what it is setting out to achieve – the forms of counter-mobilisation cannot readily be anticipated – but we are interested in what it is seeking to institute in terms of a new regime of social mobilisation. In this chapter, then, we look at what the new technologies may be capable of – in the expectation that their capabilities will find appropriate counter-mobilisations.

MOBILISATION IN THE INFORMATION SOCIETY

As we have already indicated, ICTs will have a profound impact on work and leisure, and, particularly, on their interrelation. It is clear that, in the information society, work is being substantially transformed under various forms of automation. Deskilling of a good deal of work will continue, extending increasingly into jobs in the service sector, where women especially are most likely to be affected.[11] It need hardly be said that those at the lower end of the skills hierarchy are the first to suffer: a good number must anticipate the usual maladies of increased machine-pacing and even deskilling right out of a job.

However, still more profound will be the consequences of the integration of work processes on the basis of ICT networks.[12] The effects will undoubtedly be differentiated and uneven, and will depend on the abilities of workers, their circumstances, and the requirements of future jobs, but what is certainly being anticipated is a heightened capability to routinely monitor labour processes by virtue of access to and control over ICT networks. For many, this increased surveillance will result in downgraded and 'policed' labour, as work and productivity rates are remotely monitored on a 'real-time' basis.[13] For some – a minority of perhaps 20 per cent – there will be occupations that are richer in skills and job satisfaction, most obviously for the privileged 'symbolic analysts', identified by Robert Reich,[14] who are charged with managing and co-ordinating labour and matériel, marketing and sales, in the 'post-industrial' age. Doubtless others, too, will make some gains, since the need to come to terms with more integrated work processes that militate against fragmentation requires knowledge of the system for which one is responsible, a condition that might improve worker skills in particular areas.[15] But what is crucial is that with all forms of work, whatever the skill base, which are mediated through the electronic networks, there is the possibility of heightened surveillance of what gets done. And, because of the possibilities inherent in surveillance, work can actually be organised to allow greater autonomy and independence for workers – apparent autonomy and independence. It is this transformation of

work – 'the individualization of labour' that Manuel Castells underscores in his work on the 'Information Age'.[16] Castells emphasises that this technological transformation especially exacerbates the trend towards increased 'flexibility' of labour. If workers and work processes may be monitored as a matter of routine through the network, then one can readily envisage a 'new vulnerability of labour under conditions of unrestrained flexibility that portends the creation – at the furthest points of the network – of a "disposable work force" '.[17] On the way, we will certainly witness a generalised expansion of 'flexi-work' (temporary contracts, payment by result, fractional employment, etc.), and, within the advanced capitalist societies, the perpetuation of an 'underclass' on the periphery of metropolitan labour markets.

The likelihood is that the realm of 'leisure' and 'free' time will also be further subsumed under the regime of consumerism – the trends apparent in Fordist society will expand and deepen. Commodified entertainment and services will be pumped into households in a steady, metered flow. The tendency will be towards increasingly privatised and passive recreation and consumption. In this consumer Cockaigne, an increasing number of social functions and activities will be mediated by the domestic television or computer console: not just entertainment, but also information services, financial and purchasing transactions, communication, remote working, medical and educational services. Through the domestic console, and through it alone, we shall gain access to what has been called the 'network marketplace'. In order to become socially and culturally enfranchised, the individual household must necessarily become heavily capitalised, investing in the essential video, communications and computing technologies. Technologies will proliferate in the home to mediate consumption and reproduction, to facilitate the increasingly demanding and complex experience of everyday living. As André Gorz has argued, this process is subordinating the domestic sphere to 'the productivist criteria of profitability, speed and conformity to the norm'. Through the Information Revolution capital is invading the very cracks and pores of social life: 'the industrialisation, through home computers, of physical and psychical care and hygiene, children's education, cooking or sexual technique is precisely designed to generate capitalist profits from activities still left to individual fantasy'.[18]

What we are arguing, then, with respect to leisure time, is that the new technologies can, potentially, extend and deepen capital's time discipline. Increasingly, leisure will become more amenable to arrangement by capital, which can now access the consumer via electronic information consoles capable of penetrating the deepest recesses of the home, offering movies, sport and tele-shopping round the clock – priced, metered and monitored by corporate suppliers. 'Free' time becomes increasingly subordinated to the 'labour' of consumption. The great virtue, moreover, of the new technologies lies in their capacity to transcend some of the limitations of Fordist time-

discipline. For, under Fordism, with its rigid division of the day into work time and reproduction time, there develops both a constraining inflexibility in the exploitation of time and also a limitation on the depth and intensity of (productive) time use. With the potential combination of work, leisure and consumption functions in the domestic information terminal, however, the previously rigid distinction between production (work time) and reproduction (free time) may be eroded. Domestic information networks facilitate the restructuring of patterns of time use on a more flexible and individual basis; they provide the technological means to break the times of working, consumption and recreation into 'pellets' of any duration, which may then be arranged in complex, individualised configurations and shifted to any part of the day or night. The move is towards work that may be performed at any time (and, when the occasion demands, all the time). Thus one may talk about the arrival of 'flexi-timers' as a constituent part of a wider process of 'flexibility', the wider objective being to intensify and de-rigidify the exploitation of both labour power and 'consumption power'.

Related to the annexation of time is the colonisation of social space. The impetus of Fordism as a social system was based upon control through the centralisation and concentration of spatial structures and relations. One of the most insistent claims from the proponents of the 'information society' is that the new technologies can halt this centralising tendency and inaugurate a new era of decentralisation. Thus, twenty years ago, the influential Nora Report argued that information technology 'allows the decentralisation of even the autonomy of basic units', such that we can expect the passage 'from an industrial, organic society to a polymorphous information society', one that is composed of 'innumerable mobile groups'.[19] It is, indeed, the case that decentralisation is on the agenda. This is apparent in the new 'demassified' media (cable, video, digital television, the Internet) that are now beginning to undermine those patterns of centralisation, synchronisation and standardisation characteristic of the mass media. These new media, it is suggested, provide tailor-made communication and recreation, promoting thereby greater diversity, choice and freedom. Rather than representing the road to freedom and democracy, however, we would suggest that decentralisation in fact refines and streamlines the effective exercise of power. First, it should be stressed that the decentralised 'electronic cottage' or 'electronic home' will in fact be embedded within a social structure increasingly subject to the centralising and managerial tendencies of bureaucratically organised regulation. Large-scale systems for the co-ordination of national statistical data will promote social modelling, policy making, and management; and centralised mechanisms of administration and regulation will be reinforced by the formation of integrated intelligence systems handling, for example, welfare, social security or tax data. A further, and crucial, area of centralisation is to be found in the formation of police and military information

systems. A second point to be made – and to be made emphatically – is that decentralisation complements and reinforces such overarching tendencies toward centralisation. Decentralisation, dissemination, fragmentation, individualisation, privatisation, isolation, marginalisation – these are the modalities through which power will flow through civil society in the Information Age. Decentralisation of the spaces of production and consumption/reproduction: mobilisation and, simultaneously, immobilisation.

Our argument, then, is that the 'communications revolution' is taking place within a much broader restructuring of social life, one that can be seen – historically and theoretically – as both the extension and the reconfiguration of Fordism. As such, this 'revolution' marks a significant extension of relative or technological mobilisation to spheres of life beyond the workplace. Through ICTs, with their wide-ranging applications, social life opens up to more effective colonisation; the rhythm and social space of everyday life become, potentially, subject to a more effective codification according to the prevailing relations of power.

MOBILISATION AND VISIBILITY

We may also consider technological mobilisation from the perspective of the visibility of society. The new technologies that routinely distribute programming and services through electronic networks are, at the same time, recording the multitude of transactions. It is in their nature, that is to say, to monitor the activities, tastes and preferences of those who are networked. The network society is a more transparent society, and a more transparent society is, potentially, a more disciplined society.

We approach this discussion by way of a further historical contextualisation. At the end of the eighteenth century, Jeremy Bentham outlined his plans for an institutional architecture of control. What Bentham devised was a general mechanism applicable to prisons, asylums, schools, factories – for the automatic and uninterrupted functioning of institutional power and control. This mechanism, the Panopticon, is a building of circular structure with a series of individual cells built around a central 'well'; at the centre is an inspection tower from which each of the cells could be observed and monitored. A calculated illumination of the cells, along with the darkening and masking of the central tower, endows the 'inspective force' with 'the unbounded faculty of *seeing without being seen*'.[20] The essence of the Panopticon, Bentham suggests, consists in 'the centrality of the inspector's situation, combined with the well-known and most effectual contrivances for seeing without being seen'. What is of importance, he argues, is 'that for the greatest proportion of time possible, each man should actually *be* under inspection'; but it is also desirable 'that the persons to be inspected should always feel themselves as if under inspection' for 'the greater chance there is,

118

of a given person's being at a given time actually under inspection, the more strong will be the persuasion – the more *intense*, if I may say so, the *feeling*, he has of his being so'.[21] The inspector is apparently omnipresent and omniscient, while the inmates, cut off from the view of each other, are reduced to the status of 'solitary and sequestered individuals'. The inmate is marginalised, monitored, and, ultimately, self-monitoring: 'indulged with perfect liberty within the space allotted to him, in what worse way could he vent his rage, than by beating his head against the walls?'[22]

Jeremy Bentham considered the Panopticon to be an architectural paradigm capable of generalisation. This insight was, of course, developed most fully by Michel Foucault in his historical and philosophical exploration of forms and relations of power. For Foucault, the Panopticon, as a mechanism and edifice for channelling the flow of power, amounted to a major landmark in the history of the human mind. Historically, it represented a bulwark against the mobile disorder of the swarming crowd, against forbidden circulations and 'dangerous mixtures'. The Panopticon was precisely a form of mobilisation – and here Foucault's work intersects with that of Gaudemar – the production of an architecture of control and supervision, eliminating confusion through the elaboration of a permanent grid of power. What Bentham did was to crystallise a sea-change in the social economy of power: his contribution was part of a wider

> effort to adjust the mechanisms of power that frame the everyday lives of individuals; an adaptation and a refinement of the machinery that assumes responsibility for and places under surveillance their everyday behaviour, their identity, their activity, their apparently unimportant gestures; another policy for that multiplicity of bodies and forces that constitutes a population.[23]

This policy, according to Foucault, was implemented through the creation of spaces that are at once architectural, functional, and hierarchical. The Panopticon contained 'so many cages, so many small theatres, in which each actor is alone, perfectly individualised and constantly visible':

> the crowd, a compact mass, a locus of multiple exchanges, individualities merging together, a collective effect, is abolished and replaced by a collection of separated individualities. From the point of view of the guardian, it is replaced by a multiplicity that can be numbered and supervised; from the point of view of the inmates, by a sequestered and observed solitude.

Within the Panoptic machine, the individual 'is seen, but he does not see; he is the object of information, never a subject in communication'. The inmate was subjected to 'a state of conscious and permanent visibility that assures

the automatic functioning of power'.[24] So insidious were the relations of power that the individual became self-monitoring:

> He who is subjected to a field of visibility, and who knows it, assumes responsibility for the constraints of power; he makes them play spontaneously upon himself; he inscribes in himself the power relation in which he simultaneously plays both roles; he becomes the principle of his own subjection. By this very fact, the external power may throw off its physical weight; it tends to the non-corporal; and, the more it approaches this limit, the more constant, profound and permanent are its effects: it is a perpetual victory that avoids any physical confrontation and which is always decided in advance.[25]

The Panopticon, then, was a machine that ensured the infinitesimal distribution of power, one that turned the monitored individual into a visible, knowable and vulnerable object. It represented a generalisable 'type of location of bodies in space, of distribution of individuals in relation to one another, of hierarchical organisation, of disposition of centres and channels of power, of definition of the instruments and modes of intervention of power'.[26] According to Foucault, the Panoptic machine, 'at once surveillance and isolation and transparency',[27] was an integrated system of surveillance/intelligence and discipline/control.

Foucault considered Bentham's Panopticon to be a significant event in the history of the human mind. What we want to suggest is that the new communication and information technologies – particularly in the network society – permit a massive extension and transformation of that same (relative, technological) mobilisation to which Bentham's Panoptic principle aspired. What these technologies support, in fact, is the same mechanism of power and control, but now freed from the architectural constraints of Bentham's stone and brick prototype. On the basis of the information revolution, not just the prison or factory, but the social totality, may come to function as the hierarchical and disciplinary machine.

If we consider the loops and circuits and grids of what has come to be called the network society we can see that a technological system is being constituted to ensure the centralised, and furtive, inspection, observation, surveillance and documentation of activities on the circumference of society as a whole. Cable television networks, for example, can continuously monitor consumer preferences for programming material, along with details of any financial or communicative transactions. We have the now innumerable, and increasingly interlinked, networks of bureaucratic and commercial data banks that accumulate and aggregate information on the activities, transactions, needs and desires of individuals or social groups. And, of course, this is the age of the, now mundane, surveillance camera, of telephone tapping, and of ever more sophisticated and integrated police

computer systems. The population becomes visible and knowable to the different computerised 'inspective forces'. Here, as Foucault suggests of the Panopticon, is 'a machine for dissociating the see/being seen dyad: in the peripheric ring, one is totally seen, without ever seeing: in the central tower, one sees everything without ever being seen'.[28] The individual becomes the object of surveillance, no longer the subject of communication. And, like the Panopticon, the network society too is a 'system of individualising and permanent documentation'.[29] The observed and scrutinised individual, subjected to continuous registration, becomes the object of knowledge (of files and records). Seen and known.

We are not suggesting that there is, or will be, a single omniscient and all-seeing 'inspective force' in the 'wired society'. The nodal points on the electronic grid will be multiple and differential. There is, of course, the problem – a pressing political and civil liberties issue – of increasingly centralised state and police surveillance/intelligence activities, which, as David Leigh suggests, represent 'a very pure form of bureaucratic utopia: the official is kept invisible, and the citizen is stripped naked'.[30] This political and repressive use of the new information and communications technologies must always be kept to the fore. But we are also talking of more ordinary and routine surveillance activities, undertaken from more diffuse and numerous power centres. As opposed to the more active and calculative amassing of data by control agencies, there exists also a more passive and mundane gathering and collation, by bureaucratic and commercial organisations, of what has been called 'transactional information'.[31] For any electronically mediated activity – cable viewing, electronic financial transactions, telephoning, for example – spawns records that can yield up a harvest of information about individuals or groups: their whereabouts and movements; daily patterns of work and recreation; contacts, friends, associates; tastes, preferences, desires. Such information, when accumulated and processed, becomes an invaluable asset to a plurality of corporate and political interests. These different, but related, tendencies point to the increasing importance of surveillance and social monitoring. Joel Kovel has, in fact, argued that surveillance is 'a process inherently tied to the development of technology'. Surveillance, he suggests, originates in the labour process, where there developed a need for 'watching the producer and controlling what was being done'.[32] This phase in the development of surveillance techniques, which found its apotheosis in Taylor's Scientific Management and in the Fordist factory, has now been superseded by more extensive and ambitious surveillance:

> The same craft has been taken over by the state as its target shifts to the domestic population. What began with control of the worker and flourished into the technology of Scientific Management in the early years of

the century, has turned to directly political ends. Computerised electronic surveillance has ushered in a whole new phase of domination.[33]

Technologies, as they have actually existed, have been constituted to watch and control, to control through watching. New information and communications technologies extend this capacity. In them is perfected the ability to mobilise and control through watching and monitoring: power expresses itself as surveillance and Panopticism, now on the scale of society as a whole. The electronic grid is a transparent structure in which activities taking place at the periphery – remote working, electronic banking, the consumption of entertainment or information, tele-shopping, communication – are visible to the electronic 'eye' of the central computer systems that manage the network(s). The 'technical' process of administrating the numerous electronic transactions is simultaneously, and integrally, a process of observation, recording, remembering, surveillance. The electronic worker, consumer or communicator is constantly scanned, and his or her needs/ preferences/activities are delivered up as information to the agencies and institutions at the heart of the network.

Jeremy Bentham's Panopticon – as the prototype of a regimen of power relations – is, then, a central figure for understanding the modalities of power in the information society. In the Panoptic machine – whether it is constructed of bricks and mortar, or through electronic links – mobilisation is achieved by means of the (serialised, cellular) isolation of individuals, combined with the development of surveillance and intelligence by centralised agencies.[34]

THE MOBILISATION OF KNOWLEDGE

Information is thought to be the key to a new phase of economic growth. And, more ambitiously, freely flowing information is held up as the means to achieve a future libertarian and communicative democracy. At the beginning of the Information Age, Tom Stonier argued that 'in a postindustrial society, a country's store of information is its principal asset, its greatest source of wealth'. 'As our knowledge expands', he maintained, 'the world gets wealthier'. He could then go on to suggest that 'whereas material transactions can lead to competition, information transactions are much more likely to lead to co-operation – information is a resource which can be truly shared'. And, even more fantastically, 'no dictator can survive for any length of time in communicative society as the flows of information can no longer be controlled from the centre'.[35] Information is regarded as the principle of redemption.

Although we remain highly sceptical about this putative information utopia, it nonetheless remains the case that a significant mutation is taking

place in the social economy of information/knowledge. We have already indicated that the media industries, and, more importantly, the electronics, telecommunications and data processing industries, are undergoing a process of convergence and integration. This upheaval should also be understood as a transformation in the existing structures of information production and circulation – as an important recomposition of the present social ecology of information/knowledge. The emerging information mega-industry divides into trading and non-trading components. The latter category includes certain activities within the private sector (banking, insurance), along with central and local government operations, and also military and policing applications. As to the non-commercial exploitation of information – the bureaucratic and control applications – we have already touched upon this in our discussion of surveillance. Bureaucratic social management and police or military surveillance manifest themselves as the compulsive and incessant gathering of what is called 'intelligence' by the 'security state'.

But if information is being marshalled in the political domain, it is also circulating on an ever greater scale in the marketplace. We have an explosion of new media products: video games, videocassettes and discs, cable and satellite channels, personal computers. And we also have the commodification of new areas of information: 'a much wider range of information has become profitable because it can be flexibly processed, selectively re-arranged, and quickly transmitted and disseminated by a virtuoso new technology'.[36] Thus scientific and technological knowledge, demographic information, education, medical care, public reports and statistical services, libraries, and much more, all become transformed into information commodities.

Pushing in this same direction is state intervention that seeks to transform what have hitherto been public resources into commercial enterprises. The liberalisation and privatisation of British Telecom during the 1980s, for example, was part of the strategy to open up the information sphere to market forces. So too has been the attempt to hive off government information services to private organisations whenever feasible, and when not, to introduce commercial criteria into the government's own administration of information services. According to the influential 1981 Rayner Report[37] on government statistical services, 'subsidy of statistical publications should be quickly curtailed', all information for businesses 'should be charged for commercially', and while 'more flexible means of enabling the public to have access to figures held in government should be exploited...the costs of providing such facilities should be covered by appropriate charges to the individuals or bodies concerned'.

All of this has serious implications. We will see an increasing scarcity of information that is not considered to be commercially viable. For instance, the annual publication of social statistics (providing information on family

structures, health, education, housing and the like), the *General Household Survey*, was 'suspended' in 1997, with serious doubts as to whether it would be resurrected. This followed massive above-inflation increases in the price of government publications.[38] As long ago as 1979 the standing Royal Commission on the Distribution of Income and Wealth was peremptorily wound up since it was of no interest to the affluent and seemed merely to inflame the 'politics of envy'. Relatedly, reliable information on poverty in the UK is difficult to obtain in the 1990s, since there is no commercial interest (the significance of poverty is political – yet another reason for its neglect and, for some, even the denial of its existence).[39] Furthermore, the information that is available will be differentially distributed: 'hard' (financial, commercial, scientific) data for the wealthy corporate sector; trivial data, through teletext channels, for the domestic consumer. The implication, of course, is that the principle of public knowledgeability, of the availability of information resources as a public service (an ideal imperfectly realised at the best of times), is fundamentally undermined.

Can this amount to an Information Revolution? Does it put us on the threshold of an 'Information Society'? We think not. This political and commercial annexation of information only appears to be a novel occurrence. We think it merely extends the logic of appropriating information and knowledge which, as Kovel suggests, has its roots in the labour process. This was described long ago by Karl Marx in terms of the tendential separation of mental from manual labour, suggesting that capital strives to monopolise the intellectual aspect of the labour process in order to increase productivity and to ensure control. It was a development that, as we suggest elsewhere in this book, found its apotheosis in Taylor's Scientific Management. With Scientific Management the project of appropriating the skills and knowledge of workers became systematic and compulsive. What Taylor realised was that it was to their traditional skills and rule-of-thumb knowledge that his workers owed their independence and resilience in the face of discipline and control. On this basis he undertook

> the deliberate gathering in on the part of those on the management's side of all the great mass of traditional knowledge, which in the past has been in the heads of the workmen, and in the physical skill and knack of the workmen, which he has acquired through years of experience. The duty of gathering in of all this great mass of traditional knowledge and recording it, tabulating it, and, in many cases, finally reducing it to laws, rules, and even to mathematical formulae, is voluntarily assumed by the scientific managers.[40]

Taylor aimed to concentrate all 'brainwork' in his centralised 'planning department'. It was with machinery, however, that this gathering in of skill and knowledge became truly systematic. Through technology we saw 'the

separation of the intellectual faculties of the production process from manual labour, and the transformation of those faculties into powers exercised by capital over labour'.[41] With Henry Ford's assembly line this process reached its historical culmination. Here the skills of the worker were truly embodied in the machinery: control of the labour process assumed the guise of objective necessity, and domination expressed itself through the form of technological 'rationality'. In the Fordist factory, as one contemporary observer noted, 'automatic machines show a transfer of thought, skill or intelligence from person to machine'.[42] In the subsequent history of the labour process, this automatic and impersonal functioning of power through the technological appropriation of knowledge/skill has been intensified and extended, including the Taylorisation and mechanisation, through information and communications technologies, of many forms of intellectual labour.

Our argument is that this gathering in of skill/knowledge/information, hitherto most apparent in the capitalist labour process, is now entering a new and more pervasive stage. What we are seeing is the progressive collection, centralisation, and concentration of knowledge on a wide social scale, and, thereby, the establishment of what we would consider to be a kind of social Taylorism.[43] In an intensive consumer society, as we suggested earlier, needs – material and psychic – are met by commodities. As Ivan Illich has suggested, the 'professionally engineered commodity' replaces the 'culturally shaped use-value', and we see the substitution of 'standardised packages for almost everything people formerly did or made on their own'.[44] The consequence of this consumerisation is a tendential depletion of social skills, knowledge and self-sufficiency. Jeremy Seabrook has written perceptively of the 'plundering of people, the shedding of skills, the loss of human resource' and of 'the process of wrenching away from working class people needs and satisfactions they had learned to answer for each other, and selling them back, in another form, as commodities'.[45] We are talking here of a process of social deskilling, the depredation of knowledge and skills which are then sold back in the form of commodities – or, alternatively, professionally administered through bureaucratic agencies and organisations.[46]

It is this appropriation and concentration of social knowledge and skill that the new ICTs are frequently designed to promote. They underpin a more extensive, efficient and systematic colonisation of social knowledge. Potentially, all social functions are to be incorporated and metamorphosed into information commodities: education, entertainment, health care, communication, and so on. With the new ICTs, previously dispersed and inaccessible information/knowledge can become processed and possessed. We see the 'migration of information from the home to the organisation', though much of this information, until recently, 'would not have been collected at all, but would instead have been stashed away in our homes'.[47] Through data banks and information services we shall have to buy the

information necessary to function in a complex industrial society – or be deprived of it if we are too poor.

More than this, people themselves are increasingly relegated to the status of data; their actions and transactions are recorded as digits and ciphers by the ubiquitous and always watching information machines. Already credit agencies, finance houses and large retailers are constructing databases on customers and potential customers, categorising them, analysing them, scrutinising their movements, so that they might be used to the optimum benefit of the corporation. In advanced capitalist societies, on-line links give instant access to buying patterns, demographic traits, balances outstanding, and so on. Increasingly, people are objects of surveillance: objects of knowledge and information.

It is worth noting that, although this surveillance has been developed chiefly as an extension of market endeavours, capital has not been entirely responsible for its spread. The growth of the modern state, integrally connected as it is with the rise of corporate capitalism, has contributed independently and massively to the expansion of surveillance. Anthony Giddens has reminded us of the importance of nationalism, citizenship, war, and the preparation for war, as key factors stimulating heightened surveillance (and its converse, control of information dissemination).[48] Inexorably the state has amassed files, increasingly computerised and interlinked, on health, taxation, social security, employment, education, vehicle ownership, housing, crime, and intelligence. During the 1980s especially, when the state noticeably raised its coercive profile in response to social unrest and in order to facilitate the necessary restructuring to regain competitiveness, Giddens' warning of the risks of totalitarianism inherent in states that so intensively scrutinise and manipulate their people deserved close heed. As the millennium ends, and New Labour has come to office, those risks have by no means diminished.

As Bentham's Panopticon expresses the social relations of surveillance and control, another figure expresses the social relations of what we have called generalised Taylorism. We are referring to H. G. Wells's less well known conception of the World Brain or World Encyclopaedia – the dream of an unlimited, concentrated, and accessible reservoir of knowledge. According to Wells,

> an immense and ever-increasing wealth of knowledge is scattered about the world today, a wealth of knowledge and suggestion that – systematically ordered and generally disseminated – would probably…suffice to solve all the mighty difficulties of our age, but that knowledge is still dispersed, unorganised, impotent.[49]

The knowledge systems of the world must therefore be concentrated in the World Brain, in the creation of 'a new world organ for the collection,

indexing, summarising and release of knowledge'.[50] Wells ponders 'the creation of an efficient index to all human knowledge, ideas and achieve-ments...the creation, that is, of a complete planetary memory for all mankind';[51] 'the whole human memory', he believes, 'can be, and probably in a short time will be, made accessible to every individual'.[52] For Wells, 'the time is ripe for a very extensive revision and modernisation of the intellectual organisation of the world':[53] 'this synthesis of knowledge is the necessary beginning to the new world'.[54] The world 'has to pull its mind together' through this new kind of 'mental clearing house', the World Brain.[55]

Like Jeremy Bentham's Panopticon, the World Brain is a perverse utopian proposal. And it is one that should be taken seriously. The World Brain is an intellectual 'invention' with considerable social and political resonance.[56] The World Brain anticipated what we can now see as an emerging new regime of information production, circulation, consumption and control; as a new economy and politics of knowledge. Wells, of course, saw this 'new encyclopaedism' as a benevolent phenomenon. His was the Fabian ideal of knowledge as a social resource: knowledge as neutral, containing all goodness within itself. In reality, however, things are somewhat different. What we have in the World Brain is the utopia of technocratic planning, administration and management. The encyclopaedic dream represents, in fact, a technocratic consummation of what has been termed the public sphere. In the place of informed debate and interchange and of public knowledgeability (as aspirations, at least), we are left with the commerciali-sation, collation and manipulation of data. As Jürgen Habermas has demonstrated, the public sphere has undergone a long process of decline. Historically, we have seen the displacement of a political public sphere by a depoliticised consumer culture that erases the difference between commod-ity circulation and social intercourse, and by social engineering through the massaging of 'public opinion'. Critique has become integration, acclama-tion, consumption.[57] The public sphere becomes publicity and public opinion. And now publicity and public opinion assume the diminished and alienated form of the 'world encyclopaedia' of the 'Information Society'. Public debate and discourse have given way to the avaricious and indis-criminate amassing of information. For the Fabian Wells – as for the masseurs and diagnosticians of public opinion – it seemed, in the early part of the century, self-evident that the free and bountiful flow of information would bring people together. In reality, information can divide them, render them ignorant, silence them, manipulate them, monitor them, alienate and isolate them. For the majority of us, as André Gorz has argued, the 'information explosion' does not promise greater freedom or independence:

> The expansion of knowledge rather has gone in parallel with a diminution
> of the power and autonomy of communities and individuals. In this re-
> spect, we may speak of the schizophrenic character of our culture: the more

we learn, the more we become helpless, estranged, from ourselves and the surrounding world. This knowledge we are fed is so broken up as to keep us in check and under control rather than to enable us to exercise control.[58]

What is missing in most accounts of the Information Society is an understanding of the way in which knowledge and information mediate relations of power.

In the Information Society there is no one central 'planning department' as there is in the Taylorised factory. The centres of power are multiple and differential; the archives of commerce and control are relatively dispersed. But in each of them social knowledge and resources are appropriated and transformed into power and capital. Stores of collective knowledge, and of popular memory and tradition, are tendentially displaced by the estranged objectivity of data banks and information reservoirs.[59] Moreover, information, when it is harvested on a massive and systematic scale, becomes intelligence. Information on natural resources, or on the activities and transactions of individuals, becomes politically significant when it is held in large quantities that can be processed and aggregated by technological means. What we are suggesting, in fact, is that in the Information Society the intelligence function is the paradigm for all information gathering. In the words of one information apparatchik, what we are seeing is:

> the maturation of the intelligence function from its origins as a government spy service to full growth as an intellectual discipline serving the private and public sectors alike....Today's proliferation of information banks and analytical centres for investment counselling, political risk assessments, and 'futures' estimates are witness to the growth of the intelligence discipline outside traditional government circles.[60]

Very much the same reasoning is evident in the advocacy of retired Director of the Central Intelligence Agency (CIA), Stansfield Turner. Worrying what the CIA is to do with itself now that the communist enemy has been defeated, Turner has no hesitation in urging that it extends its intelligence activities into the economic realm. It is, he is assured, an unproblematic shift towards 'a more symbiotic relationship between the worlds of intelligence and business', not least because 'national sovereignty' concerns can readily incorporate threats from economic competitors. Since 'the pre-eminent threat to US national sovereignty now lies in the economic sphere', then the CIA may legitimately include under its widening intelligence gathering umbrella the close observation of foreign businesses around the world.[61] Behind the myth of the Information Society there is the reality of a growing commercial and political exploitation of social knowledge and information.

THE CLOSED WORLD OF
INFORMATION

In this chapter, we have considered information and communications technologies from the point of view of social mobilisation. For these technologies represent – and have long represented – one of the fundamental means by which capital has sought to achieve control over society. They have been a means whereby knowledges have been appropriated (by both state and capital), and then turned against the society in which they originated. It constitutes a long historical project that has taken a variety of forms: the Benthamite Panopticon; the Taylorist-Fordist factory; the dream of the World Brain; and now the vision of the global network society. Driving this project has been the concern to impose a rational and efficient order, first in the sphere of production, and then across society as a whole. This desire to institute a coherent order is what we describe as the cybernetic imagination of capital.

We may see this as a process whereby knowledge is instituted as a socially oppressive force. Bernard Doray describes the Taylorist system – which constituted a seminal moment in the history of social rationalisation – as a 'rational madness'.

> If the term 'Taylorist madness' has any meaning, it is because it helps us to see through coherent economic and technical systems to perceive the contradiction between the objective socialisation of labour and the subjective expropriation of the agents of the labour process.
>
> The reason why the assembly line so often appears to be the 'boss' in a mechanised shop, and why machines seem to be the real subject of the collective labour process, is that they are Janus-like entities. They simultaneously isolate the operatives and articulate, collectivise and socialise their work; like any disciplinary system which imposes rules for socialisation but denies those who obey them access to its laws, Taylorism is experienced as a form of persecution.[62]

We may see the development of the network society in terms of the extension of this logic beyond the immediate labour process. Now it is the new information networks that impose rules for socialisation, dictating the logic of simultaneous collectivisation and isolation. We live in an order in which all aspects of life – work, communication, leisure, consumption, education – are increasingly subordinated to the logic of the Information Society. The pursuit of rationality, efficiency and mastery has become a perverted form of rationality at the scale of the social totality.

Proponents of the cybernetic imagination tend to emphasise the rational aspect of their information strategies. They believe that the mobilisation of knowledge will bring about more and more effective forms of social management. We think that more attention should be paid to the

irrationality that underpins their compulsion to order. For what is clear is that precisely what we do not have at the present time is a well-managed social world. The global space that has been instituted through the new information and communications technologies has turned out to be a catastrophic space. John Berger goes so far as to consider his new world order to be the fulfilment of the Hell depicted in the sixteenth century by Hieronymous Bosch:

> There is no horizon here. There is no continuity between actions, there are no pauses, no paths, no pattern, no past and no future. There is only the clamour of the disparate, fragmentary present. Everywhere there are surprises and sensations, yet nowhere is there any outcome. Nothing flows through: everything interrupts. There is a kind of spatial delirium.[63]

This, it seems to us, is indeed the achievement of the real-time global information society. The pursuit of order results in the creation of what Berger describes as the 'space of hell'. It is the oppressive space of a closed world.

We have emphasised here the force of the cybernetic imagination because we think it is important to recognise what drives the mobilisation of knowledge. We need to acknowledge fully the force of that which presents itself in terms of straight-forward rationality and efficiency. Our task is to expose, problematise and critique this force. But, in emphasising the logic of enclosure associated with the Information Revolution, our concern is also with the possibilities now for counter-mobilisation. For, as John Berger argues, 'another space is vitally necessary...an horizon has to be discovered'.[64] Where, then, we might be asking, are the areas of resistance to the cybernetic imagination of capitalism today?

6

PROPAGANDA
The hidden face of information

It is in the context of industrialisation, urbanisation and the formation of the nation state in the late nineteenth and early twentieth century that we need to situate concern with propaganda in social science research. It was these transformations, brought about by the accelerating growth of industrial capitalism, which were central issues in the classical tradition of sociology. They are reflected, for instance, in Tönnies' concepts of *Gemeinschaft* and *Gesellschaft*, in Durkheim's distinction between mechanical and organic solidarity, and in Simmel's urban sociology, as well as in Marx's political economy. While European social thought is best known for grappling with the significance of these profound changes in ways of life, concern about them reached a distilled form in American 'mass society' theory:

> The movements of population and the contact between people from the ends of the earth, the opening of world markets, and the spread of modern technology, the growth of cities, the operation of mass media of communication, the increasing literacy of the masses of people all over the world, have combined to disintegrate local cohesion and to bring hitherto disparate and parochial cultures into contact with each other. Out of this ferment has come the disenchantment of absolute faiths which expresses itself in the secular outlook of modern man.[1]

As traditional bonds and values have weakened, it is argued, so has the individual become increasingly segregated, isolated and alienated. As society becomes ever more subject to the principles of rationalisation,[2] so do the mechanisms of social cohesion break down. As De Fleur and Ball-Rokeach emphasise, 'the most important element of this idea was that ineffective social organization failed to provide adequate linkages between individuals to maintain an integrated and stable system of social control'.[3]

It was in this context of mass society theory that communications sociology came into being. The new communications technologies of the early twentieth century were clearly destined to play a crucial role in what soon

came to be called the Great Society. For Louis Wirth, it was upon the mass media that 'to an ever increasing degree the human race depends to hold it together. Mass communication is rapidly becoming, if it is not already, the main framework of the web of social life'. His argument is that 'in order to communicate effectively with one another, we must have common knowledge, but in a mass society it is through communication that we must obtain this common body of knowledge'.[4] However, if the mass media had become central channels of communication and information dissemination, then the implications remained open and uncertain. On the one hand, they might be appropriated by dictatorial regimes 'to orchestrate the sensibilities of rootless, volatile populations detached from traditional sources of orientation'; alternatively, they had 'enormous potential for spreading knowledge and establishing rational standards of judgement in an enlarged democratic public'.[5] For better or worse, mass communications would henceforth play a formative role in the political process. In a world in which 'impersonality has supplanted personal loyalty to leaders' and 'literacy and the physical channels of communication have quickened the connection between those who rule and the ruled', Harold Lasswell argues, 'most of that which formerly could be done by violence and intimidation must now be done by argument and persuasion'.[6]

What Lasswell is advocating here is not free and open networks of communication. The logic of his position moves less towards argument as an end in itself than towards the persuasive use of communications channels to engineer public opinion and consent. In democratic as in totalitarian systems, Lasswell reminds us, the communications process is underpinned by relations of power. It is at this point that we address the question of propaganda: ours

> is an atomized world, in which individual whims have wider play than ever before, and it requires more strenuous exertions to co-ordinate and unify them than formerly. The new antidote to wilfulness is propaganda. If the mass will be free of chains of iron, it must accept its chains of silver. If it will not love, honour and obey, it must not expect to escape seduction.[7]

DIVERGENT PARADIGMS

What we want to argue here is that within the abundant literature on propaganda and communications there are two distinct theoretical paradigms. In saying this, we are not referring to oppositional stances, but rather to divergent emphases which may coexist within the same texts. The most familiar approach – but, in our view, the least interesting or productive – is that which, from the perspective of communications theory, applies a psychological model to the study of propaganda. Essentially what it does is to transpose a behaviourist stimulus–response framework onto the sender–

receiver model of the communication (and propaganda) process. Thus, Harold Lasswell, writing in the late 1920s, suggests that 'the strategy of propaganda...can readily be described in the language of stimulus–response': 'the propagandist may be said to be concerned with the multiplication of those stimuli which are best calculated to evoke the desired responses, and with the nullification of those stimuli which are likely to instigate the undesired responses'.[8] James Carey refers to this as a transmission or transportation view of communication, one that understands communication as fundamentally a matter of 'persuasion, attitude change, behaviour modification, socialization through the transmission of information, influence or conditioning'.[9] Propaganda is 'the attempt to affect the personalities and to control the behaviour of individuals'.[10] Intrinsic to this model is the idea of an active communicator-propagandist (stimulus) and a passive, inert receiver (response). Propaganda entails a process of deliberate manipulation or seduction, and this manipulation is performed on isolated, susceptible individuals (the detached monads described in mass society theory). Furthermore, the assumption is that this process of persuasion appeals to the emotions and works by 'emotional possession': the individuals in the mass audience are 'likely to be influenced by excited appeals as those appear in the press or over the radio – appeals that play upon primitive impulses, antipathies and traditional hatreds'.[11]

The development of effects studies in mass communications research has largely been a matter of the displacement of this 'hypodermic' model in favour of a more situational approach. Mass media have, quite rightly, come to be seen as working amidst other influences on attitudes and behaviour, in a broader social arena. Variables have been introduced between sender/stimulus and receiver/response: psychologists have, for example, elaborated personality and learning theory and developed concepts of selective perception and cognitive dissonance; and sociologists have emphasised the mediating influence of both interpersonal relations and structural variables like class or sex. The theoretical orthodoxy has progressively shifted away from the idea of powerful media towards an acknowledgement of the active receiver, the obstinate and recalcitrant audience. What has become clear is that, whilst the media may have agenda-setting and reinforcement functions, they are 'not omnipotent in terms of controlling the minds and behaviour of the mass audience'.[12]

Whilst we do not want to dissent from the idea of an active audience, we do think it significant that, as the 'hypodermic' model has been discredited, so has the concern with propaganda evaporated. It has been banished to a peripheral region of mass communications theory: the study of psychological warfare and operations. The reason for this, we would suggest, lies in the (fundamentally behaviourist) communications model that informs this approach. The problem, for us, is its limiting emphasis on effects at the level of the individual, in terms of individual attitude, opinion or behaviour

changes. Propaganda has, regrettably, been conceptualised exclusively in narrow psychological terms, and, moreover, identified with the strong ('hypodermic') version of this model. Consequently, as more sophisticated and attenuated variants have emerged, so has the very notion of propaganda been depreciated and discredited.

As communications and propaganda became the preserve of psychology and sociology, rather than of political philosophy and political economy, so were key issues obscured and important debates deferred. We are behind Terence Qualter when he suggests that,

> preoccupied with the mechanics of empirical research and the trivia of de-
> tailed case studies, scholars turned away from such still unanswered ques-
> tions as the role that public opinion can or ought to play in a democracy,
> and the impact of propaganda and the manipulation of public opinion on
> the theory and practice of democratic government.[13]

It is here that we come to our second theoretical paradigm for the study of propaganda, one that conceptualises propaganda within a broader political theory and political economy of communications. Whilst this approach has been overshadowed, and even eclipsed, by the narrower communications paradigm, it is, in our view, more productive, and it raises fundamental and urgent questions about the relation between communication, information and the political process in our society.

What this approach does is to locate the study of propaganda and com-munication within the wider context of political phenomena and theory: legitimation, democracy, bureaucracy, social administration, public opinion, social control, the nation state. Its fundamental concern is with the principles of administration and governance necessary to ensure integration and cohesion in the Great Society. The indispensable prerequisite for administrative control across the expansive territory of the modern nation state is an effective communication and information infrastructure. William Albig notes that

> communication is the fundamental human institution in that it sets the
> limits of community size and by its nature affects all types of human asso-
> ciation. And the integration of any social unit [he continues] is dependent
> upon the capacity to transfer ideas, to transmit administrative orders and
> to prevent disintegration at outlying points.[14]

Only through the extensive flow of communication and information can administrative unity and integrity be assured. In this sense we can argue that the nation state is essentially and intrinsically an information society.

If communication and information underpin administrative cohesion and power, then it is all the more crucial for political management and

integration. With the dissolution of traditional and localised communities, and with the emergence of a communications infrastructure, Alvin Gouldner suggests, 'social interaction was less requisite for cultural communality. People might now share information and orientations, facts and values, without mutual access and interaction'.[15] Through this process there evolved the idea of a 'public' as an audience for communication, and of public opinion as a political force: 'The organised sway of public opinion in the Great Society was possible only when opinion could be formed and expressed by large groups within relatively short time periods'.[16] We would emphasise that much of the early literature on propaganda intersects with the study of public opinion.[17] The common concern is with the flow of communication and information between citizens, and between citizens and government in the Great Society. There is a recognition in public opinion research that 'the quality of public opinion depends to a large extent on the effectiveness of public communication'.[18] Free circulation of, and access to, information is considered to be crucial for the effective articulation of public opinion, and, thereby, for the democratic process.

What this ideal presupposes is a rational public. It invokes a rational process of judgement and decision-making on the basis of freely available information and effective communication. This faith in rationality is particularly apparent in the work of the Chicago School. Thus, for Robert Park,

> public opinion is determined by conflict and discussion....The public is never ecstatic. It is always more or less rational. It is this fact of conflict, in the form of discussion, that introduces into the control exercised by public opinion the elements of rationality and of fact.[19]

This faith in the possibility of a rational 'universe of discourse' reflects and perpetuates eighteenth-century Enlightenment philosophy. It presumes that process of 'public reasoning' (*das öffentliche Räsonnement*) – the 'public use of reason' – which, Habermas argues, characterised the eighteenth-century public sphere (*Öffentlichkeit*).[20]

PROPAGANDA AND PUBLIC OPINION

Not all observers, however, were as sanguine as Robert Park and the Chicago School. For many others the Enlightenment ideal of rational political discourse had proved to be an empty utopia: channels of communication and information were imperfect and inefficient, and the citizens of the Great Society frequently proved to be quite irrational and 'often poor judges of their own interests, flitting from one alternative to the next without solid reason or clinging timorously to the fragments of some mossy rock of ages'.[21] What became particularly apparent was the ambiguous role of the

new communications media in the process of information dissemination and rational decision-making. Whilst the new technologies were indispensable for 'public conversation' in the twentieth-century nation state, they also made possible the manipulation of public debate and the public sphere. Rational discourse could be skewed by the mechanisms of propaganda. Whilst signalling the importance of 'public discussion' and the 'availability and flexibility of the agencies of public communication', Herbert Blumer argued that 'there is interference with effective public discussion' and that 'today most students of public opinion find that their chief concern is the study of propaganda'.[22] Insofar as public opinion research was concerned with the possibilities for rational and democratic public discourse, it had necessarily to confront those forces that might subvert, obstruct or influence the process of opinion formation.

Whilst propaganda was commonly associated with the exploitation of mass media by dictatorial and totalitarian governments, what was more important, in the longer term, was a growing recognition by political theoreticians that propaganda was, in fact, *an integral feature of democratic societies*. An increasingly pragmatic and 'realistic' appraisal of the political process suggested that 'in a world of competing political doctrines, the partisans of democratic government cannot depend solely upon appeal to reason or abstract liberalism'.[23] What became apparent was that 'propaganda, as the advocacy of ideas and doctrines, has a legitimate and desirable part to play in our democratic system'.[24] Writing on the eve of the Second World War, one commentator suggests that 'the peculiar weakness of democracy' is 'that of allocating disproportionate freedom to the individual at the expense of authority and of the security which authority guarantees....Democracy is always in danger of dissolving into anarchy, political and moral'. In the face of this always potential instability, democratic societies must elaborate propaganda that is 'positive and affirmative of new freedoms': although 'democracy stands by the principle of free discussion, [it need not] be squeamish about the efficient use of propaganda, as emotionalized ideology, in making its views persuasive'.[25]

The modern democratic state is, necessarily and inescapably, the propagandist state. The very complexity of the developed nation state appears to be such that a 'free market' of ideas and debate must be superseded by the (scientific) management and orchestration of public opinion. Lasswell makes the point succinctly: 'The modern conception of social management is profoundly affected by the propagandist outlook. Concerted action for public ends depends upon a certain concentration of motives'. 'Propaganda', he continues, 'is surely here to stay; the modern world is peculiarly dependent upon it for the co-ordination of atomized components in times of crisis and for the conduct of large scale "normal" operations'.[26]

What emerges in this political science research is an approach to propaganda that is quite distinct from the behaviourist emphasis, with its

stimulus–response paradigm, its focus on attitude and behaviour modification, its concern with the atomised individual, its theory of 'emotional possession', and so on. This alternative perspective, which places the study of propaganda in the context of political science, has in our view considerable relevance and interest. Whilst we would dissent from many of the substantive judgements made by Lasswell *et al.*, we believe that their fundamental theoretical paradigm raises crucial issues about the interrelation of propaganda, public opinion and mass communications, and about transformations in the nature of political control in the early part of the twentieth century. In drawing our attention to the relation between information/communications and power, we shall argue, this approach identifies perhaps the central axis of the political order, and one that remains crucially important today.

In developing the understanding of propaganda, this perspective makes two fundamental points. The first is that *propaganda is a matter of the politics of information*. It is a question of accessibility and restrictiveness in the flow of information within the modern nation state. At one level this is about information management and 'special pleading' (propaganda, public relations, advertising). According to Albig, special pleading is 'an inevitable concomitant of the growth and organization of society during the past century'.[27] But just as important as the manipulation of information is its restriction and censorship. Indeed, censorship undermines the principles of free and rational public discourse. Censorship and secrecy are complementary to explicit propaganda and information dissemblance. In Walter Lippmann's words 'without some form of censorship, propaganda in the strict sense of the word is impossible. In order to conduct a propaganda there must be some barrier between the public and the event'. 'Every official is in some degree a censor. And since no one can suppress information, either by concealing it or forgetting to mention it, without some notion of what he wishes the public to know, every leader is in some degree a propagandist'.[28]

THE ENGINEERING OF CONSENT

The second important point is that *propaganda and information management are normative aspects of modern democratic societies*. Far from being exceptional, anomalous or aberrant elements in the democratic process, propaganda is a *constitutive* aspect of 'actually existing' democracy, democracy in the mass society. Whereas propaganda was, in the words of William Albig, 'incidental to the development of tribes or simple folk peoples', it is 'essential to the development of unanimity in modern states'.[29] Contrary to the behaviourist emphasis on the individual, the point to be made here is that the 'relevant audience' of propaganda is the public;[30] only with the emergence of the public and of democratic public opinion can and does propaganda become an important social force.

Whilst the pure theory of democratic government through public debate sounds lofty, its reality is more problematic and unmanageable. We have already referred to Lasswell's argument that, given the complex and atomised nature of modern societies, the 'concerted action' of propaganda is necessary to ensure 'a certain concentration of motives'. Ellul makes the further point that 'public opinion is so variable and fluctuating that government could never base a course of action on it; no sooner would government begin to pursue certain aims favoured in an opinion poll, than opinion would turn against it'.[31] The implication is that a central, directive agency must both articulate and orchestrate public opinion to ensure 'rational' government. Modern societies, Wirth suggests, 'have learned that in the face of their size and complexity and their internal heterogeneity, the engineering of consent is one of the great arts to be cultivated'.[32] The management of consent is, however, a delicate matter insofar as any government remains ultimately accountable to public opinion. It 'cannot follow public opinion', argues Ellul, 'but it cannot escape it either'. Since 'the government cannot follow opinion, opinion must follow the government': 'the point is to make the masses demand of the government what the government has already decided to do'.[33] This management of public discourse and opinion – ultimately through control over the various channels of information – has become an intrinsic aspect of 'normal' political rule in democratic society.

In this context, Harold Lasswell suggests that 'propaganda attains eminence as the one means of mass mobilization which is cheaper than violence, bribery or other possible control techniques'.[34] Idealistic debate on the public sphere and rational democratic government here metamorphoses into concern with the mechanics of social management and social control. From the earliest days of propaganda and opinion research, with an acute sense of the disruptions entailed in the transformation from *Gemeinschaft* to *Gesellschaft*, great attention was paid to the possibilities of social cohesion in the mass society. For Robert Park, the new social order 'is more or less of an artificial creation, an artefact. It is neither absolute nor sacred, but pragmatic and experimental'.[35] And this for him raised the issue of social control. The same issue is raised by Louis Wirth in terms of the manufacture of consensus. He argues that the 'lack of a social mind to go with the social body is the deficiency that we must supply if organised social life, on the scale on which we must now live it, is to endure', and he goes on to suggest that 'the only reasonable equivalent of "mind" in the individual organism that we can think of as an essential in the social organism can be supplied through consensus'.[36] The central issue is that of creating social and moral integration in a society in which the public and public opinion count as a social force, and in which coercion has been delegitimised as a form of social control. As Morris Janowitz observes, concern with social control within this intellectual tradition does not focus on the social psychology of conformity;

rather it stands for 'a comprehensive focus on the nation state and a concern which has come to be called "macrosociology" '.[37] Social control here addresses the reproduction of mass society particularly, and the role of information, communications and public opinion in this process.

With this emphasis the Enlightenment ideal of reason becomes translated into rationalisation and the technocratic regulation of society. Faith in a rational public gives way to the invocation of expertise and to the scientific management of public opinion. In the name of science and rationality and efficiency, political rule becomes a matter of social engineering, and the machinery of propaganda and information management becomes more pervasive. 'There has always been some propaganda', Albig points out, 'but in the modern age, it is organized, intentional and relatively more effective'.[38]

This subsumption of propaganda into the very form and structure of social control in the modern nation state is particularly clear in the writings of Walter Lippmann during the early 1920s. Lippmann points to two dilemmas of mass society. The first is that of the competence of public opinion: 'The ideal of the omnicompetent, sovereign citizen is, in my opinion, such a false ideal. It is unattainable. The pursuit of it is misleading. The failure to produce it has produced the current disenchantment'.[39] The second problem is that of the increasing complexity of social organisation; it has attained 'a complexity now so great as to be humanly unmanageable'.[40] The implication of this is that central governments have been compelled to assume responsibility for the control and co-ordination of increasingly diffuse societies. In this process, they have realised 'the need for interposing some form of expertness between the private citizen and the vast environment in which he is entangled'.[41] They have created 'a technocracy which has sought to co-ordinate and manage the Great Society, and at the heart of this project is systematic intelligence and information control'. The gathering of social knowledge, Lippmann argues, is, on the whole, still haphazard; not, as it will have to become, 'the normal accompaniment of action'.[42] If mass society is to be governed effectively and rationally, then control over the circuits of information is essential. 'It is no longer possible', Lippmann continues, 'to believe in the original dogma of democracy; that the knowledge needed for the management of human affairs comes up spontaneously from the human heart'. The whole process has now become a matter of scientific management, of social engineering. In a phrase that seems to invoke F. W. Taylor, Lippmann suggests that the manufacture of consent has 'improved enormously in technic, because it is now based on analysis rather than on rule of thumb'.[43] Society as a whole, it seems, is to be run on the same lines of rationality and efficiency as the Taylorist factory. The same technocratic note is present in Edward Bernays' writings on the 'engineering of consent': 'Engineering implies planning. And it is careful planning more than anything else that distinguishes modern public

relations from old-time hit or miss publicity and propaganda'.[44] With the scientific management of public opinion through the centralisation of communications, information and intelligence activities, Lippmann suggests, 'persuasion has become a self-conscious art and a regular organ of popular government'. His judgement on this – and it is one with which we agree – is that 'a revolution is taking place, infinitely more significant than any shifting of economic power'.[45] What makes it a revolution of such importance? It is to the clarification of this question that we now turn.

SOCIAL CONTROL AND INFORMATION MANAGEMENT

On the basis of this reading of early propaganda and public opinion research, we want now to draw out two themes that seem to us to have general and continued importance. The first relates to the growing significance of information flows and information management, and the second to the nature of social control, within contemporary capitalist societies. What our arguments point to, we would claim, is the increasingly systematic and systemic presence, in these societies, of propaganda and information control.

WHEN WAS THE INFORMATION REVOLUTION?

It is frequently argued nowadays that information is becoming a determining social resource and phenomenon. Daniel Bell has gone so far as to argue that we are witnessing the transformation from industrial to post-industrial society, in which the 'axial principle' is the 'centrality of theoretical knowledge...as the director of social change', and in which 'knowledge, not labour, is the source of value'.[46] Recent developments in information and communications technologies (ICTs) argue a future 'information society' of freedom, plenty and harmony. Within this futurological perspective, the information explosion is seen as intrinsically beneficial. The greater the flow of information and communication, the better: 'with increased communication can come increased knowledge, increased creativity and increased understanding among people'.[47] The particular importance of ICTs, however, is for 'managing the mass society, since it is the mechanism that orders and processes the transactions whose huge number has been mounting almost exponentially because of the increase in social interactions'. ICTs, as an 'instrumental mode of rational action', permit the scientific and efficient co-ordination of a complex social organisation.[48]

What characterises such invocations of the 'information society' is a strongly technocratic orientation. ICTs are seen as (socially neutral) instruments, capable of enhancing social rationality, planning and efficiency. What this perspective represses and censors, however, are relations of power

in contemporary society. Richard Swift puts forward an alternative interpretation of the 'managed society':

> Management has become normal. It taps into all of us. We don't expect anything else. We are told what to do at work, what to buy at home and increasingly how to think. The modern world is too complicated. We can't imagine any other way for things to run.[49]

What Swift sees is not rationality but rationalisation. From this perspective the new technologies of information extend and intensify the rationalisation of control.

If one examines the growing role of information in society, evidence does indeed point to control rather than efficient social management – or, more accurately, it suggests that control is an integral part of social scientific management. There are four related forces underpinning the system of information management and control. First, there are the institutions of active persuasion, such as propaganda agencies, public relations and advertising.[50] Second, there are the various mechanisms of secrecy, security and censorship, which try to restrict popular access to 'classified' categories of information.[51] Third, there are the increasing developments towards the commodification and commercialisation of information, which subordinate the flow of information to business values and priorities (via market forces, patents, copyright, etc.).[52] And finally, there is the proliferation of information gathering by corporate and political interests (opinion polls, market research, social surveys, but also more sinister forms of surveillance); it is this collection of 'increasingly detailed information about individuals and family units that not only threatens their privacy, but dramatically increases the power of those with access to the data to create and deliver specialized propaganda'.[53] What we have, then, is an ever more intensive and extensive regulation of the information environment. Our argument is that propaganda, from being a process of *ad hoc* information manipulation, has become transmogrified into the increasingly systemic and integrated machinery of global information control. In his pioneering study of the information industries, Herbert Schiller describes this 'control of the information and ideational apparatus' as a cohesive system of 'mind management'.[54]

The mobilisation of information and knowledge resources is, as we have suggested, generally seen as an expression of the late twentieth-century 'information technology revolution', which is supposed to take us from industrial to post-industrial society. Our argument here, however, is that, whilst the new ICTs may enhance and streamline the management of information, this does not mark some qualitatively new phase of social evolution. It seems to us that they rather extend processes of rationalisation and control under way since early in the century. The scientific management

of information resources – contemporaneous with the scientific management of the factory – was the crucial mechanism for assuring the organisational coherence of the nation state (mass society). And the governance of this Great Society demanded the development of a systematic and co-ordinated management of public opinion. It was in this (pre-electronics) period that the apparatus of 'mind management' took shape. It was at this time that core information industries – mass communication, advertising, public relations, opinion polling, market research – were established, and propaganda became the 'scientific' and systematic engineering of consent. What we want to argue is that this, rather than more recent developments, marks the inauguration of the Information Revolution. It was, we would emphasise, not a technological, but a political revolution. Propaganda and information management must, in Lasswell's words, constitute the pre-eminent 'means of mass mobilization' in the modern nation state. When Walter Lippmann writes of a revolution more significant than any shifting of economic power, it is precisely this Information Revolution that he designates. Contrary to the arguments of Bell and other futurologists, we would argue that industrial societies have long been information societies: the technocratic strategy of information, communication and opinion management has been integral to political rule through most of the twentieth century.

KEEPING CONTROL: THE DIALECTIC OF ENLIGHTENMENT

Within the early twentieth-century research on propaganda we have sought to disentangle two distinct intellectual strands. And we have argued that the approach which locates propaganda in the context of political theory is of greater importance, theoretically and politically, than that which works within the framework of behaviourist psychology. The former, macrosociological approach is concerned with propaganda, information and public opinion in terms of the democratic process and of social control in the modern nation state. Within this literature we can identify apparently divergent positions on the nature and significance of propaganda in democratic society. There is that which sees democracy as a process of rational and informed debate within the public sphere, and propaganda as the wilful obstruction or manipulation of rational political discourse. And, over against this, is the more pragmatic approach which, despairing of the growing complexity of society and doubting the 'ideal of the omnicompetent, sovereign citizen', concludes that 'the problems that vex democracy seem to be unmanageable by democratic methods'.[55] From this perspective, propaganda – no longer a pejorative term – has a vital role to play in the management of democratic opinion and the engineering of democratic consent. Faith in the rational, informed citizen becomes belief in the

rational, scientific technician and expert; the need is felt for 'trained professionals who can deal with increasingly difficult problems of adjustment, interpretation and persuasion'.[56] If these approaches seem divergent, and perhaps even contradictory, there is a sense in which this is more apparent than real. Both, in fact, share a common philosophical tradition and foundation; both have their roots in the Enlightenment principle of reason and rationality. In the first case, appeal is made to the reason and judgement of the individual citizen. In the second, it is to the scientific rationalism of the expert, and to the rationality of the social system. Within this latter perspective, the 'more objective' reality of scientific management and administration seems to promise a more 'efficient' democratic order than the often inarticulate, irrational and uninformed citizen. In this historical and philosophical shift from reason to rationalisation we have the dialectic of Enlightenment.

Within the early propaganda and public opinion research, this technocratic perspective assumes that the scientific management of society, information and opinion is axiomatic if democracy is to be preserved in the mass society. As Albig noted, the partisans of democratic government cannot depend simply upon appeal to reason or abstract liberalism. Lasswell might suggest that the 'practice [of propaganda] by specialists would appear to clash irreparably with some fundamental canons of a society which calls itself democratic',[57] but he only does so in order to squash the idea. His clear conviction is that propaganda is necessary and inevitable in democratic societies; and that enlightened, democratic propaganda can be differentiated from the manipulative practices of totalitarian regimes. On this issue, the general consensus is that democratic society can justify and legitimate propaganda and information management on the basis of the ends to which they are applied: 'Its propaganda will be that of the common adventure for civilisation, the approach of experiment and tolerance, the co-operative commonwealth. Its propaganda will not be negative; it will be positive, and affirmative of new freedoms'.[58]

Should these words be unpersuasive, open to dismissal because they were articulated as long ago as the 1930s, then consider the reflections of Joseph Nye and William Owens – Nye the sometime Chairman of the US National Intelligence Council and current Dean of the John F. Kennedy School of Government at Harvard University, Owens a serving admiral and former Vice Chairman of the Joint Chiefs of Staff. Their joint article, 'America's Information Edge', was published in the journal *Foreign Affairs* in 1996.[59] Convinced that the '21st century, not the twentieth, will turn out to be the period of America's greatest pre-eminence', Nye and Owens attribute this to the fact that 'the United States is better positioned than any other country to multiply the potency of its hard and soft power resources through information' (p. 35). The 'hard power' refers to the most advanced military systems available which, as we emphasise in Chapter 7 of this book, always

incorporate the leading edge of ICTs, while 'soft power' signals America's 'ability to achieve desired outcomes' through exploiting its comparative advantage in creating, processing and disseminating information (p. 21). Nye and Owens stress that it is not crude fire power, but rather '[i]nformation dominance [which] will be the key in the information age' (p. 27). Fortunately, the USA, with its world-leading movie industry, its global media, and – not least – Voice of America, is set fair 'to capitalize on its formidable tools of soft power to project the appeal of its ideals, ideology, culture, economic model, and social and political institutions' (p. 29). Such a refrain is instantly evocative of Harold Lasswell's tunes from the inter-war period.

But how adequate is this position? Just how distinct is information management in the cause of democracy from dictatorial propaganda and information control? If there are those, like Lasswell, Nye and Owens, for whom the principle seems clear-cut, there are others who perceive a more muddy and ambiguous reality. For Francis Wilson, there is a 'narrowing range between the democratic management or manufacture of opinion and the totalitarians who carry techniques a step further in order to proclaim a new freedom for their selfless followers'.[60] And for Francis Rourke,

> it is no exaggeration to say that the possibility of controlling communications has now opened up an avenue through which the gap between totalitarian and democratic government can progressively be narrowed, as modern dictators gradually substitute persuasion for coercion, and as democratic leaders acquire the ability to manufacture the consent upon which their authority is supposed to rest.[61]

Experience of the real world suggests that principles may be undermined. Democratic and totalitarian information politics may, at times, converge. The assumption, however, is that this is an exceptional, aberrant and undesirable situation. The conviction remains that the (ideal) role of information and communications in democracies is fundamentally and essentially different from their role in totalitarian states.

It is this ideological, and even disingenuous, premise that we should question. What we would argue is that propaganda and information management in contemporary democratic societies is on a continuum with that in totalitarian regimes. Our thesis is that, in the nation state of late capitalism, information management is inherently at risk of being totalitarian. It is not simply that the communications and information media in democratic societies are, exceptionally and occasionally, abused or misused by powerful (dictatorial) interests. What we have is an ever more extensive information apparatus – propaganda, censorship, advertising, public relations, surveillance, etc. – through which opinion management has become not only authoritarian, but also routine and normative. Our

argument is that the totalitarian aspect of this process is to be found in its increasingly systematic (totalising), integrated and 'scientific' ambitions and tendencies. Now, we must emphasise that this argument does not presume the existence of a manipulative and conspiratorial élite of mind managers.[62] The logic of information control and management is, rather, an integral and systemic aspect of the modern nation state. Anthony Giddens has advanced a very persuasive argument that information control is fundamental to, and constitutive of, the administrative unity and coherence of the nation state: 'the administrative power generated by the nation state could not exist without the information base that is the means of its reflexive self-regulation'. Distantly echoing the early mass society theoreticians, he attributes this necessity for co-ordinated information management to the complexity and territorial expansiveness of modern societies. Information and communications control are indispensable for both the cohesion and the regulation of social systems spanning such large spatial terrains. And what Giddens sees here, at the heart of administrative and bureaucratic 'efficiency', are the seeds of totalitarianism. 'Rational' and 'scientific' co-ordination of the nation state – necessary to ensure its coherence and reproduction – expresses itself as control and domination. Totalitarianism, argues Giddens, 'is a tendential property of the modern state'.[63]

This tendency towards information management and control, we want now to suggest, expresses the technocratic current of the Enlightenment tradition. This is the current of rationalisation, scientific management and social engineering, efficiency and expertise, that of social control: 'Enlightenment behaves towards things as a dictator towards men. He knows them in so far as he can manipulate them'.[64] It is in this technocratic philosophy of control that both totalitarian and democratic (in Lasswell's sense) systems of propaganda and information management have their common source. If the development of communication and information resources is, ideally, the prerequisite for rational public discourse in the mass society, then the process of achieving this has – historically, and perhaps even logically – encouraged the centralisation and reinforcement of that state apparatus which has tended precisely to undermine rational discourse (in favour of rationalisation and control). The democratic public sphere has been eroded, as Habermas suggests, both by the forces of commercialisation and consumerism, and by that process of political management and manipulation which Habermas refers to as 'refeudalisation'.[65] Rationality has, through the dialectic of Enlightenment, been transformed into rationalisation, technocracy and scientific social management. And propaganda and information management have, in this process, become normative and integral aspects of social control.

This political approach to propaganda raises fundamental and difficult issues about the relation between communications, information and the democratic process. Must the complexity and scale of the Great Society

necessitate social engineering and opinion management (as Lippmann believed)? Is it possible to rescue a sphere of rational debate from the logic of rationalisation? Can the industries and apparatuses of information control be turned to democratic ends? These questions are even more critical today than they were for propaganda and public opinion research at the first dawn of the 'information age'. Our understanding and account of the context of information control in democratic societies suggests that there can be no simple answers to these questions.

PART III

THE POLITICS OF CYBERSPACE

7

CYBERWARS

The military information revolution

At present, discussion of ICTs and the 'information society' is overwhelmingly positive. To be sure, there is some anxiety about the economic circumstances that surround developments, but this is far outweighed by unbounded enthusiasm for improved communications, for leaps in productivity, and the prospect of much better education services. Few commentators even bother to address the dreary topic of electronic warfare, though the military roots of ICTs are undeniable, simply because they appear so archaic and irrelevant to the world as it is today.

Of course, this ought not to be surprising. Outright victory of the West in the long Cold War has immeasurably boosted the confidence of capitalism which, though it remains troubled by seemingly intractable problems, at last enjoys the solace and security that there is no alternative posed as a systemic threat. Capitalist practices and principles have now extended across the globe, exercising a reach against which any previous way of life – slavery, feudalism, colonialism – appears decidedly small-scale and even provincial. In the aftermath of 1989 and the unchallenged permeation of market relations into hitherto excluded territories there is now much less need to defend against the 'communist menace'. The United States stands alone and triumphant as the only superpower. In addition, we have been able to enjoy a 'peace dividend' whereby military calls upon the exchequer have been reduced to 4 per cent or less of Gross National Product. To top it all, a stunning victory in the 1991 Persian Gulf War by the American armed forces (notably assisted by the British, all in the name of the United Nations), has encouraged some to conceive of a 'New World Order' where the major powers are stable, sympathetic to the market system, and capable of keeping dissident nations in order without being seriously threatened themselves.

Such is the confidence in the supremacy of the victors that, if pressed, the military roots of ICTs may now be conceded without embarrassment. In the new era of peace and progress, we may even celebrate earlier military imperatives since these, if once powerful, have long ago been left behind, and what remain seem to be beneficial and beneficent technologies. A

popular argument has it that, just as surgical knowledge leapt ahead in circumstances of war, and just as the long-distance bomber pioneered the long-distance aeroplane, so too might we acknowledge the stimulus military demands gave to computer communications because today we may enjoy having these technologies in abundance, and perhaps even earlier than they might otherwise have appeared. So, while we might have to admit that radar sped ahead during the Second World War, and that massive investments in weaponry during the Vietnam War stimulated the production of the microchip,[1] we might also insist that the new technologies have outgrown their origins. It is well known that the Internet itself, perhaps the centre-piece of techno-boosterism today, emerged from the military's attempts to develop secure means of communication amongst its members.[2] If such a marvellous technology can emerge from the military machine, then surely we ought not to be over-concerned about defence playing a prominent part in technological innovation. In an age of peace and prosperity – how better to describe the 'information society'? – when a new millennium dawns, then we may indeed rejoice in information and communications technologies that herald so much of a positive kind, wherever they might have come from. An ugly chrysalis perhaps, but the splendid butterfly flies free from its shell.

In this chapter we want to insist that the military origins of the Informa-tion Revolution remain pertinent and pressing. This is the case whether one examines the creation of the most advanced computer communications technologies or focuses on the character of information made available to the public, particularly in times of tension. The cutting edge of ICTs remains the 'bleeding edge' of military innovations. We shall document this in what follows, but from the outset we would also stress that this is not simply a matter of the misapplication of technologies which, given different circumstances, might be put right once military imperatives are removed. Our main claim is that it is in the realm of Information Warfare that a logic of control and domination, a principle which influences much technological change, can be shown to be exercising its most pernicious influence.[3] This principle, one which drives the development of ever more sophisticated systems of command and control, is something which simultaneously develops technologies the better to survey and control putative opponents while also building into the technologies mechanisms which may even remove the need for human responsibility in decision-making. That is, more and more weaponry is designed and developed to exercise control over the enemy while at the same time taking away from its users the need to exercise judgement in what they do. Control thereby is at once exercised over the enemy as well as over those who use these technologies. This is expressed in 'launch on warning' weaponry, in surveillance systems programmed to evoke automatic responses to pre-established stimuli, in the spread of the 'cybernetic battlefield' where the enemy appears as a picture on the video screen and where responses are conditioned by well-practised

simulations. It expresses the integration of human decision-making into ultra-sophisticated technologies with the exclusion of human concerns and choices in favour of a planned and programmed course of action directed at the enemy, which is observed and assessed, the better that it may be controlled, in unprecedented ways.

THE REPUBLIC OF TECHNOLOGY

For post-industrialists and futurists technology is neutral, appearing 'as value-free, referred to efficiency as its only touchstone of value'.[4] Thus, to take a single example, one advocate of computer literacy asserts that 'the purposes for which the power and versatility of the computer are used are human choices; they are not the inevitable consequences of the machines themselves'.[5] Computers in themselves are asocial; they are not 'in themselves responsible for the power that often exploits them'.[6] Hence computers can be both potentially liberatory and potentially menacing – though the former is more probable – and the issue is one of their use or misuse rather than some intrinsic tendency. If the abuse of technological potential can be obviated, then it is a force for human betterment and progress. 'The machine', Daniel Boorstin contends, 'is the great witness to man's power....The power of the machine is man's power to remake his world, to master it to his own ends'. It is this unswerving faith in technological advancement and deliverance that characterises the Republic of Technology.[7]

We think that society has been seduced by 'a collective fantasy of technological power', such that 'whatever the question, technology has typically been the ever-ready...answer'.[8] Technology has become second nature, a given and unquestionable part of the order of things. Such is the standing of technology that 'there is an appearance of arrogance when one attempts a moral examination of the technological enterprise'.[9] Technology contains the 'promise of liberation and enrichment, and to refuse the promise would be to choose confinement, misery, and poverty...technology has the tendency to disappear from the occasion of decision by insinuating itself as the basis of the occasion'.[10] Technology has become both means and ends, the instrument of progress but also its fulfilment. As Langdon Winner observes, 'in our times people are often willing to make drastic changes in the way they live to accommodate technological innovation while at the same time resisting similar kinds of changes justified on political grounds'.[11] Technology has become the myth of our times.

Modern society is fixated by the idea of progress, growth and development without end, and by the power of instrumental reason to achieve this dream. The 'hidden motor' of this technological development is, according to Cornelius Castoriadis, the idea of 'total mastery', 'the fantasy of total control, of our will or desire for mastering all objects and all circumstance'.[12]

The fundamental myth of our time is that of control, omnipotence, domination, and its power lies in the fact that it appears to be a purely neutral phenomenon, an expression of reason and rationality that is incontestable. This, argues Castoriadis, is the myth which, more even than money or weapons, constitutes the most formidable obstacle in the way of any reconstruction of human society.

The culture of technology is one of normalised and routinised control. 'The delusion that underlies the present system', argued Christopher Lasch, 'the delusion that we can make ourselves lords of the universe...is the heart and soul of modern technology'.[13] What it represents, according to Arnold Gehlen, is a separation of the intellectual from the moral impulses of Enlightenment rationality, a separation in which the latter 'are now reduced to the unhappy role of seeking in vain to hold back the advance of the efficient, the functional, the technologically possible'.[14] As Leo Marx reminds us,

> The initial Enlightenment belief in progress perceived science and technology to be in the service of liberation from political oppression. Over time that conception was transformed...by the now familiar view that innovations in science-based technologies are in themselves a sufficient and reliable basis for progress.[15]

In our society technique has become central both to our relationship to the external world and to our self-image. 'This is what is happening today', writes Arnold Gehlen, 'when for instance we look at cybernetics, to the theory of techniques of regulation, for clues to the working of our own brains and nervous systems'.[16] At the heart of technique is the drive to control both external and internal worlds.

The tendency towards control and domination is not, then, external to the technological project. It is not the abuse or misuse of a fundamentally neutral, and even benign, technological system. Rather, it is a constitutive and integral factor. In our view the clearest expression of this will to power is to be found in military technologies. Its most refined expression comes in the form of nuclear weapons. These, argues Joel Kovel, are 'not just an aberration but the logical result of an entire attitude toward the world'.[17] Military technologies are the most perfected expressions of the compulsion to command and control. Yet, within social theory, the military tends to be treated as an exceptional and atypical variant of the technological project: 'neither the expanded role of surveillance, nor the altered nature of military power with the development of the means of waging war have been made central formulations of social theory'.[18] 'The impact of war in the twentieth century', Anthony Giddens continues, 'upon generalised patterns of change has been so profound that it is little short of absurd to seek to interpret such patterns without systematic reference to it'.[19] We want to argue that

military developments are central, rather than marginal, to the technological project. As the purest expressions of 'rational' command and control, military technologies are axial to our understanding of broader relations of control and coercion.

INFORMATION WARFARE

Technology has long been a key element of war. There are obvious limitations to relying on the physical prowess of soldiers, and organisational imagination and deployment can only provide so much advantage.[20] A moment's reflection is enough to demonstrate that technology can provide a decisive edge – one may think here of the stirrup, the long bow, the sword, the Maxim gun, even of the Armalite rifle.

One consequence of the palpable advantages of superior technology in battle has been a recurrent faith in a 'technical fix' to the problem of war. If only, goes the reasoning, one could come up with a 'wonder weapon' which the enemy did not possess, then victory – and thereby peace – would be readily achieved. The difficulty with this conviction, of course, has been that the search for superior weaponry has led to an arms race wherein developments on one side have been quickly matched by advances on another, resulting in technological advantage to any protagonist being decidedly short-term, though the contest ensured the spread of increasingly destructive arsenals all round. Nonetheless, the technical fix conviction has remained resilient throughout the twentieth century, from Germany's Big Bertha guns on the Western Front, the V-1 flying bombs that rained on London in 1944, to the search, during the 1980s, with the Strategic Defense Initiative, to construct technologies capable of acting as an impervious electronic barrier to any forms of rocket or air attack launched on the United States.

The Great War is regarded as a watershed for several reasons, not least because of the enormity of the casualties sustained on all sides and the mobilisation of very large proportions of total populations in support of the war effort. Above all, perhaps, the period 1914–18 brought about what has been called the 'industrialisation of war', by which is meant the close harnessing of industrial production to the military struggle. Engineering, chemicals, and energy supply were crucial elements of this process in which not only was the economic strength of a nation perceived to be essential to its capacity to prevail in times of war,[21] but also in which it was recognised that the closeness of fit between industry and war requirements could be crucial. Strong and responsive industries were increasingly seen as central to the war effort.

It is this integration of industry and the military which has fuelled the arms race, since technological superiority – across the board, as well as at the point of weapons' production itself – is a major goal to which industry may

contribute, notably by committing itself to harnessing science as a productive and innovative force to the pursuance of war (and the maintenance of a credible defence).

It is possible to depict the period from around 1914 through the 1960s and into the 1970s as one of *Industrial Warfare* to help identify several of its major characteristics. These include:

- *mobilisation of large elements of, and indeed, entire populations to support the war effort.* This involved major changes in the labour force (women taking over many occupations to release men of fighting age), 'digging for victory', and, of course, a related increase in perception of civilian populations as legitimate targets by combatants (something which helps explain the enormous growth in civilian casualties of war in the twentieth century, dramatically illustrated in the 50 million deaths during the Second World War, most of them civilians).[22]
- *sustained efforts to dovetail industrial production and the military struggle in a strategy of 'total war'.* To this end munitions factories are established, automobile plants transformed for the manufacture of tanks, textiles dedicated to the production of uniforms, and coal output massively increased. Everything is geared, to recall a speech of Winston Churchill late in 1939, to 'victory. Victory at all costs'.
- *participation of huge numbers, at least by historical standards, of combatants*, generally involving the conscription of a majority of males between the ages of 18 and 34. Equipped with the best arms and munitions the country could supply, these troops represented the 'massed forces' which actually fought the wars.
- *strenuous efforts to plan the war effort*, something which extended from government take-over of industries such as transport and energy that were deemed essential to the war effort, through to elaborate and detailed strategies drawn up by high-ranking military commanders who would decide centrally how best to deploy their forces and then direct subordinates to implement that plan.

Over the past generation or so we have seen the unravelling of Industrial Warfare, to be replaced, in an incremental but accelerating manner, by what one might term *Information Warfare* or *Cyber-warfare*. Cyber-warfare places an enormously greater emphasis on the informational dimensions of war than its industrial predecessor. This is not to say that information has not long been important in armed conflict. Of course it has often been crucial, as the parade of spies, informants and traitors, and the assiduity with which the military has sought them and the intelligence they might provide, testifies. The key difference, however, is that information in warfare nowadays has a massively heightened and more pervasive role than hitherto, whether it involves the observation of one's enemy (or potential enemies), arranging the deployment of one's resources, or the management of public opinion at home and abroad. Furthermore, information has permeated all dimensions of modern warfare, whether in the form of satellites which may survey the enemy, in computers which record and assess military requirements

wherever they may be, or in 'smart' weapons which are pre-programmed to 'fire and forget'. That is, information is no longer simply a matter of intelligence about an enemy or about one's resources; it is now, and as a matter of routine, incorporated into the weaponry and decision-making systems themselves. As military historian John Erikson has observed,

> Modern military operations are not to do with weapons. They are to do with information, command, control....Information does things. It fires weapons. It tells them where to go. The signals network is the key thing....It's not about the muscle, the strong arm of the warrior. It is his nervous system that matters. Signals and communications.[23]

We may at this point signal some of the distinguishing features of *Information Warfare*.[24]

- With the dispersal of the military around the globe (chiefly with United States and NATO forces), there have developed exceptionally complex and durable systems of *command and control* to co-ordinate, assess and oversee these resources. Especially evident in the important instance of command and control of nuclear weapons, the computer communications infrastructure to handle and protect information flows is a prerequisite of contemporary warfare.[25] It is at once a source of vulnerability (for example, one may recall here the anxiety about hackers accessing Pentagon and Ministry of Defence computers during the 1990s), while command and control systems are a priority target for any combatant in war today.
- Following the collapse of the Soviet Union and the removal of the attendant threat of a collision of superpowers, the expectation is that future conflicts[26] will be what Manuel Castells appositely terms 'instant wars',[27] by which is meant relatively brief encounters (outside of civil war situations which are problematical for obvious reasons), with active operations lasting only for days or a few weeks, in which the United States (or NATO and/or UN approved forces) is victorious by virtue of overwhelming superiority of its military resources.
- This means that war will no longer require mobilisation of the population (at least not inside the major powers, where an important aim is to wage 'clean war' in which their own civilian population will be unscathed). Conduct of war will rely on *relatively small numbers of professional soldiers, pilots and support teams*. This represents a shift in the military towards what has been called 'knowledge warriors',[28] a term which underscores the centrality of personnel adept, not in unarmed combat or even in riflemanship, but in handling complex and highly computerised tools such as advanced fighter aircraft, surveillance systems, and guidance technologies.
- *Great attention is devoted to 'perception management' of the population at home and, indeed, round the world.* This is especially pressing in democratic nations where

public opinion is an important factor in the war effort[29] and where a genuine worry for military leaders is a concerted domestic reaction against the war, since this may seriously impinge on the fighting capability of their forces. Further, there is widespread apprehension that the public will react to vivid pictures of the wrong sort (say bloodied bodies rather than 'precision strikes on legitimate targets'). Inevitably, this impels military leaders into careful planning for, and management of, information from and about the war, though at the same time assiduous efforts must be made to avoid the charge of censorship, since this flies in the face of democratic states having a 'free media' and undermines the persuasiveness of what does get reported. Perception management must therefore combine ways of ensuring a continuous stream of media coverage that is positive and yet ostensibly freely gathered by independent news agencies. Coverage of the Gulf War in 1991 may be seen as evidence of first rate 'perception management', since it achieved massive media attention yet was antiseptic in substance.[30] To this degree Jean Baudrillard's proclamation that the 'Gulf War never happened'[31] is correct, in so far as the television and media coverage was managed most adroitly by the military allies.

- Information Warfare is conducted *using exceptionally sophisticated technologies*. Obviously this is most evident amongst the forces of the United States which have massive resources (the US defence budget – currently in excess of $300 billion per year – is bigger than that of every prospective enemy and neutral country combined).[32] Just one indication of this is that about one-third of the British Ministry of Defence's equipment procurement budget, currently about £9 billion per annum, is accounted for by 'Command and Information Systems' alone.[33] When added to expenditure on 'Weapons and Electronic Systems' and 'Aircraft Systems', over half the budget is accounted for. Perhaps not surprisingly, the Ministry of Defence is spending increased proportions of its total budget on technologies rather than personnel.[34] One ought to note that many of these advanced technologies are also adopted by other nations, not least because of the thriving export business in weaponry and the comparatively low entry costs for purchasers. For this reason, many countries, especially in the Middle and Far East, have access to cutting edge technologies of destruction.
- The technologies of cyberwar are *information saturated*. We may even speak now of the digitalisation of the battlefield, though computerisation reaches much further, to the entire range of command and control facilities.[35]
- Information Warfare does not require the mobilisation either of the citizenry or of industry for the war effort. It relies instead on *capturing only the leading edges of industrial innovation for military purposes* – for instance, electronic engineering, computing, telecommunications and aerospace.
- Information Warfare, for a variety of reasons, requires meticulous planning, but this is *planning for flexibility of response*, in contrast to the elaborate and cumbersome plans of the Industrial Warfare period. Today, enormous volumes of information flows, along with the incorporation of software into weapons themselves, feed into complex planning for war which prioritises 'mobility,

flexibility, and rapid reaction'.[36] Game theory, simulations (frequently using sophisticated video facilities), and the production of systems are an integral element of Information Warfare, as is the necessity to plan on the basis of the 'certainty of uncertainty'.[37]

• Such is the complexity of this planning for flexibility *that many aspects of Information Warfare are pre-programmed*, thereby taken out of the hands of the actual combatant. As a director of the United States' National Defense University puts it, now and in the future, 'many decisions will be fully automated'.[38] In part this is in response to the premium placed upon speed of action in modern warfare – for instance, once a missile has been launched, then the counter-missile that has been designed to intercept and destroy it must be released in the shortest possible decision time, something that computers may manage quicker than human beings.[39] In such ways are judgement and responsibility taken out of the hands of military personnel and placed in technologies.

The Persian Gulf War, lasting but five weeks in January and February 1991, has been aptly called 'the first Information War'.[40] 'Desert Storm' manifested most of the traits identified above, from little or no threat to the civilian population of the major protagonist (the United States), to careful organisation which enabled the burdensome movement of 500,000 allied forces (most of whom were non-combatants – and even most of the soldiery encountered no direct enemy fire) and matériel several thousand miles into the arena of battle while maintaining a flexibility of response that was expressed in an astonishingly swift advance across the desert in Kuwait,[41] to meticulously handled 'media friendly' coverage in what has been described as 'the most "communicated" event so far in human history'.[42]

The Western forces intervened in this regional dispute because there was a perceived threat to their access to oil supplies, as well, no doubt, as because of the aggression of Saddam towards Kuwait and its people when he invaded. It appears that the economic motive was decisive, since there were simultaneous accounts of even worse abuse of civil populations coming out of the former Yugoslavia, yet the major powers were reluctant, vacillating and late to become involved there.[43]

The Allied Forces were insuperably better equipped and prepared than were the Iraqis,[44] and the consequences were evident in the respective losses: 300 or so on the American and British side, between 30,000 and 60,000 on the enemy's, many of these on the 'Turkey Shoot' as they fled, under fire, back to Iraq on the Basra road, their country having endured forty-two days of war in which, it has been estimated, more explosive power was delivered than during the whole of the Second World War.[45]

'Desert Storm' was convincing proof of Information Warfare's 'technophilic approach to fighting',[46] from the stealth fighters, laser-guided bombing and Patriot missiles which endeavoured to intercept Scuds launched on Israel and Saudi Arabia,[47] through to the 'largest complete

C3I[48] system ever assembled...to connect not only the US forces in the Gulf, but to sustain bases in the United States, the national command authority in Washington, and other coalition forces'.[49]

Above all, noted an *Economist* correspondent in his post mortem,

> the key was the information advantage provided by a communications network that linked satellites, observation aircraft, planners, commanders, tanks, bombers, ships and much more. It enabled the allies to get around...OODA (observation, orientation, decision and action) loops at breath-taking speed in a sort of continuous temporal outflanking. A completely new air-tasking order – a list of hundreds of targets for thousands of sorties – was produced every 72 hours, and would be updated even while the aircraft were airborne. Iraq's radar eyes were poked out, its wireless nerves severed.[50]

NEEDS OF INDUSTRY, NEEDS OF WAR

Preparation for warfare has absorbed stupendous sums of public money and diverted research and development away from civilian priorities. It has also powerfully shaped the constitution and development of ICTs and has nurtured the growth of a culture of control and surveillance.

As the House of Commons Defence Committee observed, procurement by the armed forces 'represents by any standards an enormous programme of direct purchase of goods and equipment from industry. Clearly it has a major impact on British industry and equipment'.[51] More recently, the Department of Defence has testified that it 'is British industry's largest single customer'.[52] One academic calculation has estimated that over 12 per cent of UK manufacturing is dependent upon defence sales. In itself a striking figure, this pales in comparison with the 37 per cent of British engineering industry reliant on military markets.[53] Though engineering is not synonymous with ICTs, it is in this sphere that these new technologies are concentrated and, moreover, they are increasingly becoming its dominant component. Illustrative of this is the fact that just two sub-sectors of engineering – aerospace and electronics – absorb over half the total defence procurement allowance,[54] and it is in these areas, themselves converging, that most advanced forms of ICTs are to be found.

Such military hegemony must, necessarily, have an overriding influence on the direction of research, development and exploitation of the new technologies and, thereby, on the shape of technological and economic development more broadly. The military-industrial lobby imposes a dynamic of corporate and military self-interest which distorts and perverts economic and social priorities through procedures, moreover, which are largely closed to public scrutiny.[55]

It can be argued, for example, that high expenditures on defence tend to undermine economic competitiveness. The reason for this lies in the channelling of research and development (R&D) funds away from the civil sector into military applications which have minimal commercial use. Thus, electronics is the most R&D intensive sector in the British economy, absorbing fully 30 per cent of all R&D funding, but it has 45 per cent of this coming from government, chiefly the Ministry of Defence, and around two-thirds of the sector's R&D commitment is defence-related.[56] While these disproportionate resources have driven technological developments in militaristic directions, it is also the case that military contractors have found it difficult to transfer their expertise and products to civilian products and markets. The upshot is that the vigour of the economy is considerably depleted and drained by the military incubus.

To question the direction of R&D expenditures is not just to ponder implications for economic competitiveness and vitality, it also confronts the common belief that technologies are pre- or para-social phenomena that 'society' can choose to put to either good or bad use. To take but one prominent example, the capacities of the super computers for the Strategic Defense Initiative (SDI) project that ran from 1983 to 1993 have been shaped by the military's requirements for machines that will allow simulation and real-time control of highly complex systems. Such a development has no clear civilian applications and neither do £100,000,000-plus programmes to develop Trident and Tomahawk missiles. In such ways the particular needs and priorities of the military are privileged, whilst other applications are discarded, displaced and devalued.

Military priorities are, then, at the heart of the 'information revolution' and, like other social and economic resources, education is being harnessed to them. Appropriately skilled and qualified personnel are needed to develop, maintain and operate sophisticated weapon systems. This means that the military creams off large numbers of students considered to be crucial for its operations. It has been suggested that, taking into account Ministry of Defence employment and its funding of R&D in private industry, 'rather over thirty per cent of all Britain's highly qualified scientists and engineers are employed in the defence sector'.[57] Moreover, it is argued that the 'brightest and the best' graduates tend to be drawn into military R&D,[58] lured by the prospect of working on 'Projects so advanced that they stand on the verge of the future'.[59] Joseph Weizenbaum describes the trajectory of 'desirable' graduates of his university:

> Students coming to study at the artificial intelligence (AI) laboratories of MIT...or the other such laboratories in the United States, should decide what they want to do with their talents without being befuddled by euphemisms. They should be clear that, upon graduation, most of the companies they will work for, and especially those that will recruit them

most energetically, are the mostly deeply engaged in feverish activity to find still faster, more reliable ways to kill even more people....Whatever euphemisms are used to describe students' AI laboratory projects, the probability is overwhelming that the end use of their research will serve this or similar military objectives.[60]

Military research can also have profound implications for academic freedom and the unrestricted communication of intellectual work. In the view of David Dickson, military support 'is the root of a new Faustian bargain being offered to universities: more funding for basic science provided they are prepared to accept more controls on the findings of their scientists'.[61] Thus, in the United States, a deputy director of the Central Intelligence Agency expressed his worries that 'indiscriminate publication' of research results in scholarly journals 'could affect the national security in a harmful way'; academics in the field of computing, he contended, should refer sensitive research to government so it could be vetted prior to publication, as is the case already in the field of cryptography.[62] The message here is unmistakable: if academic researchers want funding, then they should become advocates of military strategies.

THE BLEEDING EDGE

If information and communications technologies are the cutting edge of 'progress', then military ICTs are its bleeding edge. War, and preparation for war, have been the most fundamental stimulus to the development of the new technologies. As one commentator bluntly states, 'electronics is what war is all about'.[63] One might even ask whether war is what electronics is all about.

Computer communications technologies are essential to the entire repertoire of modern military equipment: strategic and tactical nuclear missiles; airborne warning and control systems (AWACS); ground-to-air missiles; electronic measures; battlefield communication systems; surveillance satellites; and so on. From the foot soldier equipped with glove-back computer, assault rifle, night-sight devices, and portable missiles, to the 'geek' analysing information collected by unmanned sensors (satellites, drones, electronic bugs, etc.) and responding by launching cruise missiles at chosen targets, the centrality of computer communications technologies is inescapable.[64] The Exocet missiles, for example, which were so devastating during the 1982 Falklands War, were 'smart' weapons which contained such sophisticated electronics that the user could 'fire and forget'; their speed, range, accuracy and skimming capacities made them practically 'invulnerable' to enemy defences.

Supporting and integrating electronic weapon systems are increasingly indispensable command, control, communications and information (C3I)

networks. These are crucial to maintain what have been referred to as peace-time and war-time 'information regimes'.[65] In non-war conditions they are used to manage routine military affairs and logistics, to facilitate long- and short-range communications, and to observe and analyse the actions of enemies and potential enemies. In war conditions they are all the more essential. With speed of detection and response at a premium in modern warfare because of the rapidity with which any attack may be executed, armed forces are spending billions of dollars to improve the detection and communications stages of their defence networks. Only the most advanced computers could offer any hope of achieving this, and accordingly computer systems are massive investments. Such is the urgency for speed of response that defence interests are now seeking ways to computerise the decision-making processes of military encounters, for example, by developing 'launch on warning' programmes with help from expert systems and perhaps even totally automated systems. 'There is no technological reason', writes Frank Barnaby, 'why warfare should not become completely automated, fought with machines and computerised missiles with no direct human intervention.'[66]

As such a route is followed, the military becomes utterly reliant on information systems to conduct its affairs: without such communications, control and surveillance structures the military would be disabled even before engaging in battle. Such reliance has led military planners to conceive a strategy of 'decapitation': if one side aims to be victorious in a nuclear confrontation, then it is useless trying to attack missile silos or ground troops since they are so large and dispersed that a retaliatory strike would be inevitable. Instead, it must pre-emptively destroy the enemy's C3I systems, hoping to eliminate disconnected forces in the ensuing turmoil.[67]

Nations now compete to gain advantage over advanced computer communications technologies: one side produces electronic systems to guide aircraft, ground and naval forces; another develops electronic measures to jam these systems; the former retaliates with counter-measures; the latter with counter-counter-measures; and so it goes. With the development of the Strategic Defense Initiative (SDI), and the complementary Strategic Computing Initiative (SCI), this whole process reached a totalising conclusion.[68] The promise of 'machine intelligence' technology was that it would co-ordinate battle, defence and control systems for both terrestrial and space wars. These developments cannot be dismissed as the 'misapplication' of otherwise neutral or benevolent technological progress. We would argue that they are, in their essence, the ultimate expressions of an entirely rationalistic and technocratic attitude towards the world.

MILITARY SURVEILLANCE

The modern state, Joel Kovel argues, operates through surveillance: 'The technocrat peers out of his tower, sends killer-satellites into orbit, arms his

CIA, monitors the Other, and waits to get before he is gotten'.[69] The state today is, he maintains, 'characterised by the emergence of the technology of surveillance....Computerised electronic surveillance has ushered in a whole new phase of domination'.[70] Surveillance and intelligence procedures become increasingly central to the state, and it is in military command and control activities that this has found its purest expression.

As we have said, information is crucial to military and control agencies. There is an insatiable hunger for data, information, knowledge and intelligence about any factors affecting 'national' interests. The consequence has been the construction of a massive system of interlinked technologies to routinely and continuously monitor and inspect events and activities – military and civilian – around the globe.[71] Thus, the United States National Security Agency (NSA), which employs some 70,000 persons, monitors communications signals throughout the world. It achieves this through an extensive grid of listening and watching posts, and through 'what are believed to be the largest and most advanced computers now available to any bureaucracy on earth'.[72] On this side of the Atlantic, Britain's Government Communications Headquarters (GCHQ) in Cheltenham has some 5,000 staff and close links with the NSA.[73]

Alongside computers, satellites have become a linchpin of surveillance activities. According to two commentators, it is getting to the point where the military 'would be struck deaf, dumb and blind should their satellites be destroyed'.[74] Necessarily these systems are hidden from public view, secrecy being essential to ensure security from the enemy. Thus is constructed an anonymous and unexaminable, national and world-wide, web of surveillance and transmission of messages between defence agencies. As William E. Burrows observed:

> the system that does all of this watching and listening is so pervasively se-
> cret – so black – that no individual...knows all of its hidden parts, the
> products they collect, or the real extent of the widely dispersed and deeply
> buried budget that keeps the entire operation functioning.[75]

The security services assume themselves to be continually under attack from enemies and malcontents. Constantly wary of the spy, they come easily to be pervaded by suspicion and fear of disclosure, characteristics which reinforce their impenetrability, distance them from public accountability, and serve to corrode democratic values and open government.[76]

Computer communications systems have become increasingly central to nuclear defence strategies. Nuclear weapons reached 'maturation' during the 1960s and have not themselves changed dramatically (except in numbers and warheads) during the intervening period. What has developed, however, is the 'vertical integration' of warning and intelligence systems with weapon systems, and the 'horizontal integration' of dispersed military command

points into a single centralised command structure. Such strategic developments depend, of course, upon the construction and articulation of complex electronic surveillance and C3I networks into 'surely...the most technologically elaborate organisation ever constructed by man'.[77] With the SDI programme and concept nuclear surveillance strategies, already accelerating for over two decades, reached a point of massive, and – as it transpired – decisive, escalation.[78] SDI was the ultimate C3I system, intended to gather, process and act upon information pertaining to potentially thousands upon thousands of missile launches, tens of thousands of warheads, and possibly hundreds of thousands of decoy missiles. It relied on the incessant and untiring observation of potential enemies' territories for the slightest sign of mobilisation. SDI surveillance and computer networks would have been required to perform all these functions almost instantaneously and with complete reliability without benefit of testing in real conditions. The information-gathering and processing requirements placed on this surveillance and intelligence system were mind-boggling. SDI was run down in the early 1990s, transformed into the Ballistic Missile Defense Organisation and oriented towards protecting against theatre missile attack. Yet even at this scale, it remains a formidably ambitious endeavour to protect the United States by the earliest possible – remote and automatic – detection of enemy movement. In it the panoptic project surely finds its most pure expression.

The surveillance machine is not only directed against external enemies, however. In its pursuit of internal 'subversives', Britain's secret security service, MI5, has at its Mayfair headquarters a Joint Computer Bureau with the capacity to hold 20 million records, with files on some half a million people, and a network of 200 terminals accessing the mainframe.[79] Leaks and occasional exposés have revealed that surveillance is exercised on trade unionists, CND activists, educationalists and media personnel, as well as on what might be thought to be more obvious candidates.[80] A recent defector from MI5 has alleged that Peter Mandelson once had his telephone tapped and a file detailing his private life.[81] In addition, MI5 works in close association with the Special Branch of the police force, thereby extending its information gathering network nationwide.[82] The security services also have access on request to a vast array of data banks, including the Police National Computer, Inland Revenue records, British Telecom files, and data held by the Department of Health and Social Security.

In the name of security, state surveillance has become a pandemic, and even normative, feature of modern society. In the process, it has extended from intelligence activities to routine policing activities. This has been encouraged particularly by the expanding police use of computer facilities which has promoted new forms of proactive and pre-emptive policing. As it becomes possible to maintain 'a broad data base that can be inexpensively screened, it becomes prudent to consider everyone a possible suspect initially'.[83]

Such developments can be seen, in Foucaldian terms, as part of 'an irreversible continuing historical process of more intensive and extensive social control'.[84] As a former Commissioner of the Metropolitan Police, Sir Kenneth Newman, has expressed it, 'it would be better if we stopped talking about crime prevention and lifted the whole thing to a higher level of generality represented by the words "social control" '.[85] However, what is particularly significant is that these surveillance and control strategies are modelled on the military paradigm. In their computerisation strategies, 'the police are moving to a more military style of operation'.[86] Thus the policing strategy of 'targeting and surveillance', which undertakes surveillance activities in order to 'target' individuals, groups, locations or areas of special interest, is military in origin. It was developed by Sir Kenneth Newman out of his experiences as Chief Constable of the Royal Ulster Constabulary in the late 1970s, where the British army had 'set up, under the direction of the leading counter-insurgency theorist Frank Kitson, just such a system for the collection and analysis of masses of intelligence information'.[87] Rather than being some extraordinary and exceptional state of affairs, the military paradigm of surveillance technologies interlinked with command and control systems that are insistently hidden from the public eye, has become a generalised model for control and policing strategies.[88]

THE MILITARY INFORMATION CULTURE

Why have we made so much of these military aspects of ICTs? Why put so much emphasis on military command, control and surveillance networks? Are these not just extreme and atypical (mis)applications of the new technologies? Why not leave this exotic specialism to defence experts and investigative journalists? Why not look on the bright side?

We still insist on the centrality of the military paradigm within the current process of economic and social restructuring that is now taking place. One good reason for such insistence is the almost complete repression of this issue in post-industrial and futurological literature. For most celebrants of the 'information revolution', war and weaponry simply seem to be another world, another universe. When they are, very occasionally, referred to, then military ICTs are actually seen as providing a panacea for war and strife. Tom Stonier's book, *The Wealth of Information* (1983), provides an exemplary illustration of this logic. According to Stonier, the information society will be 'a world of peace and plenty unprecedented in recorded human history'.[89] 'War', he avers, 'is an institution on the demise':

> That ancient institution, first appearing in force with the rise of the an-
> cient civilisations, no longer fulfils social needs and is disappearing in the
> post-industrial era, as slavery disappeared in the industrial era. The pri-

164

mary social need for war, the need to expand to match growing popula-
tions, is being met more effectively through technological ingenuity and
relative population stability.[90]

For Stonier, authoritarianism and conflict will be undermined by the general
availability of communications and information resources. In his view,

> no dictator can long survive for any length of time in communicative soci-
> ety as the flows of information can no longer be controlled from the cen-
> tre....The reduction of the threat of war in the post-industrial society,
> coupled with the increasing tendency towards consensus democracy, is a re-
> sult of our extending communications networks.[91]

Christopher Evans' book, *The Mighty Micro* (1979), expressed a cognate faith
in technology. His conviction was that the computer's predictive authority
would deter all would-be warriors. For when

> statistics are fed into the computer's unemotional, apolitical interior, what
> comes out is as true and objective an appraisal as can be made from the
> facts. Furthermore, whenever the data involves confrontation between nu-
> clear powers, the unequivocal message that spills out – to both sides – is:
> You will lose![92]

Martin Libicki of the United States' National Defense University speculates
along similar lines. He reasons that 'virtual reality' systems are already
available to allow 'simula-warfare'. This being so, he asks, 'if both sides are
civilized enough to simulate warfare, why should they fight at all?'[93] Much
the same trust in computers and 'ultra-intelligent machines' to forestall
nuclear annihilation informed Ronald Reagan's conviction that SDI can
render nuclear weapons impotent and obsolete.[94]

One reason, then, to emphasise the military aspects of IT is to counter
this complacent and deluding technological utopianism. But we are not just
correcting oversights and omissions. We also want to make a stronger
theoretical case for putting the military project centre stage. As Anthony
Giddens has so powerfully argued, its significance for the control of
authoritative resources (for power over people), especially of the means of
violence, has made the military fundamental to the social, economic and
political genesis of the nation state. Giddens elaborates on the wider plane
of industrialisation as a whole to demonstrate that technological, adminis-
trative and organisational structures have been profoundly shaped by the
needs of war and defence. Integrally related to these developments,
surveillance and control frameworks directed against external enemies of the
nation state have developed in tandem with the monitoring of internal
populations, and with all has been erected a gigantic panoply of information

and communications technologies dedicated to prepare for, and if necessary wage, war.

There is no need to invoke conspiracy theories and Big Brother imagery to explain these surveillance and control activities. Indeed, as Nicholas Abercrombie and his colleagues observe, much of 'the growth of the state apparatus may derive from those very pressures that originally produced individual citizenship' since the recognition of the rights of individuals necessarily resulted in 'Individuation [which]...leads to greater surveillance and control of large populations'.[95] What cannot be ignored, however, is the fact that military imperatives have played a major role in the growth of the state and the systems of surveillance that are its requisites. As Giddens argues, 'surveillance as the mobilising of administrative power – through the storage and control of information – is the primary means of the concentration of authoritative resources involved in the formation of the nation state'.[96] The logistics of administration and control in the nation state are interwoven and indissociable. The profoundly important and difficult consequence of this is that 'tendencies toward totalitarian power are as distinctive a feature of our epoch as is industrialised war'; totalitarianism is 'a tendential property of the modern state', developing out of the 'consolidated political power generated by a merging of developed techniques of surveillance and the technology of industrialised war'.[97] Giddens' most important political insight is that 'there is no type of nation state in the contemporary world which is completely immune from the potentiality of being subject to totalitarian rule'.[98]

How much more profound this awareness of totalitarian tendencies is than the futuristic blind faith in the logic of technological progress and the spread of democracy. Even a cursory glance at the world that surrounds us must demonstrate that, rather than trusting benign technological advance, we need to struggle against authoritarian and oppressive tendencies found in already constituted technologies.

At root, our argument is that we should be vigilant and aware of the ambivalence of technological rationality and, ultimately, of what passes for reason itself. Military and control technologies ought not to be considered as a specific and exceptional matter: they are at the centre of the project of technological rationalisation. If we want to sustain – and perhaps even survive – the technological project then we must confront, rather than repress, this its dark side. The military system of technology has not been some vast historical accident. It has been a fundamental and intrinsic aspect of scientific, technological and industrial development.

Giddens argues that totalitarianism is a tendential property of the modern state. He does not argue that all states are equal in this respect. Nor does he suggest that any national state will necessarily succumb to this temptation. However, with the rapid growth of electronic warfare and C3I technologies, the totalitarian tendency becomes increasingly more actual

than potential. In this global military structure we have perhaps the ultimate consummation of the rationalised and technocratic ordering of society. Here authoritative and administrative control cohere in pursuit of total mastery. Technocracy is political domination shaped by technical and instrumental reasoning, 'a streamlined kind of domination, much the most powerful – materially – the world has ever seen, but the same pustule for all that'.[99] Within a technocratic order

> the logic of the machine settles into the spirit of the master. There it dresses itself up as 'value-free' technical reasoning. And the hidden meaning of this is domination – precisely because it is hidden and disguised as value free. Thus it dominates – and denies that it dominates – all in the same gesture. The more it denies, the more it dominates; and the more it dominates, the more it denies. Give it enough time, and it will come up with 'limited nuclear war'.[100]

Within the technocratic project, even to its military-nuclear culmination, 'the technical world view itself becomes the very embodiment of neutrality and objectivity...the technical world view becomes mythical thought'.[101] Ultimate goals go unquestioned; technological control and mastery become an absolute value. In this 'Pentagon of Power', writes Lewis Mumford,

> there is no visible presence who issues commands: unlike Job's God, the new deities cannot be confronted, still less defied....The ultimate aim of this technics is to displace life, or rather to transfer the attributes of life to the machine and the mechanical collective, allowing only so much of the organism to remain as may be controlled and manipulated.[102]

In its military culmination, this displacement of life becomes literal as well as metaphorical.

What we are emphasising here is the centrality of the military project. Questions about the social value of technological systems cannot, and will not, be addressed until we are prepared to confront, in real seriousness, the significance of military science and technology. Military technologies, we maintain, are characteristic of the dream of total control that has long inhabited the technological domain. They exemplify 'a system that deliberately eliminates the whole human personality, ignores the historic process, overplays the role of the abstract intelligence, and makes control over physical nature, ultimately control over man himself, the chief purposes of existence'.[103]

8

EDUCATION AS
KNOWLEDGE AND
DISCIPLINE

We noted in chapter three that it is today quite the conventional wisdom to emphasise the central significance of education in the 'information society'. Thinkers such as Robert Reich, Peter Drucker and Manuel Castells, and eminent politicians across the globe, reason that education is a requisite of success – even of survival – in this new world. The more ambitious politicians (and politicians are ambitious everywhere) consider that a high-quality education system is crucial to the achievement of their ambition to see their nations thrive, since 'symbolic analysts' occupy the upper reaches of the jobs hierarchy in informational capitalism. In the world today capacities such as analysis, conception, planning and communication are at a premium. If any nation is to capture a high proportion of these rewarding and well-paid positions, then its government's educational strategy is crucial to its ambitions for peace and prosperity. Even where nations have less grand goals, and one might suppose that there are a few which do, they must strive to produce a workforce which may operate in a 'network society', and this too calls for a response from the education system. Either way, the ability of education to produce the appropriate sort of 'human capital' is critical. Of necessity, then, it is to the forefront of any attempt to meet the challenges and opportunities of the 'information age'. There seems to be no escape from the fact that 'in the global economy of the 21st century it will be the skills, inventiveness and creativity of the workforce that will give companies – and nations – their competitive edge'.[1]

Commentators frequently reflect in these terms on educational policies, evaluating them as positive or negative responses to the arrival of the 'information society' and its attendant stresses and strains. The recurrent theme here is one of education's capacity to adjust effectively to new economic challenges. From the premise that governments now have less opportunity to control their economies since these are not delimited by national borders, it follows logically that national well-being hinges on a country's capacity to win a disproportionate share of the world's most attractive jobs for its citizens. For this reason, Phil Brown and Hugh Lauder quite correctly write of 'global knowledge wars'[2] being fought between

nations, the chief weaponry of which is the education system and its capacity to produce appealing and employable labour.

In this chapter we too want to address the issue of what is happening in education. However, we want to approach the issue from a rather different angle from that which the policy-makers prefer. Our main concern is not with the blunt question: how is education meeting the challenge of globalisation? Instead we want to reflect on developments in British schools and further education colleges, focusing here on the 16- to 19-year-old age groups, in broader terms, highlighting features of the relations between education, knowledge and power. To be sure, we will have a good deal to say about the connections between economic change and educational transformations, but we want to set these in a wider context, one which queries, for instance, how education itself comes to be conceived, what gets defined as knowledge, and how an appropriate curriculum comes to be designed and put in place.

These are by no means idle questions, since we know, at the least from the writings of Michel Foucault, that knowledge (and where do we find this more evidently than in the education system?) is always intimately connected to power. What is to be considered as knowledge? Who is regarded as a knowledgeable person? What knowledge is regarded as legitimate? Each of these questions is crucial to our understanding of what is happening, and why it is taking place, in education today. For this reason, in this chapter we intend to examine some of the key developments in the education system itself, concentrating on developments in the UK, all the while keeping an eye fixed on the power/knowledge relation.

We have argued that the transformations taking place over recent decades may best be conceived as a shift from a Fordist to neo-Fordist mode of production.[3] This transition involves a multitude of related factors such as global expansion and integration of economic and financial activities, a diminishment of national sovereignty, greater penetration of market relationships into everyday life, increased flexibility of production and consumption, changed work patterns, as well as an acceleration of the pace of change itself. These socio-economic trends have palpable, if complex, consequences for social stability. Most obviously, perhaps, the very acceleration of change itself induces a pervasive sense of uncertainty and apprehension amongst wide sections of the public, something which influences, in diverse ways, feelings of social solidarity and contentment. Further, what has been described as the 'collapse of tenure' at work[4] that accompanies neo-Fordist employment practices (a 'contingent' workforce, burgeoning part-time and temporary work arrangements, high levels of long-term unemployment) has serious, if differentiated, implications for social order (increasing discipline here, stimulating unrest there). Again, neo-Fordist employment contracts have important effects upon family circumstances, which in turn influence household relationships and

child-rearing practices that eventually find expression in the character of social order.[5]

There can be no doubt, therefore, that the emergence of neo-Fordism is associated with changes in the form and modalities of social order. Now, it has been a truism of social science, since at least the days of Emile Durkheim around the start of the twentieth century, that education is a central agency, rivalled only by the family, of social regulation. Education is a crucial site in which the young absorb social values, learn about appropriate behaviour, incorporate into their psyches a sense of social belonging, and are encouraged to accept as legitimate otherwise challengeable phenomena. There are here compelling reasons to prioritise and explore changes in the character of education during the present era, focusing on education as an especially important endeavour to produce effective means of discipline and regulation which accord with the transition to neo-Fordism. What we offer in this chapter, then, is a series of questions, explorations and agendas, centred around the relation between education, social control and the socio-economic system.

NEO-FORDISM AND SOCIAL CONTROL

In his account of Fordism, Benjamin Coriat[6] argues that this *'regime of accumulation'* entailed a sequence of interconnections which centred around mass production, changes in the relationship of classes, and new forms of social regulation. Fordism, he maintains, was built around a combination of factory labour and consumer and welfare dependence orchestrated by the Keynesian state apparatus. The emerging regime of neo-Fordism may be seen in terms of new articulations of production, consumption, class alignments and social control. The hallmark of neo-Fordism is its flexibility (decentralised, fragmented, disseminated), manifested in changed forms of production and patterns of consumption, and class relations which are characterised by increasing individuation and differentiation, though with particularly marked divisions between core and peripheral workers. These are defining features of neo-Fordism's accumulation strategy, core elements of its patterns of organisation. But what about new forms of regulation and management? How might agreement, even consensus, be achieved about the legitimacy of neo-Fordist ways of life?

At one level, much of this latter is a matter of reasserting control in the face of a perceived insubordination contingent upon the decline of the Fordist/Keynesian consensus. At the heart of this collapse 'is the failure of an established pattern of domination', one that 'can be resolved only through the establishment of new patterns of domination...through the restoration of authority and through a far-from-smooth search for new patterns of domination'.[7] The initial stage in this reassertion of discipline involved what

John Holloway referred to as the transitional, or 'macho', period of confrontational tactics, aimed at destroying vestiges of Fordism/ Keynesianism. It is expressed very much as the imposition of centralised control from above with even economic policy being subordinated to the 'politics of hegemony'.[8] For instance, during this period unions were weakened by changed legislation (for example, by outlawing secondary picketing and minimising the numbers of official pickets allowed during disputes), strikers were confronted and defeated (most famously the miners in 1984–85), and unemployment allowed to soar to intimidate those left in work.

Education was a key area in and through which there have been efforts to reassert social and moral discipline, and many of the Thatcher/Major governments' strategies between 1979 and 1997 might be thought to have exemplified the macho posture. Teachers were held responsible for perpetuating, perhaps even for generating, the 'English disease' and for failing to stimulate scientific and technological education.[9] This was the argument of then Prime Minister James Callaghan's 1976 landmark Ruskin College speech, and it has been the message of innumerable critiques from the Black Papers of the 1970s to the Adam Smith Institute's polemics in the 1980s. Too concerned with academic subjects and their promotion in the education hierarchy, teachers were alleged to be incapable of responding appropriately to the changed vocational demands of the 'real world' because of their snooty dedication to impractical and over-cerebral study. Teachers, through their political bias or, at best, through their liberal unworldliness, were thought to be responsible for Britain's failure to develop its scientific and technological base and to compete effectively in world markets. Moreover, the education service was increasingly seen to be an immense demand upon public resources, and, it so followed, in straitened times for everyone, this had to be overseen with greater acuity and accountability as an 'audit culture' grew uninterruptedly during the 1980s.

The necessary solution was said to be the establishment of more central-ised control and direction, and a bundle of policies and initiatives provided just that. The Education Reform Act of 1988 and its successor, the 1993 Education Act; the introduction of a National Curriculum; concerted calls for an improvement in 'teacher quality' that culminated in the formation of the Teacher Training Agency in 1994, an organisation which issued strict guidelines to university departments responsible for teacher education on what to do and what was acceptable; and reforms to ensure the better management of the teacher force. Alongside these moves to change teachers and teaching, there has also been an undermining of local authority controls over education and an assertion of government power. Thus, the Department of Education and Science – revealingly retitled the Department for Education and Employment in 1995 – became markedly dirigiste and centralist. This process of centralisation, and its associated interventionism,

was perhaps most manifest in the growth of the Manpower Services Commission (MSC), which was succeeded by the Training Agency (TA), that functioned to by-pass and erode local government and local education authorities. At the level of schools and further education, centralised direction, inspection and control aimed to reduce local autonomy in favour of more centralised power.

Discipline has been targeted pre-eminently at the clientele of schools and colleges, at the young people destined to become the workforce of tomorrow. In the context of the crisis of Fordism and high unemployment, 'the young workless [have been seen as] some sort of delayed high explosive device attached to the hull of the ship of state'.[10] Young people as a whole have been seen as a disruptive and destabilising force, and outcries against mugging, hooliganism and urban violence intensified demands for discipline and control. In face of 'threatening youth',[11] it has been necessary to teach young people their proper place in the order of things, to reduce unrealistic expectations, and to subjugate them to the 'real' world. The 1985 White Paper on *Better Schools*, for instance, was clear that 'discourtesy, disorder and disruption' must be replaced by 'high standards of conduct within the school and beyond', by 'good behaviour and self-discipline'.[12]

EDUCATION FOR FLEXIBILITY

However, neo-Fordism is not just about clearing away the debris of a now outdated disciplinary structure. It is also about 'integrating the responsible worker' and 'moving towards the construction of a new consensus'.[13] The objective here is to elaborate a new commitment and involvement from the worker, new forms of integration, a new conformism and complicity. Traditional forms of organisation are to be replaced by a new individualism, and out of this reconstructed and remoralised sense of self new forms of organisation are to be made. The race is on to establish increasingly individuated work relationships, with labour ideally linked on a network which allows him/her to be constantly and routinely monitored, while also supplied with the technological know-how and motivational characteristics to allow self-stimulation and autonomous development.

Fundamental to the shaping of this new individualism and to the moralisation of the neo-Fordist workforce was the promulgation, by a broad church of educational and para-educational agitators, of a new philosophy of education. This evolving orthodoxy was centred around a reconceptualisation of the relationship between education and training. It can be characterised in terms of:

- the teaching of competencies and skills rather than traditional subjects;
- experiential, project-based and problem-solving pedagogy rather than didactic academic methods;

- individualised learning contracts in which students assume responsibility for their own development;
- an increased orientation to the world of business and industry;
- an emphasis on technological and computer 'literacy';
- a focus on personal and social as well as technical and vocational education;
- new forms of profiling and assessment which are criterion- rather than norm-referenced;
- a commitment to 'lifelong learning', defined as routine re-education and re-training throughout the course of one's working life.

The objective throughout was education for flexibility, education for the flexible production required by neo-Fordism.

An important document that brought together the various elements of this new pedagogy was produced in 1982 by none other than the Rubber and Plastics Processing Industry Training Board. Recognising that the education system has failed to 'produce the range of skills, abilities and knowledge required to sustain and expand the productive power and prosperity of the nation', it argued for a new vocationalism, but one that 'is not simply preparation for work, but the acquisition of competencies of a general character that will be called upon by the young person in a broad spectrum of situations arising in both his working and personal life'. Here we have the now familiar invocation of skills, competencies, personal learning agendas and learning contracts, work experience, relevance, profiling and so forth. But there is also a clear insight into the significance of these various elements: the objective is to create a person who is 'a competent adult, in a variety of situations in working and private life'.[14] 'A fully developed person', we are told,

> a mature adult, is one who is able and prepared to accept responsibility for himself and his actions and has developed a range of competencies to support that position....The long path of learning that starts in the pre-school period and leads through school and out into adult life is directed towards the goal of acquiring a range of competencies at a level that enables the possessor to cope with situations and pressures he will encounter and to establish a measure of genuine autonomy. Knowledge alone is not sufficient to develop competency. Skills, attitudes and experience are also necessary.[15]

Similar principles of flexible education are also to be found in the various pronouncements of the influential 'Education for Capability' movement. The message was much the same: *competence, coping, creativity, co-operation.* There was the same insistence that training should equip the student for both work and life: 'The challenge is to discover a more rewarding education in which thinking and doing and making are fused into a new concept of

living and learning'.[16] There was the same emphasis on 'discovery methods', project work and independent learning. According to Tyrell Burgess, there 'is a continuum of learning, whose logic is the same, from the new-born babe to the research worker on the frontiers of knowledge. Each is engaged in the formulation of problems, in solving them and in testing the solutions'.[17] The new pedagogy was concerned with 'method', process, competence. It was predicated, according to Burgess, on both a new theory of learning and a new theory of knowledge.

This pedagogy had its strongest roots in further education, where some of the most pressing problems of adjustment to neo-Fordist ways were manifest amongst those aged 16 to 19 years. The Fordist experience of a transfer from full-time education to full-time job for well in excess of half of all 16-year-olds collapsed during the 1980s. Manufacturing jobs dramatically declined, and apprenticeship schemes were deemed outdated and cumbersome, and thus opportunities for the young school-leaver shrank dramatically. For many, particularly those in the most depressed regions, this resulted in a transition straight from school to the dole,[18] but it also brought about a range of educational schemes in response to the changed times. Not surprisingly, then, it was in the further education sector and amongst those between 16 and 19, that the 'education for flexibility' philosophy was most powerfully articulated. It found perhaps its clearest expression in publications from the Further Education Unit (FEU), the Manpower Services Commission (MSC) and its successor the Training Agency, and in the introduction of National Vocational Qualifications (NVQs) which were consciously designed to improve employment prospects for the young by better harmonising education and the world of work. Nevertheless, this 'education for capability' ethos soon found its way into the school system, especially through the spread of General National Vocational Qualifications (GNVQs). Its influence has been deeply felt in higher education too, as we shall see in the following chapter.

Recognising the need 'to provide a flexible adaptable workforce able to cope with change', the Further Education Unit put an emphasis on the development of competence and 'personal effectiveness', not just for work but also for the 'world outside employment'. To this end, 'trainees should acquire an insight into a learning strategy, which will enable them to find out what skills and knowledge they need to add to their existing stock'.[19] It emphasised the 'development of initiative, motivation, enterprise, problem-solving skills and other personal qualities', and encouraged active partnership in learning and the promotion of self-reliance in the learner, thus fostering personal development as the only way to cope with 'a world of increasing complexity'.[20]

We need not overstate the consistency and cohesiveness of these positions for it to be clear that we were witnessing the emergence of a new strategic philosophy of education/training, one that was dedicated to producing an

adaptable, flexible, integrated, self-controlling workforce for the embryonic regime of neo-Fordism. However, what does seem increasingly and, initially at least, paradoxically clear is that *the new instrumentalism was in fact rooted in progressive educational traditions*. Thus both pedagogies shared, for example, a common focus on child/student-centred approaches, experiential learning and relevance, the continuum between work and life, and the use of negotiated, criterion-referenced forms of assessment. As Andy Green observes, 'the training paradigm has evolved precisely by drawing on key progressive themes and elaborating them in new ways'.[21]

Geoffrey Partington[22] usefully outlines four different categories of progressivism:

- *Child-centred progressives*, 'who conceive progress in terms of each child being more fully enabled by education to develop individual interests and potentialities authentically and without constraints';
- *Radical progressives*, who judge education 'by the extent to which it succeeds in promoting a basic reconstruction of society';
- *Liberal progressives*, concerned with 'the fuller integration of ever larger proportions of children into liberal knowledge';
- *Instrumental progressives*, 'whose central concern is to make education increasingly more efficient in serving what they see as the economic, political or cultural needs of their own society'.

Instrumental progressivism is what particularly concerns us here.

What appears paradoxical is the discrepancy between progressivist ideals, on the one hand, and the functionalist and technocratic objectives of the new instrumentalism, on the other. Is the problem one of the misuse of what are fundamentally sound, liberatory and progressive techniques and principles? We would argue that it is not so simple. We cannot counterpose a 'pure' and emancipatory progressivism against its profanation and subordination to relations of power. Instrumental progressivism is clearly about control, but it is about a particular expression and modality of control, and this is the significant issue. As Philip Cohen has argued, this approach constitutes 'a modern version of self-improvement', an 'attempt to construct a...mobile form of self-discipline, adapted to changing technologies of production and consumption'.[23] The form and function of discipline are being redefined in more 'subjective' terms, shifting from external controls towards mechanisms which may elicit voluntary co-operation.

It is important to note that this form of (self-) discipline is not specific to what has been called the new vocationalism. This reform of feelings, motivations and aspirations is also characteristic of earlier, and apparently more humane, forms of progressivism.[24] According to Andy Hargreaves, even in the 1960s and early 1970s, progressivism was shaped by 'the call for a new economic man characterised by adaptability and the need for the

installation of an "internal supervisor" in those engaged in the shifting relations of dominance and subordination in industry'.[25]

An insight into the common basis of both radical and instrumental progressivism is provided by Basil Bernstein in an article 'On the Classification and Framing of Educational Knowledge'.[26] In this essay, which asks how forms of experience and identity are maintained and changed by the formal transmission of educational knowledge, Bernstein distinguishes what he calls 'collection' and 'integrated' codes:

> Any classification of educational knowledge which involves strong classification gives rise to what is here called a collection code. Any organisation of educational knowledge which involves a marked attempt to reduce the strength of classification is here called an integrated code.[27]

Collection codes are characterised by well-insulated subject hierarchies within educational knowledge, and under this system 'social order arises out of the hierarchical nature of the authority relationships, out of the systematic ordering of the differentiated knowledge in time and space, out of an explicit, usually predictable, examining procedure'.[28] In the case of the integrated code, there is a shift to a curriculum in which the contents stand in open relation to each other and classification is reduced, and the consequence, according to Bernstein, of this disturbance in classification of knowledge, is 'a disturbance of existing authority structures'.[29]

What is especially important in Bernstein's argument is his recognition that progressivism, which exemplifies the integrated code, reflects a changing relationship between knowledge and power. His concern is with the implications for social control and social order of a significant transformation in the status of knowledge. As such, the direction of his inquiry is very much cognate with Lyotard's examination of the postmodern condition of knowledge.[30] 'The growing differentiation of knowledge at the higher levels of thought, together with the integration of previously discrete areas', make necessary, in Bernstein's view, 'a form of socialisation appropriate to these changes in the structure of knowledge'.[31] Changes in workplace knowledge and skill requirements – the displacement of context-tied expertise in favour of general principles from which a range of diverse operations can be derived – also have important implications for the socialisation process: 'In crude terms, it could be said that the nineteenth century required submissive and inflexible man, whereas the late twentieth century requires conforming but flexible man'.[32] There is, here, in Bernstein's account, an acute awareness of the interrelationship between knowledge structures and systems on the one hand, and power structures and principles of control on the other.

In terms of the transmission of educational knowledge, the shift from collection to integrated codes 'involves a change in what counts as having

knowledge, in what counts as a valid transmission of knowledge, [and] in what counts as a valid realisation of knowledge'.[33] This change of code, Bernstein continues, 'involves fundamental changes in the classification of knowledge and so changes in the structure and distribution of power and in principles of control'.[34] With the integrated code, there is a concern with the general principles, the deep structures of knowledge, upon ways of knowing (rather than states of knowledge). In contrast to the didactic theory of learning associated with the collection code, the learning process characteristic of the integrated code is more group- or self-regulated and is 'likely to exhibit considerable flexibility'. Thus different concepts of what counts as knowledge have implications for the organisational framework of knowledge acquisition and for the forms of power and control that underpin this process. For example, in the case of assessment, the integrated code tends to emphasise the dispositional attributes of the student, to 'encourage more of the pupil/student to be made public; more of his thoughts, feelings and values'. The consequence, Bernstein argues, is that 'more of the pupil is available for control...socialisation could be more intensive and perhaps more penetrating'.[35]

FROM AUTHORITARIAN TO THERAPEUTIC CONTROL

Bernstein's analysis provides insights into the nature and significance of what we have called instrumental progressivism. It also allows us to relate contemporary pedagogical and curricular changes to broader social processes. What Bernstein makes clear is that strategies of instrumentalism have not been created *ex nihilo*, but rather that they come out of wider changes in the structures of power and control. In its account of the shift from the collection code to the integrated code, Bernstein's work in fact converges with many of the broader concerns of historians and sociologists of social control.

For Morris Janowitz the historical development of social control is associated with 'the reduction of coercion' and with 'a commitment to procedures of redefining societal goals in order to enhance the role of rationality'.[36] This growing rationalisation may also be associated with a more abstract and depersonalised form of social regulation. Control becomes less dependent upon direct coercion, and increasingly impersonal, automatic, routine and banal in its operation. It also becomes ever more intensive and extensive – Stanley Cohen refers to this process as 'thinning the mesh and widening the net'.[37] 'Rational' control becomes invasive and pervasive, proactive as well as reactive.

As social control becomes increasingly 'rational', impersonal and continuous, it can be characterised in terms of one fundamental principle: surveillance and information gathering. According to Anthony Giddens

> information storage is central to the role of 'authoritative resources' in the
> structuring of social systems spanning larger ranges of space and time than
> tribal cultures. Surveillance – control of information and superintendence
> of the activities of some groups by others – is in turn the key to the expan-
> sion of such resources.[38]

Direct and coercive supervision is increasingly replaced by surveillance and
the accumulation of coded information. In similar vein, Edward Shils refers
to the 'cognitive passion' of control agencies, and notes that 'the cognitive
appetite is an anomic one – it is incapable of satiation'. What we have seen,
continues Shils, is 'an invasion of personal privacy of an extreme character'
reinforced by the 'belief that it is perfectly proper to gather knowledge
about the individual's past, his inner life, and his idiosyncrasies'.[39]
Individual privacy is increasingly eroded by cognitive intrusion and
intrusive perception, and this penetrative seeing and knowing is increasingly
reinforced by technologies of observation and recording.

As we made clear in Chapter 5 of this book, the question of the relation-
ship between surveillance, knowledge and control has been most fully
developed in the work of Michel Foucault. Foucault argues that power and
knowledge imply each other, 'that there is no power relation without the
correlative constitution of a field of knowledge, nor any knowledge that does
not presuppose at the same time power relations'.[40]

Axiomatic to the accumulation of knowledge about a subject population
is its visibility. Foucault insists that

> The exercise of discipline presupposes a mechanism that coerces by means
> of observation; an apparatus in which the techniques that make it possible
> to see induce effects of power, and in which, conversely, the means of coer-
> cion make those on whom they are applied clearly visible.[41]

The paradigmatic case of seeing/knowledge/power is, for Foucault, Jeremy
Bentham's Panopticon. This structure, for example a prison or asylum,
allows inmates located around the internal circumference of a wheel-like
building to be continuously observed from a central inspection tower. The
inmates are seen, but they cannot see. Nor can they communicate with one
another; they remain in 'a sequestered and observed solitude'. Within the
Panopticon the punished/ill individual is observed in two ways:
'surveillance, of course, but also knowledge of each inmate, of his behaviour,
his deeper states of mind'.[42]

For Foucault, the Panopticon is not a historical curiosity, but rather an
'indefinitely generalisable mechanism',[43] a monument of modern power
relations. What Foucault emphasises is a distinctively modern power and
control system, one which hinges on universal visibility, upon an extensive
and intensive process of surveillance and knowledge gathering. What is

particularly distinctive about its operation is that it dispenses with coercion in favour of self-policing. The Panopticon 'induces in the inmate a state of conscious and permanent visibility that assures the automatic functioning of power'. Insofar as the inmates are continuously observed they internalise the relations of power and regulate themselves. The operation of power, moreover, is automatic and impersonal. We are, says Foucault, 'in the panoptic machine, invested by its effects of power, which we bring to ourselves: since we are part of its mechanism'.[44]

The Panopticon is a prefigurative element in the formation of what Foucault calls a 'disciplinary society'. What Foucault helps us to understand are the mechanisms through which individuals are rendered compliant within 'the disciplinary culture of the therapeutic state'.[45] This disciplinary or therapeutic culture is characterised by surveillance and cognitive intrusion, and the consequence of this absolute visibility is to 'automatise' and 'disindividualise' the functioning of power. Christopher Lasch wrote of the increasingly expansive and intensive activities of the 'therapeutic state', of the invasion of individual privacy by its 'tutelary apparatus'.[46] Such areas of life as physical and mental health, childcare, moral behaviour and even sexuality are subjected to surveillance and administrative documentation. Lasch described 'the shift from an authoritative to a therapeutic mode of social control – a shift that has transformed not only industry but also politics, the school and the family'. 'Observation', he notes, 'initially conceived as a means to more effective forms of supervision and control, has become a means of control in its own right'.[47] The education system constitutes an important element of this shift towards therapeutic discipline. Like other elements of the 'tutelary complex', it 'both reflects and contributes to the shift from authoritative sanctions to manipulation and surveillance – the redefinition of political authority in therapeutic terms'.[48]

CYBERNETICS AND SOCIAL CONTROL

Changes in the education system, we are arguing, constitute an aspect of a broader transformation in patterns of social control. Contemporary forms of social control are, in our view, continuous with the 'disciplinary society' Foucault sees emerging early in the nineteenth century. What might appear to be innovative and progressive developments towards self-regulation are, we maintain, fundamental to the panoptic model. The theme of the Panopticon – 'at once surveillance and observation, security and knowledge, individualisation and totalisation, isolation and transparency'[49] – remains the paradigm for social control.

However, there has been a highly significant disciplinary innovation in the late twentieth century in the development of information and communication technologies. These have not changed the master pattern of control, though

the computer is today the fundamental technology of seeing and knowing, surveillance and information storage. What the computer has achieved is the extension and intensification of panoptic control; it has rendered social control more pervasive, more invasive, more total, but also more routine, mundane and inescapable. On the basis of the new technologies, surveillance becomes continuous and encompassing, 'a diffuse panoptic vision'.[50]

Cybernetics, through its escalation of this panoptic vision, becomes fundamental to the process of social control. We can speak of 'a *cybernetic society*, in which the moral principle of democratic societies – individual autonomy – becomes more and more anachronistic and is replaced by *technical imperatives* handed down from the administrative economic spheres'.[51] With Bentham's architectural Panopticon cognitive and scopic intrusion ensure power without coercion: 'Thanks to the techniques of surveillance, the "physics" of power, the hold over the body, operate according to the laws of optics and mechanics...without recourse, in principle at least, to excess, force or violence'.[52] To these laws, the electronic Panopticon adds those of cybernetics, of information processing and handling, and in so doing it intensifies the mechanisms of social control. This generalised panopticism operates through individual, and ultimately social, interiorisation of surveillance. As Marike Finlay argues, disciplinary constraint 'functions by means of the internalisation of procedures of discourse within the consciousness of the "controlled" subjects'.[53] At one level, this entails a vulnerable sense of visibility, such that these subjects come to 'watch themselves', to exercise power over their own selves. It also entails the introjection of procedures and behaviours – ways of acting, of speaking, of thinking – appropriate to a disciplinary institution. That institution defines the parameters and the conceptual framework through which the subject experiences and thinks about the world. In the case of the electronic Panopticon,

> there is an internalisation of such discursive procedures as means/end logic, a problem-solving conception of knowledge, and certain patterns of information and ordering. Once internalised, all of these procedures have a surveillance capacity over the subject's social interaction.[54]

The subject's relationship to both internal and external realities (and possibilities) becomes fixed around certain rationalist principles, and alternative perceptions and relationships become foreclosed.

The computer, according to Sherry Turkle, 'changes people's awareness of themselves, of one another, of their relationship with the world...it affects the way that we think, especially the way we think about ourselves'; it 'holds up a new mirror in which mind is reflected as machine'.[55] Turkle is, of course, building upon the conceptual foundations of cybernetic theory which, for some considerable time now, have interpreted social, psychologi-

cal and biological processes in terms of the processing of information. The language of servo-mechanisms, self-regulation, feedback loops and control loops, it was claimed, applied to all – mechanical, natural, social, human – processes. Furthermore, the recognition that people and computing machines had fundamentally common features meant that 'the analogy between them becomes more compelling'.[56]

Recognising that people are increasingly coming to see themselves as information processing machines, Theodore Roszak suggests that this may reflect 'a haunting sense of human inadequacy and existential failure'.[57] Referring to what he calls the 'data processing model of the mind', Roszak suggests that this conception

> even if it is no better than a caricature – easily carries over into a prescription for character and value. When we grant anyone the power to teach us how to think, we may also be granting them the chance to teach us what to think, where to begin thinking, where to stop.[58]

This cybernetic model is not, then, simply a neutral, technical, phenomenon. It entails a particular concept of mind, of reason, of knowledge and skill, and it forecloses alternative conceptions. It privileges mechanistic over holistic thinking; cognition over intuition; calculative over deliberative rationality.[59] It also reinforces the dissociation of reason from the emotional life.[60] Thus, according to Christopher Lasch, the cybernetic image of the machine-like self 'satisfies the wish to believe that thought can divorce itself from emotion'; it is predicated on the faith that thought can 'overcome the emotional and bodily limitations that have encumbered humanity in the past'. Underpinning this image, Lasch argues, 'is the fantasy of total control, absolute transcendence of the limits imposed on mankind by its lowly origins'.[61] In accepting this cybernetic discourse, and internalising its procedures, we imprison ourselves within its horizons.

INSTRUMENTAL PROGRESSIVISM

Our discussion of instrumental progressivism has sought to locate this pedagogical strategy in the context of broader patterns of social control. The real significance of developments in schools and colleges since the 1980s can only be grasped adequately, we believe, from this disciplinary perspective. Rather than merely meeting 'the needs of industry', these initiatives constitute 'a massive state intervention in socialisation', 'a new "science" of youth in which notions of work preparation and "life" management are united, an attempt to technologise previous cultural patterns that are regarded as either inadequate or no longer produced "naturally" '.[62] As such, this expresses a strategy which requires situating in the context of other control measures aimed at youth.

We want to look at two aspects of the new pedagogy in particular: first *profiling and assessment*; and then the question of *skills and competencies*. Profiling is at the core of panoptic discipline. It is central to that process whereby 'ever widening aspects of student life and identity [are] brought within scrutiny [and] the possibility is created for ever stronger forms of social control and the "pedagogic colonisation of everyday life" '.[63] Profiles and records of assessment have become a constitutive feature of all the educational and training schemes and profiling has been advocated by a wide range of organisations. They are a fundamental aspect of student-centred, 'progressive' teaching methods, and have the objectives of both recognising and documenting achievement as well as increasing motivation by stressing 'positive qualities such as enthusiasm, enterprise, adaptability, persistence, punctuality, willingness and capacity to accept responsibility, ability to participate constructively in group activity and ability to work independently',[64] as well as academic achievement.

The principles upon which profiling is based are characterised by Patricia Broadfoot as threefold: a formative principle, which emphasises diagnosis of strengths and weaknesses and 'mastery and achievement rather than norm-referencing and failure'; a concern for 'open and collaborative relations between teachers and pupils'; and a summative function, which provides 'information about skills, aptitudes and capabilities which will be useful for pupils, their teachers and their families, and for potential consumers of such records'.[65]

What is seen by many as the emancipatory aspect of profiling, with its emphasis on guidance, counselling and negotiation, has its roots in progressivism. But so too do the control dimensions. As Bernstein argues, with reference to the integrated code, assessment becomes more intrusive and penetrating, taking into account the attitude and dispositions of the student. Profiling is concerned not just with cognitive and academic achievements, but also with social and behavioural qualities, with the evaluation of personality.

The belief that profiling will motivate students has strong control dimensions. In the words of Tyrell Burgess and Elizabeth Adams, 'the emphasis on a factual account of what students have achieved and experienced and an acceptance of accounts by students themselves of what they have done suggests a new place for students in the management of their own education'.[66] A Schools Council research programme found teachers to believe that 'students who were involved in their own assessment would feel that their behaviour would affect their own future' and that 'the realisation that qualities such as courtesy and discipline or behaviour were being formally recorded would encourage better behaviour'.[67] What we see here is that process of self-regulation characteristic of Bernstein's integrated code; that internalisation of patterns of thinking and behaving which is characteristic of panoptic discipline.

F. Allen Hanson[68] has documented the enormous extension of the 'examined life' in recent decades, a growth that has been spearheaded by educationalists. He distinguishes authenticity tests from qualifying tests, the former assessing a qualitative state such as devotion to a cause (for example, the monarch, religion, a trades union), the latter an ability of one sort or another (for example, driving a car, operating a machine). Once upon a time authenticity tests were very widespread (Hanson, for instance, reminds us of just how common was torture as a mechanism for judging the veracity of another's position), but these have declined appreciably, to be replaced, especially within education, in the form of intelligence tests and performances in examinations that enable assessors to measure and label an individual's abilities. Hanson is surely correct in his historical review, yet perhaps he underestimates the vitality of authenticity tests. Profiling schemes, where a very common aim is to determine a candidate's 'commitment' and 'motivation' appear, in Britain's new pedagogy, capable of integrating effectively with a battery of what are by now well-established qualifying tests.

Profiles are inescapably about power and control. This is not a question of their misuse, with the possibility that they might be used more rigorously and sagaciously, as some accounts suggest. Profiling is inherently a mechanism of surveillance and discipline, one that functions both intrusively and unobtrusively. According to Andy Hargreaves such penetrating scrutiny has been characteristic of all forms of progressivism:

> In theory, no place was private; there was no hiding place from the teacher's relentless, if benevolent, pursuit. If the conversion of developing persons into easily processable cases is one surveillance-related danger inherent in personal recording, another is the development of a principle of observation and monitoring whose sophistication and comprehensiveness is virtually unsurpassed in the history of schooling.[69]

What are the possibilities when such systems become fully computerised? Do computers not promise to bring the potential of profile surveillance to fruition?

The second aspect of instrumental progressivism that we want to look at in this section is the conception of trainee skills and competencies which has been central to so many recent initiatives.[70] This doctrine of skills has been elaborated and expounded by a number of different organisations, and there are a number of disagreements and differences of emphasis in the various positions. It has also evolved over the past twenty years in response to the changing economic and political context.[71] Again, however, we are less interested here in doctrinal variants than with the broader meaning of the enterprise as a whole. This, we would argue, is about control. The language of competence, transferability, personal effectiveness, and so on, is a

manifestation of the new technics of disciplinary power. In Basil Bernstein's terms, this is centred around that shift in what counts as having knowledge and skill which underpins the transition from 'submissive and inflexible man' to 'conforming but flexible man'. It is also, in Marike Finlay's terms, about panoptic self-regulation, through the assumption and internalisation of particular discursive procedures and constraints on knowledge.

Initially, in the late 1970s, the developing new pedagogy focused upon what were called social and life skills (SLS). Social skills are those needed when dealing with other people, both at work and in private life; life skills are those 'we need to go about our daily lives' and consist of coping skills, job finding skills and leisure skills. The focus here is on coping and surviving in a world of high unemployment and adapting to a future of enforced leisure. SLS is predicated upon a deficit model of the student and stands in the tradition of compensatory education. It assumes that young people are responsible for their own state of unemployment: unemployment is a consequence of personal deficiencies, such as illiteracy, innumeracy, lack of punctuality or communication skills, and these must be rectified. The skills taught were extremely content (or product) based: 'job-hunting skills, self-marketing skills, knowledge of how to get information on retraining opportunities, government grants and schemes, and further and higher education options'.[72] It is a matter of interview techniques, handling money, using spare time properly, talking to the boss and various other accomplishments.[73]

Retrospectively, we might see SLS as a strategy for the transitional (Holloway's 'macho') phase of restructuring. In its tendency to 'blame the victim', to focus on survival and coping, and to 'reintroduce realism', it was a provisional, containing strategy. Since the 1980s, however, we have seen the emergence of a new stage concerned with remoralisation and reintegration. Drawing upon traditions of progressivism, this new approach emphasises the positive qualities of trainees, their (albeit differential) integration into the world of work, and their self-regulation and social responsibilities. Previous governments of whatever hue are now criticised for having 'provided entitlements without matching obligations and [having] discouraged people from taking responsibility for themselves'.[74] As the nature of neo-Fordism becomes more clear, so the rhetoric of training has shifted to a concern with flexibility, basic skills, process skills, transferable skills. 'The future', it is realised,

> may demand a radically different approach to enable people to cope with non-routine tasks as well as with rapid change in job content. 'Training for versatility', 'training for flexibility', are alternative phrases which have been used to describe what is required.[75]

Overall, the new doctrine of skills contains complexities and nuances that are scholastic in their complexity. It is the consequence of a Herculean labour of social research which reflects the complicity of a great deal of such

research in the project of social engineering. With its imprimatur of 'scientific' and 'objective' methodology, such research is, according to Edward Shils, 'the highest and purest manifestation of the expansion of the cognitive interest in human beings'.[76] An early example of such work was that undertaken at the Occupational Research Unit of the University of Wales Institute of Science and Technology. Their premise was that 'there is an urgent and growing need for people at work to be far more adaptable than at present'[77] and, on this basis, it was argued that training must increasingly focus on skill transfer, skill ownership and 'learning to learn'. This entailed, pre-eminently, a shift in emphasis from what has to be learned (product) to how it is learned (process): 'The teaching of process skills, such as identification of error, awareness of standards, questioning and fault diagnosis, require very different methods from those traditionally used by the teacher or trainer'.[78] Trainees must be encouraged to 'learn to improve their ways of learning' and to 'see learning as their own responsibility'.[79] The new pedagogy thus emphasises the self-responsibility of learners who are able to 'see exactly what [is] required and put themselves forward for assessment without interference'.[80] What we see here is a thoroughgoing systematisation of progressive methods (the integrated code).

A second significant contribution from social research was that of the Institute of Manpower Studies (IMS) which was influential in shaping education policy during the 1980s. The IMS regularly made clear its emphasis on flexibility, self-reliance and occupational competence. In a number of reports it developed a dense conceptual grid which elaborated on the notion of 'abstract and open ended process skills' and sought to relate them to particular occupational groupings or 'occupational training families'.[81] 'What is new' in the IMS work, we are told, 'is the link between occupational training families and the way in which competence at work is developed. It is a combination of identifying transferable skills and of enabling young people to transfer such skills because they "own" them'.[82] What was being developed here was a form of instrumental progressivism in which self-regulation was adapted to a context in which, because of specific economic and technological factors, job specific vocational preparation is no longer an adequate socialising force. Within this perspective young people 'own' their skills, and as they move about in search of work, they take these skills with them and sell them in the labour market.

These arguments have over time converged on an endeavour to develop, increasingly at all levels of the education system, 'core skills' in the curriculum. In its 1982 report on *Basic Skills*, the Further Education Unit argued that vocational preparation should 'provide young people with a range of skills that have utility across vocational areas....Competence over a core of skills common to many occupations will improve their adaptability'.[83] The basic skills necessary to a trainee include core, transferable skills alongside vocational area skills and specific occupational skills. During the

1980s the Manpower Services Commission emphasised the importance of core skills for achieving competence, for transferability, for progression to further education, and for coping with the world outside employment.[84] Towards the close of that decade further decisive steps were taken towards systematising vocational education, while promoting this role of core skills. To this end, National Vocational Qualifications (NVQs) were supplemented by General National Vocational Qualifications (GNVQs) which stressed general, as opposed to specific, competencies.[85] Different levels of GNVQs were introduced – Advanced, Intermediate and Foundation – with an aim of ensuring that, in the foreseeable future, over half of all young people would take some GNVQ or other. In support of this, government instructed schools to make the qualification available to their pupils.

In addition, the National Curriculum Council, keen to promote cross-curricula themes while it instructed schools on what to teach, turned its attention to the identification of 'core skills'.[86] 'Core' soon came to be substituted by 'key' skills, but by 1996, aware of the urgency to 'ensure that education relates more effectively to the world of work', the Conservative administration made plans to equip all 14- to 19-year-olds 'with the key skills, behaviour and attitudes which are critical to their success in adult and working life'.[87] New Labour was bipartisan in this regard, introducing in 1997 a new GNVQ in 'key skills' itself.[88]

Developing key skills (numeracy, communication, problem solving, practical skills) has 'as much to do with how trainees are learning as it has to do with what specific knowledge they are acquiring'. Its objective is competence: 'Competence is not the same thing as having acquired skills; it is being able to apply them in the right way and at the right time…[it is] the ability to perform in a real situation'.[89]

It is only in the process of development that the 'progressive' aspects of the new instrumentalism have become clearer and more theoretically grounded. The concept of competence – defined as the possession and development of skills, knowledge and appropriate attitudes and experience – has been central to this process. Important in this context was the Further Education Unit's booklet, *Towards a Competence Based System*. The FEU argued for a 'wider definition of competence than that associated with working life', one that also includes 'life roles'.[90] This extension of competence from occupational skills to 'life skills' was intended to break down the polarisation of the education system 'between academic and vocational learning, between high- and low-level teaching, between "real" work-based and "abstract" classroom assignments, and so on'.[91] Here we have realised Stronach's 'science of youth',[92] in which life management coalesces with vocational preparation.

A second FEU document was *Ability Learning*, which made a contribution to the theoretical justification of FEU/MSC positions. Leslie Smith aimed to

mobilise a 'scientific theory' – Piaget's theory of cognitive development – to clarify the nature of general, transferable skills. There is, he argued, 'an evident similarity between a basic skills curriculum projected in [FEU] research and Piaget's account of general, transferable abilities in the adolescent/adult'.[93] Smith associated transferable ability with formal operational thinking, and argued that 'general, cognitive abilities…can be transferred from one context to another [and] have an acceptable, psychological basis'.[94]

We shall say more of Piaget in a moment, but for the present it is enough to note that this new doctrine of skills and competence is about reconstituting skills and knowledge on a new basis in order to reconstruct and control structures. As such, it is but one phase in a lengthy history of such initiatives and strategies of social control.

COMPUTER LITERACY

Computers and computer literacy are central to this instrumental progressivism.[95] The computer is the totem of the post-industrial 'revolution' in education, and computer literacy is the passport to its rewards.[96] Governments vie one with another to boast of how many computers they have managed to place in the classroom, they parade policies of 'Superhighways for Education' (1995) and a 'National Grid for Learning' (1997), ministers going so far as to assert that computers represent a 'fourth R', 'a basic skill as important as literacy and numeracy'.[97] The Conservatives designated 1982 'IT Year', and it is in the same tradition of technological boosterism that New Labour declared 1998 'Net Year'.[98] Information and communication technologies are presented as crucial for any credible education, for modernisation itself, for survival and success in the next millennium.[99] When Bill Gates of Microsoft visited England late in 1997 such was the enthusiasm of politicians to be associated with this icon of the crucial technology of the information age that none less than the Prime Minister, the Chancellor of the Exchequer, the Minister for Education, and the President of the Board of Trade took time to meet him.[100] But what is more astonishing even than this hyperbole and the innumerable tracts and initiatives about computer literacy is their conformity and predictability. Each chants a familiar litany about a new kind of learning that is individualised, student-centred, active, and experiential.

We want to focus here on computer literacy only in the context of social control. In order to do this we shall begin by exploring the concepts of learning, knowledge and the mind which inform this messianic doctrine. The fundamental premise is that of cybernetics: the belief that the human mind functions like, or as, a computational machine. According to Stonier and Conlin,[101] 'the human mind is an exquisite information processing device'. Asserting that 'the computer–brain analogy seems to be becoming

culturally acceptable', two other proponents of computer literacy suggest that 'the ways by which good organisations of knowledge in a computer are developed suggest guidelines and insights into how learning environments might lead to the development of good organisations of knowledge in a child's brain'.[102] 'Computer science', they assert, 'is not just about computer machinery. It is also about ways of describing processes – understanding, thinking, reasoning, recognising, learning. Education could well do with more precise descriptions of these activities'.[103] Computer science, according to Marvin Minsky, has 'given us a wholly new collection of concepts for thinking about Thinking itself', one that will allow us 'to compose theories of Learning, and of Education, based on adequate descriptions of mental processes'.[104]

This approach privileges rational procedures, goal-directed behaviour and cognitive structures. It emphasises that problem-solving skills entail solving problems through 'algorithmic thinking', which according to one writer 'is the third stage in problem solving that began to succeed the intuitive and prescriptive stages even before the computer era, with such precursors as scientific management'.[105] This also tends to lead to an emphasis on process (rather than product) learning. According to Kenneth Ruthven the development of computer skills is very much 'conceptualised within a process-oriented model for the curriculum which emphasises the development of information-handling and problem-solving skills'.[106] The concept of knowledge that is mobilised is instrumental in the extreme and is concerned with control. It is about the use of powerful electronic tools to manipulate and control the world. Thomas Dwyer refers to this as 'liberating control', which means control over both the environment and over oneself:

> Control over the environment would include control of social, physical and economic factors. More important, education should teach internal control. After three decades of work with progressive education, Dewey could still write, 'the ideal aim of education should be self-control'.[107]

The major exponent of this cognitive instrumentalism, the deity of the computer literati, has been Seymour Papert, whose book, *Mindstorms* (1980),[108] is a constant point of reference. Papert expresses a concern in his work with the 'theoretical consideration of education, computational models and the human psyche'.[109] It constitutes undoubtedly the most coherent and successful version of the cognitivist position with its assimilation of human psychic processes to that of the computer. Papert envisages children as miniature programmers, arguing that 'in teaching the computer how to think, children embark on an exploration about how they themselves think'.[110] The emphasis is on process skills and learning how to learn. Papert stresses 'the power of ideas and the power of the mind' and their

importance for gaining a 'sense of mastery'.[111] Fundamental to his conceptual framework is the developmental psychology of Piaget which places particular emphasis on the cognitive dimensions of infant and child maturation. It was from Piaget that Papert took over the idea of 'child as epistemologist', of 'children as the active builders of their own intellectual structures'.[112] Subsequently, his project was to 'uncover a more revolutionary Piaget, one whose epistemological ideas might expand known bounds of the human mind', and to do this by placing Piaget's psychology within the framework of artificial intelligence theory.[113]

What should be clear by now is the affinity between Papert's position (and, indeed, the doctrine of computer literacy in general) and the instrumental progressivism we discussed earlier in this chapter. Papert, who refers to himself as 'an educational utopian', locates his work within progressive traditions. There is, he suggests, a form of educational computing, characterised by drill and practice, which reinforces traditional and reactionary educational structures. Within such structures, the teacher is 'an authority figure who prescribes the exercises and judges their performance', while the child learns 'how to accept authority in a way prescribed by school and society': 'Replacing the human teacher by a machine changes nothing, except perhaps that it makes the process more effective by giving it a mechanical image that is in fact more resonant with what is really going on'.[114] Such an approach creates a situation in which the student is passive, programmed by the computer rather than programming it.

This is the kind of teaching situation that Bernstein refers to as the collection code. Against it, Papert counterposes a cognitivist progressivism that we can characterise in terms of the integrated code. In this approach the child programmes the computer, 'the child himself is in control, and the results of the child's programming are limited only by his imagination'.[115] According to Papert, 'the authoritarian model is broken': 'The teacher becomes a partner with the child in a joint enterprise of understanding something that is truly unknown because the situations created by each child are totally new'.[116] There is also, we are told, a change in the child's relation to knowledge, which now becomes a source of power, the capacity to 'make things work'. Interaction with the computer 'can put the learner into contact with his most private self, it can also nurture in him an image of himself as an independent intellectual agent'. Papert explicitly situates his work in the context of progressivism, in the tradition of Dewey, Neill and Montessori, arguing that their views were fundamentally correct but 'failed for lack of a technological basis'.[117]

Bernstein's observations on progressive education should make us suspicious of any attempt, such as Papert's, to counterpose egalitarian and collaborative progressivism against authoritarian and dominative didacticism. Relations of power do not just dissolve away. Because of this the question we should raise is that of the particular form which relations of

power and control assume. Into what decisive structures and procedures are Papert's students socialised?

As a number of critics have pointed out, Papert has an excessively rationalistic understanding of human development and identity.[118] This cognitivist emphasis is characteristic of instrumental progressivism. As Valerie Walkerdine has observed, the panoptic discipline that underpins progressivism is based on 'a transformation from regulation by overt coercion to regulation by covert normalisation, based on apparatuses and techniques for the classification and therefore regulation of the normal'.[119] What has come increasingly to distinguish this process of covert regulation is an emphasis on rationality. Thus, Piaget asserted the normality of a progression in child development from emotion to reason, and he 'suggested that the best course for mankind was to channel children's development away from the dominance of the emotions towards the rationality which alone would be the guarantor of progress'.[120] Development was seen in terms of the acquisition of knowledge, and the normalised child was seen as spontaneously and naturally rational. Drawing on Foucault, Walkerdine suggests that rationality came to be regarded as an intrinsic feature of development, one that could be observed, normalised and regulated. The current obsession with skills, competencies, process learning, and so on, is a further stage in the normalising 'scientific' discourse on cognitive development. Its achievement is a conception of the student or trainee as an information processing machine.

What this account suppresses is the intuitive, emotional, aesthetic side of human experience, in favour of an exclusive preoccupation with cognition. Even in terms of cognition, it privileges analytical thinking over holistic forms of understanding.[121] This faith in logic, rationalism, quantification models, finds its most developed expression in cybernetics and artificial intelligence theory.[122] As Douglas Noble has demonstrated, cybernetics has been an important shaping force in the development of instrumental progressivism: cybernetic and information theory 'came to be absorbed – through the work of Jerome Bruner and others – into an "intellectual" reform of American education, culminating in educators' recent fascination with the cognitive: problem-solving, thinking skills, and the microcomputer'.[123] There is also an affinity with cybernetics in the work of Piaget. John Broughton refers to his work as 'cybernetic bio-psychology' and suggests that what Piaget 'strives to capture in his theory, that pragmatic quality of human beings that can be comprehended within a cybernetic worldview, is purposive-rational and goal-directed action'.[124]

This cognitivist position is perhaps the most refined form of instrumental rationality. Broughton refers to it as 'systems positivism' and suggests that its significance is in 'socialising individuals in the cognitive mode appropriate to functioning within bureaucratic organisations...socialisation into deference to a particular, functionally defined form of authority'.[125]

Computer literacy, in its more 'progressive' forms, claims to liberate students, to endow them with control over their environment and their selves. Papert acknowledges that the computer makes people afraid of 'losing respect for their intuitions, sense of values, powers of judgement. They worry about instrumental reason becoming a model for good thinking'. For him, however, these are not 'fears about computers themselves but rather...fears about how culture will assimilate the computer presence'.[126] His is a use/abuse model: the computer is a neutral force in society, which may either be used beneficially or, alternatively, misused. Our own view is that the problem is a great deal more profound. The computer, we believe, is deeply implicated in transformation in our self-image and in relations of power and control. This is not some unfortunate by-product, a temporary problem of misuse, but is, rather, an intrinsic and constitutive aspect, one that is central to evolving forms of 'progressive' social control.

9

DECONSTRUCTING THE ACADEMY

The new production of human capital

As the preceding chapter demonstrated, the pedagogy of instrumental progressivism was pioneered amongst 16- to 19-year-olds in further education colleges, though it quickly made its way into schools where it reached a younger age group. In further education are found the attendant emphases of instrumental progressivism: a shift towards competencies and skills away from the primary concern with content; closer links between colleges and the world of work; a concern for project-based study rather than for discipline-led teaching; a heightened interest in experiential learning which accompanies the promotion of a student-centred approach; and all the rest.

Further education colleges and, more recently, schools have undoubtedly been the focus of instrumental progressivism. Nevertheless, its ethos and practices have penetrated deep into higher education since the early 1980s, most obviously in professional courses from the health care, business and engineering realms, but also reaching a very much wider range of degree and even postgraduate programmes.

So profound have been the changes in British higher education over the past two decades that they merit the separate discussion we present in this chapter. In the following we intend to trace the extension of instrumental progressivism into higher education, at once to develop this theme from the previous chapter, but at the same time to consider the meaning and significance of changes so deep-seated that they raise questions about the very conception and purposes of the university today.

The most visible development in higher education has been the massive increase in participation rates which have leapt from 12 per cent or so of 18-year-olds to in excess of 30 per cent in the space of twenty years (with an exceptionally rapid growth since the late 1980s). There are currently over 1.5 million students in higher education, compared with just over half a million in the late 1960s (which itself followed a period of what was then regarded as unprecedented growth after Robbins' advocacy of expansion),[1] an expansion that has been accompanied by a unit cost reduction (i.e. funding per student) of about 40 per cent over the past two decades.[2] This is

routinely described as being indicative of a transition from élite to mass higher education,[3] something which has come late in the day and as a matter of urgency in the United Kingdom, bringing with it enormous upheaval and redefinition of the purposes of higher education.[4]

Apart from the noticeable overcrowding that now must strike any visitor to university campuses, perhaps the most remarkable recent development in higher education was been the retitling of thirty or so polytechnics to call them universities in 1992. On the surface this was an overdue (and overnight) promotion of doughty triers into more esteemed company, something towards which the 'older' institutions defensively responded by labelling the entrants 'new universities' (overlooking the fact that, of the pre-1992 universities, the overwhelming majority were themselves created after 1960).[5] However, it may be more accurate to suggest that, rather than the redesignation of the polytechnics being a matter of promotion into the ranks of established and settled universities, this reclassification was more a sign of changes in the conception and conduct of universities throughout higher education.

Prominent in that change has been a heightened involvement of politicians and industrialists to ensure that universities address more adequately their priorities and problems. The polytechnics, located from the outset in what was called, somewhat misleadingly, 'public sector higher education', had much closer links to local businesses and employers especially, just as they were more innovative in producing courses and ways of teaching that had a more vocational orientation than the universities. Their mode of funding, their constituency of students, and the character of their governing bodies made the polytechnics, compared to the universities at least, more responsive to politicians and industrial bodies. Of course, even the older universities had extensive links with industry, many going back to their points of origin,[6] and they also had vocational connections (notably in law and medicine), but it remains the case that, historically, there had been little external intervention in the university itself. Universities were 'chartered' institutions, granted rights by Parliament to self-governance and independence of action. Though they were nationalised organisations insofar as government paid their bills, the state did little else other than act as provider, and even after the large public investment that led to the creation of a cluster of new universities in the 1960s (York, Sussex, Kent, etc.), there followed no interference in their day-to-day autonomy. To be sure, there were often intimate relationships built up over the years, with sponsorships here, collaborations there, the occasional advice from professional associations, and suggestions from ministers, but, especially compared with public sector higher education, the lack of outside interference was most noticeable.[7] Nowhere was this more evident than in design of the curriculum, in the conduct of teaching, and in the construction of how and by what criteria a graduate might be identified.

However, during the 1980s there was a marked increase in the range and intensity of government attempts to direct higher education. In these moves the ex-polytechnics were in general more amenable and malleable (perhaps also more vulnerable) than their university cousins, and because of this, as the polytechnics more willingly complied and were awarded the title of university, so the established universities were changed so as to become more like polytechnics themselves.

Government hold over the purse strings of higher education was a major means of influence, and much of this was exercised to inhibit higher education from developing in unwelcome directions. There was, for instance, an effort by the first Thatcher administration to switch resources away from arts, humanities and social sciences and transfer it to more practical and vocational science and technology subjects. A minister at the time, Norman Tebbit, explained this as taking away money 'from the people who write about ancient Egyptian scripts and the pre-nuptial habits of the Upper Volta valley', and giving it instead to the subjects that industry really needed. In addition, and over time more tellingly, limits were placed on the funding of student places (previously funding had followed students and depended largely on their choices of what to read at university) as a mechanism for restricting any misconceived expansion.[8]

Also significant were government inducements to persuade universities to move in more favoured directions. For instance, during the late 1980s and the 1990s social science research funds were made more conditional than the previous 'response mode' of applications (which meant that researchers sought funds for projects that appealed to their own interests and the research council asked peers to judge whether they were worthy of support), with new strictures placed on value to 'users' and 'policy' relevance, encouragement of applicants to build 'partnerships' with sponsors, and the creation of pre-set 'programme areas' by the research boards to ensure that research bids were channelled in approved ways.

More important, government initiated major projects which have intruded into the curriculum and pedagogy itself. The Manpower Services Commission's *Enterprise in Higher Education* (1987) project, for instance, set out to encourage universities to build the teaching of 'skills' into existing courses, aiming thereby to 'inbed initiative (itself) into the curriculum', for which institutions would receive financial inducements.[9] Not surprisingly, universities, hit hard by funding reductions elsewhere, were drawn to bid for these resources, and, moreover, the former polytechnics, already familiar with such vocationally oriented values, were leaders in the uptake.[10]

These sort of initiatives continued throughout the 1990s, irrespective of a change in government. For instance, New Labour published, in the year it took office, its 'Higher Education and Employment Development Programme' which celebrated earlier efforts to better integrate higher education courses with vocational qualifications and to promote work-based

accreditation. Since 1996 the programme has also promoted activities such as 'Alumni Networks' that are intended to ensure recent graduates keep universities informed about the realities of employment after college so they might 'improve the relevance and responsiveness of the curriculum'. Still more revealing of the unrelenting growth of government intervention in the inner life of the university is the programme's current plan to 'bring the key skills of new entrants to higher education up to NCVQ (National Council for Vocational Qualifications) level 3 within the first year of their course', all in the name of better co-ordinating and cohering schools, further education colleges and university level policies, and all intended to promote the relevance of education to employment. In this light it can be no surprise to read in Dearing, the most weighty report on the university since Robbins in 1963, the insistence that 'as necessary outcomes of all higher education programmes' there should be incorporated 'the key skills of communication…numeracy, the use of communications and information technology, and learning how to learn'.[11]

INSTRUMENTAL PROGRESSIVISM IN THE UNIVERSITY

Government has undoubtedly become more interventionist in higher education. Clearly, this has a great deal to do with rationing diminishing resources while expanding student numbers, but it is also integrally connected with the growth of an 'audit society',[12] something which expresses an ethos that public spending must be meticulously accounted for and effectively dispersed. This has been accompanied by the injection of business practices into the university[13] (most noticeably in a heightened and more directive managerialism and an associated demotion of academics and hierarchies based on peer recognition) by the prioritisation of income generation and entrepreneurialism, and by the increased use of market mechanisms in university affairs.[14]

It has to be conceded that marketisation has on occasion stimulated universities to do things they might previously not have countenanced – the rush to recruit full cost overseas students is an obvious instance, another is the rapid expansion of taught postgraduate courses which are largely funded by students themselves – but it is bizarre to reason that the imposition of a 'contract culture' by government may have had the paradoxical effect of making them more autonomous.[15] Innovations to increase revenue from non-state sources may have been conspicuous, but they produce marginal funds only (which is not to say that they are unimportant for that!). In truth, however keen universities have become to minimise their dependency on the state, the overwhelming majority of their income comes from that source, chiefly for teaching students and, to a lesser extent, for research.[16] Given this, it is inevitable that, when government determines to make those funds more conditional, then higher education falls victim to greater state centralisation.[17]

The major refrain of government intervention has concerned the appropriateness of universities' responses to economic exigencies. 'Higher education should serve the economy more effectively', insisted a government paper in 1987, striking a keynote that has not since been silenced.[18] The 'needs of industry' and the 'employability' of graduates have been high and inseparable priorities in this instruction. Time and again the message received from industry, and relayed through government, has been that the universities have not managed to supply appropriate outputs, that graduates have most conspicuously lacked the 'transferable personal skills' that would make them useful to employers.[19] This complaint may often be linked to the criticism that universities place too much emphasis on academic disciplines and the performance of students on this scholastic (and unworldly) terrain. Recurrently employers, and through them government, insist that what graduates must possess are *competencies* – that is, abilities to *do*, rather than merely know about – which will equip them to act effectively in the 'real world'.[20] The skills required here, though they are variable, revolve around conceptions of numeracy, communications, team-work, adaptability, self-motivation and such like. They ring a distinct chord with the pedagogy of instrumental progressivism.

It has to be admitted that the call to promote transferable skills in the curriculum comes not only from outside the university. From within have come many similar calls, and these not just to make students more employable, but also because they promise to further progressive pedagogic reform. To the fore here are those who favour a *student-centred* approach to learning, something which would relegate the domination of academics and their primary commitment to disciplinary values and peers. For far too long, say the reformers, they have imposed their own views on students, who have been compelled to act as – frequently unwilling – apprentices to experts in given subject areas. The reality is that very few students aspire to follow the paths of their university teachers into academe. Far and away the majority will never practise as professionals the subjects they read, and it is a conceit of academics to act as if they would (even in vocational areas such as engineering a large minority do not work as engineers upon graduation, while relatively few historians or social scientists practise their disciplines after leaving the university). Moreover, what students chiefly gain from university programmes are, at present, unacknowledged, or, at the most, underestimated by curriculum designers. Here one thinks of capacities to present an argument effectively, to assess and evaluate different positions in a debate, to solve problems, to improve one's writing and oral skills, to find information effectively...in short, to develop 'transferable skills'.

We would acknowledge a certain radicalism among educationalists who wish the university to adopt a policy of student-centredness. They start with the students' concerns and priorities, rather than with those of academics or,

indeed, with those of employers and government. This pedagogy has something to commend it, above all perhaps a recognition of the transformative potential for the whole person of the university experience, along with the justifiable location of students' concerns at the hub of the university.[21] However, what we must emphasise here is the conjunction of employers' and governments' desires to change the university, with that of progressives' campaigns for reform within higher education. The latter have been arguing, against odds that have been stacked in favour of academic domination, for decades. It seems, however, that significant advances can be made only now, at a time when progressive pedagogy can be forwarded for instrumental purposes. We might highlight some important expressions of this instrumental progressivism as it has been manifested in higher education in recent years.

- An emphasis on *transferable skills at the expense of knowledge of a particular subject*. In some universities transferable skills are elaborated and incorporated into the design of every course and option, grouped perhaps as skills such as 'self-management' or 'problem solving', then further placed in categories that are to be taught, practised or assessed. For example, modules might signal a category of transferable skills such as 'teamwork', then break this down into three further elements, namely: 'ability to take responsibility and carry out agreed tasks', 'ability to take initiative and work with others', and 'ability to negotiate within a framework of respect for others'. Such promotion of transferable skills necessarily relegates the place of content in the curriculum.

- A switch towards *competencies* in curriculum design, such that students may demonstrate 'things they can do' rather than, as in the past, concentrating on the degree to which students absorb knowledge of an academic discipline. Central to the competence movement is that the university should explicitly recognise transferable skills. In the past students undoubtedly developed several of these, but as far as the curriculum went they were unacknowledged and unrewarded. In contrast, today transferable skills are increasingly identified as competencies that students should be taught, and which they must practise and master.[22] The practice of describing courses in terms of *learning outcomes* that can be operationalised (in the formula, 'at the end of this course students will be able to...') is displacing the former prioritisation of 'topics to be covered' in an 'apprentice' and 'adversarial' way that was, thereby, inherently provisional, incomplete and subject to argumentation.

- The transfer of *assessment away from unseen examinations* at the end of three years towards a variety of methods of assessment – but especially towards course work of one sort or another (essays, projects, presentations, reviews, etc.) undertaken throughout the course. In addition, assessment increasingly takes the form of specific tasks which include a significant amount of negotiation of topic, approach and subject between students and tutors, with the range of transferable skills built into the exercises.

- Rapid development of *modular programmes* which facilitate student choice, a process caricatured as developing a 'pick and mix' degree, but one which affirms that students have rights and responsibilities to plot their own degree programme. This emphasis on the student demotes the academic, while simultaneously underlining the self-responsibility of the student to create, through judicious choice and reflection, their own mode of study. In this regard one may note the boast of at least one modular degree programme which claims that, while handling several thousand students at any one time, no two individuals undertake exactly the same programme of study. For us, this individuation of higher education is an especially significant mode of control since, while it reduces the import of the content of education, it increases the responsibility of individual students for their own educational success (or failure).

- An important ingredient of higher education involves the widespread adoption of the concept of the *reflective practitioner*.[23] This encapsulates the ambition to encourage routine and constant self-reflection on the part of students, the better to allow them to choose their own future options, as well as to learn more effectively from their past and ongoing experiences.

- Intimately tied to this is what is perhaps the most common transferable skill currently sought after in higher education – *critical thinking*. Just about everywhere the expressed intent to stimulate 'critical thinking' abounds, and it is something that can appeal as easily to the businessman who wants imaginative problem-solvers, to the accountant who strives to encourage lateral thinking, as to the iconoclast who wishes to see students questioning the interests that might lie behind intellectual positions. We suspect that it is difficult to find any degree programme in the country that does not profess to develop 'critical thought'. After all, if one aims to create reflective practitioners who constantly scrutinise themselves and their actions, then a necessary adjunct is a quality of critique. It is our view that the only way such a potentially destabilising concept as 'critical thinking' can find inclusion on degrees such as Midwifery and Business Administration, Estate Management and Tourism Studies, is to denude it of real force by limiting it to pre-established (and incontestable) goals. In such a way 'critical thinking' is 'operationalised'[24] as a practical 'competence' which might allow the more effective delivery of babies (while the organisation of welfare services is out of bounds), or might reflect on how best to maximise corporate interests (but will not open wider questions about business behaviour), or may consider novel solutions to managing estates (but will not query the need for estates to be managed), or might encourage better ways of handling tourists (but will not countenance the thought that perhaps tourism should be abandoned).

- An integral element of instrumental progressivism is the development of *ongoing monitoring* of the student and the *extension of surveillance* into hitherto untouched realms of the student's life and psyche. Ongoing monitoring is most evident in the much more regular assessment, and the increase in things subject to assessment, which is so much a feature of modularisation and its consociate

semesterisation. In consequence students receive feedback on their progress at much more regular intervals than hitherto (not merely in the now twice – and sometimes more – yearly assessment round, but also because of more routine assessments such as presentations and group activities), and they also get information about many activities (oral abilities, time management, and the gamut of transferable skills) which formerly scarcely received note when knowledge was, at least officially, the primary concern. Of course, a major rationale for such trends is that they improve the self-reflection of the student now charged with taking responsibility for his or her own learning.

• In addition, however, we may see much more systematic, and even more regular, surveillance, in the introduction of *student profiling*.[25] A logical extrapolation of student-centredness and the diminishment of disciplinary judgement, profiling promises to record and evaluate everything and anything deemed significant that is undertaken by the undergraduate. It is impeccably progressive, placing at the core the individual student, but promises to document all that happens – performance in and out of class, relationships with peers as well as with staff – in 'records of achievement' that will contribute to an individuated 'graduate profile'. This will replace the (relatively) uninformative degree certificate with a 'portfolio' that includes self-assessment statements gathered by the student, performance on a clutch of modules (and a statement of why these were chosen) experiences on field trips, transferable skills that were practised, participation in sports clubs, involvement in the students' union, activities such as helping with induction, etc. Profiling is at a relatively early stage in British universities, but it is likely to advance in the future. Not least this is because it contributes to ambitions to inculcate the habit of 'lifelong learning' so much desired by government and business interests. Dearing's recommendation that universities should provide students each with a 'Progress File' as a means of recording 'achievements up to that point, and which is intended for use throughout life',[26] underscores and encourages that trend.

POST-FORDISM AND THE UNIVERSITY

Instrumental progressivism is developing apace in higher education, driven along by an unanticipated alliance of educational radicals and government figures alert to the expressed needs of industry. However, there can be little doubt that it is the latter which is the most consequential force. Consonant with what are presented as pressing economic exigencies, in recent years it has become the orthodoxy to commence any advocacy of change to higher education with the insistence that reform is essential because of radically shifting socio-economic circumstances.

Many of the commentators who have been touched by the social science literature refer to the arrival of 'post-Fordism' which requires a quite

different form of higher education than what went before.[27] Though the conceptual terms are inexact,[28] several themes are reiterated by all commentators, whether or not they are informed by social theory. As is clear from our earlier chapters, we prefer the term neo-Fordism because this reminds us of the fundamental continuities that are too easily overlooked by those who would focus on recent changes. Nonetheless, we share with most others agreement on a number of important features of the present era. These include:

- *Globalisation* has resulted in a massive acceleration of change and an increase in competitive challenges which have heightened uncertainty and raised the stakes in economic affairs. There has also been an associated decline of national sovereignty over economic matters, because globalisation tendentially undermines the possibility of an independent national economy.[29] The upshot is that a global, interpenetrative and largely autonomous market system exercises massive constraints on nations while being out of the control of governments.[30]

- Universities must respond to these new times by ensuring that employees are equipped with up-to-the-minute *skills and knowledge* that may match changed and changing circumstances.

- In order to ensure provision of these skills and knowledges *universities and industry/business must become more closely integrated*. If it is the case that 'in the rapidly-changing global economy, continuous acquisition of skills and knowledges is at a premium', then it is entirely consistent of government to create, as expressive of the ultimate logic of integration, a *University for Industry* to 'spearhead a skills revolution in the UK' that will boost competitiveness and employability.[31] Other universities are all encouraged to move in a similar direction.

- A crucial quality (even the primary skill) of employees is possession of the *flexibility* to be capable of timely adaptation to constantly changing circumstances, thus able to train – and routinely re-train – throughout their working life. Thus emerges the mantra of 'lifelong learning'.

- Since universities must produce graduates with the requisite flexibility to make their way in this unsettled world, so too does it follow that the *university must enhance its own flexibility*. Flexible employment demands the flexible university. Higher education must rid itself of rigid practices, for instance by becoming modular, by encouraging access, by making things easier for part-time study, by routinely amending courses, by offering short courses when needed, by making innovative deals with businesses, by opening throughout the summer months, and remaining open late into the night.

- Increased proportions of occupations in this new world, including the most appealing of these, are *symbolic* or *knowledge-intensive*. That is, in the 'Information Age', traditional sources of employment can no longer be relied upon because they have been superseded by a new kind of symbolic and information labour. In the words of the Prime Minister, 'more people now work in film and TV

than in the car industry – let alone in shipbuilding',[32] and education must respond to this trend.

Combined, these factors hoist the university to the centre stage of economic policy, since it is higher education that is charged with equipping future workforces (and responsible for continuing to prepare them in permanently volatile circumstances), and because these workforces are increasingly information/knowledge-intensive. Moreover, since governments have been compelled to abandon national economic policy by the forces of globalisation, then they must promote the one thing over which they have national leverage – hence the prioritisation given to higher education systems that are charged with making sure that the country's young have the qualities that will allow them to capture the best available jobs in global capitalism. Seen in this light, it is not surprising that the *Economist* observes that the university has 'come to look like an increasingly useful asset'.[33]

This analysis and the policy outcome may appositely be called 'Reichian', after the influential account offered by Robert Reich shortly before his elevation to the position of Secretary of State for Labor in the Clinton administration.[34] In his *The Work of Nations: Preparing Ourselves for 21st Century Capitalism*, Reich affirms that the central concerns of government must be with the higher education system's capacity to produce sufficiently appealing products so as to win a disproportionate share of the world economy's top 20 per cent of jobs. Reich's central concern is for the United States, where – because even here the notion of a distinct national economy is fallacious and hence beyond government reach – the president may act in the national interest by concentrating on policies that will ensure his people find employment as 'symbolic analysts'. These are the experts who are 'continuously engaged in managing ideas' and who 'solve, identify, and broker problems by manipulating symbols'.[35] They share the characteristic of being highly educated, thereby in command of, and comfortable with, the key skills of abstraction, system thinking, experimentation and collaboration. They are at home in the fast-paced world of global capitalism, a world that has left behind the sameness and solidity of the Fordist era (when mass manufacture and repetition were the most familiar work experiences), a world where very large numbers of 'knowledge workers' will be found inside the nation which can maintain a university system capable of producing the high level qualities of its 'symbolic analysts'. Appropriately educated in top-flight universities, symbolic analysts hold together and operationalise the global market system, and any nation which can locate large numbers of them within its boundaries is ensured prosperity and contentment.

It is this analysis which underlies Mr Blair's ambition to make 'London the knowledge capital of Europe',[36] and it is at the heart of his repeated insistence that New Labour's main policies are 'education, education, education'.[37] It is the same Reichian presuppositions that lie behind the

Department for Education and Employment's statement that higher education is one of the 'principal assets available to the UK economy as it confronts an increasingly competitive, and rapidly changing, global environment' because 'growing proportions of people are employed in industries which depend on the creation, management and dissemination of knowledge'.[38] It is the same Reichian premises which underpin Dearing's proclamation that 'in the future, competitive advantage for advanced economies will lie in the quality, effectiveness and relevance of their provision for education and training'.[39]

More and more governments regard higher education in this way as a site of 'human capital'. It is certainly the case that such an approach accords with a great deal of social analysis which emphasises the emergence of a new post-Fordist paradigm. A prominent instance is found in the work of Manuel Castells.[40] Here the category 'informational labour', estimated to account for 30 per cent of total occupations in OECD countries, is used to identify the jobs which generate change, bind together economic activities, and generally do the thinking, conceiving, planning and operationalising required by 'informational capitalism'. The occupations which come under this label 'embody knowledge and information',[41] a feature which is developed by the university.

Informational labour's centrality to the present era has a great deal to do with what is its major quality, what Castells terms its *self-programmability*. That is, informational labour has a range of general and specific skills, but none is more important than the capacity to train and re-train, a core skill of 'learning how to learn' that is the requisite for the adaptability and opportunism demanded in the dauntingly flexible world of informational capitalism. Not surprisingly, it is just this requirement that lies behind strenuous efforts, throughout the education system and beyond, to inculcate an ethos of 'lifelong learning' in a 'learning society'. For the same reason, universities must also adjust, making themselves maximally available for 'informational labour' to retool and update skills as circumstances decree.

It is in this context of profoundly altered socio-economic circumstances that we need to situate the transition in Britain, at breakneck speed, from élite to mass higher education. The extraordinary expansion of universities such that they are now part of the life course of one in three young adults ought not to be explained simply as either a result of local political considerations or even as the democratisation of higher education under pressure from the excluded. Though these are undoubtedly contributory factors, they are secondary to the widespread conviction that informational capitalism's occupational structure means that the more desirable jobs are those of the 20 to 30 per cent of the workforce engaged in information/knowledge work. If a nation hopes to prosper, then it must seize a good number of these for its citizens. Dearing saw this and accordingly concluded

that 'the UK must plan to match the participation rates of other advanced nations: not to do so would weaken the basis of national competitiveness'.[42]

It would be a mistake to think that, amidst this expansion of higher education, the university remains much as it was before. On the contrary, as we have already intimated, and as we develop below, the conception and purposes of the university are profoundly transformed in this process. Expressive of this change is the emphasis on transferable skills which we have described above as a major instance of instrumental progressivism. Later on we shall observe how 'post-Fordism' has demanded even more profound transformation in the idea of the university.

PORTFOLIO CAREERS

For the moment, however, we wish to consider further the character of informational labour in the neo-Fordist era since this has important consequences for our understanding of the changing university. In this regard it is relevant to note that it is often observed that nowadays we are witnessing a significant debureaucratisation of organisations. This finds expression in euphemisms such as 'delayering' and 're-engineering' of organisations, a process that has led to significant redundancies amongst several levels of white-collar (informational) work – a common enough experience for manual workers, but historically rare amongst non-manual employees whose work histories have typically exhibited security of tenure with progress up the bureaucratic ladder.[43] A result of recent changes in organisations is that bureaucratic career pathways are often blocked, and with their closure come the most serious consequences for much educated labour. The option of entry to a large organisation with which the employee will probably stay for some years, and in which he or she will rise steadily up the hierarchy, is being closed off.

The argument has it that the rigours of market competition combine with the necessary rapidity of response to constant turmoil to make bureaucratic structures both expensive and unwieldy. Furthermore, the extension of information and communication technologies throughout the organisation and around the globe also makes these structures unnecessary. Bureaucratic hierarchies lose much of their purpose where information networks facilitate decision-making and implementation (and where speed of response is more imperative than ever). A consequence is what Castells[44] describes as the decline of the 'vertical' and its replacement by the 'horizontal' organisation, by which he means that, as institutions have cut out levels of their bureaucracies for reasons of economy and because technologies may displace them, so have they empowered those employees who remain behind. In these new organisations, where 'flat management' prevails, those who remain are the crucial ingredient of success, and to act in a timely and efficacious manner they must be free of hindrance from above.

However, while those remaining in employ are essential, they cannot anticipate promotion through bureaucratic ranks, with attendant status, annual increments and the like, since that option has been removed. Still, it is suggested that such a prospect is neither missed nor grieved over since this type of worker does not perform effectively when constrained by bureaucratic hierarchies. Rather, in an increasingly networked society where fax, e-mail and computer make communications and information analysis, movement and storage straightforward, these workers use – and value – the (horizontal) links they make when working on a particular project. Their allegiance is thus more to the project and the 'global web'[45] of relationships they maintain rather than to a particular corporation. Their primary reference group thus becomes the peer group which works in similar domains to themselves (for example, the realm of software engineers, or of advertising copywriters, or of research bio-chemists) and their first priority is to the success of the particular project on which they happen to be working rather than to the company which has contracted for it. It follows that they experience little concern about loss of security in their careers, which are marked by movement from one contract to the next, developing reputations amongst a reference group that cuts across corporations. They want to be acknowledged more as fine designers or journalists than as employees on a certain point of the organisation's pay scale with promises of increments and a pension. By the same token employers cannot command much loyalty from these transitory workers, and for precisely this reason they cannot readily control them. These are autonomous workers who are pivotal to corporate success, and for that reason must be given their heads.

It is easy to paint an appealing picture of the spread of this 'network society' in which highly adaptable, innovative and well-educated people wield real power in the new world of informational capitalism. What is conjured is an era of contented migratory professionals, working perhaps in biotechnology or knowledge engineering, beholden to no single corporation, but crucial to the development of new products and the identification of market opportunities, and getting a buzz not from monetary reward but rather from professional recognition on the 'global web'. What movie actor doesn't put an Oscar over mere dollars? What writer a Pulitzer prize over security? What scientist the Nobel prize over administrative authority? Castells goes so far as to depict such people as possessed of a 'spirit of informationalism', by which he means to capture the vocational commitment and restless energy that simultaneously destroys and creates.[46] And Francis Fukuyama, while he bemoans a general decline of trust between people in an increasingly contractual culture, can see in these network entrepreneurs the generation of 'social capital', by which he means common bonds established between like-minded (and similarly schooled) individuals who share ethical and professional standards.[47]

There is certainly a case to be made in favour of the spread of these portfolio careers,[48] of working lives wherein people demonstrate their appeal by presenting would-be employers with evidence of success on a range of projects in a variety of organisations. Here labour flexibility may be regarded as liberating, even exciting, characteristically go-getting and in charge of its own fate. It may well facilitate compatibility between family responsibilities and career demands, and it can support defiance towards employers who have lost the ability to achieve compliance through appeals to company loyalty and threats about promotion. Another, much more realistic, and empirically informed, way of seeing this development, however, is as a 'collapse of tenure'[49] that has compelled most workers into a reluctant flexibility, to be employed on a series of contingent contracts that have few positive features.[50]

Yet it is striking how much the university system has colluded with the optimism of the 'portfolio career' ideologues to facilitate the development of flexible employees. It has made strenuous efforts to develop curricula in response to demands from employers that higher education should produce the required sort of graduates. Above all, this has been evident in instrumental progressivism's ambitions to create graduates who are aware of, and equipped for, future career patterns. Here the primary concern has been to develop flexibility amongst students as a means of appearing attractive to potential employers as well as capable of surviving in uncertain and unstable circumstances.

The commitment to flexibility is at the heart of most concern to develop transferable skills amongst university students. Of course, in so far as a skill is transferable it is inherently flexible, but often the association is a good deal more explicit. For instance, 'skills' – all prominent in the university today – such as being 'adaptable', 'enterprising', 'self-starting', 'self-reliant' and 'self-programmable', consciously respond to the new world of employment.[51] And 'transferable skills' like 'time management', 'problem solving', and 'working in teams', are intended to fit neatly with the needs of the flexible economy. Readers will scarcely need telling that the category 'transferable skills' can be remarkably elastic, capable of including just about anything outside the knowledge content and disciplinary orientations of subject areas. We return to this matter of definition below, but here would stress that what the ostensibly disparate transferable skills share is the premise that they will enable students better to sell themselves to future employers, and better to survive economic uncertainty, because they will have been imbued with the key quality of flexibility.

In this respect there can be few issues more pressing or prominent than that of 'computer literacy'. There are at least two reasons why this should be so. First, there is the fact that universities are very intense users of ICTs, so it is actually extraordinarily hard for students, on whatever course they take, to avoid them, whether as on-line searches, library catalogues, bulletin boards

or whatever. Second, if graduates are destined to make their way in a 'network society', then it follows that they must have some facility with the technologies of the net. Together then these account for the recurrent emphasis in many university courses on ensuring that students become adept with computer communications technologies and thus may become 'computer literate'. This is so commonplace that one may even say that 'computer literacy' is the most generic of all transferable skills.

We must insist that most talk of 'computer literacy' is wildly exaggerated (starting with the unsubstantiated claim that handling ICTs is comparable to literacy itself). Our scepticism is heightened when we recollect pressures to develop 'computer literacy' during the early 1980s. Then courses tended to stress elementary programming skills (in Basic or Fortran), spreadsheet use, as well as word processing. As the technology has become more advanced, as well as more pervasive, 'computer literacy' programmes have had to change tack. There is now no need for programming, even little need for word processing training, since the more sophisticated the technologies have become, the more they have become much easier to use. Nowadays 'computer literacy' courses involve little more than teaching novitiates to log on and off the network, find their way around the Internet, send an e-mail message, follow a Windows programme, and perhaps use a few other software packages. Increasingly students require next to no education in ICTs because they are already as familiar with them as they are with radios, television and telecommunications, and like these technologies ICTs are transparent to users (who needs to be 'telephone literate'?) before they come up to university.

This is not to deny that some students are initially disconcerted by the plethora of ICT systems they encounter when first entering the university. It is, however, to observe that a very few minutes induction, followed by access to machines and the confidence that follows from exploration and practice, are quite sufficient for them to roam the 'information superhighway'. Certainly, if they come across technical faults, then they will require help, as just about everyone else does, but the capacity to repair the computer, or even to reprogramme it, is not at all a requisite of facility on the network (just as driving on the motorways does not demand that one can fix a broken carburettor).

So why teach 'computer literacy' and why make such a fuss about it?[52] There is of course a manifest need to provide some elementary introduction to ICTs so that students may be launched on their way, but, to repeat, to describe the 'click and go' operations as a skill, still more to declare them a type of literacy, is perverse. However, the latent function of such courses seems to us to be more important. This is one that instructs students to be open to the new, to adapt willingly to constant change. In a turbulent economic environment, when employment opportunities for many are likely to be punctuated by periods of dislocation and idleness, then it is of

inestimable value if the displaced are convinced that this results from the inescapability of innovation, to which the appropriate response is to be 'enterprising' and eager to 'retrain' in the latest round of new technologies.

THE NEEDS OF EMPLOYERS

Two things are clear: a degree no longer guarantees entry into a middle-class career, as even in the recent past it once did,[53] and employers identify possession of transferable skills as essential qualities in those whom they recruit. Not surprisingly then, when universities, and especially new universities which have been pioneers in this regard, determine to incorporate transferable skills into their curricula, this has been received warmly by many of their students. Graduates are well aware that their credential is no longer the passport to a 'good job', that, indeed, in most areas there is an abundance of well-qualified candidates for each post, and that employers are emphatic that technical skills alone in any given area (whether in engineering or economics, computing or social work) are insufficient to match their requirements. Accordingly, very many students are more than content to spend time developing transferable skills as an integral element of studying for a degree.

However, when it comes to recruitment there appears to be a most serious difficulty. Time and again employers of graduates stress that they want recruits to have transferable skills – team-working abilities, problem-solving skills, communicative and numerate capabilities, etc. – but time and again they appear to find these manifest, not in those students from the new universities who have most often undergone programmes that have consciously nurtured them because of their sensitivity to the world of work, but in the products of the more élite – and preferably ancient – universities, where the language of transferable skills has penetrated least. Indeed, employers regard those graduates from the ex-polytechnics who have undergone explicit training in transferable skills as deficient for that very reason: had they been any good in the first place such students would not have required this compensatory education.[54]

Phillip Brown and Richard Scase, in their deeply disturbing study of employers' recruitment practices,[55] account for this paradox by arguing that transferable skills are but a code word for 'middle-class cultural capital'. That is, employers do want transferable skills, but these turn out to be, in all essentials, highly subjective characteristics found in abundance amongst graduates who attend the most élite institutions and come overwhelmingly from professional and managerial homes where they will have learned transferable skills almost as a second nature. Thus Brown and Scase:

> At rock bottom, the real skills for employment presented as 'personal and transferable' involve the exhibition of middle-class cultural capital, not

only manifest indirectly through academic qualifications, but also directly through the development of the socio-emotional features of middle-class identities. They are the truly generic social skills that are most acceptable to most employers.[56]

What is being argued here is that employers select graduate staff on the basis of a reputational model of universities, and that graduates from those institutions highest in the ranks, and those disproportionately from privileged homes, are presumed to have – and actually do have in the eyes of recruiters – the core transferable skills so much sought after.[57] In this respect the lower ranked universities, and those students who attend them and come from the less advantaged backgrounds, face massive hurdles – even if they have assiduously developed their transferable skills, and even if they have had them tabulated and scored, precisely because such 'skills' are, at root, vague, imprecise and perverted by employers' subjective perceptions.

Moreover, what we appear to be witnessing now is the permeation throughout hiring practices of what has long been the situation as regards recruitment for the highest levels of corporations. The 'high flyers' among graduates were always scrutinised for appropriate qualities that singled them out as 'executive material'; and 'leadership', 'independence of thought' and 'enterprise' have always been the sort of thing found most often at Merton or Magdalene. The difference is that today's recruiters seem to be applying this approach to the selection of *all* their graduates. They now want what Brown and Scase term the 'charismatic character', someone with a 'personality package' bursting with 'commercial acumen', 'self-starting capacities', 'confidence', 'oralcy' and 'entrepreneurial' zeal. And they discover these traits in students by recruiting people just like themselves,[58] while those least mirroring their self-reflection (concentrated in the less prestigious universities) are the last to be looked at.[59]

It is important to say that transferable skills are very real qualities, and that reformers in higher education are right to insist that the experience of being an undergraduate does improve these significantly. But enthusiasm for transferable skills is also a very dangerous cocktail, one which mixes highly dubious perceptions with those that may be much less disputable. It seems to be the case that employers' predispositions have led them to concur with educational progressives that transferable skills are of great value, and then to use these for recruitment in ways which few progressive teachers would approve.

Further, Brown and Scase point out that students who are taught transferable skills do value them, but that many of these students, especially those from the less prestigious universities, had not fully appreciated the need for flexibility of employment. That is, while these students were willing to be flexible at work, they were unprepared for 'portfolio careers' and unaware that a degree would no longer set them on a managerial or

professional occupation pathway. They had, for the most part, anticipated that a degree would have got them a 'good job' with 'career prospects', and in this expectation they were disappointed. Interviewing graduates a year or so after they had left university, Brown and Scase found considerable disillusion amongst those locked into temporary, insecure and unsatisfying jobs, having not fully understood while they were students that a changed corporate sector can no longer guarantee career track positions (except, ironically, for those from the élite backgrounds and premier league universities who were, also ironically, the most willing to perceive and welcome the prospect of flexible employment).[60]

What the foregoing draws attention to are inequalities of stratification that are deeply entrenched in Britain, and with which universities, the curriculum, and employers' preferences are closely intertwined. An eye to such differences, ones easily overlooked in discussions of the university and its products, alerts us to the possibility that the rapid expansion of higher education may result in there being markedly differing employment opportunities for graduates, dependent on their social origins and the standing of the institution they happen to have attended.

Furthermore, and integrally related to these inequalities, one may cast doubt on the presupposition that our 'post-Fordist' economy really does require as much as 30 per cent of the labour force to be graduates of universities.[61] There is, for instance, evidence that many graduates are now doing jobs previously performed by those with A-levels.[62] In addition, Geoff Mason detects in the financial services area (and this is a key 'Information Age' industry) a bifurcation of recruitment between 'high-flying' graduates with prospects (and good pay) and the rest (totalling as much as 45 per cent of graduates employed) entering clerical, cashiering and such like jobs.[63] Many of 'the rest' will be the products of the less esteemed universities.

This may be related to widespread doubt about the claimed maintenance of academic standards through time and the equality of institutions awarding degrees. Though in principle a degree from Derby is equivalent to one from Durham, and though it is asserted that standards throughout the system have been maintained despite the rush to mass higher education, few employers are so convinced.

It has to be conceded, moreover, that it is not just employers who express concern that the quality of graduates may either have declined and/or be differentiated by institution. The abolition of the Council for National Academic Awards (CNAA), the body which since the late 1960s had certified that degrees had achieved an acceptable threshold standard in public sector higher education, and the ending of the supervisory role of Her Majesty's Inspectorate (HMI) simultaneous with an expansion of student numbers without proportional resources, inevitably fuelled unease about the real quality of achievement, especially in the less regarded and fastest growing institutions. The *Sunday Times* of 3 September 1995 may have been

blunt to write of 'dummy degrees' being awarded, and the *Daily Telegraph* predictably conservative in arguing that 'the cost of this headlong drive to expand would be in the integrity and quality of the universities',[64] but there is a widespread perception even amongst university academics that standards are variable between institutions, and that expansion, combined with the diminution of the role of external examiners, has led to declining standards.[65]

Research from the Policy Studies Institute[66] which found that 30 per cent of all students were in paid employment during their undergraduate days (and not just in vacations, when the proportion soars), and thus unavailable for academic study for that period of time, provides support for a great deal of anecdotal evidence inside universities about declining standards. Yet increased attainment in degree classifications would seem to counter this interpretation. Today about half of all students graduate with an upper second or first class honours degree, though this stood at less than one in three twenty years ago. But sceptics reason that this is a consequence, not of harder working students[67] or even of improved teaching, but of a general easing of assessment criteria.[68] They contrast the modest entry requirements of many students with their achievements in their final assessments – all against the trend towards overcrowded universities, poorer library facilities, and less access to teachers – and explain the discrepancy in terms of a decisive shift towards course work assessment instead of unseen examinations[69] and as evidence of variable standards between universities.[70]

Confidence in the comparability of degrees from different institutions has been further undermined by research demonstrating that variability of attainment relates very poorly, if at all, to the achievements of entrants at A-level. It is difficult to maintain that there is a common standard of degree when entry to some universities requires high A-level scores while others allow entry with grades C and D (and still others with even more modest attainments), though all institutions have a roughly similar spread of degree results.[71] Faced with this, one can either proclaim that some institutions – notably those with poor A-level intakes – provide enormous 'added value' (though these tend also to be the least well resourced of the universities), or conclude that assessment standards in such places are less rigorous than elsewhere.[72]

A serious consequence of this weakening of confidence in the quality of degree standards has to be reinforcement of the reputational model[73] which employers use when recruiting graduates. After all, if one cannot be sure that an upper second from Guildhall is the same as one from Glasgow, then recourse to the perceived reputational hierarchy is understandable, though it is a rough and ready composite of snobbery, personal experience, research excellence, publicity, geographical location, A-level scores, market situation, age and ancestry.

Nonetheless, such recourse is remarkably socially selective, confirming a high degree of recruitment to the premier employment positions of those

from most socially advantaged backgrounds. The predilection of employers for élite residential universities when seeking recruits means that graduates from the new universities especially are handicapped. In turn this is a disadvantage of class, since the more élite the university, then the more exclusive are the origins of its students. Moreover, it has to be emphasised that this is not a reflection of blind prejudice on the part of those in charge of admissions policies in the élite universities. Quite the contrary, in recent years higher education in Britain has come to be markedly meritocratic, in so far as selection is on the basis of attainment in the anonymous and public A-level examinations. But the fact is that, over the same period, there has been a remarkable and associated increase in the capacity, especially of private schools (which account for but 7 per cent of the age group, but almost half the entrants to Oxbridge), to achieve extremely high scores at A-level,[74] effecting a transformation 'which over the past thirty years has turned the old public schools into bastions of modern meritocracy'.[75] Crudely, 'the high proportion of independent school students at Oxbridge is so high because these schools get a significantly higher number of excellent A-level grades'.[76] In fact, the *Financial Times'* 1996 survey of A-level performance found that over 90 per cent of the top schools were in the private sector.[77] More generally, it is the children of the professional and managerial groups who have shown an astounding capacity to do exceptionally well at A-level, whatever school they happen to attend, and it is due to this rather than to university prejudice that they disproportionately gain access to élite universities, and then in turn occupy a front place when employers look for recruits.[78] In such ways do we see the reproduction of social inequalities,[79] noting how intractable the situation has become when in a meritocractic era it is the privileged that achieve so well in formal – meritocratic – assessments.[80]

THE POSTMODERN UNIVERSITY?

It is not unusual to write in these ways about universities. Indeed, there appears to be a broad range of critical opinion which regards higher education as being driven by economic circumstances that have resulted in rapid expansion of student numbers on the cheap while closer and restrictive ties have been, and continue to be, developed with industry. The spread of instrumental progressivism to match the needs of the post-Fordist flexible economy is widely regarded as having diminished the quality of higher education, reduced the autonomy of universities, put at risk academic ideals, and set back questions of social justice by throwing judgements back on to reputational hierarchies.[81] From this perspective George Ritzer's arresting depiction of the Disneyfication of the university is met with horror precisely because it is plausible.[82] The emphasis on 'infotainment' that accompanies 'education in the Disney fashion', where

learning is 'fun', the staff 'perky', where commercial considerations dictate the curriculum, where presentation takes precedence over substance, and where students are 'consumers' for whose pleasure and convenience campuses will be sited close by shopping malls, all this is countenanced with distaste by the bulk of commentators.

However, there has been one sort of response which is particularly noteworthy. On the whole they do not dissent from the empirical description of what is occurring in higher education, but supporters of the notion that we are witnessing the spread of the *postmodern university* are quick to reject the 'narratives of decline' which abound in much writing about higher education. It may be agreed that mass higher education thwarts intimacy with students because small teaching groups are no longer viable, that new vocational pressures have had an enormous effect inside the university, and that conceptions of the academic community have been undermined by heightened pressures of specialisation, research interests and commercialisation. However, what proponents of the postmodern university refuse is to interpret these changes as symptomatic of a fall from grace, whether it be from Newman's residential collegium that taught 'universal truths', Leavis' idea of the university as a centre of moral sensibility resisting mass civilisation, or Oakshott's conviction that universities serve to nurture the 'intellectual capital' of civilisation.[83]

This refusal to mourn the passing of the old university may in part be motivated by the fact that, even in the recent past, it was an institution restricted to a tiny portion of the population. The opening of the university to a great many more than the privileged 5 per cent or so is readily celebrated as a democratisation of higher education, something which clearly resonates with the present age. However, depictors of the postmodern university do not rely upon such a 'narrative of progress' to support their view that what has come into being is not a cheapened and demeaned version of the established university, but rather a radically new phenomenon, the postmodern university.

This has a number of distinguishing features, though the primary one is the *differences* which abound in higher education. These differences – of courses, of students, of purposes, of academics, of disciplines – subvert any 'idea' of the university which conceives it in homogeneous or unitary terms. Instead, heterogeneity is a key word: the transformations of higher education over recent decades, from the push of additional numbers and constituencies to globalisation itself, means that what we now have is an extraordinary diversity of universities which are, moreover, themselves in a constant state of flux. This is consonant with the arrival of post-Fordism, since the latter's stimulation of flexibility in employment (and in lifestyles more generally) also encourages the development of the flexible postmodern university which never stands still. Peter Scott goes so far in this direction that he envisages a correspondence between the post-Fordist economy, which is

fast-changing and inherently flexible, and today's postmodern times in which no certainties are accepted and life is lived without fixed reference points. Necessarily, he continues, the postmodern university absorbs and incorporates the 'pluralism', 'fluidity', 'fuzziness' and incessant 'reflexivity' that both post-Fordism and postmodernism engender.[84]

Higher education institutions are nowadays so internally and externally differentiated that the title 'university' evokes little if anything by way of common traits. For instance, there can be no common inner life to the university when specialisation and fragmentation have extended so far that not only is it the case that colleagues across departments cannot understand one another (physicists and economists are mutually incomprehensible), but even those within departments share next to no concerns or language.[85] Today's university is no more than a collectivity of different concerns and voices. Extending this to a wider scale, Bill Readings argues that it is this plurality of differences which lies behind university proclamations that they are 'excellent' – in anything and everything, from sports facilities, research outputs, overseas connections, induction programmes, equal opportunities, entertainments, to catering services. It is, observes Readings, just the absence of underlying purposes which allows universities to endorse this wild relativism where absolutely anything may be claimed to be 'excellent'.[86] In contrast, where universities are governed by unifying ideals, then here there are priorities and hierarchies, phenomena markedly absent in postmodern times.

Moreover, when the Internet is just the most obvious source of information available from outside the university, then the historical role of the university as the authoritative source of knowledge is subverted, and it becomes just one voice of many others available in a high-tech world. Zygmunt Bauman has drawn attention to the decline in the standing of university academics: they are now but one of many conflicting contributors to knowledge, and they are themselves internally divided and discordant as well as routinely open to challenge from without. As such, they indicate a shift from intellectuals as legislators to interpreters.[87] Since we can no longer conceive of a unified university dedicated to providing authoritative knowledge – about science, ethics, or aesthetics – so then we must view it as no more than a diverse collection of commentators.

This accords with Jean-François Lyotard's well-known argument that a principle of performativity (i.e. use) predominates today, thereby undermining the former university justification that it pursued 'truth'.[88] If science is no longer discovery-led, but is rather guided by the search for patents and inventions, and if management and engineering subjects have fully entered today's universities, then previous arguments for the university must be jeopardised. Not the goal of Enlightenment, but the demands of performativity are the new definers of knowledge, as are new subjects such as Race and Ethnicity, Women's Studies, Cultural Studies, and Biotechnology.

But if the former defences of what might be included in the university are breached by performativity criteria, then the boundaries of exclusion from the university also collapse, and with them the former hierarchies, at the top of which were subjects such as Classics, Natural Science and Philosophy.[89] If performativity alone is what matters, then why not degrees in Tourism, Golf Course Studies, Environmental Change, or even Leisure Studies? And if this is so, then what characterises the university today other than its being a collection of differences, a diversity of knowledge activities pursued – and routinely abandoned – only because there is some performativity justification for their adoption?

This has been conceived as the transformation from a Mode 1 type of knowledge that is homogeneous, rooted in strong academic disciplines which are hierarchically organised, and transmitted to novitiates in an apprentice–master relationship, towards Mode 2 knowledges which are non-hierarchical, pluralistic, transdisciplinary, fast-changing and responsive to diverse needs such as students' experiences, industrial priorities, and social problems. This plurality of knowledges must announce an end to common purposes of the university, there being no possibility of agreement on goals or even on methods of work.[90] By extension, we must forego thinking about how to define what a university might be, instead simply accepting that there are an enormous number of very different institutions with radically different purposes and practices that might be called universities (for want of a better term).

The university is also being undermined because of the increasing difficulty of distinguishing it from growing sectors of industry. The suggestion here is that knowledge-rich corporations such as Microsoft and Zeneca, and even media organisations such as Channel 4, 'already possess many of the features of a university'.[91] These are brimming with highly educated employees, frequently those who possess doctoral degrees and are working on cutting-edge projects in software production, advanced electronics, biotechnology or social investigation. Moreover, such companies have many connections with universities that blur previous distinctions, frequently in the form of joint deals, shared staff and even facilities. Thus the university can no longer be identified by virtue of its separation from the 'outside world', while simultaneously 'big companies…are becoming more conscious of their role as creators, disseminators, and users of knowledge – a definition not altogether different from that of a university'.[92]

Relatedly, questioning the once privileged role of the university as regards research subverts its former distinctiveness. From within institutions, as well as from some figures in politics, serious questions are asked about the supposed interdependence and indivisibility of teaching and research that, in the view of some, characterises a genuine university. As more and more students are to be offered places on degree programmes, then it may be asked whether it is really essential that all of their teachers are involved in

research. It is commonly asserted that university work must involve research to teach undergraduates effectively. However, though it is unpalatable to many university personnel, the research evidence just does not support the assertion that research and teaching are mutually supportive.[93]

Correspondingly, voices have been raised to observe that there is no compelling reason to locate research inside universities. Already Research Assessment Exercises, and the distribution of funds on the basis of achieved ranks, mean that resources go for the most part to a cluster of fifteen or so institutions (and it has been estimated that 25 per cent of research funds in the UK go to just four universities: Oxford, Cambridge, University College, and Imperial College),[94] so why not separate these from the rest? More radical still, it has been noted that 'research can be done in any suitably equipped institute'[95] and that perhaps the best place for it is in think tanks and centres such as Demos or Harwell, rather than in universities where other matters may be a hindrance. As the *Economist* puts it, 'an intelligent Martian might wonder why a university – autonomous, chaotic, distracted by all those students – should be an efficient place in which to sponsor economically worthwhile research'.[96] Sir Douglas Hague, a recent head of the Economic and Social Research Council, argues from the perspective of the Martian, urging the marketisation of universities since 'knowledge entrepreneurs' are better able to produce research (and even teaching) that is useful than the university 'dinosaurs'.[97]

Finally, what of the educational potential of ICTs? In the minds of some academics is fixed the idea, one which draws heavily on Newman, of the university as a residential experience. But new technologies promise distance learning from one's own home, at one's convenience, accessing the best available informational sources, all at a fraction of the cost of attendance at a traditional university. The 'virtual university', already available in embryonic form on the Internet and in the pioneering work of the Open University, promises to undermine yet another foundation stone of the traditional university, leaving it unclear as to its justification or even its location, as customised network facilities allow students to study how, when and what they judge appropriate.[98] As 'cybernaut' Sadie Plant enthuses, 'technology is bringing down the walls of the ivory tower'.[99] And, she might have added, leaving no justification for the university behind.

THE END OF THE UNIVERSITY?

It is not unusual today for commentators to become excited by the 'flexibility, synergy and volatility'[100] of the postmodern university. But it is these very characteristics which, if unchallenged, would announce the end of the university as a meaningful term. If instead of an academic community we have mutual incomprehension, if research may be pursued perfectly

satisfactorily outside academe, if utility is the only criterion for inclusion in the curriculum, if courses can be studied without attendance (still less without residence)...if all we encounter is a plurality of differences, then, to say the least, the concept of the university is problematic.[101]

However, we believe that central defining features of the university remain in all institutions deserving of that title. Oddly enough, we may begin to appreciate these better when we raise doubts about the postmodern emphasis on differences by drawing attention to the empirical fact that there are *hierarchies of difference* within and between universities, hierarchies which are underlain by criteria of judgement which, at root, define the university. It is superficially appealing to contend that throughout the hundred or so institutes in Britain boasting the title 'university' there runs rampant diversity and differentiation (which in turn runs rife in the internal organisation of these institutions). It is also, on the surface, a radically democratic outlook since it denies the option either to compare institutions and then arrange them hierarchically, or to exclude aspirants from membership of the university club. But while the postmodern position highlights the complexities of locating universities on matrices of difference, it is an absurdity to suggest that differences are such as to subvert hierarchy or negate judgement. Postmodernists may resist it, but employers, students, academics, and indeed the public as a whole, do not. The upshot is that, while judgement has its gradations and grey areas, universities as a whole, and in turn departments and subject areas, are accorded a place. Here there is little doubt about the standing of universities such as Oxford, Cambridge, LSE and Imperial College, more hesitancy when it comes to Liverpool and Warwick, but a return in confidence of judgement as regards the likes of Bolton and Bournemouth. Furthermore, for most purposes evaluation is not a matter of drawing up a composite league table, but more about comparing specific subject areas and institutions, in which case, though always liable to refinement, the task is considerably eased. Of course, such judgements are more nuanced when it comes to particular subject areas or to specific needs and achievements of individual people, but acknowledgement of the difficulties of weighting differences does not negate the fact of their hierarchical character.

It is certainly not blind snobbery to recognise these hierarchies, though social status may contribute, in complex ways, to a general reputational model which puts, say, Durham above Warwick, though the latter outscores the former on criteria such as research standing. Similarly, it is not the prejudice of subject panels which assess and position research outputs and the quality of teaching provision at periodic intervals. The most telling judgements of universities concern research, the calibre of students and staff, and, to a somewhat lesser degree, teaching quality. And research activities, students' qualifications at entry and staff attainments are indisputably at higher levels in some institutions than in others. Arguably, too, as we noted

earlier, assessment standards are less rigorous in some institutions than elsewhere. To pretend that all universities are equal – equal in some way due to their exhibiting a plurality of differences – is to turn a blind eye especially to the inequalities and injustices that abound in higher education. If these are to be addressed, then the relativism, and accompanying phony egalitarianism, of postmodernism must be refused.

If university hierarchies are judged largely, but not exclusively, on the quality of their research, their students and staff members, and their teaching, then, logically, some institutions will be excluded from the category of university on the grounds that either or all their research, members and teaching are in some ways lacking. There is, however, another feature, connected to these but reducible to none of them, which defines the university. This involves the right to bestow, and have acknowledged, *credentials* on students upon satisfying the requirements of the university. It seems to us most revealing that universities have maintained the monopoly of awarding degrees and that these are recognised as the sole legitimate form of accreditation. To be sure, degrees from different universities are not seen as of equal value, but there remains in the accrediting function a defining feature of the university.

Acknowledgement that a university has a right to bestow academic qualifications, in a way not granted to private corporations however knowledge-centred they may be – though doubtless a good deal about electronic engineering could be learned at British Telecom, few would give credence to a BT degree outside the company – highlights the fact that university work cannot be reduced to the merely performative if credibility is to be retained.[102] The legitimacy of university qualifications hinges on public confidence that the teaching that takes place there, and the research that accompanies it, are guided by ideals, and maintained by standards, higher than those of the commercial and instrumental. These ideals – disinterestedness, critical inquiry, open debate, rigorous examination of evidence, and the like – are a crucial element of university life which, if under some strain, remain defining features.[103]

CONCLUSION

The university in Britain has had a tradition of being somewhat aloof from the 'needs of society'. Much of this stemmed from a paradox: so long as access was restricted to a tiny fraction of the population, then it didn't much matter what went on there. The university functioned to create and recreate an élite, and, so long as the vast majority was excluded, then academics enjoyed an extraordinary latitude in what they did. However, over many years, but in an accelerated manner over the last two decades, we have seen a shift in the university. That shift has been, with all due allowance for the undoubted diversity still remaining, towards closer ties with the demands of

the economy, and with this has come an intrusion of outside pressures into the university.

An important element of this has been an expansion of student numbers, brought about in part through pressures to open access, but more obviously to supply the 'human capital' thought crucial to a post-Fordist era of informational capitalism. Central to this process has been the development of what we have called instrumental progressivism into, and even beyond, university curricula. This has demoted the role of academics and with it the significance of earlier forms and content of learning. The vocabulary of transferable skills, competencies and profiles now has a powerful hold inside academe.

More than this, the university seems today bereft of motivating ideals and defining characteristics, so interpenetrated by ever-changing constituencies and realisation that former justifications and definitions have come to lack credibility. Postmodern thinkers would have us embrace this new unsettling condition, to celebrate the liberation that comes from differences so multifarious that judgements are untenable. We find this unconvincing, insisting that its monopoly on issuing legitimate credentials indicates the continuation of defining characteristics of the university.

PART IV

LIVING IN VIRTUAL SPACE

10

PROSPECTS A OF
VIRTUAL CULTURE

In this final part of the book, we want to shift to a consideration of the new virtual culture that has been taking shape through the 1990s. Our perspective remains a critical one, putting forward the argument that the virtual society is a pacified and managed space. In this chapter, we consider three aspects of virtual culture: first, we examine the claims that virtual technologies have created a new and dynamic knowledge space; then we look at the claims that are being made about the enhancement of communication and community, and about the possibilities of virtual politics; and, finally, we discuss critically what we regard as the technological colonisation of the future. In Chapter 11 we shall take the argument forward through a geographically-oriented analysis of the implications of new, virtual technologies for spaces and places.

A NEW KNOWLEDGE SPACE?

Virtual technologies have implications for knowledge, and consequently for the contemporary élites who live by knowledge. In the following discussion, we want to suggest that these profound implications are not – or are not straightforwardly – those that are most commonly accepted. Where the prevailing rhetoric – associated with the idea of an information revolution – envisages a new condition of cognitive transcendence, we will be concerned, rather, with what we regard as the problem with modern knowledge.

Let us begin with what we consider to be the prevalent approach to new media, through a reflection on Pierre Lévy's recent book, *Cyberculture*,[1] which provides one of the most coherent and persuasive expressions of the contemporary technocultural vision. Lévy's concern is with the potential inherent, he believes, in new information and communications technologies to both expand and enhance human cognition. And what he argues in *Cyberculture* is that there has been a quantitative technological revolution in human knowledge which, at the same time, has conspired to produce a 'new relation to knowledge'. For Lévy, what is new about new media is precisely the creation of this new and more complex relation to knowledge (regarded

as being in continuity with the aspirations of modernity, however, and not as in a postmodern relation).

Lévy describes the emergence of a new 'knowledge space' that is in stark contrast to an older knowledge space that was characterised by its linearity, hierarchy and rigidity of structure. This new space – it is the space of the World Wide Web – is distinguished by its open, fluid and dynamic qualities: it is a space of creative profusion and disorder. The key metaphor is that of an 'information deluge', creating an 'ocean of information', a 'global ocean of fluctuating signs' (pp. 90–191). The old – and, it is said, now superseded – space was one in which vested interests sought, and could achieve, control over the ordered totality of knowledge. In the new condition of disorder, or 'knowledge-flux', Lévy maintains, there can no longer be any such totalising perspective or centralised mastery over the global domain of knowledge – it is in this respect that the relation to knowledge is necessarily and inevitably transformed.

What Lévy then wants to go on to persuade us is that this new relation provides the basis for a broader social transformation – even, it seems, for a social revolution. For the new 'cognitive ecology' is said to translate directly into new social dispositions and values. In cyberspace, we are told, knowledge is no longer abstract, but has become the visible and tangible expression of the individual and groups who inhabit it; 'interactive networks' work towards 'the personalisation or incarnation of knowledge' (p. 194). Lévy considers this development in terms of some kind of return to orality

> only, this time, in contrast to archaic orality, the direct bearer of knowledge is not the physical community and its bodily memory, but *cyberspace*, the region of virtual worlds, through which communities discover and construct their own objectives, and come to know themselves as intelligent collectives.
>
> (*Cyberculture*, p. 197)

What he regards as innovative about the new techno-oral culture is its potential to support direct and immediate contact among its members. The virtual interface is conceived in terms of the return to conditions of face-to-face interaction. The potential of the new technologies, then, seems to reside in some kind of social reversion – or, we would say, regression.

On this basis, Lévy can envisage an ideal world of harmonious communities in cyberspace. New information and communications technologies make it possible, he believes, to share knowledge, 'thereby increasing the potential for collective intelligence among human groups' (p. 188). This is apparent, to take one example, in the changing culture of education, where the principle of collective intelligence is said to manifest itself through 'co-operative learning'. 'In the new "virtual campuses" ', Lévy maintains, 'professors and students pool their material and informational resources',

with the role of the teacher becoming that of '*an animator of the collective intelligence* of the groups he or she is responsible for' (p. 206). In the new knowledge sphere, the bases of social division and conflict seem to be overcome: it is as if technological harmonisation – 'global computability and interoperability' (p. 200) – translates directly into new conditions of social harmony. 'Within a few decades', Lévy concludes, 'cyberspace, with its virtual communities, its image banks, its interactive simulations, its irrepressible abundance of texts and signs, will be the crucial mediator of the collective intelligence of humanity' (p. 201). In social terms, then, Lévy's cyber-utopian vision for our new technological times is a vision of global value convergence, cultural harmonisation and new community foundation.

What, in fact, is significant about Lévy's discourse is the co-existence of a radical techno-rhetoric with a social and communitarian political vision that is actually quite conventional and even conservative. And we would say, moreover, that it is this combination of radical and what we might call pragmatic aspirations that particularly marks *Cyberculture* as a representative text of the late 1990s. What the book seeks to elaborate is what has come to be called the politics of the 'third way' – a politics in which a certain idealism is counter-balanced by a worldly accommodation to existing realities. So, on the one hand, Lévy thinks of the virtual society in terms of civilisational transformation and the emergence of a new global collective intelligence (no less). But, on the other hand, he is very well aware of the economic and corporate dynamics that are precipitating the changes that excite him so much – aware that the 'virtualisation of the relation to knowledge' is underpinned by the commercially-driven 'virtualisation of "networked" organisations and enterprises' (p. 210). This politics of the third way, through what is essentially a political philosophy of high-tech communitarianism, represents the attempt to reconcile political idealism with the corporate reality principle. The new electronic communities that seem to promise the re-enchantment of social and political life are, in fact, the functional products of network capitalism, and are in no way contrary to its interests. If, as *Cyberculture* makes clear, there is a vision of a new social order, it turns out to be a kind of social order that is not at all inconsistent with the globalising aspirations of virtual capital.

For Lévy, then, what is new about new media is the new relation to knowledge made possible by global networks. Essentially, he is telling the story of progress in the domain of knowledge, presented in terms of a kind of cognitive transcendence, through which we have come to inhabit a new, oceanic space of knowledge. This imagined revolution in knowledge is then considered to be synonymous with a revolution in social relations: the technological intimacy and immediacy of communication in cyberspace inspires the political practice of virtual communitarianism. It is a social vision that has a certain plausibility – no doubt reinforced by the commitment of corporate and political interests to its realisation.

But we think it is necessary to challenge this prevailing vision. For, it seems to us, it is a partial, a misguided, and also a complacent vision. What is new about new media is a good deal more ambiguous and problematical, we believe, than it seems in Lévy's neat and tidy technocultural account. It is concerned with a more devious story than he tells – and concerns what we regard as the fundamental disavowal at the heart of the so-called knowledge revolution. We want to suggest that the narrative of what is happening in the field of knowledge might be told from an entirely different perspective – from the perspective of the world whose reality we are being invited to abandon.

To make clear what we mean by disavowal and abandonment, let us focus on the claim put forward in *Cyberspace* as to just why the new – real-time and global – knowledge space is better than that which preceded it. Concerned as he is with establishing what is new and (consequently) better about the virtual knowledge order, Lévy argues that 'image banks, interactive simulations and electronic conferencing assure a better knowledge of the world than (the old technologies of) theoretical abstraction' (p. 197). If the old knowledge of the world was substantial and territorial, he continues, then what is distinctive about the 'better' knowledge is that it is formal and disembedded. Lévy's cybercultural vision seeks to establish a trajectory, then, whereby significant knowledge tends to become both decontextualised and accelerated: contemporary knowledge culture is regarded as fundamentally about the acquisition of generic information skills and competencies (the kind of knowledge that is operational and functional within the systemic parameters of the real-time technological space that corporate interests are now engineering into existence); and such competencies are accepted as ones that are, in their nature, ephemeral and provisional (continuously rendered obsolete as knowledge systems become subject to constant updating and displacement). And, what is crucial, we suggest, in this discourse of cognitive progressivism, even evolutionism, is the significance of what Lévy refers to as the 'deterritorialisation' of knowledge. The point is that it is precisely in so far as it overcomes and transcends the limitations of spatial and temporal situation in the real world that the new information-flux is said to provide the basis for a 'better knowledge of the world'.

Now, of course, like anyone else, we know what Lévy's real concerns are as he tells this simple and straightforward narrative of progress from localised and situated knowledges towards the establishment of a new disembedded or deterritorialised communications space – what Michel Serres calls an *'immense messagerie'*, a global message space that promises to constitute a 'new universe'.[2] And it is precisely because of its apparent simplicity and self-evidence – and the ease with which a part of all of us could go along with it – that we want to call this account into question. We want to question the unreflective assertion that the new, deterritorialised technological knowledge space is a 'better' space than the other (i.e.

embodied and situated) spaces. A lot hangs on this 'better'. Levy's claim makes sense – or makes full sense – within the narrow framework of progress in instrumental reason – which has, of course, been the most powerful discourse on knowledge in the modern era. And, of course, the key issue must then concern how this discourse has come to prevail over all others (how knowledge in the cause of mastery has eclipsed knowledge in the cause of autonomy).

If we were to adopt a more encompassing approach to knowledge-in-the-world – concerned with broader questions of global culture and democratic life – then surely we would have to scrutinise this 'better', this very partial 'better' that alerts us to only one aspect of transformation in the domain of knowledge. Such an approach would be concerned with why the technoculture's social and political vision has so little concern for knowledge in the actual – that is to say 'territorialised' – world. How is it, we would want to ask, that the 'new universe' of knowledge has come to seem more 'real' and meaningful than other – embodied and situated – kinds of knowing and engaging with the world? And what is the significance of this devaluation and displacement of the embodied and substantive knowledge cultures that prevail in real-world geographies? Hard questions have to be asked of a social vision that is based entirely on the idea of a knowledge 'revolution' alone, and in which knowledge is understood from such a narrow perspective.

We must actively resist the idea that what is at issue is just some kind of development that is internal to the domain of knowledge. Nor can we understand – and respond to – what is going on if we think of it simply in terms of purely scientific or technological revolution. What, in fact, underpins the new technocultural agenda – along with the accompanying visions of a 'new universe' or a 'global collective intelligence' – is a far more mundane and, actually, worldly logic – that of global political economy. (Indeed, what we want to argue is that what is new about new media relates to this dimension of political economy.) The technocultural discourse is in fact functioning – as we have already indicated with particular reference to Lévy – to promote and legitimate the prevailing corporate ideology of globalisation (providing its utopian – that is to say purified – articulation): the ideal of cyberculture constitutes one aspect of what Armand Mattelart refers to as the 'corporate ideology of global communication'.[3] And what we now want to suggest is that the distinction we have been following between disembedded and embedded knowledges, and between 'deterritorialised' and 'territorialised' knowledge spaces, has its grounding in the distinction between corporate network space, on the one hand, and the space of the rest of the world's populations, on the other. What is fundamentally at issue is the global political economic logic that is mobilising new information and communications media to create an extraterritorial space of enterprise, in defiance of the cultural and political realities of the actual world most of us are living in.

This extra-territorial space is a world apart, but not a 'new universe' in the sense that the technoculture intends. It is the world in which network capitalism functions – the world of electronic transactions, information flows and knowledge professions. It is the world of Robert Reich's élite of 'symbolic analysts' and 'enterprise networks'. It is Bill Gates' world of 'friction-free capitalism', a world of transnational mobility and interconnection. We must recognise that there is the growing sense, among those who operate there, that this global communication space has rendered obsolete the old order of national territories and boundaries. There is the danger, as Reich has noted, that the new global virtual class is seceding from the nation, that digital cosmopolitanism is associated with a diminished commitment to place. Claiming that 'the appetite to annex territory has already attenuated', a former CEO of Citicorp/Citibank notes 'the growing irrelevance of territory to wealth'[4] – and perhaps the growing irrelevance of those who live in territory. Zygmunt Bauman makes the point well when he compares the new 'meaning-producing élites' to the '"absentee", extraterritorial Latin-speaking and -writing élites of mediaeval Europe':

> Cyberspace, securely anchored in the ethereal websites of the Internet is the contemporary equivalent of mediaeval Latin – the space which the learned élites of today inhabit; and there is little which the residents of cyberspace could talk about with those still hopelessly mired in the all-too-real physical space. Even less can they gain from that dialogue.[5]

Cyberspace is a sequestered space, one that has lost touch with the world's realities – and consequently functions according to the belief that the world in which most of us still want to live no longer has any reality.

Virtual space claims to exist as a kind of extraterritorial space, with a post-(national) cultural form of knowledge circulating through its networks. In this context, we might invoke Bill Readings' important arguments concerning the transformation of knowledge in the university, which is one of the primary sites of its production. The logic of globalisation, according to Readings, has worked to undermine the significance of 'culture' – 'the symbolic and political counterpart to the project of integration pursued by the nation state'; and, in its place, it has instated a new technological model of knowledge, measured in terms of the criterion of 'excellence' – 'as a non-referential unit of value entirely internal to the system, excellence marks nothing more than the moment of technology's self-reflection'.[6] The kind of knowledge we now relate to in the form of 'information' is a knowledge that has become characterised by its 'dereferentialisation'. The new knowledge is valorised through its circulation, and the purging of referentiality is crucial to the efficiency of that circulation. The cyberculture exists only in terms of self-referentiality: it simply communicates with and within itself; and it is the endless circuit of

communication – of connections and interconnections – that provides the rationale for its existence. 'The Internet carries conversations between millions of people without regard to gender, race, or colour', says our Citicorp man, and the point, he seems to think, is for everybody simply to contribute to the information exchange, to participate in the big 'global conversation'.[7] Network culture exists as a kind of Esperanto culture: it is an out-of-territory and an out-of-time culture (in its own terms, it exists only in 'real-time'), a culture that is without bearings in (territorial) space or moorings in (historical) time. It is precisely its dereferentialised quality that promises to make the new knowledge the basis for a 'new universalism' (Lévy) – for the utopia of a post-referential universalism, that is to say, a universalism that requires the conditions of extraterritoriality in order to exist.

Just as the Latin-speaking élites were intent on ignoring the vernaculars in the territories that surrounded them, so now the cybercultural élites prove themselves blind to the new cultural mixtures that actually surround them, in the all-too-real global cities that have become the destinations of the world's populations. The corporate ideology of globalisation and the network society is the ideology of the 'absentee' class. It is an ideology, moreover, that disavows the realities of actual globalisation. For if deterritorialisation has been one aspect of global change, what we have also seen is the creation of new kinds of territories – global cities – in which different cultures and knowledges jostle along side each other, according to their different rhythms and orientations, creating new mixtures and *metissages*. What we actually need is a meaningful politics of engagement among all those who live in the new cultural territories (which are no longer the old national ones) – and with a commitment, importantly, to what is to be gained from that dialogue. What we are presently being offered as an alternative is the more user-friendly myth of a global community in a 'new universe'.

What we are saying is that we now have to consider the relation between extraterritorial and new territorial knowledges and cultures. For this to be possible, we must learn to recognise the diversity and richness of knowledges that now co-exist in globalised societies – the necessity, as Daryush Shayegan puts it, of 'having access to different registers of knowledge' (for 'the keys of knowledge don't all open the same doors').[8] There is a desperate need for a richer debate on knowledges in contemporary societies – in place of the shallow, progressivist marketing that attaches itself to the cyberculture slogan (and reflects the hegemony of corporate interests).

VIRTUAL POLITICS: A POLITICS WITHOUT PEOPLE

This reality of division and polarisation must surely be seen as integral to the global transformation that is now taking place, though it is scarcely acknowledged in the ideologies of the global information society. If we

recognise that this is a political-economic transformation, and that the principles governing an information economy are unlikely to differ from those at work in previous rounds of capital accumulation, then we would hardly expect it to be otherwise. But, of course, if this disturbing reality could be disavowed or denied, perhaps it might be possible to imagine that contemporary change is actually inaugurating a new and better social era. And isn't it just this mechanism of disavowal that is at work when the political-economic perspective is displaced by a technological one, as seems to be the case in much of the contemporary discourse? This, we suggest, is what is at work in the new politics of the Third Way.

The perspective of 'technological revolution' makes it possible to occlude the difficult realities of contemporary change, and even to believe that what is occurring in the contemporary world might actually be contributing to social and political amelioration. In political speeches and manifestos now, the harsher realities of division and conflict are being dissolved in the soft-focus rhetoric that appeals to social consensus and cohesion. The advocacy of technological culture is commonly linked to sensible ideals of communication and community – the restoration of community through the enhancement of communication – promising an ordered refuge from the disorders of change in the real world.

The technocultural discourse encourages us to think that something new is on the horizon. But with a little reflection – and unless you are overly impressed just by the new equipment – it should be clear that there is nothing really innovative or revolutionary in the new communitarian aspirations. What we have is, in fact, the next manifestation of some very old utopian formulations. Armand Mattelart has traced the association of communication, communion and community back to Saint-Simon in the early nineteenth century.[9] Communication has been associated with transparency, and thereby with understanding, and consequently with social harmony: the utopia or ideology of communication is about 'bringing people together', and this bringing together, it is assumed, will consolidate the bonds of community. Elsewhere, Mattelart identifies the emergence of 'the idea of communication as the regulatory principle counteracting the disequilibria of the social order'.[10] Far from being inherently emancipatory, this ideology, or religion, of communication – which has perhaps even taken over from the ideology of progress – has, for 200 years, functioned as a means of promoting social order and control.

Communication is held to promote greater social intelligibility, which in turn is supposed to enhance the 'general concord' among people (and peoples). It is, Mattelart says, a perspective in which 'every social problem tends to be formulated as a communications equation'.[11] And every solution is then formulated in terms of a new communications technological fix. Thus, Linda Harasim routinely asserts that 'the need for human beings to communicate and develop new tools to do so forms the history of civilisation

and culture', and then claims that the new computer communications networks constitute, in this context, an innovative technological means to 'enable humanity to express itself in new and hopefully better ways'.[12] In the same spirit, another network enthusiast argues that 'the global Matrix of interconnected networks facilitates the formation of global matrices of minds'.[13] And, from a self-consciously 'postmodernist' perspective this time, Mark Poster makes the same basic point, with the argument that it is communicating by computer that is crucial to the second media age: the Internet is significant, he believes, insofar as it is creating new kinds of 'meeting places, work areas and electronic cafes in which [the] vast transmission of images and words become places of communicative relation'.[14] And if, in each of these cases, communications technologies are regarded as a social and political panacea, then it must be because an inadequacy, or a breakdown, in communication is regarded as the fundamental social problem that confronts us.

Politicians are keen to put across the same hopeful message. US Vice-President Al Gore announces no less than 'a new Athenian age of democracy', made possible by the communicative efficacy of the 'global information highway'. The new electronic agora will 'allow us to share information, to connect, and to communicate as a global community'; it will 'allow us to exchange ideas within a community and among nations'.[15] Gore imagines the possibility of 'a kind of global conversation in which everyone who wants can have his or her say'.[16] And, in Britain, New Labour has the self same idea:

> We stand on the threshold of a revolution as profound as that brought about by the invention of the printing press. New technologies, which enable rapid communication to take place in a myriad of different ways across the globe, and permit information to be provided, sought, and received on a scale hitherto unimaginable, will bring fundamental change to all our lives.[17]

We are encouraged to pin our hopes on 'the network of communication links that can enable people to talk together, to see each other, and share images, texts and sounds, wherever they are around the world'.[18] On both sides of the Atlantic, the politicians of the Third Way seem to think that 'fundamental change' will really come about once we can talk properly with each other and enjoy a big one-world conversation. As if the world's problems were simply the consequence of a historical communications deficit.

And with the praise of technologically-enhanced communication, there inevitably comes the political idealisation of technological community, too. There are some, like Mark Poster, who imagine virtual communities in a 'postmodern' sense, in terms of a new kind of fluid and flexible association –

virtual community as 'the matrix of fragmented identities, each pointing toward the other'.[19] But, for the most part, the new techno-communitarianism tends to be rather conservative and nostalgic: it is centred around the imagined recovery and restoration of some original bond. Cristina Odone expresses the new ideology with great clarity. 'The Net,' she proclaims, 'has been cast over that collective space once filled by the family hearth, the churchyard, the village market place.' Network connections 'seem set to rekindle that elusive sense of belonging that lies at the core of the traditional community'. Political visions are spun out in her imagination like candy floss:

> So the Web could serve as the first building block in the creation of a whole new social solidarity, founded upon cross-cultural, interdisciplinary dialogues and cemented in an 'empowerment' and 'enfranchisement' of marginalised individuals. A brave new world where heart and soul are re-stored to the body politic by giving voice to the voiceless and public space to the individual.[20]

Here, the world is conceived in the image of the village pump or the town square. Dealing with its problems can then seem to be as manageable as sorting out neighbourhood problems in the local community. Odone says concisely what the techno-futurist Howard Rheingold can only say in a fat book, full of similar communitarian aspirations. In *The Virtual Community*, Rheingold, too, seeks to persuade us that the Internet is the modern means, not only to recover the sense of community, but also to attain 'true spiritual communion'.[21] There is a true religiosity in this kind of electronic evangelism (in the tradition, we would suggest, of the Catholic mysticism of Marshall McLuhan).

Politicians were also quick to celebrate the possibilities for kindling community. They were struggling against the oppressive legacy of Reaganite and Thatcherite economic liberalism, and were faced with the task of trying to recreate forms of social and political cohesion. It was in this cause that they turned to the philosophy and principles of communitarianism, particularly as these have been developed and propagated in the work of Amitai Etzioni.[22] Etzioni's influence has been significant both in American politics (with Newt Gingrich, particularly) and in what New Labour has called its 'tough and active concept of community'.[23] And the communitarian agenda proved, moreover, to be one that could easily be married to the new technocultural politics of the information superhighway. Al Gore was drawn to the argument that the new technologies could foster democratic communities through electronic simulation of the Jeffersonian town hall. And, in Britain, New Labour has been attentive to the American interest in such 'virtual town meetings'. There is a great desire to believe that the new information and communications technologies can put citizens (or so-called

'netizens') back 'in touch' with each other. As far as the Third Way politicians are concerned, virtual technologies promise to make community instantly available, now as a service (or a commodity) that can be piped into the electronic home – community, or interactivity, for domestic consumption.

In the British context, this new techno-communitarianism has been actively promoted by Demos, the think-tank that has Blair's ear. Issues of *Demos Quarterly* have proclaimed the virtues of new technologies for democratic community, with articles, for example on 'Networks for an open society' and 'Back to Greece: the scope for direct democracy'.[24] Indeed, in his book *Connexity*, Geoff Mulgan (the former Director of Demos, and now an advisor to Blair) develops a theoretical framework to justify the new Third Way social vision. Mulgan sees the new global order as one in which 'the world has become more interdependent and connected...more people depend on more other people than ever before'.[25] The politics of connexity seeks to work in harmony with this fortunate and benign logic, 'breaking down the barriers and separate identities that have been the main cause of human suffering and war'.[26] The objective is to promote a greater sense of transparency, mutualism and trust – the immediate relations of face-to-face community are a key reference point (we are even told that new technologies promise 'direct connection between people's minds, transcending the idea of separate selves and subjects').[27] In the new order, Mulgan argues, 'connexity widens people's horizons and makes it easier to form new communities, like the virtual communities of cyberspace, or the weak communities of shared interests or of fun'.[28] He envisages the future in terms of a development 'towards a more cellular structure that is held together by communica-tion....In a cellular order what matters is your membership of a number of different cells'.[29] Being involved in these 'small units of belonging' is like being in a club: 'Clubs are based on members, and share values and mutual commitment. They are, almost by definition, reciprocal'.[30] This is the politics of neo-communitarianism, a politics of membership and shared interests.

This, it seems to us, is an impoverished agenda. The notion of (virtual) community is about refuge in a mythic realm of stability and order. The ideal society is imagined in terms of communicative interaction within communities of affinity, irrespective of physical location (and these may be either communities of 'postmodern' decentred, fragmented subjectivities, or communities of conservative citizens, who think they have centred and coherent identities). It seems that the ideal of virtual community is, for those who can get in on the virtual life, a retreat from the disturbing realities of global change. Virtual culture and its ideology of communication sustains the illusion of consensus and unanimity among those with 'common interests'. And perhaps it is only under conditions of virtual existence that the sense of community can be sustained now? The community of interests disavows – through the new technological means that are now at its disposal

– the conflicts and antagonisms of the real world. But what, we ask, if these are in fact constitutive aspects of social and political life? What if they are actually the condition of possibility for civic and democratic culture?

Sivanandan is right, the virtual community 'is a community of interests, not of people' (and 'you need people to make a revolution', he adds).[31] It is the virtual condition of disembodiment and disembeddedness that sustains the community of interests, whereas embodied and situated existence is about the necessity of living with other people – and not just others in one's immediate community – whose existence frequently challenges and confounds our own. The new Third Way politics represents what Slavoj Žižek (following Jacques Rancière) describes as an attempt 'to suspend the destabilising potential of the political, to disavow and/or regulate it in one way or another...[and] to bring about a return to a prepolitical social body'.[32] This is the neutralisation of politics in the name of social (club) management. What is on offer, as Rancière says, is a politics without passion: 'A world where everyone needs everyone else, where everything is permitted so long as it is on offer as individual pleasure and where everything is jumbled together is proposed to us as a world of self-pacified multiplicity'.[33] Virtual politics: a politics without power, a politics without antagonism, a politics without people. This is no politics at all.

ENCLOSING THE FUTURE

> How can we live without the unknown in front of us?
>
> (René Char)

In a review article in the journal *Foreign Affairs*, the futurologists Alvin and Heidi Toffler consider, once again, the nature of technological change. They criticise the authors of the book under review for their 'continuist' perspective, which, say the Tofflers, 'underestimate[s] today's technological upheaval'. Their own perspective regards, and has always regarded, what is going on in terms of fundamental transformation and 'future shock':

> [T]echnological revolution has not 'continued' relentlessly or otherwise. Starting shortly after World War II, it leaped into hyper-drive and changed its fundamental character. The key technologies of the two centuries before and the century after 1850 were muscle-enhancing. Those since then have been, so to speak, mind-enhancing. That is not a continuation but a revolutionary discontinuity.[34]

We are, they say, experiencing 'a transformation at least as profound as the Industrial Revolution but compressed into a much shorter span of history'.[35] The Tofflers' sense of revolutionary discontinuity implies the prospect of confronting yet unknown experiences. The future, they assure us, will not be

like the past. They have to convey a sense of excitement and anticipation about the possibilities inherent in the future – the 'Third Wave' future in which something called 'mind-power' finally comes into its own. This time, we are told, the new technology will really make a difference. It won't be easy, etc., etc. (you know about the shock of the new), but this revolution will really deliver the goods. This is the big one. In articulating their epic predictions, visions and slogans, the Tofflers are being good, professional futurologists. They are doing what futurologists are paid (in their case, a lot) to do: making good promises.

There is a whole host of other self-proclaiming futurologists also seeking to distract us with this amazing technological future they all know so much about. They all play the card of discontinuity. Whatever was wrong with the past will be put right in the new and happy kind of future that science and technology is designing for us. The promises of freedom, empowerment and wealth in the discontinuous future have become routine and familiar. We are living in an age of futurology, and the discourse of transformation, upheaval and revolution is really quite banal – and, actually, quite acceptable – to us all now (water off a duck's back). Bill Gates has his vision set on 'the road ahead'[36] – the road that will take us to the world of 'friction-free capitalism' (which means to take us nowhere, really; to make where we are already seem like somewhere else). For Nicholas Negroponte, it's all about the shift from the old analogue world to one in which we will have to 'be digital'. 'Being digital is different,' he tells us, 'in the digital world, previously impossible solutions become viable.'[37] Now, be clear, these are not people who see themselves as mere forecasters – they are pleased to see themselves as serious visionaries (at a time when, for most of us, this has become an utterly devalued concept). These are the people who have seen the future and seen that it works (they live by such old clichés). More than that, they know it works because they are the ones who are now engineering it and financing it into existence (so shouldn't we trust that they have our best interests at heart?).

This whole book has been intended as a rejection of the hollow prophetic discourses of the techno-visionaries (which are often only the prophecies of their ghost writers and advertising agencies). We don't believe that we are going through a revolution. We aren't expecting any brave new world. There are just too many reasons to be sceptical about these easy-flowing promises. The cyber-missionaries want us, as David Edgerton very rightly observes, 'to give way to the new people who have "the future in their bones", those who pride themselves on "having seen the future". It is an old trick, but we still fall for it'. What they want is to ensure our compliance in their schemes (our acceptance of their commercials for 'progress'). And, to this end, as Edgerton notes, 'they want to render our knowledge of the present and past null and void'.[38] They want to neutralise our useful scepticism about revolutionary discontinuity. And they want to do so because our own knowledge would

surely make clear that there is nothing that is significantly new or innovative in their commercial dreaming. We would see through the Microsoft emperor's virtual new clothes.

And just what is it that our own knowledge would tell us? We would recognise that there are new technologies. But we would see no signs of new social relations, values, goals, or whatever. Technologies change, but society stands still. And we believe that our friends the futurologists really want it just that way (in their hearts they are all deep continuists). The only kind of change that they are interested in is market change (the revolution of the fixed wheel). What they find exciting are the vast commercial possibilities inherent in a new technological product – the Internet or digital broadcasting or virtual reality games. But when it comes to new social and political forms appropriate to the new global order, they don't have a clue – all they can come up with is interactive consumption and virtual community. Behind the cyber-rhetoric, there is both a fundamental conservatism and an impoverished imagination. Change is really the last thing they want. They want a future that just perpetuates the past. Work on your computer, consume through the digital TV, and be happy with your own personal virtual community. Just be happy with the trivial pursuits of the digital life. The fundamental principles of capitalist society will continue to exert that famous dull compulsion. If you happen to think that change would be a good thing, don't look to the technological 'revolutionaries' to make it come about. They are quite satisfied with the way things are going right now.

Continuity is painfully apparent in everything. In this book, we have described the transformations associated with the global network society as the new enclosures. What they express is the drive to subjugate more and more elements of social life to a logic of rationality and control. What they sustain is the project, first articulated by early nineteenth-century 'visionaries', such as John Herschel and Charles Babbage, to mobilise intellectual resources towards achieving economic and social efficiency. As William Ashworth puts it, 'efficient and correct mental operations, in the view of the reformers, depended completely on the organisation of the mind. Indeed, according to Herschel and Babbage, the mind should ideally function with the reliability and productivity of a well-ordered factory'.[39] This is where the praise of the functions of the symbolic analysis originates. The factory-like mind was seen as the basis of a new rationalised social order. Of course, there are now quite different ideas about the nature of the well-ordered factory, but today's symbolic analysts are still measured by their efficiency and correctness in their mental operations. The new developments of the 1990s are about making social order ever more intensive (subordinating the lifeworld as a whole) and extensive (enclosing the entire globe). In Cornelius Castoriadis' terms, the new global information order expresses, and perhaps fulfils, one of the two main significations of modern

society, that which corresponds to its capitalist dimension (we shall come to the other signification in a moment). Within this imaginary signification

> Everything is called before the tribunal of (productive) Reason and must prove its right to exist on the basis of the criterion of the unlimited expansion of 'rational mastery'. Capitalism thus becomes a perpetual movement of supposedly rational, but essentially blind, self-reinstitution of society, through the unrestricted use of (pseudo-)rational means in view of a single (pseudo-)rational end.[40]

This logic of order has now developed far beyond the aspirations of the early nineteenth-century analyticals, in both its scope and its endeavour. It has made the world a more closed and diminished space, a space of constriction and even incarceration.

But there is something that is even worse than this. For if the world's space has been colonised by this logic of order and rationalisation, so too has its time. A major achievement of the capitalist imaginary has been the colonisation of the future – and that means the colonisation of possibility. The technologies of the new world information economy have sought to overcome the 'barriers' of time, putting in place the infrastructure for what is called the 'real-time' economy, and creating what Manuel Castells describes as the 'timeless time' of the network society.[41] What this means is that global society is being subordinated to a rational and standardised temporality. Paul Virilio describes the process in terms of the institution of 'a single global time which is liquidating the multiplicity of local times'.[42] It is the time of an eternal present – in Virilio's terms 'an amputation of the volume of time'[43] – void of potential for meaningful change or transformation. The information society is obsessed with the future, but the future of its obsession is merely the endless continuation of the present. Ashis Nandy suggests that this erasing of the future may reflect a fundamental fear of the future among the Western élites. The preoccupation with futurology is, he maintains, about the desire to control and secure the future. It is precisely about trying to make the future as much like the present as possible, for the fear is really 'the fear of a future unrestrained by or disjunctive with the present'.[44] Whatever the futuristic rhetoric that surrounds it, the global information society in fact works to foreclose the real productive possibilities inherent in the future. What has finally been achieved in this respect is no less than the capitalist enclosure of the future.

The fundamental question now concerns whether there is any alternative to what is being presented to us as the road ahead – the only road ahead. Which, of course, is to ask whether we can still imagine other possibilities. For us, what is crucially at issue is, first, the very force of the logic of mastery that is at the heart of the capitalist project, and then – the disturbing corollary – the success that this logic has had in eclipsing the

other main signification of the modern period. This latter is what Castoriadis refers to as 'the signification of individual autonomy, of freedom, of the search for forms of collective freedom, which corresponds to the democratic, emancipatory, revolutionary project'; it is the signification to which corresponds 'the critical, reflective, democratic individual'.[45] We would agree with Castoriadis that this latter aspiration is presently stalled, thrown into crisis by the potent hegemony of the project of mastery:

> The project of autonomy is certainly not finished. But its trajectory during the last two centuries has proved the radical inadequacy, to say the least, of the programmes where it had been embodied....For the resurgence of the project of autonomy, new political objectives and new human attitudes are required, of which, for the time being, there are but few signs. Meanwhile, it would be absurd to try to decide if we are living through a long parenthesis, or if we witness the beginning of the end of western history essentially linked with the project of autonomy and co-determined by it.[46]

The Western technoculture has been fundamental to this neutralisation of the project of autonomy. Now, as the global information society is engineered into existence, the future seems to be mastered. The horizons seem closed. Alvin Toffler has already painted the portrait of the Third Wave. Bill Gates' plans for friction-free capitalism in the twenty-first century are already well advertised. The prophets who claim to be inviting us to step into the unknown are actually selling us what we know all too well. And, in fact, they are condemning us to live without the unknown in front of us.

Jacques Rancière has described the time of contemporary society as 'a homogeneous time...with the future being nothing but an expansion of the present'. As such, he says, it is a time 'which is no longer divided by promise'.[47] The future is no longer the other of the present – it therefore no longer contains the possibility of unknown encounters and events that would be transformative. Without the unknown in front of us, there can be no human creativity or autonomy. 'Creation', says Castoriadis, 'means the capacity to bring about the emergence of what is not given – not derivable, by means of a combinatory or in some other way – starting from the given.'[48] What is distinctive about human beings is

> this capacity, this 'possibility' in the active, positive, not predetermined sense of *making be other forms* of social and individual existence...there exists at least one type of being that creates something else, that is a source of alterity, and that thereby alters itself (*s'altère lui-même*).[49]

The otherness of the unknown future is the vital medium through which the process of creation and self-creation can become possible. Without that, there can only be the closure of meaning. The technological enclosure of the

future impounds the resource of open time that is necessary for the creative disorder of the radical imagination. We are left with nothing but the expansion of the present. We are invited to come to terms with the new technoculture which is given in compensation for the end of promise. Will this be enough? What happens to those who accept to live without the unknown in front of them?

11

THE VIRTUAL PACIFICATION OF SPACE

'So it is the Demiurge,' he said. 'One of the three major fundamental Arcana. The picture shows a tumbler standing at a bench scattered with miscellaneous objects. This means that in you there is an organiser, one who does battle with a world in disorder which he seeks to master by whatever means come to his hand. He appears to succeed, but we must not forget that the Demiurge is also an acrobat: his work is an illusion and his order illusory. Alas, he is unaware of this. Skepticism is not his strength.'

(Michel Tournier, *Friday*)

Ah! may you return to your disorder, and the world to its.

(René Char)

In this chapter, we shall be concerned with the nature and significance of what are now commonly referred to as virtual spaces, the network spaces that have been created in and through new information and communications technologies. Generally, there has been a sense of emancipatory possibilities. Thus, Linda Harasim declares, in a very enthusiastic expression of the new techno-idealism, that the digital networks have instituted no less than a new 'social environment'. 'The network has become,' she maintains, 'one of the places where people meet to do business, collaborate on a task, solve a problem, organise a project, engage in personal dialogue, or exchange social chitchat'. There is an eager expectation of emerging new spaces of conviviality: 'networlds offer a new place for humans to meet, and promise new forms of social discourse and community'.[1] Even though he mobilises a rather different terminology — derived from actor-network theory — Stephen Graham seems to be making much the same point. In his case, it is a matter of the ways in which 'new technologies become closely enrolled into complex, contingent and subtle blendings of human actors and technical artefacts, to form actor-networks'. Virtual culture is conceived in terms of new human-technological-spatial linkages, characterised as 'intimate and recombinatory', and constituting what are called new 'relational assemblies'.

In this version of the new technological vision, virtual communities exist as a great multiplicity of 'systems of sociotechnical relations across space' – systems that 'link the local and nonlocal in intimate relational, and reciprocal, connections'.[2] In their different ways, then, both of these accounts convey a sense of anticipation about the potential inherent in virtual technologies, which they see in terms of the potential for enhancing communication, opening up new and more creative ways of bringing people together, and expanding the forms of human sociality.

We have a problem with such accounts, and that is what this chapter addresses. It is not that we doubt the efficacy of the new technologies – indeed, we accept that it is entirely possible, even probable, that virtual technologies will sustain such new patterns of communication and community. Our problem is, rather, with the kind of social space or spaces that the new technologies are bringing into existence – this comfortable space of collaboration, dialogue, understanding, intimacy, reciprocity, and so on. Informed as it is by a sensible imagination of mutuality and consensus, we regard it as a banal space. The new virtual space is a pacified space. This is Bill Gates' managed world of 'friction-free' exchange. What it evokes, as Slavoj Žižek observes, is the ideal of 'a wholly transparent, ethereal medium of exchange in which the last trace of material inertia vanishes'.[3] It is an illusory space.

In the following discussion, we shall consider the ideal of virtual space, not as it is presented in the technoculture – in terms of progress and possibility – but, rather, in terms of pathology. We might regard it in the broader context of what Louis Sass refers to as a perverse tendency, inherent in modern culture, towards detachment from reality and the loss of experiential engagement with the world; it is a tendency for the world to lose its substantiality and otherness, and thereby its human resonance and significance.[4] Thus, we suggest, virtual culture is driven by the desire to suppress the complexities, difficulties and divisions that characterise real geographies. But for there to be any kind of meaningful social encounter and experience, we believe, there is need of such unaccommodating geographies. So the point of our argument is to lend support to the side of disorder. Against the 'friction-free' ideal of programmed space, we intend to assert the positive virtues of friction and inertia in real spaces. Against the comforts of accommodating spaces, we signal the value of spaces that withstand and provoke.

We shall centre our argument around a discussion of William Mitchell's book, *City of Bits*,[5] for here we may find all the elements of the modern technocultural vision, and especially the logic of unworlding. Mitchell's arguments are full of hyperbole, and we might be inclined to dismiss his imagined 'city of bits' as no more than a futuristic science-fiction fantasy. But really what is at issue is not the future. Mitchell's exaggerations are, in fact, highly illuminating about the prevailing ordinary way of thinking about space in the present. Indeed, we may say that there is nothing in *City of Bits*

that surprises us, because *City of Bits* is simply the condensation of familiar and commonsense fantasies about the relationship between technology and space. The book is interesting because it is entirely conventional – or, rather, because it works the trick of concealing banal convention in the masquerade of prophecy. First, we shall consider Mitchell's thoughts on the supposed problem of distance, seeing where that takes us. Then, in the second part of our discussion, we shall take his observations on so-called 'real-time' cities as the basis for reflecting on urbanity and urban spaces particularly.

DISTANCE AS A VALUE

Sometimes it is distance which for me guarantees presence.

(J.-B. Pontalis)

First, then, let us reflect on the question of distance. An absolutely central, and generally uncontested, theme in most accounts of contemporary technological transformation concerns the elimination of distance. There is the expectation that the new virtual media will – finally – remove the limitations inherent in real geographies. Many commentators have sought to make sense of this desire and aspiration in terms of the fulfilment of a long-standing utopian project to transcend our limited human condition of living and being within the constraints of dimensional space. Michel Serres has described it as a 'pantopian' ideal – 'all places in every place and every place in all places, centres and peripheries'.[6] In overcoming the 'tyranny of distance', it is claimed, the new virtual technologies permit us to communicate with others wherever they might be, and thereby to form new kinds of electronic communities based on interest and affinity (rather than on the 'accident' of geographical location). In the new virtual networks, there seems to be the prospect of greater closeness to others (to others with whom we shall interact through the virtual network, that is to say). Virtual relations are closely associated with ideals of intimacy, social communion and bonding – this is said to be the age of immediate communication, connectivity, and 'being in touch'. What is being said, then, is that new technologies now make it possible to be in a space where we may enjoy the kind of social intercourse that the real world has always denied to us. Where geographical distance is presented as the fundamental obstacle to human communication and community, the achievement of technological proximity appears to be a solution.

This is essentially the position that William Mitchell advances in *City of Bits*. Setting out from the assumption that 'geography is destiny', Mitchell wants to convince us of the utopian possibilities inherent in the technological creation of a virtual world, an 'incorporeal world', as he describes it, in which we shall exist as 'disembodied and fragmented subjects'. What is good about such a creation, he tells us, is that we will be 'freed from the constraints of physical space'; the new technologically-mediated world will

be a post-geographical world, 'profoundly antispatial' in its nature. At the same time, then, that the intractable physicality of the real world is giving way to the lightness of virtual life, we will also be putting an end to the 'tyranny of distance', finally overcoming the limitations that have always been imposed on us by geographical separation and apartness. The 'despatialisation of interaction' will put our destiny in our own hands.

Let us reflect on what this might actually mean by considering what Mitchell has to say about the nature of virtual engagement with the world. First, he says, there is now a new intensity of visual access. New image and vision technologies may be said to provide an 'electronic window' through which we are able to survey the world and its events: 'Right now, the same window is open in thousands of similar hotel rooms spread around the world. Ted Turner has succeeded in electronically organising them all into a gigantic, inverted panopticon'. And newer technologies promise even greater powers of visible access, with the Internet becoming 'a world-wide, time-zone spanning optic nerve with electronic eyeballs at its end points'. New vision technologies seem to make distance meaningless. 'Soon,' Mitchell claims, 'we will be able casually to create holes in space wherever and whenever we want them. Every place with a network connection will potentially have every other such place just outside the window.' In this dream of global visual accessibility, we have one clear expression of the virtual Pantopian imagination.

But it is not simply a question of the remote-sensing gaze. Mitchell also claims that there are new possibilities for enhancing our tactile engagement with the world through other distance-shrinking technologies:

> intelligent exoskeletal devices (data gloves, data suits, robotic prostheses, intelligent second skins, and the like) will both sense gestures and serve as touch output devices by exerting controlled forces and pressures; you will be able to initiate a business conversation by shaking hands at a distance or say goodnight to a child by transmitting a kiss across continents.

With new technological effectors and sensors, Mitchell argues, 'you will be able to immerse yourself in simulated environments instead of just looking at them through a small rectangular window...you become an *inhabitant*, a *participant*, not merely a spectator'. Increasingly, we are told, 'cyberspace places will present themselves in increasingly multisensory and engaging ways....We will not just look at them; we will feel present in them'. This desire to achieve 'immersive, multisensory, telepresence' – to 'make contact' across the world – again expresses the Pantopian ideal.

In the case of both visual and tactile access, what is at issue is the mobilisation of remote technologies to overcome the imagined constraints of distance. Mitchell presents this as a reasonable and realisable aspiration, and many seem willing to accept this enthusiastic vision. But let us consider

what they are actually buying into through their acceptance. In what context can this Pantopian vision make sense? In terms of what kind of conceptual system, we should ask, does this obsession with the elimination of distance assume significance? Mitchell's pronouncements on the nature of virtual engagement (only) make sense, we suggest, within a scheme that imagines and treats our relation to the world in terms of a technological interface. In Mitchell's cybernetic scheme, voyeurism concerns the capacity for monitoring and surveillance of the world, and telepresence is about the capacity for interaction with and manipulation of it. Through increased interconnection and integration of these functions (essentially those of input and output within the technological system), it is possible to achieve increased efficiency and thereby 'empowerment' within the system. Mitchell thinks in terms of the creation of an integrated technological circuit: 'from gesture sensors worn on our bodies to the worldwide infrastructure of communications satellites and long-distance fiber, the elements of the bitsphere will finally come together to form one densely interwoven system'. What is envisaged ultimately is a new intimacy between what Mitchell calls 'we cyborgs' and our electronic environment, such that 'the border between interiority and exteriority is destabilised' and 'distinctions between self and other are open to reconstruction'. We may consider the aspiration to overcome distance as precisely an expression of this desire to enhance the interface and achieve mastery within a new virtual space.

It is within the terms of a cybernetic logic, then, that distance has no place. It is within the context of the cybernetic system that it becomes a force to be exorcised (it is associated with the friction or noise that impedes systemic efficiency). Within the cybernetic imagination, the technological abolition of distance becomes the prerequisite for creating a new and better kind of technocultural order. And through the institution of this virtual new order, something else takes the place of distance – something that is called 'presence at a distance'. 'Presence at a distance' is the cybernetic ideal that has now become the central myth in prevailing discourses on virtual futures.[7] In the world of 'presence at a distance', the system works to expel all that is uncertain, unknown and alien – all the qualities of otherness that may attach themselves to distance. 'Presence at a distance' is about the technological synthesis of direct communication – re-creating the conditions of immediate, face-to-face community in the immaterial conditions of an alternative, virtual world. It involves the simulation of immediacy in order to make this the measure of the world. Void of all distances, the virtual world is conceived as the place of generalised and globalised intimacy.

Now, what is both significant and problematical is that this simplistic discourse on distance (bad) and intimacy (good) has been able to present itself as the foundation for a broader social and political vision. It is almost entirely on the basis of the space-transcending capacities inherent in 'remote' technologies that Mitchell sketches a 'new' social vision – a politics for new

virtual intimacies. Along quite predictable lines, he claims that the emerging worldwide computer network 'subverts, displaces, and radically redefines our notions of gathering place, community, and urban life'. What is crucial is that bodily location has ceased to be an issue in the way we construct our communities: whole new possibilities for social interaction are opened up through the advent of 'electronically augmented, reconfigurable, virtual bodies that can sense and act at a distance but also remain partially anchored in their immediate surroundings'. 'Today,' says Mitchell,

> as telepresence augments and sometimes substitutes for physical presence, and as more and more business and social interactions shift into cyberspace, we are finding that accessibility depends even less on propinquity, and community has come increasingly unglued from geography...communities increasingly find their common ground in cyberspace rather than on *terra firma*.

What Mitchell assumes throughout his exposition is that, because of their new technological nature, such virtual communities must necessarily be new, innovative and desirable in their social nature. It is, of course, conventional now to believe that technological innovation should be linked to social innovation – the power of belief generally works to inhibit any suspicion that possibilities inherent in technological innovation might, rather, be mobilised for socially conservative objectives. Only such a power could explain how the rhetoric of the new technoculture so often succeeds in deflecting attention away from the impoverished and regressive social philosophy at its heart. For what the new technological scheme nurtures at its heart is the social and political scheme of communitarianism. Like Harasim (with her networlds as 'new places for humans to meet'), and like Graham (with his 'intimate relational connections'), Mitchell too is concerned with the possibilities of virtual community, with the prospects for electronic bonding among those who share interests and common values (his question is the communitarian one: 'how should communities define their boundaries and how might they maintain their norms within these boundaries?'). What is quite clear is that, even if they are distributed in cyberspace, Mitchell's 'virtual gathering places' are conceived in terms of a very unradical ideal. It seems as if there is a strange affinity between virtual futurism and communitarian nostalgia.

In its perverse ambition to abolish all distances, the technoculture in fact aspires to perpetuate, now by technological means, what Iris Marion Young (following Michel Foucault) calls 'the Rousseauist dream' – the dream of 'a transparent society, visible and legible in each of its parts, the dream of there no longer existing any zones of darkness...zones of disorder'.[8] Through the institution of virtual communities, it seeks to revalidate Rousseau's ideal of social transparency in which 'persons cease to be other, opaque, not

understood, and instead become mutually sympathetic, understanding one another as they understand themselves'. And it sustains, too, the desire for communicational immediacy: 'Immediacy is better than mediation because immediate relations have the purity and security longed for in the Rousseauist dream: we are transparent to one another, purely copresent in the same space, close enough to touch, and nothing comes between us to obstruct our vision of one another'.[9] Is this not like Mitchell's intimate 'bitsphere', in which the border between interiority and exteriority is destabilised, and distinctions between self and other dissolved?

There is undoubtedly a certain kind of allure in the Rousseauist dream. But it is alluring because, like a dream, it suspends the condition of being in the world. The Rousseauist project involves a fundamental disavowal of reality, and retreat from a world imagined as 'incomprehensible chaos'. As Jean Starobinski remarks of Rousseau, 'because he dreams of total transparency and immediate communication, he must cut any ties that might bind him to a troubled world over which pass worrisome shadows, masked faces, and opaque stares'.[10] What motivates the Rousseauist project is the desire to be free from all difference and otherness. Rousseau was intolerant of 'the obligations of the human condition, in which the possibility of communication is always counterbalanced by the risk of obstruction and misunderstanding'. And, 'if every reality raises the possibility of encountering an obstacle, he prefers *that which does not exist*'.[11] For Rousseau, the world should be a space without obstacles. J.-B. Pontalis makes the pertinent observation that, whilst his life was errant, Rousseau's spirit was sedentary: 'Rousseau *self*-travelled. Paradoxically, his comings and goings were less of a search for other human beings whose strangeness and difference would accentuate their alterity, than a chance to immediately live at a distance from that "other" '.[12] The world, with all its opacity and disorder, is regarded as a place from which to retreat.

What are we to make of this? The technoculture aspires to be rid of the burden of geography for it considers geographical determination and situation to have been the fundamental sources of frustration and limitation in human life. It seeks to institute, in place of that intractable world, an alternative 'antispatial' order that it believes will be more accommodating. A new and different space – a neutralised and pacified space – is substituted for the other one. Mastery is achieved at the cost of losing the world: which is to say that the choice has been made in favour of 'that which does not exist'. For the most part, virtual culture is a culture of disengagement from the real world and its human condition of embodied (enworlded) experience and meaning. We might think of it in terms of the progressive disavowal – both intellectual and by technical means – of the real complexity and disorder of actual society and sociality. What is preferred is the order that can be established in a domain where the dangers and the challenges of the real world are negated – a domain purged of worrisome shadows, masked faces and opaque stares.

Virtual culture is a culture of retreat from the world. But what we want to make clear is that this logic or temptation of retreat is far more than just a problem of virtual culture. Clearly, we are concerned with a transformation in our relation to the world that precedes the development of new information and communications technologies. The loss — or denial — of reality is a phenomenon that has more profound origins — and it must be considered, therefore, beyond just the narrow terms of the virtual technology debate. Dorinda Outram has put this question of the loss of distance as a meaningful reality into an interesting historical perspective. Acknowledging the contemporary difficulty in achieving 'a focused attentiveness on what is other, other either in time or space',[13] she locates the origin of this attenuation of otherness in the eighteenth century. In reflecting on these origins, she remarks on the significance of a transformation in the meaning of mobility at the end of the Enlightenment (at the time of Rousseau, that is to say). In this period, Outram argues, an increasing concern with the interior of the self became associated with a weakening sense of external reality — 'the loss of the sense of the reality "out there"'. And this weakening was associated, in turn, with a growing anxiety about mobility in the world. In this context, Outram points to the contemporary significance of travel literature, and then pertinently observes how the Enlightenment concern with travel was bound up with utopian fantasies: 'Mobility was becoming linked up to escape, to the wish to travel endlessly to elsewheres which were literally no-wheres. In No-where, in Utopia, one can momentarily forget the erosion of the reality of the world'. (And, of course, we are suggesting here that the same anxieties continue to be associated with the same drives towards reality substitution.) Outram goes on to suggest what would be at issue in the writing of a history of mobility in the Enlightenment:

> It is a history which shows a truly momentous shift in world view, which saw the decline and final collapse of ways of thinking about mobility which had been present since the Roman empire or even earlier. This is a historical shift which we have yet to come to terms with. It might indicate to us that the last battles might well be fought over the meaning of passage and the possibility of place.

In reflecting on what has happened to the meaning of distance, we must surely take this historical shift as a crucial point of reference, recognising that it considerably precedes the development of modern communications technologies.

But, of course, technological developments in communication have, subsequently, become very significantly implicated in this experiential transformation. We might consider their significance, then, from this perspective of mobility and the meaning of passage. First, communications technologies have worked towards the neutralisation of space. In his

observations on the new transportation systems and new media technologies (radio and television) of the early twentieth century, Heidegger comments lucidly and insightfully on the creation of a new space. 'All distances in time and space are shrinking,' he observes, 'Man puts the longest distances behind him in the shortest time.'[14] What is created as a consequence of this technological innovation is 'a world in which everything is equally near and equally far. The distanceless prevails'.[15] What is the significance of this condition of distanceless? 'What is happening here when, as a result of the abolition of great distances, everything is equally far and equally near? What is this uniformity in which everything is neither far nor near – is, as it were, without distance?'[16] These are fundamental questions. The technological erosion of great distances actually brings with it an illusory sense of closeness and intimacy. Technologically contrived intimacy has nothing to do with nearness, for nearness does not consist in shortness of distance:

> What is least remote from us in point of distance, by virtue of its picture on film or its sound on the radio, can remain far from us. What is incalculably far from us in point of distance can be near to us. Short distance is not in itself nearness. Nor is great distance remoteness.[17]

The world of illusory technological intimacy is, at the same time, one in which we also arrive at 'the abolition of every possibility of remoteness'. Without nearness, there can be no remoteness – nearness is necessary in order to 'preserve farness'.[18] These are important observations, going against the banal grain of commonsense beliefs about distance and the conquest of distance, contesting the perverse desire to eliminate the human significance and value of remoteness. The question is raised as to whether there is any longer a basis for meaning – both aesthetic and moral – in a world that has been deprived of both nearness and distance.

Second, technological developments have contributed enormously to the pacification of experience in space, to the loss of attentiveness, that is to say, to what is other in space and time. Technological immediacy may, in fact, work to insulate us against the possibility of being touched by the other. Richard Sennett has interpreted the development of technologies of transportation from just such a perspective. Thus, in the twentieth century, he maintains, the automobile has served to 'detach the body from the spaces through which it moves....The act of driving, disciplining the sitting body into a fixed position, and requiring only micro-movements, pacifies the driver physically'.[19] The technological construction of such 'sealed spaces' has allowed us to manage and control what we have come to think of as our 'interface' with reality – 'it is possible for a passively moving body to lose all physical contact with the world'.[20] New virtual transactions – travels through virtual space – can massively extend such possibilities. For they offer whole new dimensions of mobility and, at the

same time, make detachment from the real world ever more efficient and systematic – the ultimate sealed space. Gilles Châtelet remarks on the advent of the 'thermostat-citizen', who is no more than a 'cybernetic tapeworm'.[21] What virtual culture promises is an alternative space that will entirely fulfil the desire for effective disconnection and refuge from the world – a space where it will be possible, perhaps indefinitely now, to go on ignoring the erosion of the world's reality. In the virtual space, the distanceless is truly brought to dominance – the uniformity of an information space is substituted for a space of vivacity and experience. The 'city of bits' – the pacified technospace – would be the ultimate space of accommodation for the passively moving body. What could be the meaning of passage in such a space?

Contemporary accounts of and debates around virtual technologies are focused on the potential of a new technocultural order – 'we have reinvented the human habitat', says William Mitchell. Against this, we are counterposing the argument that the new technologies may, rather, be contributing to the depletion of the real resources of social life and experience, through the erosion of significant external reality. Now, we do not expect that the progressive expansion of distance-shrinking technologies will be interrupted – too great a part of the population (or perhaps it is a great enough part of most of us) can find comfort in the prospects of virtual life. Moreover, we have suggested that what is fundamentally at issue – the modern disposition to evade what is 'out there' – is not just a question of technological 'dependency', but has far deeper psychic-cultural roots. Our counter-position cannot really (or in any simple way) be about opposing the new technologies as such. The point is, rather, to keep in mind and play the crucial insight that the question concerning technology is not, fundamentally, a technological question. It means resisting the restricted and facile terms in which the technoculture sets the agenda – the terms, that is to say, of progress and progressive empowerment and mastery. And it means shifting the debate onto the richer and more rigorous terrain of social and political analysis, where the ideals of intimacy, immediacy and community will have less credibility – and where it may be possible to mobilise against them more complex and challenging social values. If we are to resist the logic by which technology becomes the measure of all things, we need above all to secure a critical intellectual vantage point beyond its empire.

Consider what is at issue with respect to the question of space and distance. The technoculture is already telling us of whole new possibilities of mobility and 'presence at a distance', of incredible voyages in cyberspace, and of virtual encounters with other so-called cybernauts in new electronic 'meeting places'. We think that it is necessary to consider the nature of these journeys in compressed space and time, and to do so, moreover, in the context of a broader reflection on the meaning of passage. For the technological system that seems to be about opening up new possibilities might

actually turn out to be more about possibilities further closed down. What the virtual culture is seeking to institute is a spatial order in which the difference between face-to-face and distantiated forms of communication is erased – a kind of space in which immediate communication becomes the model for all communication (for Al Gore, the Internet constitutes 'a kind of global conversation', and the point is 'to share information, to connect, and to communicate as a global community').[22] The world 'out there' is thus conceived in the image of the world of intimacy and community (held to be a world of consensus). It is reduced to the parochial dimensions of what is known and familiar and predictable. This is a space in which distance and its otherness is turned into illusory proximity and spurious affiliation. In this respect, then, we suggest that the technocultural project be regarded as a scheme to achieve magical control over distance and its imagined disruptive potential. Virtual culture works to nullify the meaning of passage.

What is the value of distance? And on what basis might we rescue the meaning of distance? Gabriel Josipovici offers one response to these questions in his book, *Touch*. Reflecting on what he values positively as the experiential possibilities of separation, he asks us to think in terms of the 'therapy of distance'. To illustrate his point that sense and meaning may be made out of distance, Josipovici invokes the experience of pilgrimage, considered as

> a journey into the experience itself.... When the pilgrim touched the shrine at the end of his or her long journey it was an attempt not so much to bridge the distance that separated him or her from the holy as an instinctive way of making that distance palpable.[23]

Josipovici, of course, recognises that the rise of modernity undermined the meaning of pilgrimage, making distance an enemy. Nonetheless, he believes that this disposition is still rooted in the body's relation to the world, and he thinks that distance may still be mobilised as an existential resource in contemporary society. Josipovici refers to his own impulse, on the occasion of his first visit to Los Angeles, to dip his hand in the ocean. Why, he asks, did he feel that need to touch and not just see?

> The memory of my action that day [he suggests] helps to establish its distance from me now, its otherness, its incomprehensible vastness and ancientness, and so makes real for me its presence in a world which I also inhabit, and helps confirm that it will remain quite other than all my imaginings.[24]

There may still be a significant and meaningful relation to absence. Rather than pursuing its technological abolition, then, says Josipovici, we might actually be concerned to 'bring distance to life'.

Josipovici raises important issues concerning the quality of otherness that attaches to distance. In the face of the accumulating virtual ideal of myriad intimate 'connections' within communities of the 'like-minded', we should take seriously the crucial point that all real experience is experience of the other. And we should take heed of Josipovici's concern about what happens when distance is killed. 'To abolish the actual journey,' he notes, 'with all its attendant dangers and attractions, with all its temptations and seductions, was also to abolish the therapy.' And he is surely right to say that 'there is no substitute for the therapy of distance'[25] (when the therapy was abolished what took its place was the pseudo-therapy of technology). But, whatever its merits, there is at the same time a fundamental problem with this argument, for Josipovici's thinking is suffused with a nostalgia. What he holds on to in the present is simply the residue of what he considers to have been only truly available in the pre-modern past. We are left to reflect on the consequences of progress in the rational appropriation of the world for other ways of knowing it – to reflect on an experiential and imaginative loss. Josipovici's substantive concern seems to be with the revalidation of the otherness that resides in God and Nature. But we can scarcely think that divine mystery or the Romantic sublime can still provide us with a significant intellectual or existential focus. This certainly cannot be the way to rehabilitate distance. It provides no meaningful alternative to the technocultural agenda.

The rescue of distance now can only be in the context of a social and political project. It must be in terms of putting forward a political alternative to the cloying vision of virtual intimacy, familialism and communitarianism; an alternative to the blandness of 'connecting' and 'bonding' in cyberspace and to the banal idealisation of 'global conversations' through the Internet. With its well-intentioned belief in sharing, collaboration, mutuality, and so on, it is a stultifying vision – an absolutely anti-social and anti-political vision. For cyberspace, with its myriad of little consensual communities, is a place where you will go in order to find confirmation and endorsement of your identity. And social and political life can never be about confirmation and endorsement – it needs distances. Josipovici's crucial point concerning otherness is that it represents something that is beyond our own imaginings. And this 'beyondness', we suggest, is vital, not just in the kinds of experiences that Josipovici invokes, but also in social experiences between people. Encounters with others should not be about confirmation, but about transformation. We might consider them, following Christopher Bollas, in terms of transformational object relations – the others offer the possibility of a relation which is not about possession, but 'in which the object is pursued in order to surrender to it as a medium that alters the self'.[26] Such a relation requires the renunciation of narcissistic desires to fuse with or to control the object – it requires the recognition, that is to say, of its essential otherness and of the experiential possibilities to be derived from its distance. The

therapy of distance resides in the transformational experience – this is what is vital if there is to be meaning in passage.

What we are invoking here, then, as the radical alternative to the new politics of virtual community is what Iris Marion Young describes as a politics 'conceived as a relationship of strangers who do not understand one another in a subjective and immediate sense, relating across time and distance'.[27] Democratic culture is in fact founded on the differences and distances between strangers. Consider Jacques Rancière's incisive formulation, which claims that 'democratic dialogue...resembles poetic dialogue as defined by Mandelstam: the interlocutor is indispensable to it, but so is the indeterminacy of the interlocutor – the unexpectedness of his countenance' ('an interlocutor is not a "partner" ').[28] Democracy is the dialogue premised on division:

> Grievance is the true measure of otherness, the thing that unites interlocutors while simultaneously keeping them at a distance from each other. Here again what Mandelstam says about poetic interlocution may be applied to politics: it is not a question of acoustics but of distance. It is otherness that gives meaning to language games, not the other way round. Likewise, dreams of a new politics based on a restricted and generalised otherness, on multiform networks redirecting the flows of the communication machine, have only had disappointing results, as we all know.[29]

Against the sentimental ideal of consensus and community, it is vital to protect the more robust principles of adversarial democracy, 'a coming together which can only occur in conflict': 'Democracy is neither compromise between interests nor the formation of a common will. Its kind of dialogue is that of a divided community'.[30] For those who recognise and accept this agonistic basis to political culture, the ideals of the new technoculture must surely seem both misguided and misconceived. They must insist on judging the ambitions and achievements of the virtual culture according to the measure of these other, countervailing principles.

GLOBAL CITIES: TOWARDS A STRUCTURED SPACE OF CONFLICT

> I think, chaos, les nomades, les Arabes, les Maghrebins, les noirs, les Juifs, les marginalisés, les exclus, Saddam Hussein, Gueddafi, les immigrés, the list is rich.
>
> (Rosalind Belben, *Choosing Spectacles*)

Now we want to return to William Mitchell's *City of Bits*, and to consider these general questions of technology, space, culture and politics from another perspective. In this part of our discussion of spatial pacification we

shall be concerned with developments in urban space. In particular, we want to consider contemporary transformations associated with the idea of the global city. Again we shall be opposing the technocultural agenda, which, in this case, links urban globalisation almost exclusively to the emergence of the so-called information city or virtual city. And again we want to counterpose against the technological vision an alternative agenda, one that regards the global city in terms of other kinds of possibilities and quite other social and political values.

First, then, what should we think of the idea of the global city as an information or virtual city? This interpretation has rapidly and easily become a received idea. The slick advocates of the new virtual urbanism seek to impress us with the social and political potential of what they call 'real-time' cities and 'virtual urban spaces'. They are eager to persuade us that new technological systems can radically and beneficially transform urban life and experience. But, we should be asking, just what kind of vision or utopia is it that they are wanting us to buy into? What kind of urban living would go on in the virtual city? And how much does the informatic vision correspond to the actual realities of global transformation in contemporary urban contexts?

Techno-urbanism is driven by the imagination of a historical progression through which the intractable reality of actually-existing urban environments is to be surpassed or superseded. Its core belief concerns the individual and social 'freedom' that may be achieved through virtual transactions and interactions in the information city. In *City of Bits*, Mitchell provides one of the fullest articulations of this cyber-city vision – anticipating, as he sees it, the new kind of community that 'we cyborgs' shall belong to once communities come to find their common ground in cyberspace rather than on *terra firma*. Mitchell argues that we must now 'conceive a new urbanism freed from the constraints of physical space'. This is what he imagines in the form of the future 'city of bits':

> This will be a city unrooted to any definite spot on the surface of the earth, shaped by connectivity and bandwidth constraints rather than by accessibility and land values, largely asynchronous in its operation, and inhabited by disembodied and fragmented subjects who exist as collections of aliases and agents. Its places will be constructed virtually by software instead of physically from stones and timbers, and they will be connected by logical linkages rather than by door, passageways, and streets.

Mitchell fervently maintains that 'the most crucial task before us' now is that of 'imagining and creating digitally mediated environments for the kinds of lives that we will want to lead and the sorts of communities that we will want to have'.[31] Such an imagination and creation must, of course, have serious consequences for established territorial forms of social organisation –

and particularly for urban forms as we have known them for at least 3,000 years. As he busily summons up aliases and agents and dreams of logical linkages, Mitchell feels comfortable and confident in coming to the conclusion that 'the very idea of the city is challenged and must eventually be reconceived' – that the historical achievements of urban culture and urbanity can finally be consigned to the rubbish bin of history.

Mitchell is intent, then, on persuading us that the future is all about creating the virtual alternative of 'soft cities', and that in this future information environment our primary task will be 'to figure out how to make cyberspace communities work in just, equitable, and satisfying ways'. In instituting the new order of 'programmable places', it seems as if the crucial decisions have become technical and organisational ones, concerning the choices to be made between alternative network configurations and between competing architectures of cyberspace. Mitchell has reduced the question of urban (or post-urban) futures to an entirely technological issue – his virtual planning agenda requires us to express our agency only within the meagre and restricted technological terms set by the technoculture. Now, what we want to make clear in the discussion that follows is the imaginative and political poverty of this futuristic scheme of technological advancement, concerned with the virtual transcendence of the urban 'problem'. We want to re-situate the feeble debate around the virtual city where it belongs, within the broader and more robust framework of modern urban culture and politics. It is in the historical context of urban modern-isms – we shall suggest that there have been two significant aspects of the modern urban sensibility – that we can establish a measure of the signifi-cance of virtual urbanism, and also, more crucially, recover a sense of more complex and challenging urban possibilities, not even dreamed of in the cyberscheme.

First, let us consider what emerged in twentieth-century planning as the dominant expression of urban modernism. We refer to the rationalistic aspect of modern urban planning that has been driven by the desire to impose order on the confusing reality of the urban scene. Christine Boyer has referred to the particular significance of Le Corbusier in this context: 'No longer [for him] could the traditional meandering streets dominate the material order of the city'; there must be a 'transformation of both the city and the region into a coherent and uniform order'. The imperative was to regulate and control the urban space. In the 'structured and utopian whole' of the modern city, 'disorder was replaced by functional order, diversity by serial repetition, and surprise by uniform expectancy'.[32] In this struggle to impose order and coherence, Le Corbusier sought to mobilise the power of rational vision. In his conception of panoramic control, order was associated with visibility and transparency. This was the Radiant City. 'Reviving the late eighteenth-century myth of "transparency", both social and spatial,' Anthony Vidler observes, 'modernists evoked the picture of a

glass city, its buildings invisible and society open. The resulting "space" would be open, infinitely extended, and thereby cleansed of all mental disturbance.'[33]

Underpinning the compulsion to order, then, was the struggle to achieve detachment and distance from the perceived disorder of the urban scene. Modernist planners like Le Corbusier worked towards the 'suppression of everything they hated about the city'[34] (and, of course, what they hated tells us a great deal about them). They did not want to be touched by what they perceived and abhorred as its confusion and turmoil (again we have to do with the fear of 'worrisome shadows' and 'incomprehensible chaos'). As Richard Sennett has argued, modern planning, aligned with modern technologies, 'has long conspired to free the body from resistance...weakening the sense of tactile reality and pacifying the body'; it has constantly sought to achieve a condition of 'disconnection from space' and 'desensitis[ation] in space'.[35] There has been a progressive withdrawal from the urban scene, a loss of contact with urban culture, an evasion of encounter with the others in the city – it amounts to a fundamental disavowal of urban reality. 'The geography of the modern city,' says Sennett, 'like modern technology, brings to the fore deep-seated problems in Western civilisation in imagining spaces for the human body which might make human bodies aware of one another.'[36] (For Sennett what is crucial is precisely the experience of passage through urban space – the need for the urban body to be aroused by disturbance: 'For without a disturbed sense of ourselves,' Sennett asks, 'what will prompt most of us...to turn outward toward each other, to experience the Other?'[37])

Inscribed in this historical context, it is difficult to see anything that is significantly new or innovative in the virtual planning agenda. We would say that it merely continues and perpetuates, now by microelectronic means, the long-standing project of mainstream urban modernism. It simply extends this project to establish order and coherence, this time in a substitute or proxy electronic space. These are technologies which – in new ways, and perhaps to an unprecedented degree – promise detachment and insulation from the contamination of reality. In this context, consider Mitchell's approving expectation that 'as networks and information appliances deliver expanding ranges of services, there will be fewer occasions to go out'. Or reflect on his passing suggestion, elsewhere, that we 'might just want to stay well away from dangerous places like battlefields or the South Side of Chicago'. The vaunted post-urban vision turns out to be the familiar anti-urban phobia and prejudice. The closed and airless world of Mitchell's obsessively technological imagination represents no more than the culmination of a long-established programme of urban pacification. But in this culmination, as Paul Virilio has forcefully argued, the city may finally be lost. 'And in losing the city,' Virilio concludes, 'we have lost everything.'[38]

To understand what would be lost — what Mitchell's would-be aliases and agents seem ready to lose — we must consider the other expression of urban modernism. This is the aspect of modern urban sensibility that has embraced the modern city for what it is, looking to the possibilities that are inherent in its profusion and disorder. It has put a value on embodied and situated presence in the city — on a kind of ontology and ethics of the street. What are privileged are the radical experiential possibilities of contact and encounter in the urban scene. This is the city of vital disorder. It is the one described by Robert Musil in *The Man Without Qualities*. It is the city of

> irregularity, change, sliding forward, not keeping in step, collisions of things and affairs, and fathomless points of silence in between, of paved ways and wilderness, of one great rhythmic throb and the perpetual discord and dislocation of all opposing rhythms, and as a whole resembl[ing] a seething, bubbling fluid in a vessel consisting of the solid material of buildings, laws, regulations, and historical traditions.[39]

A far cry from the coherence and order of virtual urbanity, Musil's city is one in which the streets pulse with disorderly and chaotic life. Or perhaps we might invoke Walter Benjamin's vital account of urban culture in Naples, which also takes as its central concern the meaning of passage and the possibilities of experience in space. Benjamin describes Naples as a city of mobility, in which life and activities are 'dispersed, porous, and commingled': 'Porosity is the inexhaustible law of the life of this city'.[40] Howard Caygill captures very nicely Benjamin's experiences of passage through Naples. It is experienced as a city of

> routes and intersections where things unpredictably appear and disappear....It is a place where the spatial and temporal limits of experience are in a process of continual transformation, not according to a plan but according to improvisations whose motivation remains inscrutable and whose consequences are unforeseeable.[41]

This urban space — 'a welter of sudden transitions, interminglings and improvisations' — is one in which 'everything is in a continual process of discontinuous transformation'.[42] Again, a very far cry from the space-denying fantasies of virtual transcendence. The city is where passage is eventful and meaningful.

What is at issue, then, is not a mere question of progress in virtual technologies. It is the extent to which the technological ideal of the virtual city will succeed in undermining the political principles of urbanity. We may see the issue from this perspective in terms of the defence of urban values. Taking up Bogdan Bogdanović's notion of the city as a 'tool for thought',[43] it is a matter of defending the kind of thinking that the city

makes possible, against the kind of thinking that the virtual network promotes and encourages (for the network, too, is a tool for thought; and our critique of the 'city of bits' has sought to emphasise its limitations as such).

It must, of course, be a matter of defending the city as it is now, at the end of the twentieth century, for there can never be a return to the past, nor can there be any simple appeal to the 'classic' modernism of Musil or Benjamin. The argument cannot be grounded in nostalgia. The question is whether, in the late twentieth-century conditions of urban transformation, we can find the basis for a new politics of the city. We want to outline now what we see as the possibilities for such a new urbanity, possibilities that are emerging out of the contemporary processes of urban globalisation. These are possibilities that actually reside in what the virtual imagination denies and disavows in the urban scene. What we are working towards is what might be regarded as a turbulent alternative to the pacified vision of the virtual city – an alternative in disorder.

Let us come back to consider the relation between globalisation and urbanisation. We have seen that the technocultural agenda associates globalisation with the institution of the information superhighway and the network society. Such a notion has meaning only for a relatively small minority of the world's population – for the new global cadre of 'symbolic analysts' (as Armand Mattelart argues, this idea of global communication is in fact a corporate ideology).[44] Only from their privileged and partial vantage point does the prospect of technological transcendence of spatial and temporal constraints make sense. The vast majority of the world's population have a very different understanding of globalisation, which they experience in terms of the destabilisation and disruption of their ways of life. From their perspective, global capitalism is a devastating force. As William Robinson observes, it involves 'breaking up and commodifying non-market spheres of human activity, namely public spheres managed by states, and private spheres linked to community and family units, local and household communities'.[45] These destructive transformations are associated with growing divisions between rich and poor at the global scale, what Robinson describes as a 'global social apartheid', amounting to 'a form of permanent structural violence against the world's majority'.[46] Against the ideals of virtual interaction and technological transcendence, we might juxtapose Robinson's image of globalisation as 'a war of a global rich and powerful minority against the global poor, dispossessed and outcast majority'. And against the vision of a virtual new world order, let us place the dramatically alternative possibility that humanity may be 'entering a period that could well rival the colonial depredations of past centuries'.[47] This is the other globalisation.

What of the city in this other global context? Here, of course, the future is not linked to the growth of the information city (which is the virtual

successor to the Radiant City). The urban question has quite other dimensions. Global cities are, rather, the places where the world's newly displaced and mobilised populations gather in their millions. Each represents a kind of microcosm of the new world disorder – articulating its dramatic contrasts of rich and poor, its polarisations and segregations, and its encounters and confrontations. The global city constitutes a new kind of city, where the coherent and ordered structure of the 'modern city' is overwhelmed and superseded by the sprawling chaotic megalopolis. Michael Dear and Steven Flusty picture the new urban scene of the megacity – in their case it is Los Angeles – thus:

> Conventional city form, Chicago-style, is sacrificed in favour of a non-contiguous collage of parcellised, consumption-oriented landscapes devoid of conventional centres yet wired into electronic propinquity and nominally unified by the mythologies of the disinformation sewerway....The consequent urban aggregate is characterised by acute fragmentation and specialisation – a partitioned gaming board subject to perverse laws and peculiarly discrete, disjointed urban outcomes. Given the pervasive presence of crime, corruption, and violence in the global city, not to mention geopolitically as the traditions of the nation state give way to micro-nationalisms and trans-national mafias, the city as gaming board seems an especially appropriate twenty-first century successor to the concentrically-ringed city of the early twentieth.[48]

This they call the 'spatial logic of keno kapitalism'. Its new kinds of mixture and permutation, combined with strange energies, are bringing about the dissolution of previous models of urbanity. And let us note that the global city is precisely that: global. As the 'exploding cities' of the Third World proliferate at a much faster rate than those of the First, it seems as if the distinction between 'modern' and 'undeveloped' urbanism is being eroded. Mike Davis observes how Los Angeles has now come to resemble Sao Paolo and Mexico City.[49] In the new global context, the privileged reference point of modern (as Western) urbanism and urban culture is increasingly confounded. Cities are changing, and so is the meaning of urbanity.

And maybe there is also something productive in this seemingly perverse development? The protagonist of Juan Goytisolo's novel, *Landscapes After the Battle* perceives what is going on, and does not turn away from it:

> He savors the fluid, permanent presence of the crowd, its chaotic Brownian movements, its feverish diaspora toward every point of the compass....The complexity of the urban environment – that dense and ever-changing territory irreducible to logic and to programming – invites him on every hand to ever-shifting itineraries that weave and unweave themselves, a Penelope tapestry, a mysterious lesson in topography.[50]

He is in his element, with enthusiasm

> for that non-aseptic, unsanitized medina where the street is the medium
> and the vital element, a stage-set peopled with figures and signs where
> barbarians and helots, foreigners and natives joyously take over the space
> granted their bodies in order to weave an endless, inexhaustible network
> of exuberant encounters and untrammelled desires; for the emergence, in
> the perfectly ordered Cartesian perspectives of Baron Haussmann, of bits
> and pieces of Tlemcen and Dakar, Cairo and Karachi, Bamako and Cal-
> cutta; for a Berlin-Kreuzberg that is already an Istanbul-on-the-Spree and
> for a New York colonized by Puerto Ricans and Jamaicans; for a future
> Moscow of Uzbeks and Chinese and a Barcelona of Tagalogs and blacks,
> able to recite from memory, with an ineffable accent, the verses of the Ode
> to Catalonia.[51]

Goytisolo's narrator recognises and acknowledges the 'irreversible contami-
nation' of the urban scene: 'the gradual de-Europeanisation of the city – the
appearance of Oriental souks and hammams, peddlers of African totems and
necklaces, graffiti in Arabic and Turkish – fills him with rejoicing'. And he
recognises that the transformations that have ensued 'are little by little
tracing a map of the future bastard metropolis that at the same time will be
the map of his own life'.[52] *Landscapes after the Battle* works to subvert the
dominant modern (and Western) imagination of urban space as urban order;
provocatively challenging its deep-seated fears of disorder, chaos and
contagion.

Virtual urbanism evokes the idea and possibility of the 'real-time' city. It
would be the city in which new communications technologies finally
overcame what are now thought of as 'time constraints' and 'temporal
barriers' (time is imagined as something to be defeated). This 'real' time is
an oppressive and tyrannical time, an imperious corporate time that strives,
as Paul Virilio says, 'to liquidate the multiplicity of local times'.[53] And local
times, in their diversity, constitute an important human resource – 'Cities
can be recognised by their pace', as Robert Musil expresses it in *The Man
Without Qualities*, 'just as people can by their walk'.[54] But perhaps the
liquidation of temporal diversity is not a foregone conclusion. For even as
the technoculture seeks to convince us about the supposed virtues of real-
time living, unanticipated other things are happening in our global cities.
The other reality of urban life – that of the 'dense and ever-changing
territory irreducible to logic and to programming' – is also cultivating
another time. As Goytisolo's narrator puts it, 'the modern metropolis is
already going by Byzantium time'.[55] Daryush Shayegan observes the
coexistence of different temporalities in metropolitan centres as a conse-
quence of global and post-imperial migrations. 'What disturbs western
people,' he suggests,

is that the immigrants have another rhythm of existence, another percep-
tion of time and space, other kinds of feeling and sensibility. And because
these non-western civilisations no longer exist entirely as worlds apart,
their distinctive modes of being become incorporated as enclaves within
the West, giving rise to an overlapping of levels, more or less fruitful
crossovers, more or less explosive juxtapositions.[56]

Under such conditions time may be acknowledged as a medium of
possibility – rather than as an oppressive problem to be dealt with – and we
may recognise our need for it to be complex, irreducible, varied in its
rhythms. The time of our cities can be multiple, elaborate and intriguing.
The city of our times may be Byzantine.

For us, what is significant about this evocation of 'creative, bastard
mixture' is that it actually acknowledges and valorises the primordial
energies of the global city. From our perspective, it is not a question of
celebrating these energies as such, but of recognising that they are the source
of all that is possible – whether good or bad – in the city (this point has to
be firmly made in the face of the technocultural belief that urban futures
depend on the neutralisation or suppression of these vital urban energies).
Without them the urban scene would lack all its necessary mobility and
transitive power. But, of course, once we make this acknowledgement, we
then have to come to terms with the more challenging fact that these are
volatile and ambiguous energies: while they inform the dynamic and
creative passions of urban living, they may equally express themselves in
turbulent, chaotic and frequently violent ways (as Benjamin readily
acknowledged in writing about Naples). This tension between energies
exists because the city is the place where we live with those whom we
regard, in different ways, as others, aliens or strangers – with those that we
do not understand or do not agree with or do not like. The city must,
essentially and necessarily, be a place of complex and conflictual energies:
while it may often be experienced in terms of the immense possibilities of
interaction with the others, it is also the case that this sense of possibility
can rapidly be transformed into anxieties about dangerous and threatening
energies, ones that disturb our peace of mind, frequently stirring up fears
and anxieties about those others (the crisis of contemporary urbanity may be
said to be a crisis in dealing with this reality – compounded now by the
fantasy of disavowing it through technological means). What we are
compelled to accept, then, is that difficult and often painful experiences are
integral to urban living – difference, conflict and antagonism are actually
constitutive of urban culture. This is to acknowledge the social relations of
the city in their most radical sense.

But, as we have said, just to acknowledge the presence and the force of
these energies in the city is not enough. Contemporary urban politics has
then to be concerned with the distribution of these complex energies. It is a

matter of advancing the energies of the city. Such a politics is totally at odds with the politics of virtual urbanism, with its aspirations for community and consensus. What it recognises is that passions can never be taken out of politics, and, moreover, that democracy actually emerges out of adversarial conflict. Conflict is irreducible. The point, as Chantal Mouffe argues, is to transform the antagonistic relation into an agonistic one, with the opponent regarded not as an enemy to be destroyed, but as an adversary whose existence must be tolerated.[57] As Joël Roman argues, urban public culture has been about 'the permanent confrontation of individuals and opinions, with citizenship being elaborated through a process of mutually accepted friction'. The contemporary crisis of urbanity is in fact 'a crisis in our representation of social conflict'; it is a crisis of the forms of representation and delegation necessary to allow the city to function as a 'structured conflictual space'.[58] We must be concerned with making the city a space for disputation. Against the orderly obsession that informs the new techno-urbanism, we are insisting on the importance of the disorderly side of our urban sensibility.

ORDER'S OTHER

The technoculture tells us that the new virtual technologies will provide a solution for the social problems of contemporary society. In so doing it dutifully repeats the technocratic promises that have always been attached to new communications technologies. Of course, in one respect, we accept that they do provide a solution. We might say that virtual spaces provide an anaesthetic solution, through the technological neutralisation of social relations and the pacification of social space. They contribute to what Cornelius Castoriadis termed the contemporary 'state of universal distrac-tion', amounting to 'death by distraction, death by staring at a screen on which things that one does not live and never could live pass by'.[59] Against the technocultural agenda, we have sought to elaborate some perspectives concerning the possibilities and value of experience (in the profound sense) in space. We have been concerned with the importance of social encounter in real spaces – regarded as spaces of possibility, spaces that can accommodate what is unknown, uncertain, unfamiliar, unanticipated. Where the technoculture values the security and comfort that can be achieved through virtual activities, we put a value on exposure and its discomforts, which are a consequence of embodied presence and encounter. Against the ordering logic of technological rationalisation, we have looked to the possibilities inherent in what we might regard as order's other.

One way of formulating this alternative agenda is in terms of the mean-ing and significance of distance – in terms of the battle to be fought over the meaning of passage. Against the technocultural objective of transcending – or annihilating – distance, and in the light of a deeply-rooted anxiety in the

relation to external reality, this issue concerns the institution of meanings and values around distance and our passage through space. It is a question of how we may be drawn out of ourselves by the encounter with others. Such an approach is resolutely opposed to the ideal of immediacy and intimacy in virtual community, and demands a socio-political agenda that would recognise complexity, difference and opacity as resources. This alternative politics must be conceived, as Iris Marion Young argues, 'as a relationship of strangers who do not understand one another in a subjective sense, relating across time and distance'.[60] This is of particular significance in the context of contemporary urban culture politics, and we have wanted to mobilise a more robust notion of urbanity against the empty vision of the virtual city. From the experiential perspective, we argue, to live fully in the city is to be prepared to expose oneself to its complex energies and to the otherness it furnishes (the institution of urbanity should always involve what Jacques Dewitte calls 'a certain openness, a disposition to confront others and to accommodate the unforeseen').[61] The disorder of the urban scene may be regarded, from this perspective, as a primary resource in urban life: it is out of the countless challenges of everyday encounter with its diverse others, as we weave our way through the city's dense and ever-changing spaces, that we construct, over time, our urban experiences and identities. Virtual culture is a culture of denial or disavowal in the face of these disorderly possibilities of contemporary urban reality. Among those who are now contemplating the possibility spaces of contemporary society, we believe, the key distinction may be between those who look to order and those who feel for disorder.

NOTES

INTRODUCTION: THE CHANGING TECHNOSCAPE

1 See, for example, Tom Stonier, *The Wealth of Information: A Profile of the Post-Industrial Economy*, London, Thames Methuen, 1983; Clive Jenkins and Barrie Sherman, *The Leisure Shock*, London, Eyre Methuen, 1981; André Gorz, *Farewell to the Working Class: An Essay on Post-Industrial Socialism*, London, Pluto Press, 1982. For a critical review, see Frank Webster and Kevin Robins, *Information Technology: A Luddite Analysis*, Norwood, NJ, Ablex, 1986, Chapter 6.

2 Robert Reich *The Work of Nations: Preparing Ourselves for 21st Century Capitalism*, New York, Vintage, 1992.

3 For example, Howard Rheingold, *The Virtual Community: Finding Connection in a Computerised World*, London, Secker and Warburg, 1994.

4 See, for example, Mike Featherstone and Roger Burrows (eds), *Cyberspace/Cyberbodies/Cyberpunk: Cultures of Technological Embodiment*, London, Sage, 1995.

5 See Chris Hables Gray (ed.), *The Cyborg Handbook*, London, Routledge, 1995.

6 See Frank Webster and Kevin Robins, 'Mass Communications and "Information Technology"' in Ralph Miliband and John Saville (eds), *Socialist Register 1979*, London, Merlin, 1979, pp. 285–316.

7 See James R. Beniger, *The Control Revolution: Technological and Economic Origins of the Information Society*, Cambridge, MA, Harvard University Press, 1986.

8 Bill Gates, *The Road Ahead*, London, Viking, 1995, p. 273.

9 Ibid., p. 274.

10 Ibid., p. 272.

11 Joe Bailey, *Pessimism*, London, Routledge, 1988.

12 Nicholas Negroponte, *Being Digital*, London, Hodder and Stoughton, 1995.

13 Often with great resentment and conflict. See E. P. Thompson, *Whigs and Hunters: The Origin of the Black Act*, London, Allen Lane, 1975.

14 Stephen Gill, 'The Global Panopticon? The Neo-Liberal State, Economic Life and Democratic Surveillance', *Alternatives*, 1995, vol. 20, no. 1, pp. 1–49.

15 Humphrey Jennings, *Pandaemonium, 1660–1886: The Coming of the Machine as Seen by Contemporary Observers*, Mary-Lou Jennings and Charles Madge (eds), London, Picador, 1985.

1 A CULTURAL HISTORY OF PANDAEMONIUM

1 Lindsay Anderson, 'Only Connect: Some Aspects of the Work of Humphrey Jennings', *Film Quarterly*, 1961/62, vol. 15, no. 2, Winter, p. 9.

2 Ibid., p. 5
3 Erik Barnouw, *Documentary: A History of the Non-Fiction Film*, Oxford, Oxford University Press, 1974, pp. 144–45.
4 Anderson, op. cit., p. 5.
5 Ibid., p. 12.
6 Gerald Noxon, 'How Humphrey Jennings Came to Film', *Film Quarterly*, 1961/62, vol. 15, no. 2, Winter, p. 25.
7 Charles H. Dand, 'Britain's Screen Poet', *Films in Review*, 1955, vol. 6, no. 2, February, p. 78.
8 Ibid., p. 74.
9 Jennings' book, *Pandaemonium: The Coming of the Machine as seen by Contemporary Observers*, London, Deutsch, 1985, was eventually published in an edition edited by his daughter Mary-Lou Jennings and Charles Madge thirty-five years after his death, and forty-eight years following his start on the work.
10 David Mellor, 'Sketch for an Historical Portrait of Humphrey Jennings' in M.-L. Jennings (ed.), *Humphrey Jennings: Film-Maker, Painter, Poet*, London, British Film Institute, 1982, p. 63.
11 George Pitman, 'Men of Our Time No. 8: Humphrey Jennings', *Our Time*, 1944, July, p. 13.
12 James Merralls, 'Humphrey Jennings: A Biographical Sketch', *Film Quarterly*, 1961/62, vol. 15, no. 2, Winter, p. 33.
13 Murray Bookchin, *The Ecology of Freedom*, Palo Alto, Cheshire Books, 1982, p. 324.
14 Pitman, op. cit., p. 13.
15 Fred Inglis, *Radical Earnestness: English Social Theory 1880–1980*, Oxford, Martin Robertson, 1982, p. 23.
16 Raymond Williams, *Culture and Society 1780–1950*, Harmondsworth, Penguin, 1961.
17 Edward Thompson, 'Romanticism, Moralism and Utopianism: the Case of William Morris', *New Left Review*, 1976, no. 99, September–October, p. 109.
18 W. H. D. Rouse, *Machines or Mind? An Introduction to the Loeb Classical Library*, London, William Heinemann (n.d., c. 1920), pp. 3, 4.
19 Martin J. Wiener, *English Culture and the Decline of the Industrial Spirit, 1850–1980*, Harmondsworth, Penguin, 1985, p. ix.
20 Kathleen Raine, 'Writer and Artist' in John Grierson *et al.*, *Humphrey Jennings, 1907–1950: A Tribute*, London, British Film Institute (n.d., c. 1951).
21 Merralls, 1961/62, op. cit., p. 31.
22 Kathleen Raine, *The Land Unknown*, London, Hamish Hamilton, 1975, p. 167; cf. Jacob Bronowski, 'Recollections of Humphrey Jennings', *The Twentieth Century*, 1959, January, pp. 45–50.
23 Kathleen Raine, 'Humphrey Jennings' in M.-L. Jennings (ed.), *Humphrey Jennings: Film-Maker, Painter, Poet*, London, British Film Institute, 1982, p. 51.
24 Merrall, 1961/62, op. cit., p. 30; Julian Trevelyan, *Indigo Days*, London, MacGibbon and Kee, 1957, p. 16.
25 Williams, 1961, op. cit., pp. 239–46.
26 I. A. Richards (1924), *Principles of Literary Criticism*, London, Routledge and Kegan Paul, 1961, pp. 241–43.
27 Ibid., pp. 243–44.
28 Quoted in Julian Symons, *The Thirties: A Dream Revolved*, London, Faber, 1975, revised edn, p. 85.
29 Paul C. Ray, *The Surrealist Movement in England*, Ithaca, Cornell University Press, 1971, p. 259.
30 Anthony Blunt, 'Art under Capitalism and Socialism' in C. Day Lewis (ed.),

The Mind in Chains: Socialism and the Cultural Revolution, London, Frederick Muller,1937, p. 115.

31 Anthony Blunt, 'Superrealism in London', *Spectator*, 1936, 19 June, pp. 1126–27.

32 Ray, 1971, op. cit., p. 50.

33 Ibid., p. 61.

34 See Humphrey Jennings and Gerald F. Noxon, 'Rock-Painting and La Jeune Peinture', *Experiment*, 1931, no. 7, Spring, pp. 37–40.

35 Humphrey Jennings, Review of H. Read (ed.), 'Surrealism', *Contemporary Poetry and Prose*, 1936, no. 8, December, p. 167.

36 Ibid., p. 168.

37 Humphrey Jennings, 'In Magritte's Paintings...', *London Bulletin*, 1938, no. 1, April, p. 15.

38 Cf. Mellor, 1982.

39 Jennings' collaborator in Mass Observation, and perhaps the most insensitive commentator on Jennings' work.

40 Antony W. Hodgkinson, 'Humphrey Jennings and Mass Observation: A Conversation with Tom Harrisson', *Journal of the University Film Association*, 1975, vol. 27 no. 4, Fall, p. 33.

41 Richards, coincidentally, referred to Jennings' 'powers of assimilation, of perceiving possible and hitherto unnoticed connections' (quoted in Jennings, 1985, op. cit., p. viii).

42 Max Ernst, 'Inspiration to Order' in M. Evans (ed.), *The Painter's Object*, London, Gerald Howe, 1937, p. 77.

43 Ibid., p. 79.

44 Jennings and Noxon, 1931, op. cit., p. 39.

45 Humphrey Jennings, 'Who Does that Remind You Of?', *London Bulletin*, 1938, no. 6, October, p. 22.

46 Humphrey Jennings, 'In Magritte's Paintings...', *London Bulletin*, 1938, no. 1, April, p. 15.

47 Charles Madge, 'A Note on Images' in M.-L. Jennings (ed.), *Humphrey Jennings: Film-Maker, Painter, Poet*, London, British Film Institute, 1982, p. 47.

48 Kathleen Raine, quoted in Anthony W. Hodgkinson and Rodney E. Sheratsky, *Humphrey Jennings: More than a Maker of Films*, Hanover, University Press of New England, 1982, p. 105.

49 Ray, 1971, op. cit., p. 180.

50 Raine, n.d., op. cit.

51 Humphrey Jennings, 'The Iron Horse', *London Bulletin*,1938, no. 3, June, p. 28.

52 Ibid., pp. 22, 27.

53 Mary-Lou Jennings, *Humphrey Jennings: Film-Maker, Painter, Poet*, London, British Film Institute, 1982, p. 46.

54 Ibid.

55 Merralls, 1961/62, op. cit., p. 31.

56 For general outlines of Mass Observation, which we cannot discuss in detail here, see, *inter alia*, Angus Calder, 'Mass-Observation 1937–1949' in Martin Bulmer (ed.), *Essays on the History of British Sociological Research*, Cambridge, Cambridge University Press, 1985, pp. 121–36; Tom Jeffery, *Mass Observation – A Short History*, Birmingham, Centre for Contemporary Cultural Studies, 1978; Penny Summerfield, 'Mass Observation: Social Research or Social Movement?', *Journal of Contemporary History*, 1985, vol. 20, no. 3, pp. 439–52.

57 Tom Harrisson, Humphrey Jennings, Charles Madge, 'Anthropology at Home', *New Statesman and Nation*, 1937, 30 January, p. 155.

58 Mass Observation, *First Year's Work, 1937–38*, Charles Madge and Tom Harrisson (eds), London, Lindsay Drummond, 1938, p. 8.
59 Tom Harrisson, Humphrey Jennings, Charles Madge, 'Anthropology at Home', *New Statesman and Nation*, 1937, 30 January, p. 155.
60 Charles Madge and Tom Harrisson, *Mass Observation*, London, Frederick Muller, 1937, p. 31.
61 Tom Harrisson, Humphrey Jennings, Charles Madge, 'Anthropology at Home', *New Statesman and Nation*, 1937, 30 January, p. 155.
62 Ibid.
63 Antony W. Hodgkinson, 'Humphrey Jennings and Mass Observation: A Conversation with Tom Harrisson', *Journal of the University Film Association*, 1975, vol. 27, no. 4, Fall, p. 32.
64 Ibid.
65 Ibid.
66 Tom Harrisson, *Britain Revisited*, London, Gollancz, 1961, p. 19.
67 Julian Symons, *The Thirties: A Dream Revolved*, London, Faber, revised edn, 1975, pp. 102–3.
68 See H. D. Willock, 'Mass Observation', *American Journal of Sociology*, 1943, vol. 48, no. 4, January, pp. 445–56.
69 Raymond Williams, *Orwell*, Glasgow: Fontana/Collins, 1971, p. 41.
70 Julian Trevelyan, *Indigo Days*, London, MacGibbon and Kee, 1957, p. 82.
71 Charles Madge, 'Poetry and Politics', *New Verse*, 1933, no. 3, May, p. 2.
72 Humphrey Jennings and Charles Madge, 'Poetic Description and Mass Observation', *New Verse*, 1937, no. 24, February–March, p. 3.
73 Kathleen Raine, *The Land Unknown*, London, Hamish Hamilton, 1975, p. 84.
74 For example, see Humphrey Jennings, 'Three Reports', *Contemporary Poetry and Prose*, 1936, no. 2, June, pp. 39–40.
75 Ray, 1971, op. cit., pp. 177–78.
76 Charles Madge and Tom Harrisson, *Britain by Mass Observation*, Harmondsworth, Penguin, 1939, p. 23.
77 Charles Madge and Tom Harrisson, *Mass Observation*, London, Frederick Muller, 1937.
78 Richards, 1924, op. cit., p. 245.
79 Humphrey Jennings and Charles Madge, 'Poetic Description and Mass Observation', *New Verse*, 1937, no. 24, February–March, pp. 1–6; Charles Madge 'Magic and Materialism', *Left Review*, 1937, vol. 3, no. 1, February, pp. 31–35; Charles Madge, 'The Press and Social Consciousness', *Left Review*, 1937, vol. 3, no. 5, June, pp. 279–86.
80 Charles Madge and Tom Harrisson, *Mass Observation*, London, Frederick Muller, 1937.
81 Ibid., p. 15.
82 Ibid., pp. 15–16.
83 Ibid., p. 16.
84 Ibid., p. 10.
85 Ibid.
86 Ibid., p. 21.
87 Ibid., p. 22.
88 Ibid., p. 30.
89 Ibid., p. 27.
90 Ibid., p. 23.
91 Ibid., p. 28.
92 Humphrey Jennings and Charles Madge (eds), *May the Twelfth*, London, Faber and Faber, 1937, reprinted 1987.

93 Mellor, 1982, op. cit., p. 68, note 10.
94 Charles Madge, 'The Birth of Mass Observation', *Times Literary Supplement*, 1976, 5 November, p. 1395.
95 Humphrey Jennings and Charles Madge, 'Poetic Description and Mass Observation', *New Verse*, 1937, no. 24, February–March, p. 3.
96 Mellor, 1982, op. cit., p. 66, note 10.
97 Charles Madge, 'The Press and Social Consciousness', *Left Review*, 1937, vol. 3, no. 5, June, p. 286.
98 Humphrey Jennings and Charles Madge, 'Poetic Description and Mass Observation', *New Verse*, 1937, no. 24, February–March, p. 3.
99 Ibid.
100 Though a small section was published in an issue of the *London Bulletin*, edited by Jennings. See Humphrey Jennings, 'Do Not Lean Out of the Window', *London Bulletin*,1938, no. 45, July 1938, pp. 13–14, 43–44.
101 Humphrey Jennings, *Pandaemonium: The Coming of the Machine as seen by Contemporary Observers*, London, Deutsch, 1985, p. xxxv.
102 Ibid., p. 352.
103 Ibid., p. xviii.
104 Ibid., p. 17.
105 Hannah Arendt, 'Introduction' in Walter Benjamin, *Illuminations*, London, Collins/Fontana, 1973, pp. 47–48.
106 Humphrey Jennings, *Pandaemonium: The Coming of the Machine as seen by Contemporary Observers*, London, Deutsch, 1985, p. xxxv.
107 Ibid., pp. 269–73.
108 Ibid., p. 284.
109 Ibid., p. 223.
110 Ibid., p. xxxvi.
111 Ibid., p. xxxix.
112 Ibid., p. xxxviii.
113 Ibid.
114 Ibid., p. 5.
115 Ibid.
116 Ibid., p. 6; cf. Kathleen Raine, *The Land Unknown*, London, Hamish Hamilton, 1975, p. 167.
117 Ibid., p. 37.
118 Ibid., p. 10, quoting Robert Hooke (1662).
119 Ibid., pp. 34–38.
120 Ibid., pp. 13–14.
121 Ibid., p. 348.
122 Ibid., p. 305.
123 Ibid., p. 306.
124 Ibid., pp. 25–26.
125 For example, ibid., p. 47.
126 Ibid., pp. 11–12.
127 Ibid., p. 156.
128 Ibid., p. 185.
129 In a fascinating essay historian of science William J. Ashworth describes how algebraic analysis, pioneered in the opening decades of the nineteenth century by such as John Herschel and Charles Babbage, was knowingly developed as a means of accessing the mind, the better to industrialise it. What appears at first sight to be highly abstract, even arid, was from the outset developed by its proponents as a philosophical equivalent of what was being done by factory builders like James Watt and Matthew Boulton. See William J. Ashworth,

'Memory, Efficiency, and Symbolic Analysis: Charles Babbage, John Herschel, and the Industrial Mind', *Isis*, 1996, vol. 87, no. 4, pp. 629–53.
130 Humphrey Jennings, *Pandaemonium: The Coming of the Machine as seen by Contemporary Observers*, London, Deutsch, 1985, p. 38.
131 Ibid., p. xxxviii.
132 Ibid., p. 110.
133 Ibid., pp. 185–86.
134 Ibid., pp. 6–7.
135 Ibid., p. 139.
136 Ibid., p. 79.
137 Ibid., pp. 343–44.
138 Ibid., pp. 288–89.
139 Ibid., p. 298.
140 Ibid., pp. xxxvii–xxxviii.
141 Ibid., p. xxxviii.
142 Ibid., p. 167.
143 Ibid., p. 249.
144 Ibid., p. 116.
145 Ibid., p. 10.
146 Arthur Elton, 'The Gods Move House', *London Bulletin*, 1938, no. 45, July, p. 9.
147 Humphrey Jennings, *Pandaemonium: The Coming of the Machine as seen by Contemporary Observers*, London, Deutsch, 1985, pp. 55–60.
148 Ibid., p. 129.
149 Ibid., p. 160.
150 Ibid., pp. 325–26.
151 Ibid., p. 324.
152 Ibid., p. 325.
153 Arthur Elton, 'The Gods Move House', *London Bulletin*, 1938, no. 45, July, p. 10; cf. Stuart Legg, 'A Note on Locomotive Names', *London Bulletin*, 1938, no. 45, July, pp. 20 and 25.
154 Humphrey Jennings, *Pandaemonium: The Coming of the Machine as seen by Contemporary Observers*, London, Deutsch, 1985, pp. 141–42.
155 Ibid., p. 269.
156 Ibid., pp. 328–29.
157 Ibid., p. 270.
158 Ibid., p. 349.
159 Ibid., p. 207.
160 Ibid., pp. 301–2.
161 Ibid., pp. 236–37.
162 Ibid., pp. 264–67.
163 Ibid., p. 212.
164 Ibid., p. 348.
165 Ibid., pp. 302–3.
166 Ibid., pp. 312–13.
167 Hannah Arendt, 'Introduction' in Walter Benjamin, *Illuminations*, London, Collins/Fontana, 1973, p. 39.
168 Robert Young, 'Science as Culture', *Quarto*, 1979, December.
169 Charles Madge and Tom Harrisson, *Mass Observation*, London, Frederick Muller, 1937, p. 16.
170 Ernst Bloch, 'Dialetics and Hope', *New German Critique*, 1976, no. 9, Fall, p. 8.
171 Charles Madge and Tom Harrisson, *Mass Observation*, London, Frederick Muller,

1937, p. 35; cf. Julian Trevelyan, *Indigo Days*, London, MacGibbon and Kee, 1957, p. 83.

172 Hannah Arendt, 'Introduction' in Walter Benjamin, *Illuminations*, London, Collins/Fontana, 1973, p. 38.

173 Ernst Bloch, 'Man as Possibility', *Cross Currents*, 1968, vol. 18, no. 3, Summer, p. 282.

174 Ernst Bloch, 'Dialetics and Hope', *New German Critique*, 1976, no. 9, Fall, p. 5.

175 Humphrey Jennings, *Pandaemonium: The Coming of the Machine as seen by Contemporary Observers*, London, Deutsch, 1985, p. 110.

176 See Edward Thompson, 'Imagination Power', *New Society*, 1985, 25 October, pp. 164–65.

177 Humphrey Jennings, *Pandaemonium: The Coming of the Machine as seen by Contemporary Observers*, London, Deutsch, 1985, p. 332.

178 Kathleen Raine, 'Humphrey Jennings' in M.-L. Jennings (ed.), *Humphrey Jennings: Film-Maker, Painter, Poet*, London, British Film Institute, 1982, p. 52.

179 Ernst Bloch, 'Man as Possibility', *Cross Currents*, 1968, vol. 18, no. 3, Summer, p. 281.

2 ENGAGING WITH LUDDISM

1 Frank Webster and Kevin Robins, *Information Technology: A Luddite Analysis*, Norwood, NJ, Ablex, 1986.

2 Especially David Noble, 'Present Tense Technology, Part 1', *Democracy*, 1983, vol. 4, no. 1, pp. 8–24; Part 2, *Democracy*, 1983, vol. 4, no. 2, pp. 70–82; Part 3, *Democracy*, 1983, vol. 4, no. 3, pp. 71–93; Langdon Winner, *The Whale and the Reactor: A Search for Limits in an Age of High Technology*, Chicago: University of Chicago Press, 1986. For a more recent account, see Iain Boal and James Brook (eds), *Resisting the Virtual Life*, San Francisco, CA, City Lights, 1995.

3 Toni Negri, 'Preface a l'edition francaise', *La classe ouvriere contre l'etat*, Paris, Galilee, 1978, p. 16.

4 J. G. Burke (ed.), *The New Technology and Human Values*, Belmont, CA, Wadsworth Publishing Co., 1966, p. 5.

5 John Russell, 'The Luddites', *Proceedings of the Thoroton Society*, 1906, p. 58.

6 Malcolm I. Thomis, *The Luddites: Machine-Breaking in Regency England*, New York, Schocken Books, 1972, pp. 168 and 171. This book adopts very critical positions towards E. P. Thompson's *The Making of the English Working Class*, on which we draw heavily. For a defence of Thompson and a critique of Thomis' 'compartmentalist' method, see F. K. Donnelly, 'Ideology and Early English Working-Class History: Edward Thompson and his Critics', *Social History*, 1976, vol. 2, May.

7 Harold Wilson, 'Labour and the Scientific Revolution', *Report of the 62nd Annual Conference*, Scarborough, 30 September–4 October 1963, Labour Party 1963, pp. 133–40.

8 Sir Keith Joseph, *Reversing the Trend*, Chichester, Rose, 1975.

9 Patrick Jenkin, 'The Unemployed Cannot Blame Automation', *New Scientist*, 1983, vol. 97, no. 1346, 24 February, pp. 526–27.

10 Ralf Dahrendorf, 'Towards the Hegemony of Post-Modern Values', *New Society*, 15 November 1979, p. 361.

11 Michael J. Earl, 'What Microprocessors Mean', *Management Today*, 1978, December, p. 73.

12 See *New Statesman*, 25 May 1979, pp. 756–57.

13 Barrie Sherman, 'Computers, Microprocessors and the Unions', Proceedings of the National Conference on Planning for Automation, Polytechnic of the South

Bank, 17 January 1979, pp. 19, 20. Cf. 'In short, they [the Luddites] were a defensive and to some extent a conservative movement. But they also believed in direct action. If words could not stop machines, sledge-hammers could and did. It was a short-lived but bitter movement.' From Clive Jenkins and Barrie Sherman, *The Collapse of Work*, London, Eyre Methuen, 1979, p. 21.

14 David Cockroft, 'Microelectronics: the Employment Effects and the Trade Union Response' in Trevor Jones (ed.), *Microelectronics and Society*, Milton Keynes, Open University Press, 1980, pp. 83 and 87.

15 *Trade Unions and New Technology*, Report of a Trade Union Conference on the Use and Impact of Microelectronics at Aston University, 3 November 1979, p. 30.

16 Colin Hines, *The 'Chips' are Down*, London, Earth Resources Research, April 1978, p. 5.

17 See, for example, Nicholas Negroponte, *Being Digital*, London, Hodder and Stoughton, 1995; Kevin Kelly, *Out of Control: The New Biology of Machines*, London, Fourth Estate, 1994; Bill Gates, *The Road Ahead*, New York, Viking, 1995.

18 Peter Mandelson, 'Foreword' in *Converging Technologies: Consequences for the New Knowledge-Driven Economy*, Department of Trade and Industry, September, 1998, p. 3.

19 Peter Mandelson and Roger Liddle, *The Blair Revolution*, London, Faber and Faber 1996, p. 209.

20 See E. J. Hobsbawm and George Rudé, *Captain Swing*, Harmondsworth, Penguin, 1973. For a comparative approach to Luddism, see Frank E. Manuel, 'The Luddite Movement in France', *Journal of Modern History*, 1938. In this context Gerhart Hauptmann's play *The Weavers* (1892), set in Silesia in the 1840s, is also of interest. We should also point out here that Luddism was not a single, homogeneous, phenomenon; in the areas where it occurred it assumed somewhat different forms.

21 Eric Hobsbawm, *Labouring Men: Studies in the History of Labour*, London, Weidenfeld and Nicolson, 1964, p. 14.

22 Note the observations of a contemporary observer: 'The necessity for human power thus gradually yielding before another and more subservient one, has had, in the first place, the effect of rendering adult labour of no greater value than that of the infant or girl; the workmen are reduced to mere watchers, and suppliers of the wants of machinery, requiring in the great majority of its operations no physical or intellectual exertion; and the adult male has begun to give way, and his place been supplied by those who in the usual order of things were dependent upon him for their support. [This] pave[d] the way for breaking up the bonds which hold society together, and which are the basis of national and domestic happiness and virtue.' P. Gaskell, *Artisans and Machinery* [1836], London, Frank Cass reprint, 1968. pp. 144–45.

23 E. P. Thompson, *The Making of the English Working Class*, Harmondsworth, Penguin, 1968, p. 594.

24 Ibid., p. 604.

25 M. I. Thomis, op. cit., p. 170; cf. Robert Reid, *Land of Lost Discontent: The Luddite Revolt, 1812*, London, Heinemann, 1986.

26 E. P. Thompson, op. cit., pp. 603–4.

27 Cornelius Castoriadis, 'The Crisis of the Identification Process', *Thesis Eleven*, 1997, no. 49, p. 89.

28 Karl Marx, *Capital, Volume 1*, Harmondsworth, Penguin, 1976, p. 771.

29 Karl Marx, 'The Poverty of Philosophy', *Collected Works*, Vol. 6, London, Lawrence and Wishart, 1976, p. 174.

30 Lucio Colletti, 'Introduction' in *Karl Marx, Early Writings*, Harmondsworth, Penguin, 1975, p. 39.
31 Karl Marx, 'Results of the Immediate Process of Production' in *Capital, Volume 1*, op. cit., p. 1005, original emphases.
32 Colletti, op. cit., p. 37. Following Marx, Colletti writes of the 'inver[sion] of reality, making predicates into subjects and real subjects into predicates' (pp. 32–33).
33 Karl Marx, *Capital, Volume 3*, London, Lawrence and Wishart, 1972, p. 831.
34 Lucio Colletti, 'Marxism and the Dialectic', *New Left Review*, no. 93, 1975, p. 20.
35 Colletti argues that the real achievement of Marx, as the critic of English political economy, was to see the alienated nature of capitalist reality. The laws of political economy 'which appear to have a material or objective character, are nothing other than the fetishistic objectification of human social relations which are beyond the control of men themselves. They do not represent natural objectivities, but alienation.' And: 'The reality which is the subject of discussion is upside-down, "stood on its head"; it is not reality sic et simpliciter but the realisation of alienation. It is not a positive reality but one to be overthrown and negated.' Colletti, 'Marxism and the dialectic', op. cit., p. 22. Cf. 'Marxism: Science or Revolution?' in Lucio Colletti, *From Rousseau to Lenin*, London, New Left Books, 1972.
36 Georg Lukács, *History and Class Consciousness*, Cambridge, MA, MIT Press, 1971, p. 86.
37 Ibid., p. 87.
38 Ibid.
39 Karl Marx, 'Results of the Immediate Process of Production', op. cit., pp. 1054–55. In this important passage Marx goes on to note that 'the same transformation may be observed in the forces of nature and science'. Cf. Geoffrey Kay's observation that 'with machine production the social power of capital achieves a hard material form as labour, loses all its specific human qualities and becomes human labour without specific qualities – general uniform abstract labour'. 'A Note on Abstract Labour', *Bulletin of the Conference of Socialist Economists*, 1976, no. 13, March.
40 Lukács, op. cit., p. 88.
41 Ibid., p. 90.
42 E. P. Thompson, op. cit., p. 337.
43 André Gorz (ed.), *The Division of Labour*, Hassocks, Harvester, 1976; Harry Braverman, *Labour and Monopoly Capital*, New York, Monthly Review Press, 1974.
44 David M. Gordon makes a useful distinction between 'quantitative' and 'qualitative' efficiency in machine production: 'In general, a production process is quantitatively (most) efficient if it effects the greatest possible useful physical output from a given set of physical inputs....A production process is qualitatively efficient if it best reproduces the class relations of a mode of production.'
 Gordon argues that 'production processes embody capitalist efficiency if they best reproduce capitalist control over the production process and minimise proletarian resistance to that control.' David M. Gordon, 'Capitalist Efficiency and Socialist Efficiency', *Monthly Review*, 1976, vol. 28, no. 3, July–August.
45 Jean-Paul de Gaudemar, *La Mobilisation Générale*, Paris, Editions du Champ Urbain, 1979.
46 Ibid., p. 17.
47 Sidney Pollard, 'Factory Discipline in the Industrial Revolution', *Economic*

NOTES

History Review, 1963, vol. 16, no. 2. On 'absolute mobilisation', see also E. P. Thompson, 'Time, Work-Discipline and Industrial Capitalism' in E. P. Thompson, *Customs in Common*, London, Merlin, 1991, Chapter 6.

48 Gaudemar, op. cit., p. 193.

49 Ibid., p. 198.

50 For a discussion of the continuity between Taylor and Ford, and of the political function of technology in the Fordist system, see Benjamin Coriat, *Science, Technique et Capital*, Paris, Seuil, 1978.

51 Guido Baldi, 'Theses on the Mass Worker and Social Capital', *Radical America*, 1972, vol. 6, no. 3, p. 12.

52 Henry Ford was fully aware of this: 'An unemployed man is an out-of-work customer. He cannot buy. An underpaid man is a customer reduced in purchasing power. He cannot buy...the cure of business depression is through purchasing power, and the source of purchasing power is wages.' From *Today and Tomorrow*, London, Heinemann, 1926, p. 151. See also Sergio Bologna: 'For Ford, wages became the general rate of income to be used in conjunction with the dynamics of the system. It became the general rate of capital to be injected within a framework of planned development. In 1911, Ford's ideas were the bright innovations of a single entrepreneur. It took the threat of a general overthrow of factory power relations, i.e., the threat of the workers' councils to collective capital for them to become the strategy of collective capital, or the Keynesian "income revolution".' From 'Class Composition and the Theory of the Party at the Origin of the Workers' Councils Movement' in *The Labour Process and Class Strategies*, London, Stage 1, 1976, p. 71.

53 Les Levidow and Bob Young, 'Introduction', *Science, Technology and the Labour Process*, Vol. I, London, CSE Books, 1981, p. 5, reissued by Free Association Books, 1984.

54 E. P. Thompson, 'The Peculiarities of the English' in R. Miliband and J. Saville (eds), *The Socialist Register 1965*, London, Merlin, p. 354.

55 Gaudemar, op. cit., p. 198.

56 Arturo M. Giovannitti in his introduction to Emile Pouget, *Sabotage*, Chicago, W. H. Kerr and Co., 1913, p. 11.

57 T. Glynn, 'Industrial Efficiency and its Antidote' in *The Onward Sweep of the Machine Process*, Chicago, IWW Publishing Bureau, n. d., p. 18. On the continuing relevance of sabotage throughout the Fordist period, see Bill Watson, 'Counter-Planning on the Shop Floor', *Radical America*, 1971, vol. 5, no. 3. See also the IWW pamphlet, *A Worker's Guide to Direct Action*, Somerville, MA, New England Free Press, n. d.

58 William Mellor, *Direct Action*, London, Leonard Parsons, 1920, p. 105. This does not mean, of course, that violence was not used. On the use of violence in class struggle, see Louis Adamic, *Dynamite*, London, Jonathan Cape, 1931.

59 Elizabeth Gurley Flynn, *Sabotage*, Cleveland, IWW Publishing Bureau, 1916, p. 5. See also Pouget, op. cit., p.107: 'The workers' sabotage is inspired by generous and altruistic principles'.

60 As was recognised by one syndicalist: 'In 1816 the textile workers created a sabotage of their own when they had their Luddite movement. All through the valleys of the West Riding of Yorkshire, Lancashire, and the North machines were smashed, engines broken by those bands of men who went "plug-drawing" '. E. J. B. Allen, 'Is Sabotage Un-English?', *The Syndicalist*, October 1912.

61 Gaudemar, op. cit., p. 267.

62 Carter L. Goodrich, *The Frontier of Control*, London, Pluto Press, 1975, p. 50 (originally published in 1920).

NOTES

63 Toni Negri, 'Capitalist Domination and Working Class Sabotage' in *Working Class Autonomy and the Crisis*, London, Red Notes/CSE Books, 1979, p. 101.
64 Immanuel Wallerstein, 'Eurocentrism and its Avatars: the Dilemmas of Social Science', *New Left Review*, 1997, no. 226, p. 105.
65 Noam Chomsky, 'Power in the Global Arena', *New Left Review*, 1998, no. 230, p. 6.
66 William I. Robinson, 'Globalisation: Nine Theses on our Epoch', *Race and Class*, 1996, vol. 38, no. 2, pp. 14–15.
67 Castoriadis, op. cit., p. 92 (Castoriadis' emphasis).
68 Ibid., p. 94.
69 Alain Touraine, 'Culture without Society', *Cultural Values*, 1998, vol. 2, no. 1, p. 143.
70 Kees van der Pijl, 'Cadre Class Formation and the Socialisation of Resistance', paper presented to the Colloquium on The Possibilities of Transnational Democracy, University of Newcastle upon Tyne, 11–13 September 1998, p. 2.
71 Jon Henley, 'Villagers Dig Deep to Block Mine Plan', *Guardian*, 1998, 15 August.
72 See, Stephen J. Kobrin, 'The MAI and the Clash of Globalisations', *Foreign Policy*, 1998, no. 112.
73 Quoted in John Vidal, 'A Glorious Summer for Discontent', *Guardian*, 1998, 15 August.
74 See, Ian Katz, 'Pulling the Plug on Progress', *Observer*, 1996, 14 April; 'The Luddites' Lost Leader?', *Economist*, 1996, 13 April, p. 54; David Futrelle, 'Rhetoric and its Consequences', *Chicago Reader*, 1995, 22 September. This article is available on the Internet on http://www.well.com/user/futrelle/unabom.html. There is a Unabomber Page available, as well as his Manifesto which can be accessed from this address. A very good source of information on the 'The Neo-Luddite Reaction' is available from the University of Colorado at Denver School of Education on http://www.cudenver.edu/-mryder/itc/luddite.html.
75 Kirkpatrick Sale, *Rebels Against the Future: The Luddites and Their War on the Industrial Revolution – Lessons for the Computer Age*, Reading, MA, Addison-Wesley, 1995, p. 262.
76 Ibid., p. 213.
77 Ibid., p. 244.
78 Ibid., pp. 35, 38.
79 Ibid., p. 272.
80 See, Howard Rheingold, *The Virtual Community: Finding Connection in a Computerised World*, London, Secker and Warburg, 1994. And, for a critique of techno-communitarianism, Kevin Robins, *Into the Image: Culture and Politics in the Field of Vision*, London, Routledge, 1996.

3 THE HOLLOWING OF PROGRESS

1 Wilson P. Dizard, *The Coming Information Age: an Overview of Technology, Economics and Politics*, London, Longman, 1982, p. 38.
2 *Futurist*, August, 1981.
3 James Callaghan, *Prime Minister Announces Major Programme of Support for Microelectronics*, Press Notice, 10 Downing Street, 1978, 6 December.
4 Al Gore, 'Forging a new Athenian Age of Democracy', *Intermedia*, 1994, vol. 22, no. 2, April/May, pp. 4–6.

5 George Gilder, 'The Death of Telephony', *Economist*, 1993, vol. 328, no. 7828, 11 September, p. 76
6 For example, see Preface in Barry Jones, *Sleepers Wake! Technology and the Future of Work*, Brighton, Wheatsheaf, 1982.
7 Martin Bangemann, *Europe and the Global Information Society: Recommendations to the European Council*, Members of the High-Level Group on the Information Society, Brussels, European Commission, 1994, 26 May, 1994.
8 Bill Gates, *The Road Ahead*, London, Viking, 1995, p. 273.
9 Mark Poster, *The Second Media Age*, Cambridge, Polity, 1995.
10 Kevin Kelly, *Out of Control: The New Biology of Machines*, London, Fourth Estate, 1994.
11 Ilya Prigogine, *The End of Certainty: Time, Chaos, and the New Laws of Nature*, New York, Free Press, 1997.
12 Kevin Kelly, op. cit., p. 33.
13 See Gregory Stock, *Metaman: The Merging of Humans and Machines into a Global Superorganism*, New York, Simon and Schuster, 1993; cf. Walter Truett Anderson, *Evolution Isn't What It Used To Be: The Augmented Animal and the Whole Wired World*, London, W. H. Freeman, 1996.
14 Michael L.Rothschild, *Bionomics: The Inevitability of Capitalism*, London, Futura, 1992, pp. 341, xiv.
15 Kevin Kelly, op. cit., p. 33.
16 See for example, Theodore Roszak, *The Cult of Information: The Folklore of Computers and the True Art of Thinking*, Cambridge, Lutterworth Press 1986; Clifford Stoll, *Silicon Snake Oil: Second Thoughts on the Information Highway*, New York, Doubleday, 1995.
17 James Martin, *The Wired Society*, Englewood Cliffs, Prentice-Hall, 1978, p. 15.
18 Ibid.
19 Frederick Williams, *The Communications Revolution*, Beverly Hills, Sage, 1982, p. 280.
20 Nicholas Negroponte, *Being Digital*, London, Hodder and Stoughton, 1995, p. 231.
21 David Landes, *The Unbound Prometheus: Technological Change and Industrial Development in Western Europe from 1750 to the Present*, Cambridge, Cambridge University Press, 1969.
22 See for example, John Bray, *The Communications Miracle: The Telecommunications Pioneers from Morse to the Information Superhighway*, New York, Plenum Press, 1995.
23 Bob Young, 'Science as Culture', *Quarto*, December, 1979.
24 Bill Gates, *The Road Ahead*, London, Viking, 1995, p. 274.
25 Peter Large, *The Micro Revolution*, London, Fontana, 1980, p. 12.
26 Anthony Hyman, *The Coming of the Chip*, London, New English Library, 1980, p. 123.
27 See for example, Martin Bangemann, *Europe and the Global Information Society: Recommendations to the European Council*, Members of the High-Level Group on the Information Society, Brussels, European Commission, 26 May, 1994.
28 David Dickson, *Alternative Technology and the Politics of Technological Change*, London, Fontana, 1974, p. 42.
29 Compare Christopher Lasch's resolute defence of the local and provincial in his books *The True and Only Heaven: Progress and Its Critics*, New York, W. W. Norton, 1991; and *The Revolt of the Elites and the Betrayal of Democracy*, New York, W. W. Norton, 1995.
30 Raymond Williams, *The Country and the City*, London, Paladin, 1975, p. 10.

31 Howard Newby, *The Deferential Worker: a Study of Farm Workers in East Anglia*, Harmondsworth, Penguin, 1979, pp. 11–12.
32 Wilson P. Dizard, *The Coming Information Age: an Overview of Technology, Economics and Politics*, London, Longman, 1982, p. 15.
33 James Martin, *The Wired Society*, Englewood Cliffs, Prentice-Hall, 1978, p. 4.
34 Dizard, op. cit., pp. 22–23.
35 Alvin Toffler, *The Third Wave*, London, Collins, 1980, p. 135.
36 Ibid., pp. 139, 367, 294.
37 Ibid., p. 375.
38 James Martin, *The Wired Society*, Englewood Cliffs, Prentice-Hall, 1978, p. 191.
39 Alvin Toffler, *Future Shock*, London, Bodley Head, 1970, pp. 282–83.
40 Raymond Williams, *The Country and the City*, London, Paladin, 1975, p. 331.
41 Leo Marx, *The Machine in the Garden*, New York, Oxford University Press, 1964, p. 32.
42 Jonathan Bentall, *The Body Electric: Patterns in Western Industrial Culture*, London, Thames and Hudson, 1976.
43 Leo Marx, *The Machine in the Garden*, New York, Oxford University Press, 1964, pp. 4, 229.
44 John Fekete, *The Critical Twilight: Explorations in the Ideology of Anglo-American Literary Theory from Eliot to McLuhan*, London, Routledge and Kegan Paul, 1978.
45 James W. Carey and John J. Quirk, 'The Mythos of the Electronic Revolution', *The American Scholar*, 1970, vol. 29, Spring and Summer, pp. 219–41, 395–424, Reprinted in James W. Carey, *Communication as Culture: Essays on Media and Society*, Boston, Unwin-Hyman, 1989, Chapter 5.
46 James Martin, *The Wired Society*, Englewood Cliffs, Prentice-Hall, 1978, pp. 75–76.
47 Sam Fedida and Rex Malik, *The Viewdata Revolution*, London, Association Business Press, 1979.
48 Joseph N. Pelton, *Global Talk*, Alphen aanden Rijn, The Netherlands, Sijthoff and Noordhoff, 1981.
49 Manuel Castells, *The Rise of the Network Society*. Vol.1 of *The Information Age*, Oxford, Blackwell, 1996, pp. 331, 337. Compare the strong McLuhanite theme in William Mitchell, *City of Bits: Space, Place and the Infobahn*, Cambridge, MA, MIT Press, 1995.
50 Leo Marx, op. cit.
51 Marshall McLuhan (with Q. Fiore), *The Medium is the Message: an Inventory of Effects*, London, Allen Lane, 1967, p. 26.
52 A. Burkitt and E.Williams, *The Silicon Civilization*, London, W. H. Allen, 1980, p. 154.
53 Ibid., p. 9.
54 Alvin Toffler, *Future Shock*, London, Bodley Head, 1970, p. 25.
55 Alvin Toffler, *The Third Wave*, London, Collins, 1980, p. 164.
56 Ibid., p. 18.
57 Frederick Williams, *The Communications Revolution*, Beverly Hills, Sage, 1982, pp. 9, 18.
58 Christopher Evans, *The Mighty Micro: the Impact of the Computer Revolution*, London, Victor Gollancz, 1979, p. 9.
59 John Fekete, *The Critical Twilight: Explorations in the Ideology of Anglo-American Literary Theory from Eliot to McLuhan*, London, Routledge and Kegan Paul, 1978, pp. 80, 78.

60 Margaret Thatcher, *Speech at the Opening Ceremony of IT'82* Conference, Press Office, 10 Downing Street, 1982, 8 December, p. 29. *ET* – Extraterrestial – was an extremely popular movie of the time, directed by Stephen Speilberg.

61 Michael Connors, *The Race to the Intelligent State: Towards the Global Information Economy of 2005*, Oxford, Blackwell Business, 1993.

62 Robert B. Reich, *The Work of Nations: Preparing Ourselves for 21st Century Capitalism*, New York, Vintage, 1992.

63 Cf. Walter B.Wriston, *The Twilight of Sovereignty: How the Information Revolution is Transforming Our World*, New York, Scribner, 1992.

64 Scott Lash and John Urry, *Economies of Signs and Space*, London, Sage, 1994.

65 Robert B. Reich, *The Work of Nations: Preparing Ourselves for 21st Century Capitalism*, New York, Vintage, 1992, p. 85.

66 Ibid., p. 178.

67 Ibid., pp. 178–79.

68 On government policies for higher education, as well as employers' requirements, see Phil Brown and Richard Scase, *Higher Education and Corporate Realities: Class, Culture and the Decline of Graduate Careers*, London, UCL Press, 1994; Phil Brown and Richard Scase, 'Universities and Employers: Rhetoric and Reality' in Anthony Smith and Frank Webster (eds), *The Post-Modern University? Contested Visions of Higher Education*, Milton Keynes, Open University Press, 1997, Chapter 8.

69 Manuel Castells, *The Rise of the Network Society*, Vol. 1 of *The Information Age*, Oxford, Blackwell, 1996, p. 115.

70 Ibid., p. 195. Castells projects this spirit as combining Weber's analysis of the religious 'calling' with Schumpeter's account of 'creative destruction'.

71 Manuel Castells, *End of Millennium*, Vol. 3 of *The Information Age*, Oxford, Blackwell, 1997, Chapter 6. Peter Drucker estimates that by the year 2000 'knowledge workers will make up a third or more of the work force in the United States', 'The Age of Social Transformation', *The Atlantic Monthly*, 1994, vol. 274, no. 5, pp. 53–80.

72 Peter Drucker, *Post-Capitalist Society*, New York, HarperCollins, 1993.

73 Alvin Toffler, *Powershift: Knowledge, Wealth, and Violence at the Edge of the 21st Century*, New York, Bantam Books, 1990, p. 75.

74 For example, Fred Block, *Postindustrial Possibilities: A Critique of Economic Discourse*, Berkeley, CA, University of California Press, 1990; Larry Hirschhorn, *Beyond Mechanization: Work and Technology in a Postindustrial Age*, Cambridge, MA, MIT Press, 1984.

75 Soshana Zuboff, *In the Age of the Smart Machine: The Future of Work and Power*, London, Heinemann, 1988.

76 Michael Piore and Charles Sabel, *The Second Industrial Divide*, New York, Basic Books, 1984; cf. Frank Webster, *Theories of the Information Society*, London, Rouledge, 1995, Chapter 7.

77 Labour Policy, *Information Superhighway*, London, Labour Party, 1995.

78 Charles Leadbetter, *Britain: The California of Europe?* London, Demos, 1997.

79 Scott Lash and John Urry, *Economies of Signs and Space*, London, Sage, 1994.

80 Ibid., p. 122.

81 Manuel Castells, *End of Millennium*, Vol. 3 of *The Information Age*, Oxford, Blackwell, 1997, Chapter 6.

82 Harold Perkin, *The Rise of Professional Society: England since 1880*, London, Routledge, 1989, p. 2.

83 Though see Harold Perkin, *The Third Revolution: Professional Elites in the Modern World*, London, Routledge, 1996.

84 Manuel Castells, *End of Millennium*, Blackwell, Oxford, 1997, Chapter 2.

85 Cf. Herbert I. Schiller, *Information Inequality: The Deepening Social Crisis in America*, New York, Routledge, 1996.

86 John Scott, *Corporate Business and Capitalist Classes*, Oxford, Oxford University Press, 1997, p. 20.

87 Ibid. Scott continues (in contrast to the managerialist literature which Reich exemplifies): 'A propertied capitalist class has interests throughout the corporate system, and is able to ensure its continuity over time through its monopolization of the educational system as well as its monopolization of wealth. It stands at the top of the stratification system, enjoying superior life chances to those in the subordinate service class that fill the rungs of the corporate hierarchies. As processes of ownership have become more globalized, so capitalist classes have become less "national" in character. Reflecting the disarticulation of national economies, capitalist classes have themselves become increasingly disarticulated'. Cf. Michael Useem, *The Inner Circle: Large Corporations and the Rise of Business Political Activity in the US and UK*, New York, Oxford University Press, 1984; Michael Useem and Jerome Karabel, 'Pathways to Top Corporate Management', *American Sociological Review*, 1986, vol. 51, April, pp. 184–200.

88 Anthony Giddens, *Modernity and Self-Identity: Self and Society in the Late Modern Age*, Cambridge, Polity, 1991.

89 Anthony Giddens, *Beyond Left and Right: The Future of Radical Politics*, Cambridge, Polity, 1994, p. 7.

90 See especially Krishan Kumar, *Prophecy and Progress: The Sociology of Industrial and Post-Industrial Society*, London, Allen Lane, 1978; Krishan Kumar, *From Post-Industrial to Post-Modern Society*, Oxford, Blackwell, 1995; Jonathan Gershuny, *After Industrial Society? The Emerging Self-Service Society*, London, Macmillan, 1978; Jonathan Gershuny and Ian Miles, *The New Service Economy: The Transformation of Employment in Industrial Societies*, London, Frances Pinter, 1983.

91 For example, see Manuel Castells, *The Rise of the Network Society*, op. cit., especially Chapter 4. See the critiques by Frank Webster (1997), 'Analyst of the Information Age', *City*, 1997, no. 7, June, pp. 105–21; 'Is This the Information Age? Towards a Critique of Manuel Castells', *City*, 1997, no. 8, December, pp. 157–75.

92 Daniel Bell, 'The Social Framework of the Information Society' in L. Dertouzos and J. Moses (eds), *The Computer Age: A Twenty-Year View*, Cambridge, MA, MIT Press, 1979, p. 189.

93 Daniel Bell, *The Coming Of Post-Industrial Society: A Venture in Social Forecasting*, Harmondsworth, Peregrine, 1976, p. 20.

94 Ibid.

95 Eric Hobsbawm, *Age of Extremes: The Short Twentieth Century, 1914–1991*, London, Michael Joseph, 1994, pp. 534, 535.

96 Nico Stehr, *Knowledge Societies*, London, Sage, 1994.

97 See, for elaboration, Alan Irwin, *Citizen Science: A Study of People, Experience and Sustainable Development*, London, Routledge, 1995.

98 A useful overview of ten years of social science research into ICTs is William Dutton (ed.), *Information and Communication Technologies: Visions and Realities*, Oxford, Oxford University Press, 1996.

4 THE LONG HISTORY OF THE INFORMATION REVOLUTION

1 Alexander King, 'For Better or For Worse: The Benefits and Risks of Information Technology' in N. Bjorn-Anderson *et al.*, *Information Society: For Richer, For Poorer*, Amsterdam, North-Holland, 1982.

2 Jacques Maisonrouge, 'Putting Information to Work for People', *Intermedia*, 1984, vol. 12, no. 2, March.
3 Information Technology Advisory Panel, *Making a Business of Information*, London, HMSO, 1983, September.
4 Tom Stonier, *The Wealth of Information*, London, Thames Methuen, 1983.
5 Fritz Machlup, *Knowledge: Its Creation, Distribution, and Economic Significance, Vol. 3: The Economics of Information and Human Capital*, Princeton, NJ, Princeton University Press, 1984.
6 Scott Lash and John Urry, *The End of Organised Capitalism*, Cambridge, Polity, 1987.
7 These are reviewed in Frank Webster, *Theories of the Information Society*, London, Routledge, 1995, Chapter 7.
8 Joachim Hirsch, 'Fordismus and Postfordismus: die gegenwärtige gesellschaftliche Krise und ihre Folgen', *Politische Vierteljahresschrifit*, 1985, vol. 26, no. 2; Joachim Hirsch, 'Auf dem Wege zum Postfordismus? Die aktuelle Neuformierung des Kapitalismus und ihre politischen Folgen', *Das Argument*, 1985, no. 151.
9 There is a voluminous literature available. Amongst the most significant works are: Michael Piore and Charles Sabel, *The Second Industrial Divide*, New York, Basic Books, 1984; Fred Block, *Postindustrial Possibilities: A Critique of Economic Discourse*, Berkeley, CA, University of California Press, 1990; Manuel Castells, *The Rise of the Network Society*, Oxford, Blackwell, 1996.
10 We explore this further in the following chapter.
11 Cf. 'Knowledge and power are each an integral part of the other, and there is no point in dreaming of a time when knowledge will cease to be dependent on power....It is not possible for power to be exercised without knowledge, it is impossible for knowledge not to engender power', Michel Foucault, 'Prison Talk: An Interview', *Radical Philosophy*, 1977, no. 16, Spring, p. 15.
12 Anthony Giddens, *The Nation State and Violence: Volume 2 of A Contemporary Critique of Historical Materialism*, Cambridge, Polity Press, 1985, p. 2.
13 Thomas Richards has written vividly about this with regard to the British Empire, demonstrating an obsession with information collection on colonies and colonial subjects (maps, censuses, surveys). See Thomas Richards, *The Imperial Archive: Knowledge and the Fantasy of Empire*, London, Verso, 1993; cf. Benedict Anderson, *Imagined Communities: Reflections on the Origin and Spread of Nationalism*, revised edn, London, Verso, 1991, Chapter 10.
14 Anthony Giddens, *The Nation State and Violence Volume 2 of A Contemporary Critique of Historical Materialism*, Cambridge, Polity Press, 1985, p. 181.
15 Ibid., p. 302.
16 F. A. Hayek, 'The Use of Knowledge in Society', *American Economic Review*, 1945, vol. 35, no. 4, p. 526.
17 Ibid., p. 520.
18 Ibid., p. 521.
19 Ibid., p. 520.
20 Alfred D. Chandler, *The Visible Hand: The Managerial Revolution in American Business*, Cambridge, MA, The Belknap Press, 1977, pp. 8, 12.
21 F. A. Hayek, 'Economics and Knowledge', *Economica*, 1937, vol. 4, nos 13–16.
22 Charles Jonscher, 'Information Resources and Economic Productivity', *Information Economics and Policy*, 1983, vol. 1, no. 1, pp. 21, 15.
23 See Krishan Kumar, *From Post-Industrial to Post-Modern Society: New Theories of the Contemporary World*, Oxford, Blackwell, 1995, Chapter 2; Kevin Robins and Frank Webster, 'Information as Capital: A Critique of Daniel Bell' in J. D.

Slack and F. Fejes (eds), *The Ideology of the Information Age*, Norwood, NJ, Ablex, 1987, pp. 95–117.

24 This is not, of course, to imply the necessary effectiveness of technocratic rule. Technocracy probably always approximates more to what S. M. Miller calls 'pseudo-technocratic society'. See S. M. Miller, 'The Coming of Pseudo-Technocratic Society', *Sociological Inquiry*, 1976, vol. 46, no. 3–4. And the 'human components' always remain recalcitrant and resistant in the face of attempted social engineering.

25 Lewis Mumford, 'Authoritarian and Democratic Technics', *Technology and Culture*, 1964, vol. 5, p. 5.

26 Mark Poster, *Foucault, Marxism and History*, Cambridge, Polity Press, 1984, pp. 103, 115.

27 Scott Lash and John Urry, *The End of Organised Capitalism*, Cambridge, Polity Press, 1987.

28 De-subordination 'means that people who find themselves in subordinate positions...do what they can to mitigate, resist and transform the conditions of their subordination'. Ralph Miliband, 'A State of De-Subordination', *British Journal of Sociology*, 1978, vol. 29, no. 4, December, p. 402.

29 John Holloway, 'The Red Rose of Nissan', *Capital and Class*, 1987, no. 32, Summer, pp. 142–64 ; See Chapters 8 and 9 below.

30 See Frank Webster and Kevin Robins, *Information Technology: A Luddite Analysis*, Norwood, NJ, Ablex, 1986, Part 3.

31 Raphael Samuel, 'Workshop of the World: Steam Power and Hand Technology in mid-Victorian Britain', *History Workshop Journal*, 1977, no. 3, pp. 6–72.

32 This important concept was coined by William Appleman Williams, *The Contours of American History*, Cleveland, World, 1961.

33 Richard Hofstader, *Social Darwinism in American Thought*, revised edn, Boston, Beacon, 1955.

34 Martin J. Sklar, *The Corporate Reconstruction of American Capitalism, 1890–1916*, Cambridge, Cambridge University Press, 1988.

35 Eric J. Hobsbawm, *The Age of Empire, 1875–1914*, London, Weidenfeld and Nicolson, 1987, p. 45.

36 Samuel Haber, *Efficiency and Uplift: Scientific Management in the Progressive Era, 1890–1920*, Chicago, University of Chicago Press, 1964, p. xi.

37 Something of the change that took place may be gauged by comparing Taylor's emphasis on Scientific Management as the way to run businesses with Andrew Carnegie's (1903) influential primer, *The Empire of Business*, which had been published at the turn of the century (London and New York, Harper and Brothers). In this latter the route to success is mapped in terms of personality traits – character, alertness, keenness, etc. – rather than in terms of Taylor's efficiency measures.

38 J. A. Hobson, 'Scientific Management', *Sociological Review*, 1913, vol. 6, no. 3, July, p. 198.

39 Lewis Mumford, *The Myth of the Machine: Technics and Human Development*, London, Secker and Warburg, 1967, p. 189.

40 Richard Edwards, *Contested Terrain: The Transformations of the Workplace in the Twentieth Century*, London, Heinemann, 1979.

41 Mike Cooley, 'The Taylorization of Intellectual Work' in L. Levidow and B. Young (eds), *Science, Technology and the Labour Process, Vol. 1*, London, CSE Books, 1981.

42 Morris Janowitz, 'Sociological Theory and Social Control', *American Journal of Sociology*, 1975, vol. 81, no. 1, July, p. 84; cf. David A. Hounshell, *From the American System to Mass Production 1800–1932: The Development of Manufacturing*

Technology in the United States, Baltimore, The Johns Hopkins University Press, 1987, Chapter 8.

43 Samuel Haber, *Efficiency and Uplift: Scientific Management in the Progressive Era, 1890–1920*, Chicago, University of Chicago Press, 1964, p. x.

44 Ibid., p. 44.

45 Edwin Layton, 'Veblen and the Engineers', *American Quarterly*, 1962, Spring.

46 Magali Sarfatti-Larson, 'Notes on Technocracy: Some Problems of Theory, Ideology and Power', *Berkeley Journal of Sociology*, 1972, no. 17, p. 19.

47 Charles S. Maier, 'Between Taylorism and Technocracy: European Ideologies and the Vision of Industrial Productivity in the 1920s', *Journal of Contemporary History*, 1970, vol. 5, no. 2, pp. 31–32.

48 See, for example, Stuart and Elizabeth Ewen, *Channels of Desire*, New York, McGraw-Hill, 1982.

49 Herbert Casson realised early on that 'what has worked so well in the acquisition of knowledge and in the production of commodities may work just as well in the distribution of those commodities'. Herbert N. Casson, *Ads and Sales: A Study of Advertising and Selling from the Standpoint of the New Principles of Scientific Management*, Chicago, A. C. McClurg and Co., 1911, p. 71.

50 Daniel Pope, *The Making of Modern Advertising*, New York, Basic Books, 1983; Raymond Williams, 'Advertising: the Magic System' in Raymond Williams, *Problems in Materialism and Culture*, London, Verso, 1980, pp. 170–95.

51 Alfred P. Sloan, *My Years with General Motors*, London, Sidgwick and Jackson, 1965, Chapter 9.

52 Henry C. Link, *The New Psychology of Selling and Advertising*, New York, Macmillan, 1932, p. 248.

53 David M. Potter, *People of Plenty: Economic Abundance and the American Character*, Chicago, University of Chicago Press, 1954, pp. 168, 175.

54 Quentin J. Schultze, *Advertising, Science, and Professionalism*, University of Illinois at Urbana-Champaign, 1978, unpublished PhD thesis, p. 116; cf. Susan Strasser, *Satisfaction Guaranteed: The Making of the American Mass Market*, Washington, Smithsonian Institute Press, 1989.

55 Donald L. Hurwitz, *Broadcast Ratings: The Rise and Development of Commercial Audience Research and Measurement in American Broadcasting*, University of Illinois at Urbana-Champaign, 1983, unpublished PhD thesis.

56 Edward L. Bernays, *The Engineering of Consent*, Norman, University of Oklahoma Press, 1955, pp. 3–4, 9; cf. Abram Lipsky, *Man the Puppet: The Art of Controlling Minds*, New York, Frank-Maurice Inc., 1925.

57 This is a judgement we share with management guru Peter Drucker who describes Taylorism as 'the most powerful as well as the most lasting contribution America has made to Western thought'. Peter Drucker, *The Practice of Management*, London, Heinemann, 1955, p. 248; cf. Peter Drucker, *Post-Capitalist Society*, Oxford, Butterworth Heinemann, 1993.

58 Roland Marchand, *Advertising the American Dream: Making Way for Modernity, 1920–1940*, Berkeley, CA, University of California Press,1985, p. 25.

59 Herbert S. Dordick, *et al.*, *The Emerging Network Marketplace*, Norwood, NJ, Ablex, 1981.

60 Kenneth Gill, 'Chairman's Review' in Saatchi and Saatchi Company plc, *Annual Report 1983*.

61 Saatchi and Saatchi Company plc, *Review of Advertising Operations 1984*, London, Saatchi and Saatchi, 1985.

62 Steve Winram, 'The Opportunity for World Brands', *International Journal of Advertising*, 1984, vol. 3, no. 1, p. 25; Ivan Fallon, *The Brothers: The Rise and Rise of Saatchi & Saatchi*, London, Hutchinson, 1988, pp. 197–217.

63 Kevin Robins and Frank Webster, 'The Revolution of the Fixed Wheel: Television and Social Taylorism' in P. Drummond and R. Paterson (eds), *Television in Transition*, London, British Film Institute, 1985, pp. 36–63; Kevin Robins and Frank Webster, 'Broadcasting Politics: Communications and Consumption', *Screen*, 1986, vol. 27, no. 3–4, May–August, pp. 30–44.
64 David Schmittlein, 'Mastering Management', *Economist*, 1995, 15 December.
65 Dominic Cadbury, 'The Impact of Technology on Marketing', *International Journal of Advertising*, 1983, vol. 2, no. 1, pp. 72, 70.
66 Philip Corrigan and Derek Sayer, *The Great Arch: English State Formation as Cultural Revolution*, Oxford, Blackwell, 1985.
67 Anthony Giddens, *A Contemporary Critique of Historical Materialism, vol. 1, Power, Property and the State*, London, Macmillan, 1981, p. 94.
68 Theodore Roszak, *The Cult of Information*, Cambridge, Lutterworth Press, 1986, p. 156.
69 Jürgen Habermas, *Strukturwandel der Öffentlichkeit*, Darmstadt, Luchterhand, 1962.
70 Hans Speier, 'Historical Development of Public Opinion', *American Journal of Sociology*, 1950, vol. 55, January, p. 376.
71 Alvin Gouldner, *The Dialectic of Ideology and Technology*, London, Macmillan, 1976; cf. Nicholas Garnham, 'The Media and the Public Sphere', in Peter Golding, Graham Murdock and Philip Schlesinger (eds), *Communicating Politics: Mass Communications and the Political Process*, Leicester, Leicester University Press, 1986, pp. 37–53.
72 Jürgen Habermas, *Strukturwandel der Offentlichkeit*, Darmstadt, Luchterhand, 1962, p. 194.
73 Alvin Gouldner, *The Dialectic of Ideology and Technology*, London, Macmillan, 1976, pp. 139–40.
74 Paul Piccone, 'Paradoxes of Reflexive Sociology', *New German Critique*, 1976, no. 8, Spring, p. 173.
75 Cornelius Castoriadis, 'Reflections on "Rationality" and "Development"', *Thesis Eleven*, 1984/85, no. 10/11.
76 Alvin Gouldner, *The Dialectic of Ideology and Technology*, London, Macmillan, 1976, pp. 36–37.
77 Samuel Haber, *Efficiency and Uplift: Scientific Management in the Progressive Era, 1890–1920*, Chicago, University of Chicago Press, 1964, pp. 90, 93, 97–98.
78 Walter Lippmann, *The Phantom Public*, New York, Harcourt, Brace and Co., 1925, p. 39.
79 Walter Lippmann, *Public Opinion*, London, Allen and Unwin, 1922, p. 394.
80 Ibid., p. 378.
81 Ibid., p. 408.
82 Ibid., p. 248.
83 William Albig, *Public Opinion*, New York, McGraw-Hill, 1939, p. 301.
84 Harwood L. Childs, *Public Opinion: Nature, Formation and Role*, Princeton, NJ, Van Nostrand, 1965, p. 282.
85 Harold D. Lasswell, 'The Vocation of Propagandists' in *On Political Sociology*, Chicago: University of Chicago Press, (1934) 1977, pp. 234, 235.
86 Edward Bernays refers to this as 'special pleading' and Harold Lasswell writes of 'the function of advocacy', suggesting that 'as an advocate the propagandist can think of himself as having much in common with the lawyer'. Indeed, according to Lasswell, society 'cannot act intelligently' without its 'specialists on truth'; 'unless these specialists are properly trained and articulated with one another and the public, we cannot reasonably hope for public interests'. Edward L. Bernays, *Crystallising Public Opinion*, New York, Boni and Liveright,

1923; Harold D. Lasswell, *Democracy Through Public Opinion*, Menasha, Wis., George Banta Publishing Company (The Eleusis of Chi Omega, 1941, vol. 43, no. 1, Part 2), pp. 63, 75–76.

87 Walter Lippmann, *Public Opinion*, London, Allen and Unwin, 1922, p. 43.

88 As Francis Rourke observes 'public opinion [has] become the servant rather than the master of government, reversing the relationship which democratic theory assumes and narrowing the gap between democratic and totalitarian societies'. Francis E. Rourke, *Secrecy and Publicity: Dilemmas of Democracy*, Baltimore, Johns Hopkins Press, 1961, p. xi.

89 John Sinclair, *Images Incorporated: Advertising as Industry and Ideology*, London, Croom Helm, 1987, pp. 99–123.

90 Adam Raphael, 'What Price Democracy?', *Observer* (Colour Supplement), 1990, 14 October, pp. 7–47.

91 Jeremy Tunstall, 'Deregulation is Politicisation', *Telecommunications Policy*, 1985, vol. 9 , no. 3, September, p. 210.

92 See the exceptionally informative article by Bernice Martin, 'Symbolic Knowledge and Market Forces at the Frontiers of Postmodernism: Qualitative Market Researchers (Britain)' in Hans Kellner and Peter Berger (eds), *Hidden Technocrats: The New Class and New Capitalism*, New Brunswick, Transaction, 1992, pp. 111–56.

93 Cf. Bob Franklin, *Packaging Politics: Political Communications in Britain's Media Democracy*, London, Edward Arnold, 1994.

94 James B. Rule, *Private Lives and Public Surveillance*, London, Allen Lane, 1973, p. 43.

95 Tom Stonier, 'Intelligence Networks, Overview, Purpose and Policies in the Context of Global Social Change', *Aslib Proceedings*, 1986, vol. 38, no. 9, September.

96 Michael Marien, 'Some Questions for the Information Society', *The Information Society*, 1984, vol. 3, no. 2.

97 Walter Lippmann, *Public Opinion*, London, Allen and Unwin, 1922, pp. 408, 248.

98 Kenneth E. Boulding and Lawrence Senesh, *The Optimum Utilisation of Knowledge: Making Knowledge Serve Human Betterment*, Boulder, Col., Westview Press, 1983.

99 Walter Lippmann, *The Phantom Public*, New York, Harcourt, Brace and Co., 1925, pp. 189–90.

100 Lewis Mumford, 'Authoritarian and Democratic Technics', *Technology and Culture*, 1964, vol. 5, no. 2.

101 Cornelius Castoriadis, 'Reflections on "Rationality" and "Development"', *Thesis Eleven*, 1984/85, no. 10/11, p. 35.

5 THE CYBERNETIC IMAGINATION OF CAPITALISM

1 Jean-Paul de Gaudemar, *La Mobilisation Générale*, Paris, Editions du Champ Urbain, 1979 (see also the discussion of Gaudemar in Chapter 2).

2 R. W. Dunn, *Labour and Automobiles*, London, Modern Books, 1929, p. 62.

3 Although we refer specifically to Fordism – which evolved during the first half of the twentieth century – we are, of course, describing changes that were emerging throughout the whole period of relative mobilization.

4 John Alt, 'Beyond Class: The Decline of Industrial Labour and Leisure', *Telos*, 1976, no. 28, Summer, pp. 68–69.

5 Alan Trachtenberg, *The Incorporation of America: Culture and Society in the Gilded*

Age, New York, Hill and Wang, 1982; Robert S. Lynd and A. C. Hanson, 'The People as Consumers' in *President's Research Committee on Social Trends: Recent Social Trends in the United States*, New York, McGraw Hill, 1933, pp. 857–911.

6 Les Levidow and Bob Young, 'Introduction' in *Science, Technology and the Labour Process, vol. 1*, London, CSE Books, 1981, p. 5.

7 Joachim Hirsch, 'The New Leviathan and the Struggle for Democratic Rights', *Telos*, 1981, no. 48, Summer, pp. 83, 82, 87.

8 Nigel Thrift, 'Owners' Time and Own Time: The Making of a Capitalist Time Consciousness, 1300–1880', *Lund Studies in Geography*, 1981, Series B, no. 48, p. 64.

9 Michel Foucault, *Discipline and Punish: The Birth of the Prison*, Harmondsworth, Penguin, 1979, p. 160.

10 A. Granou, *Capitalisme et Mode de Vie*, Paris, Editions du Cerf, 1974.

11 See, *inter alia*, Harley Shaiken, *Work Transformed: Automation and Labor in the Computer Age*, New York, Holt, Rinehart and Winston, 1984; Barry Wilkinson, *The Shopfloor Politics of New Technology*, London, Heinemann, 1983; Robert Howard, *Brave New Workplace*, New York, Viking Penguin, 1985; Simon Head, 'The New, Ruthless Economy', *New York Review of Books*, 1996, 29 February, pp. 47–52.

12 Manuel Castells, *The Rise of the Network Society*, Oxford, Blackwell, 1996.

13 Jeremy Rifkin, *The End of Work: The Decline of the Global Labor Force and the Dawn of the Post-Market Era*, New York, G. P. Putnam's Sons, 1995.

14 Robert Reich, *The Work of Nations: Preparing Ourselves for 21st Century Capitalism*, New York, Vintage, 1992.

15 See Fred Block, *Postindustrial Possibilities: A Critique of Economic Discourse*, Berkeley, CA, University of California Press, 1990; Larry Hirschhorn, *Beyond Mechanization: Work and Technology in a Postindustrial Age*, Cambridge, MA, MIT Press, 1984; Shoshana Zuboff, *In the Age of the Smart Machine: The Future of Work and Power*, London, Heinemann, 1988; Robert J. Thomas, *What Machines Can't Do: Politics and Technology in the Industrial Enterprise*, Berkeley, CA, University of California Press, 1994.

16 Manuel Castells, *The Rise of the Network Society*, Oxford, Blackwell, 1996, p. 265.

17 Ibid., pp. 276, 272; cf. Bennett Harrison, *Lean and Mean: The Changing Landscape of Corporate Power in the Age of Flexibility*, New York, Basic Books, 1994.

18 André Gorz, *Farewell to the Working Class*, London, Pluto Press, 1982, p. 84.

19 Simon Nora and Alain Minc, *The Computerisation of Society: A Report to the President of France*, Cambridge, MA, MIT Press, 1980, pp.126–27.

20 Jeremy Bentham, *Works, vol. 4*, J. Bowring (ed.), Edinburgh, William Tait, 1843, p. 80.

21 Ibid., p. 44.

22 Ibid., p. 47.

23 Michel Foucault, *Discipline and Punish: The Birth of the Prison*, translated by Alan Sheridan, Harmondsworth, Penguin, 1979, pp. 77–78.

24 Ibid., pp. 200, 201.

25 Ibid., pp. 202–3.

26 Ibid., p. 205.

27 Ibid., p. 249.

28 Ibid., p. 202.

29 Ibid., p. 250.

30 David Leigh, *The Frontiers of Secrecy: Closed Government in Britain*, London, Junction Books, 1980, p. 218.

31 David Burnham, *The Rise of the Computer State*, New York, Random House, 1983.
32 Joel Kovel, *Against the State of Nuclear Terror*, London, Pan, 1983, p. 76.
33 Ibid., pp. 76–77.
34 Oscar H. Gandy, *The Panoptic Sort: A Political Economy of Personal Information*, Boulder, CO, Westview Press, 1993.
35 Tom Stonier, *The Wealth of Information: A Profile of the Post-Industrial Economy*, London, Methuen, 1983, pp. 12, 63, 18–19, 203.
36 Anita R. Schiller and Herbert I. Schiller, 'Who Can Own What America Knows?' *Nation*, 17 April, 1982, p. 461. Cf. Herbert I .Schiller, *Information Inequality: The Deepening Social Crisis in America*, New York, Routledge, 1996, Chapter 2.
37 Sir Derek Rayner, *Report to the Prime Minister*, London, Central Statistical Office, 1981.
38 See Alastair J. Allan, *The Myth of Government Information*, London, Library Association, 1990.
39 See Ruth Levitas and Will Guy (eds), *Interpreting Official Statistics*, London, Routledge, 1996.
40 Frederick Winslow Taylor, 'Testimony Before the Special House Committee (1912)' in *Scientific Management*, New York, Harper, 1974, p. 40.
41 Karl Marx, *Capital, vol. 1*, Harmondsworth: Penguin, 1976, p. 548.
42 C. Reitell, 'Machinery and Its Effect Upon the Workers in the Automotive Industry', *Annals of the American Academy of Political and Social Science*, 1924, November, p. 41.
43 Frank Webster and Kevin Robins, *Information Technology: A Luddite Analysis*, Norwood, NJ, Ablex, 1986, Chapter 11.
44 Ivan Illich, *The Right to Useful Unemployment*, London, Marion Boyars, 1978, p. 24.
45 Jeremy Seabrook, *Unemployment*, London, Quartet, 1982, pp. 179, 105.
46 While we would insist on the reality of this process of social deskilling, we do not want to overstate it by denying the capabilities of, and the opportunities available for, reskilling. Anthony Giddens has forcefully reminded us that, in everyday life, processes of deskilling and reskilling are constantly being played out. (*Modernity and Self-Identity: Self and Society in the Late Modern Age*, Cambridge, Polity, 1991, pp. 137–43).
47 David Burnham, *The Rise of the Computer State*, New York, Random House, 1983, pp. 12, 11.
48 Anthony Giddens, *The Nation-State and Violence. Vol. 2 of A Contemporary Critique of Historical Materialism*, Cambridge, Polity Press, 1985.
49 H. G.Wells, *World Brain*, London, Methuen, 1938, p. 47.
50 Ibid., p. 59.
51 Ibid., p. 60.
52 Ibid., p. 61.
53 Ibid., p. 26.
54 Ibid., p. 64.
55 Ibid., p. 49.
56 See Dave Muddiman, 'The Universal Library as Modern Utopia: the Information Society of H. G. Wells', *Library History*, 1998, vol. 14, pp. 85–101.
57 Jürgen Habermas, *The Structural Transformation of the Public Sphere*, Cambridge, Polity Press, 1989, Chapters 5 and 6.
58 André Gorz, 'On the Class Character of Science and Scientists' in H. and S. Rose (eds) *The Political Economy of Science*, London, Macmillan, 1976, p. 64.

59 Jean-François Lyotard, 'Le jeu de l'informatique et du savoir', *Dialectiques*, 1980, vol. 29, Winter, pp. 3–12.
60 William E. Colby, 'Intelligence in the 1980s', *Information Society*, 1981, vol. 1, no. 1, pp. 67–68.
61 Stansfield Turner, 'Intelligence for a New World Order', *Foreign Affairs*, 1991, vol. 70, no. 4, Fall, pp. 151–52.
62 Bernard Doray, *From Taylorism to Fordism: A Rational Madness*, London, Free Association Books, 1988, p. 166.
63 John Berger, 'Against the Great Defeat of the World', *Race and Class*, 1998/99, vol. 40, no. 2/3, p. 1.
64 Ibid., p. 4.

6 PROPAGANDA: THE HIDDEN FACE OF INFORMATION

1 Louis Wirth, 'Consensus and Mass Communication', *American Sociological Review*, 1948, vol. 13, no. 1, February, p. 7.
2 See Ferdinand Tönnies, *On Sociology: Pure, Applied and Empirical*, Chicago, University of Chicago Press, 1971, Chapter 19.
3 Melvin L. De Fleur and Sandra Ball-Rokeach, *Theories of Mass Communication*, New York, David McKay Company, 3rd edn, 1975, pp. 138–39.
4 Louis Wirth, 'Consensus and Mass Communication', *American Sociological Review*, 1948, vol. 13, no. 1, February, pp. 10, 4–5.
5 Albert Kreiling, 'Television in American Ideological Hopes and Fears', *Qualitative Sociology*, 1982, vol. 5, no. 3, Fall, p. 200.
6 Harold D. Lasswell, 'The Theory of Political Propaganda', *American Political Science Review*, 1927, vol. 21, p. 631.
7 Harold D. Lasswell, *Propaganda Techniques in the World War*, London, Kegan, Paul, Trench, Trubner and Co, 1927, p. 222.
8 H. D. Lasswell, 'The Theory of Political Propaganda', *American Political Science Review*, 1927, vol. 21, p. 630.
9 James Carey, 'Mass Communication Research and Cultural Studies: an American View' in James Curran, Michael Gurevitch and Janet Woollacott (eds), *Mass Communication and Society*, London, Edward Arnold, 1977, p. 412.
10 Leonard W. Doob, *Public Opinion and Propaganda*, London, Cresset Press, 1949, p. 240.
11 Herbert Blumer, 'The Mass, the Public and Public Opinion' in Bernard Berelson and Morris Janowitz (eds), *Reader in Public Opinion and Communication*, New York, Free Press, (1946), 2nd edn, 1966, p. 45.
12 Donald F. Roberts, 'The Nature of Communications Effects' in Wilbur Schramm and Donald F. Roberts (eds), *The Process and Effects of Mass Communication*, Urbana, IL: University of Illinios Press, revised edn, 1971, p. 376. For overviews of audience and effects studies, see especially Joseph T. Klapper, *The Effects of Mass Communication*, New York, Free Press, 1960; Dennis McQuail, 'The Influence and Effects of Mass Media' in James Curran, Michael Gurevitch and Janet Woollacott (eds), *Mass Communication and Society*, London, Edward Arnold, 1977; David Morley, *Television, Audiences and Cultural Studies*, London, Routledge, 1992; Terence H. Qualter, *Opinion Control in the Democracies*, London, Macmillan, 1985, Chapters 4–5.
13 T. H. Qualter, *Opinion Control in the Democracies*, London, Macmillan, 1985, p. 29.
14 William Albig, *Public Opinion*, New York, McGraw-Hill, 1939, pp. 21, 47.
15 Alvin Gouldner, *The Dialectic of Ideology and Technology*, London, Macmillan, 1976, p. 95.

16 W. Albig, *Public Opinion*, New York, McGraw-Hill, 1939, p. 47
17 See, *inter alia*, Leonard W. Doob, *Public Opinion and Propaganda*, London, Cresset Press, 1949; Bruce Lannes Smith, Harold D. Lasswell and Ralph D. Casey, *Propaganda, Communication, and Public Opinion*, Princeton, NJ, Princeton University Press, 1946; Daniel Katz (ed.), *Public Opinion and Propaganda: a Book of Readings*, New York, Holt, Rinehart and Winston, 1964.
18 H. Blumer, 'The Mass, the Public and Public Opinion' in Bernard Berelson and Morris Janowitz (eds), *Reader in Public Opinion and Communication*, New York, Free Press, (1946), 2nd edn, 1966, p. 50. See also Bernard Berelson, 'Democratic Theory and Public Opinion', *Public Opinion Quarterly*, 1952, vol. 16, Fall, pp. 313–30; Paul F. Lazarsfeld, 'Public Opinion and the Classical Tradition', *Public Opinion Quarterly*, 1957, vol. 21, Spring, pp. 39–53.
19 Robert E. Park, *On Social Control and Collective Behaviour: Selected Papers*, Ralph H. Turner (ed.), Chicago, University of Chicago Press, (1924), 1967, pp. 219–20.
20 Jürgen Habermas, *Strukturwandel der Öffentlichkeit*, Darmstadt, Luchterhand, 1962, pp. 41, 129.
21 Harold D. Lasswell, 'The Vocation of Propagandists' in *On Political Sociology*, Chicago, University of Chicago Press, (1934), 1977, p. 236.
22 H. Blumer, 'The Mass, the Public and Public Opinion' in Bernard Berelson and Morris Janowitz (eds), *Reader in Public Opinion and Communication*, New York, Free Press, (1946), 2nd edn, 1966, p. 50.
23 W. Albig, *Public Opinion*, New York, McGraw-Hill, 1939, p. 301.
24 Harwood L. Childs, *Public Opinion: Nature, Formation, and Role*, Princeton: Van Nostrand, 1965, p. 282.
25 George E. Gordon Catlin, 'Propaganda as a Function of Democratic Government' in Harwood L. Childs (ed.), *Propoganda and Dictatorship*, Princeton, NJ, Princeton University Press, 1936, pp. 142–43.
26 H. D. Lasswell, 'The Vocation of Propagandists' in *On Political Sociology*, Chicago, University of Chicago Press, (1934), 1977, pp. 234–35.
27 W. Albig, *Public Opinion*, New York, McGraw-Hill, 1939, p. 283.
28 Walter Lippmann, *Public Opinion*, London, George Allen and Unwin, 1922, pp. 43, 247. On the close relation between censorship and propaganda, see Kevin Robins and Frank Webster, 'The Media, the Military and Censorship', *Screen*, 1986, vol. 27, no. 2, March–April, pp. 57–63.
29 W. Albig, *Public Opinion*, New York, McGraw-Hill, 1939, p. 296.
30 David L. Altheide and John M. Johnson, *Bureaucratic Propaganda*, Boston, Allyn and Bacon, 1980, p. 10.
31 Jacques Ellul, *Propaganda: The Formation of Men's Attitudes*, New York, Alfred A. Knopf, 1965, p. 124.
32 Louis Wirth, 'Consensus and Mass Communication', *American Sociological Review*, 1948, vol. 13, no. 1, February, p. 9.
33 Jacques Ellul, *Propaganda: The Formation of Men's Attitudes*, New York, Alfred A. Knopf, 1965, pp. 126, 132.
34 H. D. Lasswell, 'The Vocation of Propagandists' in *On Political Sociology*, Chicago, University of Chicago Press, (1934), 1977, p. 231.
35 R. E. Park, *On Social Control*, op. cit., p. 5, cf. pp. 209–10. See also Elisabeth Noelle-Newmann, *The Spiral of Silence: Public Opinion – Our Social Skin*, Chicago, University of Chicago Press, 1984, pp. 95–96.
36 Louis Wirth, 'Consensus and Mass Communication', *American Sociological Review*, 1948, vol. 13, no. 1, February, p. 4.
37 Morris Janowitz, 'Sociological Theory and Social Control', *American Journal of Sociology*, 1975, vol. 81, no. 1, July, p. 83.

38 W. Albig, *Public Opinion*, New York, McGraw-Hill, 1939, p. 309.
39 Walter Lippmann, *The Phantom Public*, New York, Harcourt, Brace and Co., 1925, p. 39.
40 Walter Lippmann, *Public Opinion*, London, George Allen and Unwin, 1922, p. 394.
41 Ibid., p. 378.
42 Ibid., p. 408, cf. p. 292.
43 Ibid., p. 248.
44 Edward L. Bernays, 'The Theory and Practice of Public Relations: A Résumé', in Edward L. Bernays (ed.), *The Engineering of Consent*, Norman, University of Oklahoma Press, 1955, p. 22, cf. p. 4.
45 Walter Lippmann, *Public Opinion*, London, George Allen and Unwin, 1922, p. 248.
46 Daniel Bell, 'The Social Framework of the Information Society' in Tom Forester (ed.), *The Microelectronics Revolution*, Oxford, Blackwell, 1980, pp. 501, 506.
47 Jacques Maisonrouge, 'Putting Information to Work for People', *Intermedia*, 1984, vol. 12, no. 2, March, p. 33.
48 Daniel Bell, 'The Social Framework of the Information Society', op. cit., pp. 509, 503.
49 Richard Swift, 'Everything under Control', *New Internationalist*, 1985, no. 146, April, p. 7.
50 See Frank Webster, *Theories of the Information Society*, London, Routledge, 1995, pp. 124–31; Bob Franklin, *Packaging Politics: Political Communications in Britain's Media Democracy*, London, Edward Arnold, 1994.
51 See, *inter alia*, Donna Demac, *Keeping America Uninformed*, New York, Pilgrim Press, 1984; Donna Demac, *Liberty Denied: The Current Rise of Censorship in America*, New York, PEN American Center, 1990; Des Wilson (ed.), *The Secrets File: The Case for Freedom of Information in Britain Today*, London, Heinemann, 1984.
52 See, *inter alia*, Information Technology Advisory Panel, *Making a Business of Information*, London, HMSO, 1983, September; Vincent Mosca, *The Pay-Per Society: Computers and Communication in the Information Age*, Toronto, Garamond Press, 1989; Herbert I. Schiller, *Culture Inc., The Corporate Takeover of Public Expression*, New York, Oxford University Press, 1989.
53 Oscar H. Gandy and Charles E. Simmons, 'Technology, Privacy and the Democratic Process', *Critical Studies in Mass Communication*, 1986, vol. 3, no. 3, June; cf. Oscar H. Gandy, *The Panoptic Sort, A Political Economy of Personal Information*, Boulder, CO, Westview Press, 1993; Gary T. Marx, *Undercover: Police Surveillance in America*, Berkeley, University of California Press, 1988; Duncan Campbell and Steve Connor, *On the Record: Surveillance, Computers and Privacy*, London, Michael Joseph, 1986; David Lyon, *The Electronic Eye: The Rise of Surveillance Society*, Cambridge, Polity, 1994; Simon Davies, *Big Brother: Britain's Web of Surveillance and the New Technological Order*, London, Pan, 1996.
54 Herbert I. Schiller, *The Mind Managers*, Boston, Beacon Press, 1973, p. 4. Whilst Schiller has often been accused of pessimistic and determinist tendencies, his proper emphasis on propaganda and information control by no means implies its comprehensive success and effectiveness.
55 Walter Lippman, *The Phantom Public*, New York, Harcourt, Brace and Co., 1925, pp. 189–90.
56 Edward L. Bernays, 'The Theory and Practice of Public Relations: A Résumé', in Edward L. Bernays (ed.), *The Engineering of Consent*, Norman, University of Oklahoma Press, 1955, p. 5.

57 Harold D. Lasswell, 'The Vocation of Propagandists' in *On Political Sociology*, Chicago, University of Chicago Press, (1934), 1977, p. 234.
58 G. E. Gordon Catlin, 'Propaganda as a Function of Democratic Government' in Harwood L. Childs (ed.), *Propaganda and Dictatorship*, Princeton, NJ, Princeton University Press, 1936, p. 234.
59 Joseph Nye and William Owens, 'America's Information Edge', *Foreign Affairs*, 1996, vol. 75, no. 2, March–April, pp. 20–36.
60 Francis G. Wilson, 'Public Opinion: Theory for Tomorrow', *Journal of Politics*, 1954, vol. 16, p. 611.
61 Francis E. Rourke, *Secrecy and Publicity: Dilemmas of Democracy*, Baltimore, MD, Johns Hopkins Press, 1961, p. vii.
62 For an argument which does make this assumption, see C. Wright Mills, *The Power Elite*, New York, Oxford University Press, 1956, especially Chapter 13.
63 Anthony Giddens, *The Nation-State and Violence*, Cambridge, Polity Press, 1985, pp. 180, 295. See also pp. 302, 310.
64 Max Horkheimer and Theodor W. Adorno, *Dialectic of Enlightenment*, London, Allen Lane, (1944), 1973, p. 9.
65 Jürgen Habermas, *Strukturwandel der Öffentlichkeit*, Darmstadt, Luchterhand, 1962.

7 CYBERWARS: THE MILITARY INFORMATION REVOLUTION

1 The military origins are well documented in, for example, Ernest Braun and Stuart MacDonald, *Revolution in Miniature: The History and Impact of Semiconductor Electronics*, 2nd edn, Cambridge, Cambridge University Press, 1982.
2 The Internet stems from the US military's ARPAnet (American Defense Advanced Research Projects Agency) scheme in 1969, aimed at establishing a secure means of communication between scientists engaged on military projects.
3 Cf. Paul N. Edwards, *The Closed World: Computers and the Politics of Discourse in Cold War America*, Cambridge, MA, MIT Press, 1996.
4 Cornelius Castoriadis, *Crossroads in the Labyrinth*, Brighton, Harvester, 1984, p. 242.
5 Elizabeth Gerver, *Computers and Adult Learning*, Milton Keynes, Open University Press, 1984, p. 106.
6 Ibid., p. 30.
7 Daniel Boorstin, *The Republic of Technology: Reflections on our Future Community*, New York, Harper and Row, 1978, pp. 90–91.
8 David F. Noble, *Forces of Production: A Social History of Industrial Automation*, New York, Knopf, 1984, pp. xi–xii.
9 Albert Borgmann, *Technology and the Character of Contemporary Life*, Chicago, University of Chicago Press, 1984, p. 174.
10 Ibid., p. 103.
11 Langdon Winner, *The Whale and the Reactor: A Search for Limits in an Age of High Technology*, Chicago, University of Chicago Press, 1986, p. 39.
12 Cornelius Castoriadis, 'Reflections on "Rationality" and "Development"', *Thesis Eleven*, 1984/85, no. 10/11, p. 31.
13 Christopher Lasch, 'Technology and its Critics: The Degradation of the Practical Arts' in Steven E. Goldberg and Charles R. Strain (eds), *Technological Change and the Transformation of America*, Carbonade, IL, Southern Illinois University Press, 1987, p. 88.
14 Arnold Gehlen, *Man in the Age of Technology*, New York, Columbia University Press, 1980, p. 30.

15 Leo Marx, 'Does Improved Technology Mean Progress?', *Technology Review*, 1987, vol. 90, no. 1, January, p. 71.
16 Arnold Gehlen, *Man in the Age of Technology*, New York, Columbia University Press, 1980, p. 11.
17 Joel Kovel, *Against the State of Nuclear Terror*, London, Pan, 1983, p. 131.
18 Anthony Giddens, *The Nation State and Violence: Volume Two of a Contemporary Critique of Historical Materialism*, Cambridge, Polity Press, 1985, p. 294.
19 Ibid., p. 244.
20 See for instance the analyses in John Keegan *The Face of Battle: A Study of Agincourt, Waterloo and the Somme*, Harmondsworth, Penguin, (1976), 1983.
21 Paul Kennedy, *The Rise and Fall of the Great Powers: Economic Change and Military Conflict from 1500 to 2000*, London, Unwin Hyman, 1988; cf. Paul Kennedy, *Grand Strategies in War and Peace*, New Haven, CT, Yale University Press, 1991.
22 Martin Gilbert, *Second World War*, London, Weidenfeld and Nicolson, 1989, pp. 745–47.
23 John Erikson, quoted in the *Guardian*, 1982, 11 November, p. 4.
24 See Roger C. Molander, Andrew S. Riddile, and Peter A. Wilson, *Strategic Information Warfare: A New Face of War*, Santa Monica, CA, RAND, 1996; Martin Libicki, *What is Information Warfare?* ACIS Paper 3, Washington DC, National Defense University, 1995.
25 See Paul Bracken, *The Command and Control of Nuclear Forces*, New Haven, CT, Yale University Press, 1983; cf. Joint Chiefs of Staff, *Doctrine of Command, Control, Communications, and Computer (C4) Systems Support to Joint Operations*, Washington DC, Joint Chiefs of Staff, 1995.
26 At least those with strategic significance for the United States and the NATO members. It is likely that wars with little consequence for the stability of global capitalism will be left to run their course – perhaps with major loss of life, as witness the appalling outcome of the internecine struggles in Liberia, Rwanda and the former Yugoslavia, in and around Bosnia.
27 Manuel Castells, *The Rise of the Network Society*, Oxford, Blackwell, 1996, pp. 454–61.
28 Revealingly, military thinking is much influenced by the thinking of Alvin and Heidi Toffler, who coined the term 'knowledge warriors'. See Alvin and Heidi Toffler, *War and Anti-War*, Boston, Little, Brown, 1993. The Tofflers have also written a foreword to a recent book on information war, see John Arquilla and David F. Ronfeldt (eds), *In Athena's Camp: Preparing for Conflict in the Information Age*, Santa Monica, CA, RAND, 1997.
29 The import of media presentation may also be significant in pressing major powers to intervene in situations where few strategic interests are at stake, but where public opinion is mobilised. One might also think here of the former Yugoslavia following major human rights abuses, most recently in Kosovo; one could envisage similar intervention in situations such as Northern Ireland.
30 See Hedrick Smith (ed.), *The Media and the Gulf War: The Press and Democracy in Wartime*, Washington, Seven Locks Press, 1992; Hamid Mowlana, George Gerbner and Herbert I. Schiller (eds), *Triumph of the Image: The Media's War in the Persian Gulf – A Global Perspective*, Boulder, CO, Westview Press, 1992; Phillip M. Taylor, *War and the Media: Propaganda and Persuasion in the Gulf War*, Manchester, Manchester University Press, 1992; W. Lance Bennett and David L. Paletz (eds), *Taken by Storm: The Media, Public Opinion, and US Foreign Policy in the Gulf War*, American Politics and Political Economy Series, Chicago, University of Chicago Press, 1994; Thomas A. McCain and Leonard Shyles (eds), *The 1000 Hour War: Communication in the Gulf*, Contributions in Military

Studies, no. 148, Westport, CT, Greenwood Publishing Group, 1993; Dominique Wolton, *War Game: L'information et la guerre*, Paris, Flammarion, 1991; Peter Young and Peter Jesser, *The Media and the Military: From Crimea to Desert Storm*, London, Macmillan, 1997.

31 Jean Baudrillard, *La Guerre du Golfe n'a pas eu lieu*, Paris, Galilée, 1991.

32 Gary Stix, 'Fighting Future Wars', *Scientific American*, 1995, December, p. 78.

33 Secretary of State for Defence, *Statement of the Defence Estimates*, Cm 3223, 1996, May, Figure 10.

34 Ibid., para. 174.

35 See Frank Barnaby, *The Automated Battlefield*, London, Sidgwick and Jackson, 1986; Neil Munro, *The Quick and the Dead: Electronic Combat and Modern Warfare*, New York, St Martin's Press, 1991.

36 Secretary of State for Defence, *Statement of the Defence Estimates*, Cm 3223, 1996, May, para. 171.

37 Anthony G. Oettinger, *Whence and Whither Intelligence, Command and Control? The Certainty of Uncertainty*, Cambridge, MA, Program on Information Resources Policy, Harvard University, 1990.

38 David S. Alberts, *The Unintended Consequences of Information Age Technologies*, Washington, DC, National Defense University Press, 1996.

39 Gener I. Rochlin, *Trapped in the Net: The Unanticipated Consequences of Computerization*, Princeton, NJ, Princeton University Press, 1997, pp. 188–209.

40 Alan D. Campen (ed.), *The First Information War: The Story of Communications, Computers, and Intelligence Systems in the Persian Gulf War*, Fairfax, VA, AFCEA International Press, 1992; cf. M. A. Rice and A. J. Sammes, *Command and Control: Support Systems in the Gulf War: An Account of the Command and Control Information Systems Support to the British Army Contribution to the Gulf War*, London, Brassey's, 1994.

41 There was an obvious need to manage the tension between arranging the transportation of this volume of sophisticated technology and personnel while retaining flexibility of response. See, for example, Rick Atkinson, *Crusade: The Untold Story of the Persian Gulf War*, Boston, Houghton Mifflin, 1993.

42 Danilo Zolo, *Cosmopolis: Prospects for World Government*, translated by David McKie, Cambridge, Polity, 1997, pp. 25–26.

43 From a vast literature see Ed Vulliamy, *Seasons in Hell: Understanding Bosnia's War*, London, Simon and Schuster, 1994; David Rieff, *Slaughterhouse: Bosnia and the Failure of the West*, London, Vintage, 1995; Mark Danner, 'The US and the Yugoslav Catastrophe', *New York Review of Books*, 1997, 20 November; 'America and the Bosnia Genocide', Ibid., 4 December; 'Clinton, the UN, and the Bosnian Disaster', Ibid., 18 December; 'Bosnia: The Turning Point', *Ibid.*, 1998, 5 February; 'Bosnia: Breaking the Machine', Ibid., 19 February.

44 Several commentators have wondered whether the victory would have been quite so easy against a more robust enemy than Iraq. See, for example, Mark D. Mandeles, Thomas C. Hone, Sanford S. Terry, *Managing 'Command and Control' in the Persian Gulf War*, Westport, CT, Praeger, 1996.

45 Ibid., p. 24.

46 Gary Stix, 'Fighting Future Wars', *Scientific American*, 1995, December, p. 74.

47 See Thomas A. Keaney and Eliot A. Cohen, *Revolution in Warfare? Air Power in the Persian Gulf*, Annapolis, MD, US Naval Institute, 1995; cf. Jay A. Stout, *Hornets over Kuwait*, Annapolis, MD, Naval Institute Press, 1997.

48 Command, Control, Communications and Intelligence.

49 Gene I. Rochlin, *Trapped in the Net: The Unanticipated Consequences of Computerization*, Princeton, NJ, Princeton University Press, 1997, p. 180.

50 Oliver Morton, 'Defence Technology: The Information Advantage', *Economist*, 1995, 10 June.

51 House of Commons Defence Committee, Second Report from the Defence Committee, Session 1981–1982, *Ministry of Defence Organisation and Procurement, vol. 1, Report and Minutes of Proceedings*, London, HMSO, 1982, 11 June, p. vi.

52 Secretary of State for Defence, *Statement of the Defence Estimates*, Cm 3223, 1996, May, para. 428.

53 Mary Kaldor, Margaret Sharp and William Walker, 'Industrial Competitiveness and Britain's Defence', *Lloyds Bank Review*, 1986, no. 162, October, p. 33.

54 Ibid., p. 35.

55 Mary Kaldor, *The Baroque Arsenal*, New York, Hill and Wang, 1981.

56 Mary Kaldor, Margaret Sharp and William Walker, 'Industrial Competitiveness and Britain's Defence', *Lloyds Bank Review*, 1986, no. 162, October, pp. 38–39.

57 Ibid., p. 39.

58 Council for Science and Society, *UK Military R&D: Report of a Working Party*, Oxford, Oxford University Press, 1986, p. 47.

59 Smiths Industries, Recruitment Advertisement, *Guardian*, 1986, 14 November.

60 Joseph Weizenbaum, 'The Computer in Your Future', *New York Review of Books*, 1983, 27 October, p. 61.

61 David Dickson, *The New Politics of Science*, New York, Pantheon, 1984, p. 111.

62 Admiral Bobby R. Inman, 'A Government Proposal', *Aviation Week and Space Technology*, 1982, 8 February.

63 Dirk Hanson, *The New Alchemists: Silicon Valley and the Microelectronics Revolution*, Boston, Little, Brown and Company, 1982, p. 283.

64 François Heisbourg, *The Future of War*, London, Phoenix, 1997, pp. 36–40.

65 Paul Bracken, op. cit.

66 Frank Barnaby, op. cit., p. 2.

67 Paul Bracken, op. cit., pp. 232–37; cf. Daniel Ford, *The Button: The Nuclear Trigger – Does it Work?*, London, Allen and Unwin, 1985, pp. 122–46.

68 From an extensive literature see B. Bruce-Briggs, *The Shield of Faith: A Chronicle of Strategic Defense from Zeppelins to Star Wars*, New York, Simon and Schuster, 1988; Sanford Lakoff and Herbert F. York, *A Shield in Space? Technology, Politics and the Strategic Defense Initiatives*, Berkeley, CA, University of California Press, 1989.

69 Joel Kovel, 'Theses on Technocracy', *Telos*, 1982/83, no. 54, Winter, p. 157.

70 Joel Kovel, *Against the State of Nuclear Terror*, London, Pan, 1983, pp. 76–77.

71 Jeffrey T. Richelson and Desmond Ball, *The Ties That Bind: Intelligence Co-operation between the UK/USA Countries*, London, Allen and Unwin, 1986.

72 David Burnham, *The Rise of the Computer State*, London, Weidenfeld and Nicolson, 1983, p. 121.

73 Simon Davies, *Big Brother: Britain's Web of Surveillance and the New Technological Order*, London, Pan, 1996, pp. 46–50; James Bamford, *The Puzzle Palace: America's National Security Agency and its Special Relationship with Britain's GCHQ*, London, Sidgwick and Jackson, 1983.

74 Bhupendra Jasani and Christopher Lee, *Countdown to Space War*, London, Taylor and Francis,1984, p. 4.

75 William E. Burrows, *Deep Black: Space Espionage and National Security*, New York, Random House, 1986, p. 22.

76 Cf. Phillip Knightley, *The Second Oldest Profession: The Spy as Bureaucrat, Patriot, Fantasist and Whore*, London, André Deutsch, 1986.

77 Paul Bracken, op. cit., p. 214.

78 See Paul Stares, *Space Weapons and US Strategy: Origins and Development*, London, Croom Helm, 1985; cf. Donald R. Baucom, *The Origins of SDI, 1944–1983*, Modern War Studies, Lawrence, KS, Kansas University Press, 1992.

79 Duncan Campbell and Steve Connor, *On the Record: Surveillance, Computers and Privacy*, London, Michael Joseph, 1986, p. 275.

80 See David Leigh, *The Frontiers of Secrecy: Closed Government in Britain*, London, Junction Books, 1980; Cathy Massiter, 'The Spymasters Who Broke Their Own Rules', *Guardian*, 1985, 1 March, p. 13.

81 David Leigh and David Connett, 'Critics Demand Purge of Secret Files', *Observer*, 1997, 31 August, p. 10.

82 Nick Davies and Ian Black, 'Subversion and the State', *Guardian*, 1984, 17 April, p. 19.

83 Gary T. Marx and Nancy Reichman, 'Routinizing the Discovery of Secrets', *American Behavioral Scientist*, 1984, vol. 27, no. 4, March, p. 442.

84 Ibid., p. 444.

85 Quoted in BSSRS Technology of Political Control Group, *Technocop: New Police Technologies*, London, Free Association Books, 1985, pp. 19–20.

86 Ibid., p. 59.

87 Ibid., pp. 104–5.

88 See also the efforts made to create a role for the intelligence agencies, after the Cold War, as economic advisors. Stanfield Turner, 'Intelligence for a New World Order', *Foreign Affairs*, 1991, vol. 70, no. 4, Fall, pp. 150–66; R. Hilsman, 'Does the CIA Still Have a Role?', *Foreign Affairs*, 1995, vol. 74, no. 5, pp. 104–16.

89 Tom Stonier, *The Wealth of Information: A Profile of the Post-Industrial Economy*, London, Thames Methuen, 1983, p. 189.

90 Ibid., p. 202.

91 Ibid., pp. 203–4.

92 Christopher Evans, *The Mighty Micro: The Impact of the Computer Revolution*, London, Gollancz, 1979, pp. 210–12.

93 Martin Libicki, *What is Information Warfare?*, ACIS Paper 3, Washington DC, National Defense University, 1995, August.

94 Ronald Reagan, 'Text of Reagan Address on Defense Policy', *Congressional Quarterly*, 1983, 26 March, pp. 631–33.

95 Nicholas Abercrombie, Stephen Hill and Bryan Turner, *Sovereign Individuals of Capitalism*, London, Allen and Unwin, 1986, pp. 151–52, 155.

96 Anthony Giddens, op. cit., p. 181.

97 Ibid., pp. 310, 295.

98 Ibid., p. 302.

99 Joel Kovel, op. cit., p. 9.

100 Ibid., pp. 9–10.

101 Magali Sarfatti Larson, 'Notes on Technocracy: Some Problems of Theory, Ideology and Power', *Berkeley Journal of Sociology*, 1972, no. 17, p. 24.

102 Lewis Mumford, 'Authoritarian and Democratic Technics', *Technology and Culture*, 1964, 5, pp. 5–6.

103 Ibid., p. 6.

8 EDUCATION AS KNOWLEDGE AND DISCIPLINE

1 Department for Education and Employment, *Working Together for the Future*, London, DfEE, 1997, September.

2 Phil Brown and Hugh Lauder, 'Post-Fordist Possibilities: Education, Training,

and National Development' in Leslie Bash and Andy Green (eds), *World Yearbook of Education 1995: Youth, Education and Work*, London, Kogan Page, 1995, Chapter 2.

3 See especially Part Three of Frank Webster and Kevin Robins, *Information Technology: A Luddite Analysis*, Norwood, NJ, Ablex, 1986.

4 Will Hutton, *The State We're In*, London, Vintage, 1996.

5 See, for example, Geoff Dench, *Tranforming Men: Changing Patterns of Dependence and Dominance in Gender Relations*, Brunswick, NJ, Transaction Publications, 1996.

6 Benjamin Coriat, *L'Atelier et le Chronomètre: Essai sur le Taylorisme, le Fordisme et la Production de Masse*, Paris, Christian Bourgois, 1979, Chapter 1.

7 John Holloway, 'The Red Rose of Nissan', *Capital and Class*, 1987, no. 32, Summer, p. 146.

8 Bob Jessop, Kevin Bonnett, Simon Bromley and Tom Ling, 'Popular Capitalism, Flexible Accumulation and Left Strategy', *New Left Review*, 1987, no. 165, September–October, pp. 113–15,

9 For a critique of this argument see Kevin Robins and Frank Webster, *The Technical Fix: Education, Computers and Industry*, London, Macmillan, 1989, Chapter 5.

10 Geoff Mungham, 'Workless Youth as a "Moral Panic" ' in Teresa Rees and Paul Atkinson (eds), *Youth Unemployment and State Intervention*, London, Routledge, 1982, p. 34.

11 Bernard Davies, *Threatening Youth: Towards a National Youth Policy*, Milton Keynes, Open University Press, 1986.

12 *Better Schools*, Cmnd 9469, London, HMSO, 1985, March, p. 57.

13 John Holloway, op. cit., p. 161.

14 Rubber and Plastics Processing Industry Training Board, *The Way Forward: A Practical Proposal for Introducing Changes in the School Curricula*, Fourth Report of the Study Group on the Education/Training of Young People, Brentford: Rubber and Plastics Processing Industry Training Board, 1982, pp. 9, 17, 29.

15 Ibid., p. 29.

16 Patrick Nuttgens in Tyrell Burgess (ed.), *Education for Capability*, London, NFER-Nelson, 1986, p. 32; cf. Royal Society for the Arts, *Education for Capability*, London, RSA, 1991.

17 Tyrell Burgess (ed.), *Education for Capability*, London, NFER-Nelson, 1986, p. 66.

18 See Frank Coffield, Carol Borrill and Sarah Marshall, *Growing Up at the Margins: Young Adults in the North East*, Milton Keynes, Open University Press, 1986.

19 FEU, *Supporting YTS*, Further Education Unit, 1985, p. 1, 26.

20 FEU, *Supporting TVEI*, Further Education Unit, 1985, p. 13, 21–22.

21 Andy Green, 'The MSC and the Three-Tier Structure of Further Education' in Caroline Benn and John Fairley (eds), *Challenging the MSC: On Jobs, Training and Education*, London, Pluto Press, 1986, p. 113.

22 Geoffrey Partington, 'The Disorientation of Western Education', *Encounter*, 1987, vol. 68, no. 1, January, p. 5.

23 Philip Cohen, 'Against the New Vocationalism' in Inge Bates *et al.*, *Schooling for the Dole? The New Vocationalism*, London, Macmillan, 1984, p. 105.

24 Rachel Sharp and Anthony Green, *Education and Social Control*, London, Routledge, 1975.

25 Andy Hargreaves, 'Progressivism and Pupil Autonomy', *Sociological Review*, 1977, vol. 25, no. 3, p. 614.

26 Basil Bernstein, *Class, Codes and Control, vol.3: Towards a Theory of Educational Transmissions*, London, Routledge, 1975.

27 Ibid., p. 90.
28 Ibid., p. 106.
29 Ibid., p. 101.
30 Jean-François Lyotard, *The Postmodern Condition: A Report on Knowledge*, translated by Geoff Bennington and Brian Massumi, Manchester, Manchester University Presss, (1979), 1984; cf. Michael Peters (ed.), *Education and the Postmodern Condition*, New York, Bergin and Garvey, 1995.
31 Basil Bernstein, op. cit., p. 110.
32 Ibid.
33 Ibid., p. 104.
34 Ibid., p. 106.
35 Ibid., p. 109.
36 Morris Janowitz, 'Sociological Theory and Social Control', *American Journal of Sociology*, 1975, vol. 81, no. 1, July, p. 84.
37 Stanley Cohen, 'The Punitive City: Notes on the Dispersal of Social Control', *Contemporary Crises*, 1979, vol. 3, no. 4, pp. 339–63.
38 Anthony Giddens, *The Nation State and Violence: Volume Two of a Contemporary Critique of Historical Materialism*, Cambridge, Polity, 1985, p. 2.
39 Edward Shils, 'Privacy and Power' in Edward Shils, *Center and Periphery: Essays in Macrosociology*, Chicago, University of Chicago Press, (1967), 1975, pp. 329, 341, 331, 333.
40 Michel Foucault, *Discipline and Punish: The Birth of the Prison*, Harmondsworth, Penguin, 1979, p. 27.
41 Ibid., pp. 170–71.
42 Ibid., pp. 201, 249.
43 Ibid., p. 205.
44 Ibid., p. 217.
45 John O'Neill, 'The Disciplinary Society: From Weber to Foucault', *British Journal of Sociology*, 1986, vol. 37, no. 1, March, p. 43.
46 Christopher Lasch, 'Life in the Therapeutic State', *New York Review of Books*, 1980, vol. 27, no. 10, 12 June, pp. 24–32.
47 Christopher Lasch, *The Minimal Self: Survival in Troubled Times*, London, Pan, 1985, pp. 47–48.
48 Ibid., p. 49.
49 Michel Foucault, *Discipline and Punish: The Birth of the Prison*, Harmondsworth, Penguin, 1979, p. 249.
50 Gary T. Marx, 'I'll Be Watching You: Reflections on the New Surveillance', *Dissent*, 1985, Winter, p. 26.
51 Richard Wolin, 'Modernism versus Postmodernism', *Telos*, 1984/85, no. 62, Winter, p. 27 (original emphasis).
52 Foucault, op. cit., p. 177.
53 Marike Finlay, *Powermatics: A Discursive Critique of New Communications Technologies*, London, Routledge, 1987, p. 177
54 Ibid., pp. 177–78.
55 Sherry Turkle, *The Second Self: Computers and the Human Spirit*, London, Granada, 1984, p. 3.
56 Ulric Neisser, 'Computers as Tools and as Metaphors' in Charles Dechert (ed.), *The Social Impact of Cybernetics*, Notre Dame, University of Notre Dame Press, 1966, pp. 74–75.
57 Theodore Roszak, *The Cult of Information: The Folklore of Computers and the True Art of Thinking*, Cambridge, Lutterworth Press, 1986, p. 44.
58 Ibid., p. 217; cf. Neil Postman, *Technopoly: The Surrender of Culture to Technology*, New York, Vintage, 1992.

59 Hubert and Stuart Dreyfus, *Mind over Machine: The Power of Human Intuition and Expertise in the Era of the Computer*, Oxford, Blackwell, 1986.
60 John MacMurray, *Reason and Emotion*, London, Faber and Faber, 1935.
61 Christopher Lasch, 'Chip of Fools', *New Republic*, 1984, 13 and 20 August, p. 27.
62 Ian Stronach, 'Work Experience: The Sacred Anvil' in Carol Varlaam (ed.), *Rethinking Transition: Educational Innovation and the Transition to Adult Life*, Lewes, Falmer Press, 1984, pp. 59–60.
63 Paul Atkinson, Hilary Dickinson and Michael Erben, 'The Classification and Control of Vocational Training for Young People' in Stephen Walker and Len Barton (eds), *Youth, Unemployment and Schooling*, Milton Keynes, Open University Press, 1986, p. 163.
64 DES/Welsh Office, *Records of Achievement: A Statement of Policy*, London, Department of Education and Science/Welsh Office, 1984, p. 4.
65 Patricia Broadfoot, 'Records of Achievement: Achieving a Record?' in Patricia Broadfoot (ed.), *Profiles and Records of Achievement: A Review of Issues and Practice*, London, Holt, Rinehart and Winston, 1986, pp. 5–6.
66 Tyrell Burgess and Elizabeth Adams, 'Records for All at 16' in Patricia Broadfoot (ed.), *Profiles and Records of Achievement: A Review of Issues and Practice*, London, Holt, Rinehart and Winston, 1986, p. 78.
67 Janet Balogh, *Profile Reports for School Leavers*, York, Longmans for Schools Council, 1982, p. 40.
68 F. Allen Hanson, *Testing Testing: Social Consequences of the Examined Life*, Berkeley, University of California Press, 1993.
69 Andy Hargreaves, 'Record Breakers?' in Patricia Broadfoot (ed.), *Profiles and Records of Achievement: A Review of Issues and Practice*, London, Holt, Rinehart and Winston, 1986, pp. 217–18.
70 See, for example, Beryl Pratley, *Signposts '85: A Review of 16–19 Education*, Further Education Unit, 1985; National Curriculum Council, *Core Skills 16–19: A Response to the Secretary of State*, NCC, 1990.
71 See Alison Wolf, *Competence-Based Assessment*, Milton Keynes, Open University Press, 1995.
72 Barrie Hopson and Mike Scally, *Lifeskills Teaching*, London, McGraw-Hill, 1981, p. 9.
73 John Blythe, Diane Brace and Tony Henry, *Teaching Social and Life Skills*, Cambridge, National Extension College/Association for Liberal Education, 1979.
74 Department for Education and Employment, *Working Together for the Future*, London, DfEE, 1997, September.
75 K. D. Duncan and C. J. Kelly, *Task Analysis, Learning and the Nature of Transfer*, Sheffield, Manpower Services Commission, 1983, p. 6.
76 Edward Shils, op. cit., p. 330.
77 Sylvia Downs, 'Who Learns Whom?', *Training and Development*, 1982, June, p. 9.
78 Sylvia Downs and Patricia Perry, 'Developing Learning Skills', *Journal of European Industrial Training*, 1984, vol. 8, no. 1, p. 26.
79 Sylvia Downs and Patricia Perry, 'Can Trainers Learn to Take a Back Seat?', *Personnel Management*, 1986, March, pp. 42–43.
80 Alison Wolf, *Competence-Based Assessment*, Milton Keynes, Open University Press, 1995, p. 8.
81 Christopher Hayes *et al.*, *Occupational Training Families*, Brighton, Institute of Manpower Studies, 1981.
82 Christopher Hayes and Nickie Fonda, 'The Privatisation of Skills', *Personnel Management*, 1982, October.

83 FEU, *Basic Skills*, Further Education Unit, 1982.
84 See Malcolm Skilbeck, Helen Connell, Nicholas Lowe and Kirsten Tait, *The Vocational Quest: New Directions in Education and Training*, London, Routledge, 1994.
85 Gilbert Jessop, *Outcomes: NVQs and the Emerging Model of Education and Training*, Lewes, Falmer, 1991; cf. Alan Smithers, 'All Our Futures: Britain's Education Revolution', *Dispatches Report on Education*, London, Channel 4, 1993.
86 National Curriculum Council, *Core Skills 16–19: A Response to the Secretary of State*, London, NCC, 1990.
87 DfEE, *Learning to Compete: Education and Training for 14 to 19 year olds*, Cmnd 3486, DfEE, 1996, December.
88 DfEE, *Minister Acts to Strengthen Vocational Qualifications*, DfEE, 1997, 5 August.
89 MSC, *Core Skills in YTS, Part 1*, Sheffield: Manpower Services Commission, 1984, pp. 6–7.
90 FEU, *Towards a Competence Based System*, Further Education Unit, 1984, p. 3.
91 Ibid., p. 5.
92 Stronach, op. cit.
93 Leslie Smith, *Ability Learning*, Further Education Unit, 1984, p. vi.
94 Ibid., p. 87; see also Deanna Kuhn, 'Education for Thinking', *Teachers College Record*, 1986, vol. 87, no. 4, Summer, pp. 495–512.
95 See Brieda and Tom Vincent, *Information Technology and Further Education*, London, Kogan Page, 1985.
96 For an extended critique of 'computer literacy' see Kevin Robins and Frank Webster, 'Dangers of Information Technology and Responsibilities of Education' in Ruth Finnigan, Graeme Salaman and Kenneth Thompson (eds), *Information Technology: Social Issues*, London, Hodder and Stoughton, 1987, Chapter 10, pp. 145–62; Kevin Robins and Frank Webster, 'Computer Literacy: The Employment Myths', *Social Science Computer Review*, 1989, vol. 7, no. 1, Spring, pp. 7–26.
97 Baroness Blackstone, Education and Employment Minister, *Information and Communication Technologies will be the Fourth 'R'*, London, DfEE, 1997, 29 July.
98 Cf. Neil Postman, *The End of Education*, New York, Vintage, 1995, Chapter 3.
99 For sceptical responses to this hype see Douglas Noble, 'The Underside of Computer Literacy', *Raritan Review*, 1984, vol. 3, Spring, pp. 37–64; Clifford Stoll, *Silicon Snake Oil: Second Thoughts on the Information Highway*, New York, Doubleday, 1995; Todd Oppenheimer, 'The Computer Delusion', *Atlantic Monthly*, 1997, vol. 280, no. 1, July, pp. 45–62.
100 *Guardian*, 1997, 18 October, p. 2.
101 Tom Stonier and Cathy Conlin, *The Three Cs: Children, Computers and Communication*, Chichester, Wiley, 1985, p. 194.
102 Tim O'Shae and John Self, *Learning and Teaching with Computers: Artificial Intelligence in Education*, Brighton, Harvester, 1983, pp. 246, 5.
103 Ibid., p. 268.
104 Marvin Minsky, 'Applying Artifical Intelligence to Education' in Robert J. Siedel and Martin L. Rubin (eds), *Computers and Communications: Implications for Education*, New York, Academic Press, 1977, p. 245.
105 William Paisley, 'Children, New Media, and Microcomputers: Continuities of Research' in Milton Chen and William Paisley (eds), *Children and Microcomputers: Research on the Newest Medium*, Beverly Hills, Sage, 1985, p. 23.
106 Kenneth Ruthven, 'Computer Literacy and the Curriculum', *British Journal of Educational Studies*, 1984, vol. 32, no. 2, June, p. 144,
107 Thomas Dwyer, 'Heuristic Strategies for Using Computers to Enrich

Education' in Robert Taylor (ed.), *The Computer in the School: Tutor, Tool, Tutee*, New York, Teachers College Press, 1980, p. 88.

108 Seymour Papert, *Mindstorms: Children, Computers and Powerful Ideas*, Brighton, Harvester, 1980.

109 Seymour Papert, 'Computers and Learning' in Michael L. Dertouzos and Joel Moses (eds), *The Computer Age: A Twenty-Year View*, Cambridge, MA, MIT Press, 1979.

110 Seymour Papert, *Mindstorms: Children, Computers and Powerful Ideas*, Brighton, Harvester, 1980.

111 Ibid., pp. 119, 5.

112 Ibid., p. 19.

113 Ibid., p. 157.

114 Ibid., p. 76.

115 Ibid., p. 81.

116 Ibid., p. 83.

117 Ibid., pp. 86, 85.

118 See Hubert and Stuart Dreyfus, *Mind over Machine: The Power of Human Intuition and Expertise in the Era of the Computer*, Oxford, Blackwell, 1986; John Davy, 'Mindstorms in the Lamplight', *Teachers College Record*, 1984, vol. 85, no. 4, Summer, pp. 549–58.

119 Valerie Walkerdine, 'Developmental Psychology and the Child-Centred Pedagogy: the Insertion of Piaget into Early Education' in Julian Henriques, Wendy Holloway, Cathy Urwin, Couze Venn and Valerie Walkerdine (eds), *Changing the Subject: Psychology, Social Regulation and Subjectivity*, London, Methuen, 1984, p. 164.

120 Ibid., p. 176.

121 Hubert L.Dryfus, 'Holism and Hermeunetics', *Review of Metaphysics*, 1980, no. 34, September, pp. 3–23.

122 Cf. John R. Searle, *Minds, Brains and Science: The 1984 Reith Lectures*, Harmondsworth, Penguin, 1984.

123 Douglas Noble, 'Education and Technology: Some Unexplained Questions', mimeo, 1986, p. 20.

124 John M. Broughton, 'Piaget's Structural Development Psychology: Function and the Problem of Knowledge', *Human Development*, 1981, no. 24, pp. 269–70.

125 John M. Broughton, 'The Surrender of Control: Computer Literacy as Political Socialization of the Child' in Douglas Sloan (ed.), *The Computer in Education: A Critical Perspective*, New York, Teachers College Press, 1985, p. 105.

126 Seymour Papert, *Mindstorms: Children, Computers and Powerful Ideas*, Brighton, Harvester, 1980, p. 155.

9 DECONSTRUCTING THE ACADEMY: THE NEW PRODUCTION OF HUMAN CAPITAL

1 Committee on Higher Education, *Higher Education*, Cmnd 2154 (Robbins Report), London, HMSO, 1963.

2 National Committee of Inquiry into Higher Education, *Higher Education in the Learning Society* (Dearing Report), London, HMSO, July, 1997, paras 12–15. The Dearing Report is also available electronically on http://www.leeds.ac.uk/educol/ncihe/nav.htm.

3 Martin Trow, 'Reflections on the Transition from Elite to Mass Higher Education', *Daedalus*, 1970, vol. 90, no. 1, pp. 1–42.

4 For a useful review of the issues see David Jary and Martin Parker (eds), *The*

New Higher Education: Issues and Directions for the post-Dearing University, Stoke, Staffordshire University Press, 2 volumes, 1998.

5 Peter Scott, *The Meanings of Mass Higher Education*, Milton Keynes, Society for Research into Higher Education/Open University Press, 1995, p. 11. On the persistence of the image of the most august universities being ancient see Ian Carter, *Ancient Cultures of Conceit: British University Fiction of the Post-War Years*, London, Routledge, 1990.

6 See Michael Sanderson, *The Universities and British Industry, 1850–1970*, London, Routledge, 1983.

7 Edward Thompson's edited polemic, *Warwick University Ltd: Industry, Management and the Universities*, Harmondsworth, Penguin, 1970, makes for instructive reading today. The description of industrialists' influence on the then very new university of Warwick seems minor compared to today (for example, Warwick's Council had some 30 per cent of its members from business backgrounds, a rather small proportion by the standards of a university today).

8 Ironically, this attempt at 'manpower planning' was undermined by the 1980s governments' enthusiasm for marketisation which, though it was accompanied by a reduction in university funding directly from the Exchequer, encouraged institutions to expand wherever there might be a reasonable (or even, in many cases, only a marginal) rate of return. This stimulated the expansion of popular – if inappropriate in the eyes of government – areas such as Media, Women's and Cultural Studies, as well as Sociology, History and such like. Increased government commitment to the principle that students ought to pay for themselves at university through taking out loans, and accordingly be free to choose how they invest what will increasingly be their own funds, will certainly have consequences for the take-up of particular subjects, but precisely in what directions this will go is unclear.

9 J. Heywood, *Enterprise Learning and its Assessment in Higher Education*, Sheffield, Employment Department, 1994; cf. S. Jones, 'Managing Curriculum Development: A Case Study of Enterprise in Higher Education' in John Brennan, Maurice Kogan and U. Teicher (eds), *Higher Education and Work*, London, Jessica Kingsley, 1995.

10 Martin Binks and Kate Exley, 'Gaining that Extra Degree of Ability', *Guardian*, 1994, 21 February, p. 12.

11 National Committee of Inquiry into Higher Education, *Higher Education in the Learning Society* (Dearing Report), London, HMSO, 1997, July, para. 38, recommendation 21.

12 Michael Power, *The Audit Society: Rituals of Verification*, Oxford, Oxford University Press, 1997.

13 See Mary Henkel, 'Academic Values and the University as Corporate Enterprise', *Higher Education Quarterly*, 1997, vol. 51, no. 2, April, pp. 134–43.

14 The creation of departments as 'cost centres' is one example; another is the habit of regarding students as 'customers'; a third was the ending of tenure in 1988, thereby abolishing the 'job for life'.

15 Peter Scott, *The Meanings of Mass Higher Education*, Milton Keynes, Society for Research into Higher Education/Open University Press, 1995, p. 83, passim.

16 'Higher Education Earnings, 1995–96', *Times Higher Education Supplement*, 1997, 7 November (figures taken from Higher Education Statistics Agency).

17 See Simon Jenkins, *Accountable to None: The Tory Nationalisation of Britain*, London, Hamish Hamilton, 1995. This is not to ignore the continued role of academics in acting as guardians of standards. Significantly the Research Assessment Exercises and the Teaching Quality Exercises have relied heavily on

the participation of the academic peer group. See Janet Finch, 'Power, Legitimacy and Academic Standards' in John Brennan, Peter de Vries and Ruth Williams (eds), *Standards and Quality in Higher Education*, London, Jessica Kingsley, 1997, Chapter 10, pp. 146–69.

18 Department of Education and Science, *Higher Education: Meeting the Challenge*, Cmnd 114, London, HMSO, 1987.

19 One comment from many comes from Sir Christopher Ball: 'The abilities most valued in industrial, commercial and professional life as well as in public and social administration are the transferable intellectual and personal skills. These include the ability to analyse complex issues, to identify the core of a problem and the means of solving it, to synthesize and integrate disparate elements, to clarify values, to make effective use of numerical and other information, to work co-operatively and constructively with others, and, above all perhaps, to communicate clearly both orally and in writing'.

Sir Christopher Ball, Foreword to *Transferable Personal Skills in Employment: the Contribution of Higher Education*, London, National Advisory Board for Public Sector Higher Education, 1986, May.

20 Cf. Lee Harvey, Sue Moon and Vicki Geall, with Ray Bower, *Graduates' Work: Organisational Change and Students' Attributes*, Birmingham, Centre for Research into Quality, University of Central England, 1997. Extracted in *Times Higher Education Supplement* Survey, 'Degrees to Work', 1997, 2 February, pp. i–iv.

21 Cf. Ernest L. Boyer, *College: The Undergraduate Experience in America, The Carnegie Foundation for the Advancement of Teaching*, New York, Harper and Row, 1987.

22 See Michael Eraut, *Developing Professional Knowledge and Competence*, Brighton, Falmer Press, 1994; Richard Winter and Maire Maisch, *Professional Competence and Higher Education: The Asset Programme*, Brighton, Falmer Press, 1996.

23 See Donald A. Schön, *The Reflective Practitioner*, New York, Basic Books, 1983; and his *Educating the Reflective Practitioner: Toward a New Design for Teaching and Learning in the Professions*, San Francisco, CA, Jossey-Bass, 1987.

24 We take this term from Ronald Barnett, whose work is a systematic rebuttal of, and alternative to, much of what is taking place in the university today. See his, *The Limits of Competence: Knowledge, Higher Education and Society*, Milton Keynes, Society for Research into Higher Education/Open University Press, 1994; *Higher Education: A Critical Business*, Milton Keynes, Society for Research into Higher Education/Open University Press, 1997.

25 See Alan Jenkins (ed.), *Course Based Profiling: Case Studies from Oxford Brookes University*, Oxford, Oxford Brookes University, 1996.

26 National Committee of Inquiry into Higher Education, *Higher Education in the Learning Society*, (Dearing Report), London, HMSO, 1997, July, para. 40.

27 See Phillip Brown and Hugh Lauder, 'Post-Fordist Possibilities: Education, Training and National Development' in Leslie Bash and Andy Green (eds), *World Yearbook of Education 1995: Youth, Education and Work*, London, Kogan Page, 1995, Chapter 2, pp. 19–51.

28 John Carter, 'Post-Fordism and the Theorisation of Educational Change: What's in a Name?', *British Journal of Sociology of Education*, 1997, vol. 18, no. 1, pp. 45–61.

29 Cf. William Greider, *One World, Ready or Not: The Manic Logic of Global Capitalism*, New York, Simon and Schuster, 1997.

30 The degree of globalisation is of course disputed, as is the helplessness of the nation state, especially in academic circles. The *Economist*, while itself dissenting, notes that 'the main points of this story are almost universally accepted: most tellingly, perhaps, by the world's political leaders. Left and Right, eagerly or reluctantly, bow down before global capitalism'. *Economist*, 'The World

Economy', 1997, 20 September. See also the compelling analysis by billionaire financier George Soros, 'The Capitalist Threat', *Atlantic Monthly*, 1997, vol. 279, no. 2, February, pp. 45–88.

31 Department for Education and Employment, *University for Industry*, London, DfEE, 1997.

32 Tony Blair, 'Britain Can Remake It', *Guardian*, 1997, 22 July.

33 *Economist*, 1997, 4 October.

34 See Chapter 3 above.

35 Robert B. Reich, *The Work of Nations: Preparing Ourselves for 21st Century Capitalism*, New York, Vintage, 1992, pp. 85, 178.

36 Tony Blair, Speech at Labour Party Conference, Brighton, 1995.

37 This trilogy was pronounced during the 1997 election campaign and reiterated on Mr Blair's visit to Russia as Prime Minister the same year. He repeated this view at the Confederation of British Industry conference in November 1997 when he said 'the absolute number one priority for domestic policy is education and skills. We will win by brains or not at all'. *Guardian*, 1997, 12 November, p. 23.

38 Department for Education and Employment, *Higher Education and Employment Development Programme Prospectus*, London, DfEE, June, 1997.

39 National Committee of Inquiry into Higher Education, *Higher Education in the Learning Society*, (Dearing Report), London, HMSO, 1997, July, para. 24.

40 His magnum opus, *The Information Age: Economy, Society and Culture* is published by Blackwell (Oxford) in three parts: Volume 1, *The Rise of the Network Society*, 1996; Volume 2, *The Power of Identity*, 1997; Volume 3, *End of Millennium*, 1998.

41 Manuel Castells, *End of Millennium*, Oxford, Blackwell, 1998, Chapter 6.

42 National Committee of Inquiry into Higher Education, *Higher Education in the Learning Society*, (Dearing Report), London, HMSO, 1997, July, para. 27.

43 Compare Michael Hammer and James Champy, *Re-Engineering the Corporation: A Manifesto for Business Revolution*, London, Brealey Publishing, 1993; and Simon Head, 'The New, Ruthless Economy', *New York Review of Books*, 1996, 29 February, pp. 47–52.

44 Manuel Castells, *The Rise of the Network Society*, Oxford, Blackwell, 1996, Chapter 2.

45 The concept is Reich's. See Robert B. Reich, *The Work of Nations: Preparing Ourselves for 21st Century Capitalism*, New York, Vintage, 1992.

46 Manuel Castells, *The Rise of the Network Society*, Oxford, Blackwell, 1996, pp. 195–99.

47 Francis Fukuyama, *The End of Order*, London, Social Market Foundation, 1997.

48 See Charles Handy, *The Age of Unreason*, London, Hutchinson, 1989; and *The Empty Raincoat: Making Sense of the Future*, London, Hutchinson, 1994.

49 Will Hutton, *The State We're In*, London, Vintage, 1996.

50 See Shirley Dex and Andrew McCulloch, *Flexible Employment: the Future of Britain's Jobs*, London, Macmillan, 1997.

51 See Association of Graduate Recruiters, *Skills for Graduates in the 21st Century*, Cambridge, AGR, 1995.

52 Compare Ernest Boyer's remark: 'The classroom should be a place where students are helped to put their own lives in perspective, to sort out the bad from the good, the shoddy from that which is elegant and enduring. For this we need great teachers, not computers'. Ernest L. Boyer, *College: The Under-graduate Experience in America, The Carnegie Foundation for the Advancement of Teaching*, New York, Harper and Row, 1987, p. 173.

53 Norman Bonney, 'The Careers of University Graduates: The Classes of 1960

and 1985', paper presented to the conference on 'Dilemmas of Mass Higher Education', Staffordshire University, 1996, 10–12 April.

54 Phillip Brown and Richard Scase, *Higher Education and Corporate Realities: Class, Culture and the Decline of Graduate Careers*, London, UCL Press, 1994, p. 45.

55 Ibid.

56 Ibid., p. 43.

57 Richard Donkin, 'Milk Round Still Good for Creaming Talent', *Financial Times*, 1995, 11 January, p. 11; and 'Targeting the Top Graduate Talent', *Financial Times*, 1995, 25 October, p. 36.

58 Phillip Brown and Richard Scase, 'Universities and Employers: Rhetoric and Reality' in Anthony Smith and Frank Webster (eds), *The Postmodern University?*, Milton Keynes, Open University Press, 1997, Chapter 8, pp. 85–98.

59 Kate Purcell and Jane Pitcher, *Great Expectations: The New Diversity of Graduate Skills and Aspirations*, Manchester, Careers Services Unit, 1996.

60 Phillip Brown and Richard Scase, *Higher Education and Corporate Realities: Class, Culture and the Decline of Graduate Careers*, London, UCL Press, 1994, p. 147. The confidence of these graduates is, of course, readily explained in the light of their strong market position.

61 Ewart Keep and Ken Mayhew, 'Economic Demand for Higher Education – A Sound Foundation for Further Expansion?', *Higher Education Quarterly*, 1996, vol. 50, no. 2, April, pp. 89–109.

62 'The Consequences of Mass Higher Education', *Incomes Data Reports*, 1996, 15 May; Neil Harris, 'Pity the Poor Graduate', *New Scientist*, 1993, 11 December; *Economist*, 1996, 6 April, p. 23. Cf. Ronald Dore, *The Diploma Disease*, London, Allen and Unwin, 1976; I. Berg, *Education and Jobs: The Great Training Robbery*, New York, Praeger, 1970.

63 Geoff Mason, 'Graduate Utilisation in British Industry: The Initial Impact of Mass Higher Education', *National Institute Economic Review*, 1996, May, pp. 93–103.

64 *Daily Telegraph*, 1997, 13 August, p. 21.

65 Higher Education Quality Council, *Academic Standards in the Approval, Review and Classification of Degrees*, London, HEQC, 1996.

66 C. Callender and E. Kempson, *Student Finances: A Survey of Student Income and Expenditure*, London, Policy Studies Institute, 1996.

67 B. MacFarlane, 'The "Thatcherite" Generation and University Degree Results', *Journal of Higher Education*, 1992, vol. 16, no. 2, pp. 60–70.

68 As might be expected, this argument comes readily from the politically conservative, but it also comes from the left. On this see the coruscating attacks in *Living Marxism* on declining standards in universities, which are deplored on grounds that they cheapen the credentials for which working-class students ought to have equal rights to compete. The gravamen of this argument is that élitism in education is fine, so long as there is equal opportunity in terms of access, a position evocative of the CP's instruction to its university members in the 1930s: 'Every Communist A First'. See Brendan O'Neill, 'Second Class Students', and Claire Fox, 'The Dumbing Down of Higher Education', *Living Marxism*, 1997, October. See also Claire Fox, 'Degrading Education: What Happens When Nobody Fails?', *Living Marxism*, 1996, November.

69 For empirical evidence that course work is a major factor in improving results, see Lisa Lucas and Frank Webster, 'Maintaining Standards in Higher Education: A Case Study' in David Jary and Martin Parker (eds), *The New Higher Education: Issues and Directions for the post-Dearing University*, Stoke, Staffordshire University Press, 1998, pp. 105–13.

70 Higher Education Quality Council, *Inter-Institutional Variability of Degree Results: An Analysis in Selected Areas*, London, HEQC, 1996.

71 Malcolm Bee and P. J. Dolton, 'Degree Class and Pass Rates: An Inter-University Comparison', *Higher Education Review*, 1985, Spring, pp. 45–52; Jill Johnes and Jim Taylor, 'Degree Quality – An Investigation into Differences between UK Universities', *Higher Education*, 1987, vol. 16, no. 5, pp. 581–602.

72 The Teaching Quality Assessment exercise, though a national scheme, manifestly avoided ruling on the pressing issue of comparability of standards by instructing assessors to evaluate degree programmes in terms of each institution's own aims and objectives rather than any national standards.

73 It has to be admitted that this model is also held by many academics. See the survey evidence in A. H. Halsey, *Decline of Donnish Dominion: The British Academic Profession in the Twentieth Century*, Oxford, Clarendon Press, 1992, Table 8.4.

74 For example, Oxford students' average A-level score in 1997 was 29 points (i.e. better than 2 grade As and one B), *Oxford Gazette*, Supplement (1) to no. 4452, 1997, 5 November.

75 Andrew Adonis, 'Class Apartheid', *Times Higher Education Supplement*, 1997, 10 October, p. 20; cf. Andrew Adonis and Stephen Pollard, *A Class Act: The Myth of Britain's Classless Society*, London, Hamish Hamilton, 1997.

76 Melanie Phillips, 'Does Tony Know What David Is Doing?', *New Statesman*, 1997, 24 October, p. 20; cf. George Walden, *We Should Know Better: Solving the Education Crisis*, London, Fourth Estate, 1996.

77 Simon Kuper and Parminder Bahra, 'State Grammar Schools Make a Breakthrough', *Weekend Financial Times*, 1996, 26–27 October.

78 One may note too how some of the most élite institutions would have themselves dedicated to this 'mission of…the education and training of a global intellectual élite', with the 'major role in exporting ideas, and training members of that global élite to whom we all increasingly look for the management of the global economy'. John Ashworth (then Director of the LSE) in *New Statesman*, 1996, 31 May, p. 16.

79 Cf. Pierre Bourdieu, *The State Nobility: Elite Schools in the Field of Power*, translated by Lauretta Clough, Cambridge, Polity, 1996.

80 Phillip Brown, 'Cultural Capital and Social Exclusion: Some Observations on Recent Trends in Education, Employment and the Labour Market', *Work, Employment and Society*, 1995, vol. 9, no. 1, March, pp. 29–51.

81 From a broad literature see, for the United States, Alan Bloom, *The Closing of the American Mind: How Higher Education Has Failed Democracy and Impoverished the Souls of Today's Students*, New York, Simon and Schuster, 1987; E. D. Hirsch, *Cultural Literacy: What Every American Should Know*, Boston, Houghton Mifflin, 1987; cf. Martha C. Nussbaum, *Cultivating Humanity: A Classical Defense of Reform in Liberal Education*, Cambridge, MA, Harvard University Press, 1997; and for Britain, see Nevil Johnson, 'Dons in Decline: Who Will Look after the Cultural Capital?', *20th Century British History*, 1994, vol. 5, no. 3, pp. 370–85; A. H. Halsey, *Decline of Donnish Dominion: The British Academic Profession in the Twentieth Century*, Oxford, Clarendon Press, 1992; Melanie Phillips, *All Must Have Prizes*, London, Little, Brown and Company, 1996.

82 George Ritzer, 'McUniversity in the Postmodern Consumer Society' in *The McDonaldization Thesis: Explorations and Extensions*, London, Sage, 1998, Chapter 11.

83 See J. H. Newman, *The Idea of a University, Defined and Illustrated*, Daniel M.O'Connell (ed.), Chicago, Loyola University Press, (1853), 1987; F. R. Leavis, *Education and the University*, London, Chatto and Windus, 1943; *English*

Literature in Our Time and the University: The Clark Lectures 1967, London, Chatto and Windus, 1969; Michael Oakshott, *The Voice of Liberal Learning: Michael Oakshott on Education*, Timothy Fuller (ed.), New Haven, CT, Yale University Press, 1989.

84 Peter Scott, *The Meanings of Mass Higher Education*, Milton Keynes, Society for Research into Higher Education/Open University Press, 1995. While Scott's book is an intellectual *tour de force*, it is caught in an agonising cleft stick of its own making. It denies that mass higher education can be reduced to a 'totalizing idea' because it is characterised by 'difference', yet proceeds to do precisely this by situating the university system alongside post-Fordism and postmodernism. Herein lies the puzzle of a work which repeatedly claims that higher education is now such 'an ambiguous, diverse and volatile phenomenon' that it defies being 'summed up in a single totalizing idea' (p. 165) – and then proceeds to provide one with the suggestion of a homology between post-Fordism and postmodernism and the contemporary university.

85 Zygmunt Bauman, 'Universities: Old, New and Different' in Anthony Smith and Frank Webster (eds), *The Postmodern University? Contested Visions of Higher Education in Society*, Milton Keynes, Society for Research into Higher Education/Open University Press, 1997, Chapter 2, pp. 17–26.

86 Bill Readings, *The University in Ruins*, Cambridge, MA, Harvard University Press, 1996.

87 Zygmunt Bauman, *Legislators and Interpreters: On Modernity, Postmodernity, and the Intellectual*, Cambridge, Polity, 1987.

88 Jean-François Lyotard, *The Postmodern Condition: A Report on Knowledge*, translated by Geoff Bennington and Brian Massumi, Manchester, Manchester University Press, 1984.

89 Cf. Management theorist Peter F. Drucker's agreement, where he asserts that 'there is no higher or lower knowledge....In the knowledge society knowledges are tools, and as such are dependent for their importance and position on the task to be performed'. Peter F. Drucker, 'The Age of Social Transformation', *Atlantic Monthly*, 1994, vol. 274, no. 5, November, pp. 53–80.

90 Michael Gibbons and colleagues distinguish knowledges as follows : 'in Mode 1 problems are set and solved in a context governed by the, largely academic, interests of a specific community. By contrast, Mode 2 knowledge is carried out in a context of application. Mode 1 is disciplinary while Mode 2 is transdisciplinary. Mode 1 is characterised by homogeneity, Mode 2 by heterogeneity. Organisationally, Mode 1 is hierarchical and tends to preserve its form, while Mode 2 is more heterarchical and transient. Each employs a different type of quality control. In comparison with Mode 1, Mode 2 is more socially accountable and reflexive'. Michael Gibbons, Camille Limoges, Helga Nowotny, Simon Schwartzman, Peter Scott and Martin Trow, *The New Production of Knowledge: The Dynamics of Science and Research in Contemporary Societies*, London, Sage, 1994, p. 3.

91 'Survey: Universities', *Economist*, 1997, 4 October.

92 Ibid.

93 Alexander W. Astin, *What Matters in College: Four Critical Years Revisited*, San Fransisco, CA, Jossey-Bass, 1993; cf. C. J. Sykes, *Profscam: Professors and the Demise of Higher Education*, Washington, DC, Regnery Gateway, 1988.

94 *Independent* (Education Section), 1997, 24 April, p. 2.

95 Nevil Johnson, 'Dons in Decline: Who Will Look after the Cultural Capital?', *20th Century British History*, 1994, vol. 5, no. 3, p. 380.

96 *Economist*, 1997, 4 October.

97 Sir Douglas Hague, *Beyond Universities: A New Republic of the Intellect*, London,

Institute of Economic Affairs, 1991; cf. Peter Brimelow, 'Are Universities Necessary?', *Forbes*, 1993, vol. 151, no. 9, 26 April, pp. 170–72.

98 Thus Michael Prowse, 'In due course, just-in-time electronic education, delivered to your living room by commercial companies, will undermine the most hallowed names in higher education'. *Financial Times*, 1995, 20 November; cf. Michael Gell and Peter Cochrane, 'Learning and Education in an Information Society' in William Dutton (ed.), *Information and Communication Technologies: Visions and Realities*, Oxford, Oxford University Press, 1996, Chapter 14, pp. 249–63; Eli M. Noam, 'Electronics and the Dim Future of the University', *Science*, 1995, vol. 270, 13 October, pp. 247–49.

99 *Wired*, 1995, April, p. 7; Plant develops her cybermania, with a free association jumble that 'non-linearly' leaps from Ada Lovelace, weaving, to the Internet, in her book, *Zeros and Ones: Digital Women and the New Technoculture*, London, Fourth Estate, 1997.

100 Peter Scott, *The Meanings of Mass Higher Education*, Milton Keynes, Society for Research into Higher Education/Open University Press, 1995, p. 70.

101 See Gerard Delanty, 'The Idea of the University in the Global Era: From Knowledge as an End to the End of Knowledge?', *Social Epistemology*, 1998, vol. 12, no. 1, pp. 3–25.

102 In this regard one might note, and take warning from, a recent conference devoted to examining 'pioneering company degrees' at which New Labour's Education Minister responsible for 'Lifelong Learning', Dr Kim Howells, expressed enthusiasm for their development (there are estimated to be over 1,000 'corporate universities' in the USA today). However, Sir John Egan, chief executive of British Airports Authority, warned of their lack of credibility and portability. Phil Baty, 'Howells Defends Corporate Degrees', *Times Higher Education Supplement*, 1997, 14 November, p. 4.

103 On this see the subtle analysis of former Harvard head, Derek Bok, *Beyond the Ivory Tower: Social Responsibilities of the Modern University*, Cambridge, MA, Harvard University Press, 1982.

10 PROSPECTS OF A VIRTUAL CULTURE

1 Pierre Lévy, *Cyberculture*, Paris, Editions Odile Jacob, 1997.

2 Michel Serres, *Les messages à distance*, Montreal/Quebec, Éditions Fides/Musée de la Civilisation, pp. 12, 17.

3 Armand Mattelart, 'Les nouveaux scénarios de la communication mondiale', *Le Monde Diplomatique*, 1995, August, pp. 24–25.

4 Walter B. Wriston, 'Bits, Bytes, and Diplomacy', *Foreign Affairs*, vol. 76, no. 5, pp. 176–77.

5 Zygmunt Bauman, *Europe of Strangers*, Oxford, ESRC Transnational Communities Programme, Working Paper no. 3, 1998, p. 10.

6 Bill Readings, *The University in Ruins*, Cambridge, MA, Harvard University Press, pp. 17, 39.

7 Wriston, op. cit., p. 175.

8 Daryush Shayegan, 'Le choc des civilisations', *Esprit*, 1996, April, p. 49.

9 Armand Mattelart, *L'invention de la communication*, Paris, La Découverte, 1994.

10 Armand Mattelart, *Mapping World Communication: War, Progress, Culture*, Minneapolis, MA, University of Minnesota Press, 1994, p. 36.

11 Ibid., p. 218.

12 Linda Harasim, 'Networlds: Networks as Social Space' in Linda Harasim (ed.), *Global Networks: Computers and International Communication*, Cambridge, MA, MIT Press, 1994, p. 34.

13 J. S. Quarteman, 'The Global Matrix of Minds: Networks as Social Space' in Linda Harasim (ed.), *Global Networks: Computers and International Communication*, Cambridge, MA, MIT Press, 1994, p. 56.

14 Mark Poster, 'Postmodern virtualities', *Body and Society*, 1995, vol. 1, no. 3–4, p. 192.

15 Al Gore, 'Forging a new Athenian age of democracy', *Intermedia*, 1994, vol. 27, no. 2, p. 4.

16 Ibid., p. 6.

17 Labour Party, *Information Superhighway*, London, Labour Party, 1995.

18 Ibid.

19 Poster, op. cit., p. 89.

20 Cristina Odone, 'A patchwork of catholic tastes', *Guardian*, 1995, 18 September.

21 Howard Rheingold, *The Virtual Community*, London, Secker and Warburg, 1994.

22 Amitai Etzioni, *The Spirit of Community*, London, Fontana, 1995.

23 On New Labour and communitarianism, see Stephen Driver and Luke Martell, *New Labour: Politics After Thatcherism*, Cambridge, Polity, 1998.

24 Geoff Mulgan, 'Networks for an open society', *Demos Quarterly*, no. 4, 1994, pp. 2–6; Andrew Adonis and Geoff Mulgan, 'Back to Greece: the scope for direct democracy', *Demos Quarterly*, no. 3, 1994, pp. 2–9.

25 Geoff Mulgan, *Connexity: How to Live in a Connected World*, London, Chatto and Windus, 1997, p. 1.

26 Ibid., p. 33.

27 Ibid., p. 17.

28 Ibid., p. 229.

29 Ibid., p. 118.

30 Ibid., pp. 119, 118.

31 A. Sivanandan, 'Heresies and prophecies: the social and political fall-out of the technological revolution', *Race and Class*, 1996, vol. 37, no. 4, pp. 9, 10.

32 Slavoj Žižek, 'A Leftist Plea for "Eurocentrism"', *Critical Inquiry*, vol. 24, no. 4, 1998, p. 992.

33 Jacques Rancière, *On the Shores of Politics*, London, Verso, 1995, p. 23.

34 Alvin Toffler and Heidi Toffler, 'The Discontinuous Future', *Foreign Affairs*, 1988, vol. 77, no. 2, p. 137.

35 Ibid.

36 Bill Gates, *The Road Ahead*, London, Viking, 1995.

37 Nicholas Negroponte, *Being Digital*, London, Hodder & Stoughton, 1995, pp. 231, 230.

38 David Edgerton, 'Ever Accelerating Hype', *Prospect*, 1997, April, p. 15.

39 William J. Ashworth, 'Memory, Efficiency and Symbolic Analysis: Charles Babbage, John Herschel, and the Industrial Mind', *Isis*, 1996, vol. 87, no. 4, pp. 635–36.

40 Cornelius Castoriadis, *Le monde morcelé*, Paris, Seuil, 1990, p. 18.

41 Manuel Castells, *The Rise of the Network Society*, Oxford, Blackwell, 1996, Chapter 7.

42 Paul Virilio, *Cybermonde, la politique du pire*, Paris, Textuel, 1996, p. 79.

43 Ibid.

44 Ashis Nandy, 'Introduction: science as a reason of state' in Ashis Nandy (ed.), *Science, Hegemony and Violence: A Requiem for Modernity*, Tokyo/Delhi, The United Nations University/Oxford University Press, 1988, p. 12.

45 Cornelius Castoriadis, 'The Crisis of the Identification Process', *Thesis Eleven*, 1997, no. 49, pp. 89–90.

46 Castoriadis, 1990, op. cit., pp. 23–24.
47 Jacques Rancière, *On the Shores of Politics*, London, Verso, 1995, p. 6.
48 Cornelius Castoriadis, 'Anthropology, Philosophy, Politics', *Thesis Eleven*, 1997, no. 49, p. 104.
49 Ibid., pp. 103–4 (Castoriadis' emphasis).

11 THE VIRTUAL PACIFICATION OF SPACE

1 Linda Harasim, 'Networlds: networks as social space' in Linda Harasim (ed.), *Global Networks*, Cambridge, MA, MIT Press, 1994, pp. 16–17, 34.
2 Stephen Graham, 'The End of Geography or the Explosion of Place? Conceptualising Space, Place and Information Technology', *Progress in Human Geography*, 1998, vol. 22, no. 2, pp. 167, 181, 178–79.
3 Slavoj Žižek, 'Multiculturalism, or the Cultural Logic of Multinational Capitalism', *New Left Review*, 1997, no. 225, p. 36.
4 Louis A. Sass, *Madness and Modernism*, Cambridge, MA, Harvard University Press, 1992, pp. 32–33.
5 William J. Mitchell, *City of Bits: Space, Place and the Infobahn*, Cambridge, MA, MIT Press, 1995.
6 Michel Serres, *Les messages à distance*, Montreal/Quebec, Editions Fides/Musée de la Civilisation, 1995, p. 22.
7 Jean-Louis Weissberg, 'Internet, un recit utopique', *Terminal*, 1996, no. 71/72. See also, Jean-Louis Weissberg, 'Savoir, pouvoir et reseaux numeriques', *Terminal*, 1995, no. 67.
8 Iris Marion Young, *Justice and the Politics of Difference*, Princeton, NJ, Princeton University Press, 1990, p. 229. The quotation is from Michel Foucault, *Power/Knowledge*, New York, Pantheon, 1980, p. 52.
9 Ibid., pp. 231, 233.
10 Jean Starobinski, *Jean-Jacques Rousseau: Transparency and Obstruction*, Chicago, University of Chicago Press, 1988, p. 41.
11 Ibid., pp. 252, 222.
12 J.-B. Pontalis, *Frontiers in Psychoanalysis: Between the Dream and Psychic Pain*, London, Hogarth Press, 1981, p. 121.
13 Dorinda Outram, 'Enlightenment Journeys: From Cosmic Travel to Inner Space', paper presented to the Colloquium of the International Group for the Study of Representations in Geography, Royal Holloway College, 1996, 5–7 September.
14 Martin Heidegger, 'The thing' in *Poetry, Language, Thought*, New York, Harper and Row, 1971, pp. 165–66.
15 Ibid., p. 177.
16 Ibid., p. 166.
17 Ibid., p. 165.
18 Ibid., pp. 165, 178.
19 Richard Sennett, *Flesh and Stone: The Body and the City in Western Civilisation*, London, Faber and Faber, 1994, p. 365.
20 Ibid., p. 349.
21 Gilles Châtelet, 'Relire Marcuse pour ne pas vivre comme des porcs', *Le Monde Diplomatique*, 1998, August, p. 23.
22 Al Gore, 'Forging a New Athenian Age of Democracy', *Intermedia*, 1994, vol. 22, no. 2, p. 4.
23 Gabriel Josipovici, *Touch*, New Haven, CT, Yale University Press, 1996, p. 68.
24 Ibid., p. 71.

25 Ibid., p. 75.
26 Christopher Bollas, *The Shadow of the Object*, London, Free Association Books, 1987, p. 14.
27 Young, op. cit., p. 234.
28 Jacques Rancière, *On the Shores of Politics*, London, Verso, 1995, pp. 102–3.
29 Ibid., p. 104.
30 Ibid., pp. 49, 103.
31 Mitchell wants to put the community in the place of the city. Again, we suggest, Rousseau may be a significant reference point. Consider Charles Ellison's comments on Rousseau's attitude to the city: 'Rousseau rejects the city's bonds as excessively slack and prefers, instead, a tightly knit bond of communal intimacy in a small state....The communal bond is anticosmopolitan....In the city selves are "kept apart", not totally and smoothly associated and integrated with one another...[Rousseau praises]...small republican communities, whose social bonds and terms of self and expression are diametrically opposed to those of the cosmopolitan city.' Charles E. Ellison, 'Rousseau and the modern city: the politics of speech and dress', *Political Theory*, 1985, vol. 13, no. 4, pp. 522–23. Now, we are suggesting, the republican communities have become virtual communities.
32 Christine Boyer, *The City of Collective Memory*, Cambridge, MA, MIT Press, 1994, pp. 45, 46.
33 Anthony Vidler, 'Bodies in Space, Subjects in the City: Psychopathologies of Modern Urbanism', *Differences*, 1993, vol. 5, no. 3, p. 36.
34 Ibid., p. 40.
35 Richard Sennett, *Flesh and Stone: The Body and the City in Western Civilisation*, London, Faber and Faber, 1994, pp. 17–18.
36 Ibid., p. 21.
37 Ibid., p. 374.
38 Paul Virilio, *Cybermonde, la politique du pire*, Paris, Textuel, 1996, p. 52.
39 Robert Musil, *The Man Without Qualities*, Vol. 1, London, Minerva, 1995, p. 4 [originally published in 1930].
40 Walter Benjamin, 'Naples' in *One-Way Street and Other Writings*, London, NLB, 1979, pp. 174, 171. This essay was written with Asja Lacis.
41 Howard Caygill, *Walter Benjamin: The Colour of Experience*, London, Routledge, 1998, p. 124.
42 Ibid., p. 121.
43 Bogdan Bogdanović, 'The City and Death' in Joanna Labon (ed.), *Balkan Blues: Writing out of Yugoslavia*, Evanston, Ill., Northwestern University Press, 1995, p. 46.
44 Armand Mattelart, 'Les nouveaux scénarios de la communication mondiale', *Le Monde Diplomatique*, 1995, August, pp. 24–25.
45 William Robinson, 'Globalisation: Nine Theses on Our Epoch', *Race and Class*, 1996, vol. 38, no. 2, p. 15.
46 Ibid., p. 22.
47 Ibid., p. 14.
48 Michael Dear and Steven Flusty, 'Postmodern Urbanism', *Annals of the Association of American Geographers*, 1998, vol. 88, no. 1, pp. 50–72.
49 Mike Davis, *Beyond Blade Runner: Urban Control and the Ecology of Fear*, Westfield, NJ, Open Media, 1992, p. 20.
50 Juan Goytisolo, *Landscapes After the Battle*, London, Serpent's Tail, 1987, pp. 85–86.
51 Ibid., p. 120.
52 Ibid., pp. 85–86.

53 Virilio, op. cit., p. 79.
54 Musil, op. cit., p. 3.
55 Goytisolo, op. cit., p. 86.
56 Daryush Shayegan, 'Le choc des civilisations', *Esprit*, 1996, April, p. 44.
57 See, Chantal Mouffe, *The Return of the Political*, London, Verso, 1993.
58 Joël Roman, 'La ville: chronique d'une mort annoncée?', *Esprit*, 1994, June, pp. 9, 11.
59 Cornelius Castoriadis, 'The Crisis of the Identification Process', *Thesis Eleven*, 1997, no. 9, p. 93.
60 Young, op. cit., p. 234.
61 Jacques Dewitte, 'Le bonheur urbain', *Le Messager Européen*, 1994, no. 8, p. 322.

INDEX